MEMORY AND THE IMPACT OF POLITICAL

TRANSFORMATION IN PUBLIC SPACE

D0861526

A book in the series

RADICAL PERSPECTIVES

A *Radical History Review* book series

Series editors: Daniel J. Walkowitz, New York University

Barbara Weinstein, University of Maryland at College Park

MEMORY AND THE IMPACT OF POLITICAL TRANSFORMATION

IN PUBLIC SPACE ▪ *Edited by Daniel J. Walkowitz and Lisa Maya Knauer*

Duke University Press ▪ Durham and London ▪ 2004

© 2004 Duke University Press
All rights reserved
Printed in the United States of America on acid-free paper ∞
Designed by Amy Ruth Buchanan
Typeset in Dante by Keystone Typesetting, Inc.
Library of Congress Cataloging-in-Publication Data appear
on the last printed page of this book.

*Earlier versions of the following articles were previously published
and are reprinted with permission of the publisher, Duke University
Press.*

Andrew Ross, "Wallace's Monument and the Resumption
of Scotland," *Social Text* 65 (winter 2000).

Cynthia Paces, "The Fall and Rise of Prague's Marian
Column," *Radical History Review* 79 (winter 2001).

Kanishka Goonewardena, "Aborted Identity: The Commission
and Omission of a Monument to the Nation, Sri Lanka, circa
1989," *Radical History Review* 82 (winter 2002).

Mary Nolan, "The Politics of Memory in the Bonn and Berlin
Republics," *Radical History Review* 81 (fall 2001).

Teresa Meade, "Holding the Junta Accountable: Chile's 'Sitios
de Memoria' and the History of Torture, Disappearance, and
Death," *Radical History Review* 79 (winter 2000).

Bill Nasson, "Commemorating the Anglo-Boer War in Post-
apartheid South Africa," *Radical History Review* 78 (fall 2000).

CONTENTS

History, as radical historians have long observed, cannot be severed from authorial subjectivity, indeed from politics. Political concerns animate the questions we ask, the subjects on which we write. For more than thirty years the *Radical History Review* has led in nurturing and advancing politically engaged historical research. Radical Perspectives seeks to further the journal's mission: any author wishing to be in the series makes a self-conscious decision to associate her or his work with a radical perspective. To be sure, many of us are currently struggling with what it means to be a radical historian in the early twenty-first century, and this series is intended to provide some signposts for what we would judge to be radical history. It will offer innovative ways of telling stories from multiple perspectives: comparative, transnational, and global histories that transcend conventional boundaries of region and nation; works that elaborate on the implications of the postcolonial move to "provincialize Europe"; studies of the public in and of the past, including those that consider the commodification of the past; histories that explore the intersection of identities such as gender, race, class, and sexuality, with an eye to their political implications and complications. Above all, this series seeks to create an important intellectual space and discursive community to explore the very issue of what constitutes radical history. Within this context some of the books published in the series may privilege alternative and oppositional political cultures, but all will be concerned with the way power is constituted, contested, used, and abused.

Memory and the Impact of Political Transformation in Public Space is the first of two planned volumes on public history with origins in the *Radical History Review*. Both of these collections, by internationalizing issues recognizable to historians in the United States, familiarize the seemingly foreign from a radical perspective and expand the far-too-often U.S.-centric field of public history. A future volume will examine race and empire in

national narratives; the essays in the present volume, each a lively window on to public spaces around the globe—from Sri Lanka and Harbin, China, to South Africa and Scotland—demonstrate how historical interpretations of public sites have shifted with the rise and fall of political regimes and changing political currents all over the world. Nor is "revisionism" anything new; these essays trace reinterpretations as far back in time as the medieval and early modern eras. Moreover, historians play a supporting role at best in these struggles; rather, what we see time and again is the central role of politicians and a politically charged citizenry, with historically specific interests, constraining curators, architects, and those with a dissenting view of the past. The sites of these contests, however, represent a radical expansion of the sphere of public history and the arenas in which the past is contested. Museums and monuments are well known sites for historical presentation. However, in accounts of unbuilt monuments or repressed songs in Nicaragua, this collection reminds us that if History is the winners' story, then the radical historian exploring the politics of space needs to look for absence and listen to silence.

Lisa Maya Knauer and Daniel J. Walkowitz

History and memory have become highly contentious public issues in recent years, and political events place these struggles over historical interpretations in high relief. As we assembled the manuscript for this book, the World Trade Center was attacked. As a monument, the World Trade Center lent itself to markedly different readings in its life and death. Some saw the towers as arrogant and vulgar representations of capitalist greed and insolence. Architectural critics derided their massiveness, blandness, and sheer ugliness. Others saw them as more benign symbols of the global city.

The towers' status as part of U.S. and global public history, and of millions of people's private and collective memories, was evidenced in the moments following the attacks and reinforced in the succeeding months. From the very first, History and Memory were referenced continuously by President Bush and then-mayor Guiliani and by scores of others. Politicians and media pundits incorporated a particular rendering of U.S. (and global) history into a new national narrative rolled out to legitimate the "war on terrorism." These narratives invoked the Twin Towers as symbols of national unity.[1] But simultaneously we saw alternative, often oppositional, histories and memories articulated and enacted—some of them literally before our eyes. Even as the towers collapsed, thousands of ordinary New Yorkers of all colors, classes, and religions went out into the public spaces of the city—streets, subway stations, parks—to bear witness and seek solidarity but also to search for their own meanings. These spaces also became intensely social, animated by an uninterrupted flow of people coming to mourn, debate, and protest.[2]

How public space was used became a matter of urgent concern as city and federal authorities, invoking national security, tried to limit access to certain public spaces in the city and restrict their uses. These tensions between what is now labeled "homeland security" and the "right to the

city" have continued and deepened. And almost immediately—certainly long before the smoke and dust cleared from the Lower Manhattan skyline—politicians, scholars, and critics took to the airwaves and editorial columns to opine about what kind of monument or memorial (or both) should be built at what came to be known as "ground zero." The questions that animated the public debate represent many of the same questions that have surfaced in public history controversies around the world in recent years. Who has the right (or power, or authority) to decide what happens at a particular site? Is it more appropriate to reconstruct a building or monument that has disappeared or been destroyed, or should something completely new occupy that space? What is the proper "tone" for a memorial: should it be a site of mourning, celebration, or both? How do competing interests (commerce versus contemplation, multinational versus local capital, business versus residence) get mediated? If all of a city and nation's commemorative and reconstructive energies are focused on a single location, will other sites be ignored and other histories left out or obliterated?

Carried out in op-ed pages, public forums, and the proverbial back rooms and boardrooms, the ongoing discussions illustrate the transformative power of a political event to reshape the historical meanings we impose upon, or derive from, a contested public space. In these cases memory becomes central to shaping how an event is understood and who authorizes the understanding. New players can be empowered while the authority of others can be diminished. The needs and desires of a relatively small group of people (the families of the twenty-eight hundred killed in the attacks and rescue efforts) assumed a privileged position, effectively erasing other histories and memories.[3] And as the discussion over the WTC site—and the "war on terrorism"—demonstrates, even "the September 11 families," as they have come to be known, do not speak with a single voice.[4] The WTC controversy illustrates how public tragedies, wars, and other social and economic changes affect how we see ourselves and how we wish others to see us. However, the findings—and what, if anything, is done with them—also reflect the politics of the moment. In this regard much of the public discourse in the United States concerning the destruction of the WTC and plans to rebuild has been marred, in our view, by a narrow self-centeredness ("the attack on America") and lack of historic depth. The events of 9 / 11 are presented as the greatest tragedy, the most horrible crime, and the worst scene of destruction in recent history; to suggest otherwise brands one as disloyal and potentially suspect.

Yet these issues are not unique to New York City, the United States, or to the present, although one would hardly know that from reading the local and national press in the days following September 11. But the exceptionality, immensity, and intensely personal character of the WTC bombings to Americans provide compelling reasons to decenter the U.S. story—if only to provide a fresh perspective and some distance from it.

To be sure, the present collection is not the first such account of recent struggles over how a society wishes to see itself remembered and/or memorialized. In fact, struggles over history and memory have produced a virtual cottage industry in the past twenty years. A perusal of the endnotes in the essays that follow demonstrates extensive use of this material in thinking about how the past is contested and represented in public spaces, museums, and in the built environment (from architecture to statuary). The bibliography at the end of this volume further attests to the scope of this literature and hints at its richness. There has been intense public interest and heated debate over what are often seen as "academic" topics. However, much of the public discourse in the United States has been rather narrowly focused. Critics of the "new social history" or historical revisionism allege that the left-wing political agenda of historians has led to overly ideological and distorted representations of U.S. history. Usually described as "the culture wars," a substantial body of the literature on history and memory has rehearsed these battles well. Another set of debates has focused on war and memory, with particular emphasis on the Holocaust and World War II. A central question has been, Who is authorized to interpret events that are viewed as national narratives?

These debates, we believe, are permeated with "American exceptionalism"—the belief that ours is the national narrative that matters, that we are the world—and a surprisingly ahistorical perspective. Significant political events, such as wars and revolutions, that have occurred in the past, and outside the United States, have often involved rewriting or reinterpreting history.[5] The past decade has witnessed a proliferation of Truth and Reconciliation commissions following changes in political regimes. We have seen, for instance, the dismantling of the apartheid government in South Africa and the dissolution of the Pinochet dictatorship in Chile, as well as the end of civil war in Guatemala and El Salvador. The essays in this volume, then, offer fresh perspectives on what have become parochial debates focused solely on the United States, and on equally stale discussions about the supposed agency of historians, relocating the frame of the

U.S. story with examples of the monumental impact of political transfor-
mations and disputes over public sites around the world. Thus, the United
States is an "absent presence" in this volume.

Collectively, the authors represented here shift the terms of discussion
in at least three productive ways. First, they internationalize the discussion,
demonstrating that similar struggles over history and memory occur
worldwide. Second, they remind us that although historians are often bit
players in these accounts, the history is no less contested and the memories
no less problematic. Indeed, these essays uncover a much broader social
and political arena in which the past is made and unmade by numerous
social agents, including politicians, architects, interest groups, and the mili-
tary. And third, they demonstrate that struggles over the past are not new
conspiracies of postmodern historians; citizens have fought over the mean-
ing of historical sites for hundreds of years. Political transformations, then,
serve as triggers or flashpoints for renewed struggles over the legacy of the
past. All of the essays look at the impact of recent political transformations
on the forms, places, and voices through which public histories are told in
different countries. By assembling essays that deal with varied temporal-
ities, geographies, and societies of differing scales and political natures, we
hope this collection broadens the terms of the discussion as they are usu-
ally understood, not only in the United States but elsewhere as well.

The two halves of this volume's title merit further discussion. Nations—
as Anderson, Bhabha, Sommer, and others have reminded us—are con-
structed and bound together by imaginative, narrative, and symbolic
means.[6] Ruling regimes of all political stripes selectively utilize the past as a
strategic resource and erect historical monuments, construct grand build-
ings, and, more recently, create touring exhibitions of their "national trea-
sures" to bolster their international image, shore up domestic support, or
placate critics.[7] Questions of how the nation is imagined, and who lays
claim to defining and defending it, are intimately intertwined with ques-
tions of history and historical representation. Histories are both temporal
and spatial, and in this volume we are concerned with the specific social
space of the nation—although the boundaries of that space are open to
question.

While the overall framework is the nation, and how political changes at
the national level affect the ways in which histories are made and under-
stood, many of the projects analyzed by these authors are quite local—a
few square miles of northeast China; an archaeological excavation in the

historic center of Vilnius, Lithuania; the memory-landscape of rural villagers in El Salvador's Chalatenango Province. When debates over history and memory become public matters, like those surrounding the World Trade Center site, the controversies invariably take on a myopic character—they are seen as bound up with political and social divisions in that particular city or country. Much of the burgeoning, and often excellent, scholarship on these subjects has taken a similar form, hewing to the specific cultural, national, or regional context and rarely looking "abroad." The literature thus reproduces and reinforces divisions that can be both productive and limiting. Numerous monographs and collections exist on postcoloniality, on American culture, or post-Soviet Europe, but they mostly remain within the context and culture presented by the site-specific public memory controversies. The intent of this volume is to cut across these political, cultural, and geographical divisions. We want to ask how these specifically situated controversies and these varied contexts speak to each other, and we look for broader currents. The underlying issues of memory and history, we believe, offer insights that transcend the local political configurations that are usually granted substantial (if not sole) explanatory power.

■ ■ ■

The volume is organized into five sections that trace a rough typology of public history sites and spaces. Nearly all of the public history initiatives these authors examine are related to multiple locations, and all address, in one way or another, the relationship between memory and place. We begin with monuments, which are the most time-honored, spatially fixed, and unquestioningly acknowledged as "public history" sites.

Publics have been trained to view monuments and historical markers, whether massive obelisks, towering representational statues, or modest plaques, as carrying an aura of unity, universality, and timelessness. Yet the decisions about what sites to mark and the formal aspects of the monuments are often highly politicized and contentious. Recall, for example, the early outcry when Maya Lin's minimalist design was selected for the Vietnam Veterans Memorial in Washington. However, signs of the struggles are often erased in the final product. The essays in the first section, "Monuments," document four such struggles. These essays demonstrate that decisions about which sites deserve to be memorialized implicitly contain decisions about other sites that are left unmarked. Sometimes recent events

redefine how contemporary social actors understand both the past and monuments that were erected in another era. In Andrew Ross's analysis of the monument honoring the thirteenth-century Scottish nationalist hero William Wallace, Ross argues that contemporary mass media representations—as well as the fits and starts of Scots nationalism, which occasionally takes the form of calls for independence from "the English yoke"—can substantially alter how we view the past. Sometimes, as Ross demonstrates, the alteration is quite literal: the commercial success of the movie *Braveheart* led to the erection of a new monument to Wallace in the form of a statue looking remarkably like Mel Gibson, who portrayed Wallace in the movie.

In this volume, as Cynthia Paces notes in her study of Prague's Old Town Square, "empty spaces tell as many stories as . . . historical monuments." Paces's discussion of Prague's Marian Column, for example, moves from the fourteenth century to the present, arguing that the planned monument's meaning has changed with the political tides. Moreover, the power of memory—individual and collective—does not always depend on a physical marker. In fact, as French historian Pierre Nora has argued in his influential work on *les lieux de memoire* (memory sites), sometimes the creation of a marker lulls people into complacency; if the marker does the memory work for us, argues Nora, we are less vigilant and can allow ourselves the luxury of forgetting.[8] Paces's essay examines how the political changes that carved the Czech Republic out of the former Czechoslovakia affected plans for a tribute to the Virgin Mary in Prague's Old Town Square—the long-awaited Marian Column. As the very shape and texture of the nation change, history takes on radically different meanings. In addition, even when there is agreement about which sites to mark, not all of the monuments that are planned are actually built. For every monument erected, others remain on the drawing board, as Kanishka Goonewardena effectively demonstrates in his study of Sri Lanka. Lack of consensus about the symbolic language that could best represent the newly independent state of Sri Lanka, with its precarious claims to multiethnicity, effectively sidelined the effort to create a national monument.

Anna Krylova examines another stillborn project, the proposed (but never built) monument to the Unknown Russian Soldier of the Second World War. Krylova, like Goonewardena, looks at how the emergence of new national formations impels the reinterpretation of history. This time, however, the new national formations are the former Soviet republics, some of which had been independent countries prior to the establishment

of the USSR. Within both Russia and its neighboring areas, scholars, political leaders, and ordinary folks contested the role of Russian language and culture and also the legacy of the Soviet period. Within that seventy-year span, debates over the meaning of the Second World War and the Soviet role in that war expose some of the deep social and political rifts in Russia today. Whereas Goonewardena's article focuses on struggles among political elites, Krylova's essay studies debates involving a broader social spectrum, including World War II veterans, old and new Communists, members of other political parties, and professional historians.

In the United States that war continues to be refought on television and in Hollywood, and it has been the subject of several controversial museum exhibitions. But historians, political elites, and citizens in countries that fought on both sides of that conflict have seized on the Second World War as a defining moment, as the essays in the next section of the book on museums further elaborate. Mary Nolan's article engages a wide range of debates concerning the politics of Holocaust memory and memorialization in postwar, and then postunification, Germany. She focuses on the public, political, and scholarly responses to a controversial photo exhibit documenting the Wehrmacht's campaigns in Ukraine, White Russia, and Serbia. Nolan details how right-wing nationalism fueled the claims by German politicians—in language that echoes the rhetoric of the *Enola Gay* controversy in the United States—that the exhibit was "unbalanced" and represents sloppy historical research.

As Daniel Seltz illustrates, the politics of postwar history are no less vexed in Japan. In a comparative study of museum political culture, Seltz examines a number of Japanese museums that depict the history of the atomic bomb and the war. Intense political pressure from all sides has produced a dehistoricized narrative at the "official site"—Hiroshima's Peace Memorial Park and Museum—which focuses on the "creation of a sacred atmosphere." Seltz contrasts Hiroshima with newer exhibitions in Nagasaki, Kyoto, Kawasaki, and Osaka, which have suggested broader, more open-ended definitions of peace. Certain sites may be more or less subject to national political pressures—that is, the politics of place are often refracted through the prism of internal geopolitics. Seltz also suggests how the winds of political change may affect interpretation: the death of the emperor in 1989, as well as claims that Japan should "contribute" to the United States' Gulf War campaign, made it possible to ask new questions about both the country's past and its future.

Museums are often viewed as warehouses of the past and repositories of national narratives. While most discussions of museum politics focus on the content—what goes on inside the four walls—museums are also part of the built environment, most often in cities. The essays in the third section of the book move out into the cityscape, viewing it as a complex, variegated terrain in which multiple and often divergent narratives are imagined and enacted. Sometimes political changes move a city from one national jurisdiction to another. This is the case in the former Russian and now Chinese city of Harbin, examined by James Carter, and the visitor must look hard beneath the surface of the contemporary city to discern vestiges of that now discordant history. Memory work becomes a process of excavation. Digging into the ruins of the past is literally the subject of John Czaplicka's article about Vilnius (formerly Vilna). Here an archaeological site, the duke's castle, becomes a staging ground for a discussion of Lithuania's desire to "return to Europe" but under the aegis of an essentialized, romanticized, and ethnically problematic rewriting of the city's and country's past.

The essays in the fourth section of the book consider the politics of remembrance in memory sites—both efforts to memorialize recent national traumas and the need to continually reinterpret the ancient past in light of current political shifts. These essays also engage issues of memory and forgetting but most poignantly in societies where political change threatens to reopen wounds that are fresh or incompletely healed. Under such circumstances widespread amnesia is accepted as the price of social peace after a civil war or the ending of a dictatorial regime. Such was the case in newly democratized Chile, argues Teresa Meade. In Meade's view Chileans across the political spectrum agree that the best way to put the past behind is not to dwell on it too much. Therefore, the memory sites that correspond to the Allende years and the repression, torture, and killings of the Pinochet regime are incompletely marked, and the extant markers tell only part of the story at best. Only the first-person narrative of a witness to those troubled times makes them fully legible.

Personal narrative in the shape of informal storytelling plays a powerful role in postwar El Salvador, analyzed by Irina Carlota Silber. Silber's essay is based on ethnographic research among residents of Chalatenango Province, where some of the bloodiest massacres of the decade-long civil war took place. Memory work, in particular the narratives of the survivors of those gruesome events, animates the landscape and commemorates the

past, subtly subverting the government's attempts to carry on with business as usual. In a country where the majority of people live in conditions of crushing poverty, Silber asks how reconciliation and the process of democratization can be predicated on a policy of forgetting past violence and injustice. As Meade discusses in her analysis of post-Pinochet Chile, reconciling national conflicts through a politics of forgetting comes at a cost. The legal case against the former dictator, which began its slow march through the Spanish and British court system a decade after he left power, demonstrates how unpleasant episodes that have been erased or silenced can reemerge with devastating force. In contrast to the unmarked or incompletely marked sites discussed by Meade and Silber, a visit to Israel's Masada monument, analyzed by Yael Zerubavel, is a regular feature on tourist itineraries and, until recently, an obligatory part of school curricula. Zerubavel, in fact, suggests that Masada's significance may be blunted by overexposure.

Narratives in public sites, then, can take many forms—they can be presented in images and displayed, condensed and congealed into monuments, represented in physical spaces or projected through storytelling. But they can also be animated as public spectacle, in performances and parades, or translated and transcribed into popular music and song. The final section of the book moves beyond physical sites to look at these performative enactments of histories. T. M. Scruggs's article on Nicaragua considers popular song as a medium for the construction, negotiation, and preservation of popular memory. Songs are a mass-mediated form of public history, particularly the socially conscious popular song movements in Latin America. "Regime changes," to use President Bush's infelicitous term, often have reverberations in a country's "soundscapes." After the electoral defeat of the Sandinistas in 1990, the new ruling elite eradicated many visual markers of the Sandinista era, most notably the vibrant murals. But, according to Scruggs, Sandinista-era songs continue to circulate through live performance and powerful public events, providing an aural counternarrative to the neoliberal policies and aesthetics of the conservative elite.

Bill Nasson's essay on the changing meanings of the Boer War in postapartheid South Africa takes traditional "brick and mortar" monuments as a starting point for examining how black and white South Africans in the new, "nonracial" South Africa view monuments commemorating Afrikaner resistance to European rule. When the white minority is no

longer the dominant political force, is what was formerly seen as national history downgraded to the status of a sideshow? Nasson's analysis explores how the physical monuments, with their aura of fixity and immutability, are animated through rituals of remembrance such as parades and even battlefield tourism. In both Nasson's and Scruggs's essays performative acts of remembrance are crucial to the active construction of meaning.

While this book is formally structured around these four types of sites, several other typologies run through the volume and pull the individual essays into dialogue and contrast with each other. Two major political transformations in particular animate these essays. The first is the wave of national liberation and decolonization movements in much of the "third world" during the second half of the twentieth century. As former European colonies in Africa, Asia, and the Caribbean gained formal political independence, the new regimes had to grapple with the intellectual and ideological legacies of European rule—including the monuments, icons, and cultural and educational institutions left behind. The second sea change is the reorganization of Eastern Europe and the former Soviet bloc, beginning in the late 1980s and highlighted by the dismantling of the Berlin Wall in 1989, which was broadcast live throughout the world. What these two processes of decolonization and reconsolidation share is their transnational or global scope. Each comprises concurrent or sequential changes in several different nations and often involves wholesale redefinitions of national territory and identity (including redrawing the borders and renaming the country).

Our own interest in this subject was piqued in part by the breakup of the former Soviet bloc and its wider cultural and historiographic ramifications; therefore, a substantial number of essays (Czaplicka, Krylova, Nolan, Paces) look at how histories are imagined, narrated, and memorialized throughout this region. In some cases (the former countries of Yugoslavia and Czechoslovakia) national boundaries are rewritten by splitting off regions. In Germany, by contrast, independent countries were reunited after half a century to create a new / old nation. Mary Nolan probes behind the rhetoric of an "eternal Germany" to look at how the same events are understood in cities that were formerly capitals of separate and politically opposed countries.

As noted earlier, the Second World War is cast as a defining moment on all sides of that conflict. The reenactment of that same war through cinematic, televisual, monumental, and other narrative means, in different

countries, and its incorporation into different mythologies, raises some larger questions about the relationship of war and national identity. Although wartime memories are often mined to bolster national unity, they can also be divisive when the experience of one group—military veterans, for example is given a privileged status in interpreting the war. But we need to be careful in making international comparisons, and the role of veterans—and the military in general—needs to be more thoroughly theorized in particular national contexts. In the United States, World War II veterans' voices were heeded in the *Enola Gay* controversy, whereas in Russia veterans of that same war were seen as relics of the now-discredited Soviet era, and a Russian counterpart to the stateside World War II commemorative industry remains stillborn. And several of these authors caution against presuming that all members of a group, whether war veterans or victims, share the same interests and speak with the same voice.

Many of these essays also examine conflicts on a national scale that occur within geopolitical regions. In some instances the transformations have to do with extending the democratic promise underlying nominal independence. For example, nearly a century after South Africa had won formal independence from direct colonial control, the apartheid government began to crumble. In early 1990, in a dramatic gesture, President F. W. Botha released Nelson Mandela from prison, paving the way for the dismantling of apartheid and a more democratic government and society. Nasson's essay examines how the Boer War—seen by many Afrikaners as their anticolonial struggle—is reinterpreted in the postapartheid era.

Some of the democratic transitions were less dramatic, more protracted, or less definitive. During the 1980s and 1990s several Latin American countries that were previously ruled by right-wing military dictatorships began what was often a slow and halting transition to democratic rule. In some instances, such as Chile, which is examined by Teresa Meade, military dictators lulled by fantasies of their own invulnerability permitted the elections that rudely voted them out of office. In El Salvador, the subject of Irina Carlota Silber's essay, a decades-long civil war was finally ended when the guerrilla forces led by the FDR-FMLN and the ruling right-wing ARENA Party signed peace accords in 1992. However, there were also political changes in which the pendulum swung from left to right. In Nicaragua, after a decade in power, the government of the Sandinista National Liberation Front lost elections in 1990 to the U.S.-backed opposition. T. M. Scruggs looks at the impact of this shift on Nicaragua's musical landscape.

In Israel, on the other hand, the focus of Yael Zerubavel's contribution, the last two decades have seen both subtle and profound shifts in political life and public discourse. These developments include several elections, in which the nature of government changed profoundly, and a protracted conflict with the Palestinians (which has involved war, occupation, assassination, suicide bombings, popular uprising, and an intermittent peace process). Political transformations are thus often closely intertwined with cultural, ethnic, and religious fissures in the body politic. This is also evident in Kanishka Goonewardena's discussion of Sri Lanka. Geographically and culturally far removed from many of the other countries treated in this volume, Sri Lanka underwent a national crisis at the end of the 1980s, marked by civil war and ethnic insurrection. Sri Lanka, in fact, experienced several waves and kinds of political transformation in quick succession. The challenges to the newly independent nation were both internal (competing territorial claims, revolutionary impulses) and external (threats from powerful neighbors).

Indeed, sometimes the path to a common goal—achieving national reconciliation in the wake of upheaval and trauma—takes very different twists and turns because of the nature of the political transformation at issue. In South Africa, for example, the process is resolved. There may be substantial electoral shifts, or even fairly radical changes in political alliances, but the apartheid era is definitively over. In Chile, by contrast, according to Meade, the political transformation remains unresolved. The impact of truth and reconciliation efforts reverberates very differently in these countries' struggles over historical memories.

For many of the writers represented here, debates about nationality and nationalism are crosscut and complicated by ethnic and religious differences and divisions. Where Goonewardena looks at how a new state, Sri Lanka, works to create a new national mythology, other authors explore how new pressures shape existing national mythologies (in Scotland and Israel, for example). The complex nature of Jewishness and its somewhat vexed relationship to national identity pops up both in places where it is part of the dominant national narrative (Israel) and in areas where its claims are more precarious (Lithuania, the Czech Republic, Germany). Zerubavel's article on Masada explores how, in the modern state of Israel, a particular incident of ancient, prestate Jewish history is both foregrounded and sacralized to bind Jews—both Israeli citizens and diasporic (mostly American) Jewish tourists—to the state of Israel.[9] If a particular narrative of

Jewishness is perhaps excessively, even oppressively, present at Masada, to the exclusion of other (Palestinian and Arab) claims of belonging, Jewishness has been evicted elsewhere.[10] In exploring the controversies surrounding a monument to the Virgin Mary in Prague, Cynthia Paces examines the construction of a Czech "imagined community" that equates the Czech nation with Catholicism, effectively erasing a centuries-long Jewish presence. Jews were also a significant presence in pre–World War II Vilna (now Vilnius), notes John Czaplicka. But, as in Prague, the politics of remembrance surrounding the reconstruction of the duke's castle imagines a return to a "pure" (Christian) Lithuania. Elsewhere, however, as Mary Nolan notes, the absence of Jews as the result of the Holocaust has animated a national debate in Germany about the yet unbuilt Monument to the Murdered Jews of Europe.

These efforts to turn sites that are significant to a single religious community into national landmarks within multiethnic nations interrogate the very concept of the modern, secular nation-state. But "site sacralization," a process by which historical actors designate locations as significant and even evoking a quasi-religious sense of reverence, is also part and parcel of tourist development.[11] As leisure is increasingly commercialized and industrialized under late capitalism, more countries, regions, municipal governments, and specific interest groups try to enter the growing "heritage tourism" market, including socialist and formerly socialist countries. As Barbara Kirshenblatt-Gimblett notes, history becomes "heritage" and places invent or reinvent themselves as "destinations"—in part by promoting existing attractions or creating new ones from scratch.[12]

Culture and tourism are often promoted as a potent balm to heal the wounds of the past, while providing economic fuel for postconflict recovery. We have seen politicians and business leaders extol the curative powers of cultural consumption in the wake of the events of 9 / 11, and the various plans for the World Trade Center site were scrutinized for their ability to inject a hefty dose of tourist dollars into the faltering municipal economy. Several authors, including Zerubavel, Nasson, and Meade, explore the relationship of public history sites and projects to the burgeoning leisure and tourist industry. Zerubavel and Nasson, in particular, address the contradictions that arise when commercial objectives—commodification, privatization, increasing tourist traffic, and profitability—run counter to other needs, such as preservation or the desire to maintain a more reverential atmosphere.

Several of the essays deal with forms of expression not usually considered within the framework of "public history," taken to mean museums, monuments, and exhibitions (and sometimes documentary film or photography). Specific essays, and indeed the collection as a whole, work to broaden our understanding of the politics of public history: who makes it, in what kinds of social spaces, and in what forms. Profound political changes have powerful reverberations in the everyday lives of ordinary people. These political shifts often necessitate multiple and varied reinterpretations of history to engage with a changed present. That is, representations of the past reverberate within the vernacular realms of popular culture and daily life. They both reflect and constitute a resource to negotiate political change. Most of the chapters look at physical representations and contestations of the past. Even the unbuilt monuments and unmarked sites are inherently visual in their frame of reference; these are physical landscapes that should be marked, structures that ought to have been constructed or restored.

Less-tangible but no less social spaces are created through performance and everyday practices. Music is often a useful barometer of how people make meaning of political and social events—that is, how recent and past histories are shaped and reinterpreted.[13] In Scruggs's essay on popular music in Nicaragua before, during, and after the Sandinista era, it is not only the song lyrics that are significant but also the musical forms themselves that simultaneously register and intervene in broader social processes. When the national airwaves are dominated by nonnational music as a result of their takeover by corporate, neoliberal interests, the memory work of singer-songwriters and audiences alike creates a repository of national memory, becoming an alternative public sphere.

Economic, cultural, and political processes of change, then, are closely intertwined, although they do not always follow parallel courses. After the bloody suppression of the Tiananmen Square protests, the Communist regime in China has sought to forestall an indigenous "perestroika" through highly controlled experiments at marketization. These include efforts to turn historic sites such as the Buddhist temple and Russian Orthodox church analyzed by James Carter into tourist attractions.

We hope that the variety of issues, sites, and national contexts covered by these essays will prompt readers to reflect on the nature of political change and its impact on how histories are understood, contested, and represented. In both South Africa (Nasson) and Eastern Europe / Russia

(Krylova, Nolan, Paces, and Czaplicka), for example, we can discern huge reconstructive reimaginings of history in the wake of profound changes in the national state. However, we need to be wary of facile parallels. In South Africa the contours of the nation were not at issue but, rather, who spoke for the nation. Eastern Europe, by contrast, saw civil wars over space, memory, and definitions of national belonging. Is there a difference between struggles where anticolonialism was a factor and those where ethnically defined nationalism comes into play? We do not presume to provide definitive answers but rather to suggest some useful frameworks to advance the discussion.

■ ■ ■

A final word about race. Implicit in many of these essays is the way in which national identities are refracted through the prism of race. While this is clear in the most obvious examples (South Africa leaps to mind), in most countries the "imagined community" is racialized (and also gendered). In Nicaragua, for example, both indigenous identity and African heritage occupy problematic spaces in the national imaginary. While indigenousness is lauded as a cultural resource, labeling someone an *indio* is an insult. The geographical and linguistic isolation of the English-speaking Afro Caribbean population on Nicaragua's Atlantic coast contributes to the construction of an ideal national subject who is figured as *mestizo* (literally, "mixed," but used to describe someone of Spanish and Indian ancestry). Similarly, in the Jewish state of Israel, the issue of indigenousness has been complicated by racial, ethnic, linguistic, and religious differences. The authorized "national" histories often erase Palestinian Arab narratives or consign them to a remote past. Israeli Jewish identity is itself a problematic construction, as the Jewish population is not culturally homogenous. Diaspora myth-making often romanticizes the Israeli-born *sabra*. However, in current-day Israel, *ashkenazim* (Jews of German or East European ancestry—a minority of the Jewish population) occupy a privileged position in the country's political and cultural institutions, while the more numerous *mizrahim* (Jews of Middle Eastern or Levantine heritage) remain second-class citizens, and their linguistic and cultural distinctiveness is frequently racialized.[14] Ethnicity and religion are often racialized, as evinced by Czaplicka's and Paces's analyses of the problematic figure of the Jew as racial outsider in the national histories of Czechoslovakia and Lithuania.

These issues are only hinted at in this volume, however, and certainly merit a fuller discussion. A second volume of essays, provisionally entitled *Race and Empire: Narrating the Nation in Public Space*, will also draw together an international array of authors to explore the complex intertwinings of racial and national identities around the world. This subject, too, is familiar to U.S. historians and the American public. But this second volume will again look at how museums and public memorials in places as diverse as New Zealand, Australia, South Africa, France, and Canada confront similar problems incorporating the experiences of racial "minorities" and colonial pasts into national narratives.

■ ■ ■

The creation of this book has involved collaboration on numerous levels. This project had its origins in the pages of *Radical History Review*. Daniel J. Walkowitz, a longtime member of the journal's editorial collective, invited Lisa Maya Knauer to help edit a series of articles on the impact of political transformation on public history. As we reviewed the initial submissions, and began to brainstorm additional commissions, we realized that these individual essays would benefit from being placed in closer dialogue with each other. Our colleagues in the RHR editorial collective have given this project their enthusiastic support, as has Valerie Milholland, our editor at Duke University Press. The comments of two anonymous reviewers were helpful in clarifying the focus of the volume and, in particular, in helping us revise this introduction to more fruitfully engage the issues raised by the authors of these essays. We also benefited from the input of Judith Walkowitz and Max Page, who read and offered useful critiques of the introduction. Finally, Daniel J. Walkowitz wishes to acknowledge the support of the Stanford Humanities Center, where he spent 2001–02 ruminating about this project.

NOTES

1. To be sure, there were some critical voices raised, but they were largely confined to university symposia, the alternative media, and newspaper op-ed pieces. Most broadcast and print journalism joined the chorus of flag waving.

2. The most densely used space was Union Square Park, itself a rich palimpsest of historical layerings. After the fall of the towers police barricades were set up along Fourteenth Street, and only those who could prove that they lived or worked in the

restricted zone were allowed entry. People began to congregate along the police barricades, getting as close as legally permissible to what became known as "ground zero." Union Square was the only public park along Fourteenth Street, but it also occupied a unique historical space, as a site of radical public protest dating back to the nineteenth century. It became the central staging ground for rituals, performances, and protests. For an analysis of the gentrification and the reconstruction of Union Square Park in the 1980s see Deutsche, *Evictions*. The late public historian Deborah Bernhard spearheaded an effort to commemorate the working-class histories of Union Square. See David Firestone, "Public Lives: A Life's Work: Honoring Those Who Labored," *New York Times*, Sep. 4, 1998, B2. The protests and memorials at Union Square Park and elsewhere have been the subject of several photography exhibitions and video documentaries. An impressive dossier of images from New York and around the world can be found (as of March 11, 2004) on the Independent Media Center's Web site (http://NYC.indymedia.org). For a lively and intelligent take on the problematics of memory and the construction of "9/11" see Barbara Kirshenblatt-Gimblett's essay, "Kodak Moments, Flashbulb Memories: Reflections on 9/11," available on the Tactical Media Group Web site, http://www.nyu.edu/fas/projects/vcb/case_911/pdfs/kodak.pdf (accessed Feb. 5, 2004).

3. One irony, noted by several commentators and scholars, was that the Washington Market area, which was razed to build the World Trade Center, was home to a thriving, multiethnic Middle Eastern community in the late nineteenth century and early twentieth.

4. Some families have been especially vocal opponents of the U.S. government's use of their loved ones' memories to justify its military actions. See, for example, the statement issued by "Families for Peaceful Tomorrows" on the second anniversary of the September 11 attacks, which is available (as of March 11, 2004) at: http://www.peacefultomorrows.org/voices/voices.php?id=P211.

5 When the Twenty-Sixth of July Movement entered Havana in January 1959, crowds expressed their dissatisfaction with Batista's dictatorship (and U.S. support for his regime) by toppling the monument to the USS *Maine*, commemorating the event that precipitated (or perhaps *legitimated* would be a more appropriate verb) the United States' entry into what Philip Foner pointedly relabeled the Spanish-Cuban-American War of 1898. When the Paris Commune was defeated, the victorious Royalist forces worked to erase the traces of the Commune and took measures to prevent the erection of popular monuments to the Communards—most notably, preemptively constructing the Basilica of Sacre Coeur on the site of the Commune's last stand. See David Harvey, "Monument and Myth," 200–228.

6. Anderson, *Imagined Communities*; Bhabha, *Nation and Narration*; Sommer, *Foundational Fictions*.

7. There is an extensive literature on these subjects. Arjun Appadurai's often-cited essay "Disjuncture and Difference in the Global Cultural Economy" poses the idea of selective uses of the past. The essays in Hobsbawm and Ranger, *The Invention of*

Tradition, explore the cultural politics of nationalism. For discussion of the politics of museums, monuments, and touring exhibits see Bennett, *The Birth of the Museum*; Duncan, *Civilizing Rituals*; Karp and Levine, *Exhibiting Cultures*; Kaplan, *Museums and the Making of "Ourselves"*; Boswell and Evans, *Representing the Nation*.

8. Nora introduced the concept of *les lieux de memoire* in an influential article, "Between Memory and History." He later expanded on this in the seven-volume series *Realms of Memory*.

9. The concept of site "sacralization" comes from MacCannell, *The Tourist*. See extended discussion below. A cogent analysis of the politics of Israeli settler museums can be found in Katriel, *Performing the Past*.

10. See Deutsche, *Evictions*. Deutsche adopts the term *evictions* from the housing movement to refer to historical erasures, to histories and peoples that are not just ignored but uprooted and displaced.

11. See MacCannell, *The Tourist*.

12. Kirshenblatt-Gimblett, *Destination Museum*.

13. Within the areas of popular music studies, ethnomusicology, and anthropology there are numerous articles and monographs exploring how music and dance forms reflect broader social processes or directly play a role in social movements. See, e.g., Averill, *A Day for the Hunter, a Day for the Prey*; Hernandez, *Bachata*; Simonett, *Banda*.

14. See Ella Shohat, "The Narrative of the Nation and the Discourse of Modernization"; and Lavie, "Blowups in the Borderzones."

MONUMENTS: BUILT AND UNBUILT

■ *The four essays in this opening section detail contested efforts to commemorate the past in monuments, both built and unbuilt. These struggles belie contemporary complaints from conservative politicians and media pundits that debates over historical representation result from efforts of left-wing historians with a "political agenda." Indeed, here we see struggles over monuments, commemorations in stone and space that date from as far back as the fourteenth century.*

Historians are also largely invisible in these battles. The meanings of these monuments—even those only envisioned but never constructed—changed with the political tides, and historians were generally nowhere to be seen in the discussion. Instead, political elites and the public more broadly constituted shaped these histories, much as they sought to shape the meaning and memory of the nation. In Sri Lanka, as Kanishka Goonewardena illustrates, divisions among elites stymied the construction of a national monument to the new nation. In contrast, Anna Krylova's essay on the fate of a planned monument to Soviet World War II soldiers shows the role public opinion plays in shaping what is to be memorialized in post–Soviet era Russia. Unlike the Enola Gay controversy in the United States, where veterans dominated the discussion, Soviet veterans had to fight to be heard, since their participation in post-Soviet Russia was seen as an embarrassing reminder of the now-discredited Soviet past. Krylova's story is one of the few in which historians' voices do emerge, but are barely audible amid the cacophony of public debate.

To open these discussions, Andrew Ross's essay illustrates the ways popular culture can both reflect and shape the politics of memory. Starting with his own boyhood memories, Ross traces how the massive monument to Scotland's national hero William Wallace has evolved in the social imaginary from a fact of nature to a political symbol to a pop culture icon whose resonance—and even contemporary appearance—is drawn from depictions shaped as much by Mel Gibson's Braveheart *as by struggles over Scottish devolution.*

WALLACE'S MONUMENT AND

THE RESUMPTION OF SCOTLAND

Andrew Ross

Scotland is once again a blip on the radar screen of the "international community." Its fledgling parliament is regularly cited as a regional symptom of new global order, good or bad, depending on the speaker's viewpoint. There is even a major media spectacle to furnish these opinions with strong visuals—the Hollywood blockbuster *Braveheart*, which brought the feats of William Wallace, patriot hero of the medieval Wars of Independence, to a worldwide audience. Indeed, casual consumers of the buzz surrounding the film could hardly be faulted for believing that the country's nationalist revival has had something to do with the rediscovery of an ancient warrior tradition.

Understandably, this perception will be most whimsical to those of us who grew up with William Wallace in our backyard—in the form of the massive monument to his memory that dominates the lower Forth Valley. Since I was weaned in the shadow of the Wallace Monument before the resurgence of Scottish nationalism toward the end of the 1960s, I can recall a time when the famous memorial was more a fact of nature—a stark feature of the landscape—than a resonant political symbol. Built in the 1860s in the Scottish baronial style to evoke a medieval tower castle, and topped by a representation of the Crown Royal of Scotland, it juts high over the Forth Valley like some jumbo joystick, jammed forever in gear and encrusted with the light rime of ages (see fig. 1). Its thirty thousand tons of stone are quarried from its volcanic seat, the Abbey Craig, whose dramatic shape had been sculpted by the retreat of a glacial ice sheet. As a result the monument resembles an outcropping of the craig itself, rising to a height of 220 feet and towering 530 feet above the carselands, once a vast peat moss known as the Sea of Scotland and more recently the home of the great coalfields of the nation's central industrial belt.

As a child I was understandably impressed by the monument's custody of William Wallace's mighty sixty-six-inch broadsword, a relic with all the

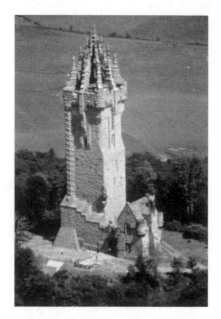

1. The National Wallace Monument. Photo provided by Argyll, the Isles, Loch Lomand. Stirling and Trossachs Tourist Board. Reprinted by permission.

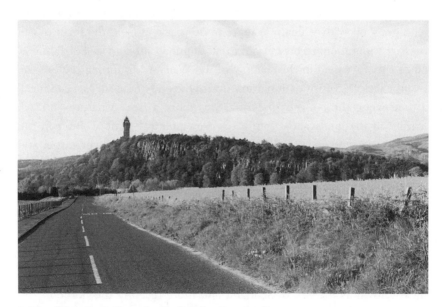

2. The Abbey Craig, from the Forth Valley Carselands. Photo by Andrew Ross.

incantatory power of Excalibur itself. But what caught my fancy more was the knowledge that the valley where I lived had once been an ocean floor and that the bones of a seventy-foot great whale had been found on the northern slopes of the Abbey Craig in the early nineteenth century (fig. 2). Geologic history took precedence over human history.

In retrospect this is a peculiar confession, since I lived in a landscape peppered with some of the more climactic events in regional history. From the monument's height you can look across at Dumyat, an Iron Age dun fort of the Maeatae Picts, on the ramparts of the defiant Ochil Hills, the most southerly of the geological dividers of the Highlands from the Lowlands. Directly below is Airthrey Park, site of the 843 battle in which Kenneth McAlpin defeated the Picts and formed a united Scotland for the first time. In an oxbow of the Forth at the foot of the craig are the twelfth-century ruins of Cambuskenneth Abbey, where Robert the Bruce convened his first Parliament and where James III and his queen are buried. And on a dandy southerly bluff sits Stirling Castle, the favorite fifteenth- and sixteenth-century residence of the Stuart kings and the so-called cockpit of Scotland, on account of its command over the most easterly point at which the river could be forded. You can see also the ruins of Stirling's old jail, in front of which Andrew Hardie and John Baird, Radical leaders of a republican uprising in 1820, were executed by dragoons who drew taunts of "Murder!" from the semimutinous crowd in attendance. Directly below and on the horizon are the sites of the three primary battles of the Wars of Independence—Stirling Bridge (1297), Falkirk (1298), and Bannockburn (1314)—and, over in the Ochils, the heather-carpeted field of Sheriffmuir, where the Jacobites suffered a crushing defeat in the 1745 uprising.

These are all sites of romantic history, much prized by the modern tourist industry, yet they had little hold over me as a child. In large part this had something to do with the strange death of Scottish history itself. For one thing I was never taught any of it at school. In the 1960s and 1970s the history that was deemed most important for us to know and learn was the reformist growth of the British state in the nineteenth century, and, as far as Europe was concerned, the causes and campaigns of the two world wars seemed to be paramount. From the Whig, and unionist, view of the British experience, Scottish history ended with the Treaty of Union in 1707, so in my state school there was no curricular attention to post-Union events, with the exception, perhaps, of a cursory account of the Jacobite threat to the Hanover throne. Since we were viewed, pedagogically, as compulsive

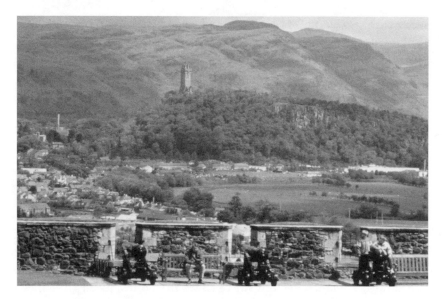

3. The monument, the craig, and the Ochil Hills, from Sterling Castle.
Photo provided by Argyll, the Isles, Loch Lomand. Stirling and
Trossachs Tourist Board. Reprinted by permission.

moderns, there was precious little mention of early modern history in any
form. That has now changed, as a result of the nationalist renaissance, and
indeed the new Museum of Scotland in Edinburgh immerses the visitor
fully in the life of the pre-Union nation.

Depending on your perspective, the strange death of Scottish history
could have been either the hapless by-product of the steady Anglicization
of the national education system (analyzed by George Davie in *The Demo-
cratic Intellect*, his classic study of the nineteenth century) or the enlight-
ened result of the nation's "improvement" through full participation in the
affairs of the multinational British state. Today, these two perspectives are
much more clear-cut and mutually opposed than they once were. For
much of the period of the Union (which may eventually come to be seen as
a mere interregnum), it was customary to be both nationalist and assimila-
tionist, dedicated, on the one hand, to the preservation of cultural identity
and the traditional estates of civil society—legal, educational, religious—
while fully allied, on the other, with the corporatist thrust of industry and
Empire. These were the discrepant loyalties that secured a dual identity for
the stateless nation—allowing for a high degree of autonomy while enjoy-
ing the dividends of its junior partnership in imperial affairs directed by

Westminster. Freed from the stressful demands of high state politics, Scots elites had cultivated the appearance and institutional affect of self-rule, while banking on the Union's gilt-edged name. Was this balancing act as surreal as it sounds? A glance back at the building of the monument gives us some insight into the peculiar condition of nonnationalist nationalism that ensured that Scottish sovereignty after 1707 was kept "undead," in Tom Nairn's phrase, and temporarily confined to a rather shallow grave.

1869

By the first decades of the nineteenth century, the spirits of Ossian were no longer walking the glens, and a cult of William Wallace sprang up, with poems, songs, and busts to honor his memory, alongside that of Robert Burns, the national bard, and Walter Scott, the ace unionist nationalist (fig. 4). Statues of Wallace were erected in Dryburgh, Lanark, Falkirk, Aberdeen, and other sites, and there was much sentiment for a national monument, some of it emanating from radical quarters. In 1832, for example, after the passing of the Reform Act, a memorial was erected to those 1820 Radical martyrs who had been beheaded in Stirling and Glasgow. At the ceremony, the historian Peter McKenzie raised a toast to a nationalist Wallace that was a clear riposte to the only recently deceased Scott: "I hope that the monument now erected would have the effect of shaming Scotsmen, if nothing else will do, into the erection of a monument to that first and greatest of Scotland's patriots. See the thousands of pounds they are now collecting for a monument to Sir Walter Scott, and will they, after this, basely forget Sir William Wallace?"[1] A more conservative case for a monument was expressed in an article in the *North British Review*. The writer contended that Wallace was "a simple Saxon recusant against Norman supremacy, who fell to be ranked with such English heroes as the bold outlaws of Sherwood Forest." Such comments, aimed at the fragile attempt to forge a "North British"[2] consensus in place of the less conciliatory Caledonian one, were carefully worded, for they walked a very fine line.

Letters began to appear in a range of newspapers, Whig and Tory, arguing the case for a national monument. Charles Rogers, chaplain to Stirling Castle, and the inspiration for a rash of monument-building in the region, took the lead in choosing the Abbey Craig site and formed a committee to raise subscriptions. An open air meeting was called for Bannockburn Day (June 24, 1856) to inaugurate the campaign.

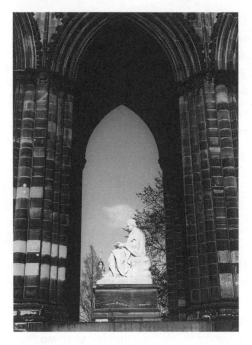

4. "The silent way"—Walter Scott Monument,
Edinburgh. Photo by Andrew Ross.

On that day a grand procession was led from Stirling Castle to the
King's Park, with every sector of polite society represented—from the
Guilds and Masons to the Highland regiments, parliamentary personages,
lord-lieutenants of counties, officials from municipalities, country gentle-
men, clergymen, and the peerage—and with a vast, exuberant crowd in
attendance. An editorial in the *Stirling Observer* reported: "No Scotchman
could be indifferent to the anticipated proceedings. . . . The greatest excite-
ment prevailed and the greatest anxiety was manifested to lend *eclat* to a
demonstration that was deemed national and patriotic." All-important
here was the choice conjunction of "national and patriotic," for it goes to
the heart of the paradox of unionist nationalist sentiment. Speaking as the
committee president, the Earl of Elgin described the proposed tribute to
Wallace as a "tardy honor," and he drew a lesson in politics from his
example by warning "how little a nation gains from forcing foreign institu-
tions, foreign laws, and a foreign religion upon a reluctant and high-
spirited people." The comparison with Irish affairs was most relevant,
though the earl also mentioned the example of the American colonies.

These comments served as a prologue to celebrating the resolute skills of the Scots in having engineered "an intimate union with a people more wealthy and numerous than themselves without sacrificing one jot of their national independence—these results are due to this struggle, which commenced on the plains of Stirling, and was consummated on the field of Bannockburn." Elgin's tribute was a typical, if locally shrewd, commentary on the negotiated settlement of the Union; the canny Scots had gotten a good deal, and they could somehow thank Wallace for putting them in a position from which to negotiate. "Degenerate nations fall," the earl sagely concluded, while "patriotic ones persist."[3]

Subscription lists were opened in every town in the United Kingdom, as well as in India, North America, and Australia. As subscribers pitched in from near and far, the *Stirling Observer* noted dryly that "the amount of their subscription increased in exact ratio to their distance from the land of their sires." Five years later, an even greater crowd gathered for the laying of the foundation stone, resulting in a heady infusion of the carnivalesque into the official pomp and circumstance. "The streets," the *Observer* again noted, "were swarming with people whose 'get up' would have made an anchorite smile." Coloring the motley scene was "an infinite variety of sashes, cockades, flags, and mystic emblems of the brethren of the 'mystic tie.' "[4] A local observer memorialized the event:

> From early morning, trains arrived from all parts. 40 bands of music and pipers innumerable discoursed martial and patriotic airs, "Scots Wha Hae," "God Save the Queen," and the "Mason's Anthem" being the favorites. Various estimates were made of the numbers present, one being placed as high as one hundred thousand, the procession itself extending fully two miles. Conspicuous in the line were 30 companies of Volunteers representing as many regiments . . . the various Artillery and Rifle Volunteers, Curling Clubs, Gardeners Lodges, and Oddfellows and St. Crispin Lodges . . . the ancient society of Omnium Gatherum, the master and pupils of Allan's and Cunningham' Mortifications, the Stirling Cadet Corps, the Seven Incorporated Trades, the Convener Court, the Guildry Officer carrying the Stirling Jug, the members of the Guildry, the Town Officials, the Town Chamberlain bearing on a silver cushion the silver key of the burgh.[5]

The last time, it was noted, that so many men in uniform had gathered was for the Battle of Bannockburn itself. On this occasion it was the

Reverend Rogers who took the opportunity to stress the continuity be-
tween Wallace's example and the achievements of the Union. "Wallace
was responsible," he proclaimed, "for placing a new dynasty on the English
throne, and under Providence was the means of uniting these kingdoms
together on equal terms and with equal rights." The *Stirling Observer* edi-
torial (June 27, 1861) struck a more nationalist chord, while cautioning
against anti-English sentiment: "Let every Scotsman honor Wallace in his
own way without running down his neighbor, merely for expressing the
same sentiments of love and veneration in a different manner from him-
self." Readers were further encouraged to heed not "the scoffs and jeers of
The Times and other Cockney periodicals, and give some color to their
ridiculous assertion that our nationality is only a species of provincialism."

The tension between expressions of national self-regard and anti-Union
sentiment was clearly evident in this and other newspaper reports. Given
the massive turnout, and the emotional zeal triggered by the Monument
Movement, this kind of thing could easily get out of hand, and would need
to be tightly managed, in the press and elsewhere. By the time the monu-
ment was opened in 1869, the hue and cry had dampened considerably (in
the customary Scottish manner), the committee was in debt, and the
ceremony to hand the building over to the stewardship of the Stirling
Town Council was brief and officious, with no provision at all for a large
public demonstration. Concerns about the political exploitation of the
monument were publicly aired. A typical editorial (in the *Courant*, Septem-
ber 15, 1869) cautioned that the monument should not be a "peg [on which]
to hang 'patriotic' nonsense, Scotch provincialism, or worse 'seedy Radi-
calism.'" Monuments can "galvanize dead patriotisms, and stir up ani-
mosities which have been laid for centuries." The *Scotsman* was more sniffy
(September 21, 1869), maligning Rogers as a "national incubus" whose
"monumental craze" will lead to such an "eruption" of building that "no-
body's ancestors are safe from being crucified in stone and lime." Monu-
mentalism, it preached, was a "mode of exhibiting the vanity of the living
at the expense of the dead," and the tribute to Wallace was "a piece of
monstrous folly. . . . One of the fairest craigs in Scotland has been disfigured
by a vulgar and meaningless mass."

Rogers, who seems to have drawn fire from all sides, had earlier re-
signed from the committee. His most valiant feat, in his own eyes, had
been to save the monument from a design that would certainly have stirred
up animosities. The committee had initially chosen an entry that displayed

a Scottish lion (representing liberty) vanquishing an English monster (representing tyranny) "with serpent legs and jaws horribly distended."[6] Rogers's efforts to kill the design engaged him in a long-running dispute with the Association for the Vindication for Scottish Rights, which had backed the monster slayer. The association was one of the groups that sprang up in the 1850s to protest creeping Anglicization, most visible in the English aristocratic patronage (led by Victoria herself) of the rural moors, estates, and rivers. Anglicization only went so far down the social order, yet there was little reason, as historian Christopher Harvie notes, for any person of influence, ambition, or wealth to support nationalist reforms being pushed by fringe eccentrics like the Scottish Rights agitators.[7] Devotions to identity were simply not lucrative enough to draw men on the make away from the fast revenue of Empire.

Because of its natural advantages—coal and black-band ironstone—Scotland's Victorian economic miracle had established itself in the forefront of the Industrial Revolution. At home and in the colonies a combination of entrepreneurial gusto and engineering innovation made Scotland the "Workshop of the Empire." Its engineering, textiles, coal, iron, processing, agriculture, commerce, and shipping were mainstays of British imperial growth until 1914. To a country well primed for emigration, the empire provided a steady stream of professional opportunities for the surplus of intellectuals trained in Scottish universities, whether as administrators, physicians, engineers, soldiers, missionaries, or suppliers of essential imperial commodities like opium.

Indeed, it has often been pointed out that the Scottish habit of exporting its most resourceful youth had left no native intelligentsia to fire up the nationalist cause at home. Writers like Burns, Ramsay, and Scott had fostered a renewed interest in folklore, adding to the torrent of romanticism that would usher in nationalist movements in nineteenth-century Europe. By contrast, the nation's Victorian intellectuals—sages and statesmen like Thomas Macauley, John Ruskin, William Gladstone, Thomas Carlyle, and John Stuart Mill—who might have played the organic role of a Kossuth in Hungary or a Mazzini in Italy, were all Scots exports, no more identified with the parochial cause of Scottish nationalism than a thousand other cosmopolitan players of the age. Since all causes deemed progressive were firmly hitched to the British star, the forms of cultural nationalism took on a studied antiquarian air, as the cult of Highlandism descended on a Lowlands majority hitherto scornful of things clannish and Celtic-sounding.

Compulsory Celtification was adopted as the polar opposite of Anglican gentility and as a fantasy foil to the starchy servility of native professional elites. This fake Gaelicism, entirely foreign to most Scots, brought on a plague of tartan kitsch for which there has existed no known antidote until recent times.

It would be a mistake to conclude that the fanciful veneration of figures like the Highland clan warrior were pure exercises in nostalgia, near-psychedelic surrogates for a vibrant political nationalism of the Risorgimento kind (a European pantheon of national liberation leaders—Mazzini, Garibaldi, Kossuth, Louis Blanc, Karl Blind—actually wrote letters in support of the campaign for the Wallace Monument). The cult served a different purpose for each population that used it. For example, the over-wrought wildness and barbarism of eighteenth-century Highlandism had been a conqueror's vehicle for the pacification or "improvement" of the region, while the regal Victorian version of the myth—noble, glammy, and militaristic—served well in the further incorporation of "North Britain."[8]

For Scots themselves, the adoption of the Celtic cult was quite strategic. However apocryphal and alien to Lowlanders, however embarrassing to the educated, improved Scot, and however co-opted into the regimental rituals of imperial militarism, Highlandism publicly displayed a residual spectrum of Scottish experience that could not be fully assimilated and was thus irreducible to stark British patriotism. Scots of all classes, therefore, found it expedient to pay lip service to this antique iconography because it helped in some way to keep the English lion from the drawbridge. The Celtic twilight was a bizarre, consensual hallucination, but it offered more assertive protection, as a last line of defense, than the ten-shilling words of the lawyers, ministers, and professors who formed the staid vanguard of civil society. In this respect the Gael cult formed an integral part of the system for preserving Scottish autonomy, shamelessly baroque in its theatrical ploys, sharply effective in its bureaucratic ends.

It is now widely accepted that this autonomy was preserved to a degree unparalleled among stateless nations. Lindsay Paterson and David McCrone, the most persuasive champions of this thesis, argue that the key to this self-determination was the patronage delivered by the nation's political managers in the form of a lavish, nepotistic flow of resources and opportunities that allowed civil society to maintain "a course that was probably not much different from the direction that would have been followed had Scotland retained a Parliament."[9] Under these conditions,

and in line with the emergence of full-frontal Protestantism—a Scottish passion—as a defining principle of British patriotism, the paradox of unionist nationalism came to make perfectly common sense. "On the one hand," write Paterson and McCrone, "Scotland had to be in the Union to realize its true potential as a nation; thus to be a true nationalist, it was necessary to be a unionist. On the other hand, to be a true unionist, it was necessary to be a nationalist because, in the absence of Scottish nationalist assertion, the Union would degenerate into an English takeover of Scotland. Scotland had to remind England (and itself) repeatedly that it was a partner in the Union, and that it retained the ultimate right to secede."[10] As long as Empire delivered the goods, the paradox of unionist nationalism would remain serviceable for the bankers and merchants, the professional estates, local government stalwarts, and the Protestant working class. When that multilayered enterprise began to unravel, the hairy ghosts of Wallace and others would come stepping out of the old stonework.

1969

One hundred years after its 1869 opening, the Wallace Monument was in a rather inhospitable shape: draughty, ill lit, and sparsely adorned with features of interest other than the "muckle" sword and the marble busts of Great Scots in its Hall of Heroes. The icon of a million biscuit tins, tea towels, and hip flasks, it was nonetheless struggling to attract tourists. At one particularly low point I remember hearing of a desperate scheme, aborted early, to hire camels to transport visitors up the arduous path that scaled the craig. Even so, it was nowhere near as rundown as other historic sites in or around my hometown, like the Alloa Tower, once the ancestral home of the Earls of Mar and now a smelly shell where the boys of the Young Bowery gang would meet to sniff glue, chug ale, and set fire, in fits of distraction, to the overgrowing bracken. Deindustrialization had begun to ravage the region, and the flow of welfare patronage and public provision had begun to dry up. Prosperity was no longer assured either through imperial markets or through administrative statism, and Britishness was fast losing its attraction north of the border. After their long marriage of convenience, unionism and nationalism were finally about to be prized apart.

The Scottish National Party (SNP) had registered its first electoral success in 1967, and, at the high watermark of this initial, evangelical re-

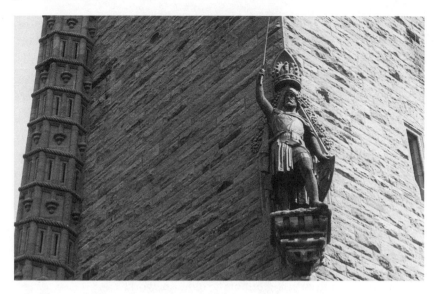

5. Wallace statue, from the monument. Photo by Andrew Ross.

surgence, would win eleven Parliament seats with a third of the Scottish vote in the 1974 general election. Several months before that election, Ann McLaren and myself, representing our school, Alloa Academy, inched our way into the finals of the national debating tournament. The judges for this event, held in the Union debating hall of Glasgow University, were Margo MacDonald, the SNP's ebullient young MP for Govan (and the tabloids' latest "blonde bombshell"), and Manny Shinwell, octogenarian veteran of Red Clydeside and a godfather of Scottish Labour. Our task was to uphold a motion that favored the nationalist revival, so our shameless speeches that evening converted every cliché of Scottish culture—Kailyardism, Clydeside macho, *Sunday Post* parochialism, hairy Highlandism, football madness, and ninety-minute patriotism—into a high-calorie feast of national virtue. In the matter of judging our efforts, MacDonald, a socialist and nationalist, registered bright enthusiasm just as Shinwell tallied his surly skepticism. Thwarted, as we saw it then, by the paternalist male left's distaste for cultural politics—just another flight of false consciousness—we placed third, disappointed but not devastated.[11]

Of course, leftists had good reason to be skeptical of the SNP's romantic alchemy. Few were more caustic than Tom Nairn, the most consistently acute analyst of Scottish politics. In the early 1970s he had nothing but scorn for fantasies of national rebirth in a land where, as he put it, "the

ideal has never, even for an instant, coincided with the fact. Most nations have had moments of truth, Scotland, never." "The belief," Nairn scoffed, "that a bourgeois parliament and an army will cure the disease is the apex of lumpen-provinciality, the most extreme form of parochialism."[12] Nairn's derision was leveled at two presumptions. The first was that the Scottish cause was simply an extension of the decolonization movements of the postwar period. In fact, the Scottish condition had never been exactly colonial. Self-colonization was more accurate, a condition voluntarily chosen, albeit by a tiny, and undemocratic, native elite. Consequently, the "regional distortion of development within capitalism" that rendered it unequal in the Union had little in common with the patterns of colonial underdevelopment. For Nairn, nationalism was a "bourgeois escape" from feudal or colonial conditions that barred economic advancement. Scotland's plight, whatever it may be, was not that of small postcolonial nations like Jamaica or Malawi. Second, Nairn saw the romantic vehicle of cultural nationalism as hopelessly anachronistic. Unlike in Europe, romanticism had been disconnected from any true nationalist politics in nineteenth-century Scotland and had stagnated into "a fossilized and recessive culture" with an "in-growing nature" that eventually sprouted a Hyde-like "possessing demon" in the shape of "the great Tartan monster."

Nairn had taken a tough line indeed. In response, one could argue that national esteem had endured precisely, and perhaps only, because Scotland was not a normative model of colonial extraction. For all that, its natives still displayed most of the schizo trademarks of self-loathing, cultural cringe, and social paralysis that are traits of a begging-bowl, colonial condition. So, too, the monster of cultural nationalism, however schlocky and recidivist, had kept afloat daydreams of self-determination, borne along by eccentric aristocrats, poets—at once rhapsodic and choleric—and dingbat schoolteachers (in high school, my first English teacher, like Hugh McDiarmid, was a communist and a nationalist, who assigned us to read Molotov, inveighed against apartheid, and made a mockery of polite English diction). There were the occasional border raids like the liberation of the Stone of Destiny from Westminster in 1950 and the political theft of the sword from the Wallace Monument on two occasions, in 1936 and 1972, and at least one massive show of public interest that drew two million signatures to a Covenant for Home Rule in 1949 and 1950. There was also a long-standing political tradition in Westminster, where almost thirty Home Rule bills had been introduced and aborted since 1889. More impor-

tant, perhaps, the sentiment for home rule had always run much more strongly among the popular classes and their organic leaders, mindful that the Union's dividends had never trickled down very far. All of these currents have now outlived the "alibis of inaction" that Nairn would later diagnose as part of the national pre-Thatcherist condition.

By the 1970s, however, there was plenty of life left in the alibis. In a gesture to devolution that was intended to stave off separatist sentiment, the Labour Party mounted a Scottish referendum in 1979. Less than 40 percent of the electorate supported a proposal for a toothless assembly, so the issue was retired. At the time, I was working as a roustabout in the North Sea oilfields, the SNP's great economic hope ("It's Scotland's Oil!" "Rich Scot or Poor Briton?"). Swallowing the bittersweet pill of the emigrant, I left Scotland for good a few months later. In the interim Margaret Thatcher's high-handed reign had begun, bankrolled by the profits extracted from those same oilfields, and she pledged, among other things, to disembowel Scotland's socialist guts.

1997

Several weeks before the Tory meltdown in the general election of 1997, Michael Forsyth, secretary of state for Scotland (and probably the last to wield any tangible power in that intolerable satrap's office), delivered a notorious speech in front of the well-weathered, medieval ruins of Arbroath Abbey. Sounding each note of the Conservative Party's death-wish campaign against plans for devolution of parliamentary power to Scotland, the secretary shot off broadsides against the SNP's newly formed policy of "Independence in Europe." Of late, Forsyth, a foaming apostle of Thatcherism, had tried every trick in the great book of tartan flimflam-mery to dress up Tory policy for a populace that had turned a deaf ear to the entreaties of the unionists (as Scottish Tories had long called themselves). His flirtation with the garb and symbols of Gaeldom began when he donned the philibeg, and other antique accessories, for the lavish film premieres of *Braveheart* and *Rob Roy*, and it ended ignominiously with the loss of his own parliamentary seat in 1997. In the interim Forsyth persuaded the queen to part with the Stone of Destiny, stolen eight hundred years earlier by Edward I, Hammer of the Scots, only to suffer the jeers of the Edinburgh throng as he marched the stone up the Royal Mile alongside the Royal Company of Archers.

But the Arbroath Abbey speech marked an especially low point for Tory opportunism, for it was there that Forsyth invoked the 1320 Declaration of Arbroath to buttress his party's position that Scotland, hand-in-glove with Westminster, must fiercely protect its independence from the dissolute snares of Euro-federalism. The most venerable document in Scottish political history, the Declaration was a 1320 letter to Pope John XXII from Scottish nobles, barons, and freeholders, asserting the independence of the nation, with its lineage of 113 kings "unbroken by a single foreigner," and the right to live free from the interference of the English Crown. Arbroath's eloquent appeal to liberty against English tyranny was much more likely to be invoked by nationalists than Tories. No less than Sean Connery, the SNP's poster boy, would have occasion to intone some of its most stirring lines in a public debate later that year on the devolution referendum, soon to deliver a resounding majority vote for a restored Scottish Parliament: "It is not for glory. It is not for riches. Neither is it for honour. But it is for liberty that we fight and contend—which no honest man will lose but on his life."[13]

Forsyth's appropriation of the spirit of Arbroath was a brazen move, while his use of the twelfth-century abbey as a backdrop violated the impartiality rules of Historic Scotland (the state agency that manages historic sites), which forbade the use of such monuments for political purposes. In a country where medieval events can still resonate powerfully in modern politics, the opportunity to exploit ancient stones is difficult to pass up. But it can also backfire, as it did for the cheeky Tory. Those who know the Declaration as more than a simple paean to liberty pointed out the further irony of its use here by Forsyth. The Declaration reads like a typical medieval pledge of fealty to the pope, yet it was also one of the first statements of modern constitutional doctrine. Its assertion of autonomy from arbitrary or foreign rule appealed to the people's right to remove any Scottish king who yielded to English feudal claims. The doctrine of contractual governance, or popular sovereignty, was effectively introduced through the principle that ineffectual monarchs could be deposed if they shackled the nation to the Plantagenet yoke. In this light it was tempting for many to read the Declaration, 677 years later, as a warning against the hubris of Scotland's Tories. For almost two decades the Conservative Party had been stripped of any popular mandate among Scottish voters, and Tory rule from Westminster had come to be seen as akin to the English overlordship so fiercely resisted in the Declaration. In this scenario Forsyth

and his kind would deputize for the inept king of 1320, and would need to be dispatched by the populace, as indeed they were in a matter of months.

Of course, the Scottish secretary was behaving no differently from any other canny politician in exploiting the stuff of history for gain. It would be fair to point out that the Declaration itself had been an expedient vehicle for legitimizing Robert the Bruce's violent seizure of the Scottish throne in 1306 in the heat of the Wars of Independence that vanquished Edward's armies. The Declaration inserts Bruce smoothly into the long, "unbroken" lineage of 113 kings, and it sanctions, after the fact, the removal of a legitimate king, John Balliol, in 1295, who had proven himself "useless" (*rex inutilis*) by permitting the subjection of the country to Edward I. In one tidy bulletin the Declaration outlawed any claims for the restoration of the Balliol line and legalized Bruce's usurpation of the throne.[14] By easing the antagonism of the nobility to Bruce's martial coup d'etat, it also handed control over the national past to his line and that of the Stuarts, the ultimate family of losers, who would do their best to forget the spirit of Arbroath for the next three hundred years.

One figure presents an obstacle to this smooth propaganda of the Bruce: William Wallace, a young priest in training who became the guerrilla warrior hero of the Wars of Independence and, ever since then, the national, martyred symbol of patriotic derring-do. Wallace's status as a commoner (though still a knight's son) who made no compromises and struck no deals, stands as a foil to the incurable treachery of the nobility, Bruce above all others. His vexed alliance with Bruce is sharply drawn out in *Braveheart*, albeit with cavalier attention to historical fact. The story of aristocratic perfidy fit neatly into the Hollywood repertoire of lowborn heroes and blue-blood villains. It also played well at home among popular nationalists long receptive to the belief that the Scottish peerage had repeatedly sold out the nation to its southern paymasters, most notably in 1707 when they were offered money bribes and other incentives to sign away the nation's sovereignty.

Conveniently for mythmakers, the historical record on Wallace is scant. Even if we allow for the fact that most of what is known about his life and deeds comes from English sources, given to embellishing his status as a folk devil, it is not so easy to see the rebel from Ellerslie as a plain exponent of nationalism in a distinctively modern guise. Notwithstanding the Hollywood idyll about avenging his slain wife,[15] Wallace probably first took up arms in the name of John Balliol, his deposed king. Edward Cowan puts it

6. A Wallace statue in Stirling. Photo by Andrew Ross.

well: "Wallace was certainly a conservative who acted for his absent king, John, but History placed him in a revolutionary situation." As the Lowland leader of a widespread insurgency, his military feats, after the guerrilla phase of Selkirk Forest and the Battle of Stirling, were as much an affront to the established order of the Scottish nobility as to the English Crown. As a result no compatriot peer interceded for him on the path of Scots betrayal and English show trial that led to his appointment in London with the scaffold in 1305.

Nor was his ghost ever likely to rest in peace, with every politician in the land, from Bruce up to the present day, seeking to exploit his legacy. Yet the greatest irony of Wallace's story is surely how a student of theology, moved by dint of his feudal station as a knight's son to defend the feudal rights of an absolute sovereign, would come to symbolize popular limitations on power that would resonate throughout Scottish history.[16] For there is a straight line of descent from Wallace's inspirational exploits and the Arbroath doctrine of "limited sovereignty" to nationalist arguments for greater self-dependence advanced in the most recent *Claim of Right for Scotland* (1988). The product of a constitutional convention convened by the Campaign for a Scottish Assembly, the *Claim of Right* asserted that

Westminster's constitutional concept of the Crown-in-Parliament was entirely of English heritage, owing its authority to traditions of *unlimited* parliamentary sovereignty. Drawing on the theological concept of a covenanted nation, the *Claim* contended that this English heritage is quite at odds with the Scottish heritage of *limited* sovereignty, whereby rulers are subject to popular consent and the assent of the community. Appeals to this tradition had been made in two previous *Claims of Right*: in 1689, as a response to the Revolution Settlement, affirming the preference for a contractual monarchy over a divine right monarchy; and, again, in 1842 as a protest, which led to the Disruption in the Church of Scotland, against Westminster's decision to let landlords impose their own ministers.

The 1988 *Claim*, prepared by a broad swathe of representatives from Parliament, the Kirk, the estates, and civil society, began by describing its raison d'etre: "Parliamentary government under the present British constitution had failed Scotland and more than Parliamentary action was needed to redeem the failure."[17] The immediate vehicle for this failure, of course, was the Middle England tyranny of Thatcherism, cast increasingly as unlawful according to those same Scottish traditions inspired by the Declaration of Arbroath and the empowered commons of Wallace. An English overlord—this time in the form of the grocer's daughter from Grantham—would once again serve as midwife to an insurgent Scottish nationalism. Once again Wallace played an ambiguous role in this drama of national recovery, proving no less baneful to those, like Forsyth, who sought to appropriate his legacy than to those who sought to suppress the memory of his lesson. After all, Forsyth's own parliamentary seat had lain in Stirling itself, the site of Wallace's most famous victory and the location of the monument.

2004

Today's visitor finds much changed since the monument's centenary year, three and a half decades ago. A Scottish assembly meets daily in Edinburgh, having resumed more or less where Parliament left off in 1707. Tom Nairn is considered a longtime proponent of independence, though his conversion has been more intellectually honest than many others. The country is littered with museums honoring the decisive decline of its industrial past—coal mining, shipbuilding, textile mills, gems, fisheries, railways, jails. At the foot of Wallace's monument the very light industries of the future hum in a Silicon Glen cluster called Innovation Park: Bio-Reliance;

Neural Innovation, Ltd.; Interactive Development; the Institute of Nano-technology; Siemens Network Systems; Zeda Forensic Technology. The monument itself has undergone the makeover required of postmodern tourism and is attracting 160,000 visitors a year, four times the 1993 volume. In 1999 it broke the million pound revenue barrier so prized by the Scottish Tourist Board. The Disney touch is evident in an audiovisual "talking head" display that dramatizes dialogues between Wallace and his antago-nists. The Hall of Heroes boasts an expanded and more politically correct pantheon: writers (Muriel Spark, Naomi Mitchison, James Kelman, Irvine Welsh, Ian Crichton Smith), men of science (John Logie Baird, Alexander Fleming), media figures (Lord Reith, Bill Forsyth, Sean Connery), and political radicals (James Maxton, Jimmy Reid, Mary Phillips, Flora "Blue-bell" Drummond). And, alongside the ever-inventive kitsch of Caledonia, heralding what McCrone terms "Scotland the Brand," the gift shop boasts a pricey facsimile of the Sword (retailing at about $1,200) and a fancy pewter chess set (at $2,000).

Outside, facing the parking lot, is a newly sculpted statue of Wallace, whose features are unmistakably those of the character depicted in *Brave-heart*. Visitors routinely refer to this as the "Mel Gibson statue," and there is no doubt that the monument's renewed fortune is due to the film's popularity. Like the historical Wallace himself, *Braveheart* has drawn many competing claims on its symbolism. For example, not a few of the monu-ment's daily American visitors hail from the South, where *Braveheart* has been adopted by the neo-Confederate movement as a potent political token of both Scottish and Confederate secession and where its depiction of "angry white males" has fed into the recent attempts to celebrate cracker and redneck pride. Increasingly, Scotland is the mother country for these unreconstructed "Celtic" southerners, spearheaded by white su-premacist groups like the League of the South. Indeed, Mark Potok, of the Southern Law Poverty Center, has concluded that "the film is on the shelf of every white supremacist in America," and it was a huge hit among prominent conservative Republicans like Bob Dornan and Pat Buchanan.[18] Scotland's resurgent nationalism resonates strongly with Dixie brethren bent on a second secession from the "English" northern states.[19] In a part of the United States where conflict rages daily around monuments, flags, and statues that evoke the heritage of the Old South, the Wallace Monu-ment stands as a proud beacon for Celtic Confederate hopes of redeeming the Lost Cause of the War between the States.[20]

7. Wallace / Gibson (sculpted by Tom Church,
stonemason). Photo by Andrew Ross.

How was Wallace depicted in the film? As a cross between the canny
Scot who thinks with his head and a more typical Gibson character driven
to acts of heroism by bursts of near-psychopathic intensity (this latter type
Scots would know, and appreciate, as a "heid the ba"—a head-banger,
loosely speaking). Yet Gibson, a fierce right-wing moralist, seems to have
found a much broader political meaning in his film. Speaking of Patrick
McGoohan's role as the English king: "He knew instinctively what he had
to do when he came in, and he did it with great charm, and with his
diabolically funny lines, 'The trouble with Scotland is it is full of Scots.' It
was sinister, amusing, and scary all at the same time, because it brings up
images of the ethnic cleansing practiced today in Bosnia. This is what King
Edward I—who was known for his brutality—did, thirteenth century eth-
nic cleansing."[21]

Who knows whether Gibson was simply peddling the film's relevance
to the hot spot du jour or whether this was his own insight into historical
events. In any event his film had a huge impact in countries touched by the
Scots diaspora. At home *Braveheart*'s crude ethnic nationalism appalled
Scots intellectuals and civil elites who had come to believe that the resump-

tion of politics was a result of *civic nationalism* and had nothing at all to do with the vulgar "blood and soil" regionalism of ethnic-based movements. Not a drop of blood, it was proclaimed, had been spilled in the many decades of struggle for home rule. It had all been very civilized. In fact, the roots of this civic nationalism are habitually traced to the invention of the concept of civil society by Scottish Enlightenment thinkers, like Adam Ferguson, who were trying to make sense of the new apolitical environment of the post-1707 stateless nation where legal, educational, and religious elites were left holding a kind of subparliamentary power.

When Scottish civil society's run of autonomy was finally put to the sword by Thatcherism, there was no alternative for the civil elites who sought to maintain their long-standing privileges but to "resume business as a political society."[22] Thatcher's attempted evisceration of civic corporatism shattered what was left of the Union consensus, radicalized the conservative minded, and triggered a general desire for a form of civic identity that would be national in form and potentially sovereign in substance. The prospect of a minimal state, fueled by enterprise culture and little else, was widely perceived, even among the middle classes, as antithetical to "Scottish traditions" of public provision—traditions that had some basis in history but were also constructed, in part, to lend succor to the fainthearted as they braced to cross the Rubicon of home rule.

To further convince mainstream Scotland that this nationalist turn was principled, and not simply a churlish backlash to Middle England Tory rule, the estates initiated a lengthy process of constitutional deliberation through the *Claim of Right* and the Constitutional Convention. The aim was the forging of a sober consensus about the deepening of democracy through regional devolution. All the loose talk, and the wild crooning, of hairy nationalism (including ethnic-based tendencies like the paramilitary Siol Nan Gaidheal [Seed of the Gael]) had to be safely marginalized. Spirited local democracy was now the goal of home rule, achieved through a radical dispersal of power from an overcentralized polity to the people themselves.[23] New Labour, under Tony Blair, had no choice but to grant these devolutionary powers through a second national referendum in 1997 (timed for the seven hundredth anniversary of Wallace's victory at Stirling), which successfully translated them into the first truly democratic Scottish Parliament. New Labour was obliged to devolve power in order to salvage (or, in Blairspeak, modernize) the British metropolitan state, but it did so at the cost of exposing its cobwebbed English core to similar cur-

rents of change. Resting on a constitutional basis that is partly mystical and certainly atrophied, this English center, like its devolving satellites in Scotland, Wales, and Northern Ireland, must soon face a decisive revision of sovereignty.[24]

In Scotland that revision has partly begun and may yet result in full-fledged popular sovereignty. The *Braveheart* tendency played a supporting role, stirring up populist sentiment as only a good flag-waving fight can do. Every party, but especially the SNP, tried to harness its visceral appeal, and the Wallace Monument's staff was under strict orders from the Scottish Tourist Board to keep all "political discussions" at a distance. No doubt this was standard policy at all the board's sites, but as Eleanor Muir, the monument's manager, pointed out, a large portion of the visitors are English, so there is good reason to exercise tact in dealing with Wallace's history. "We, as a nation, can be quite aggressive to the English, but they are the most appreciative of visitors," a response she admits she finds "peculiar." Ultimately, she conceded, there is a bottom line to pursue: "We all owe Mel Gibson our wages."[25]

However lucrative to the tourist industry, the atavistic, ethnic wrath depicted in *Braveheart* was deeply distrusted by elites, shamed to the core by the displays of emotional disorder that it begot. The avoidance of shame—a central routine of Scottish life—demanded a more sensible delivery of self-determination than by the blood-stained Jacobinist vehicle of "old animosities" and clannish affinities. Now that a proper deliberative body has returned to Edinburgh, it may well be that some authentic form of popular accountability will hold sway and that the new Scotland will become a rip-roaring success, a shining exemplar of bottom-up democracy in a federated Europe, or, even an egalitarian fountainhead of socialist policymaking. There are even those who dream that Scottish identity politics—one of Europe's most hackneyed comedy routines—may provide a model for the remaking of political orders everywhere, in a world that will be safer and more just when the fallacy of the correlation between states and nations is more widely acknowledged. More sobering judgments were formed on the basis of the all-white Parliament's largely reactive and lackluster first year—distinguished by a crushing silence about all-important land reform of the lairdly redoubts of grand acreage, and scarred by a debate about the repeal of Section 28's ludicrous classroom ban on "gay sex lessons," which brought the foul gas of bigotry and homophobia bubbling to the surface of the national culture.

When all is said and done, we cannot discount the suspicion that Scottish politics has resumed for reasons as germane to the self-interest of national elites (pursuing the main chance through Europe now that Britain has lost its luster and lucre) as those that influenced the handover of power by the parcel of rogues that signed the Treaty of Union in 1707. If the latter is indeed the case, then there will be other episodes in the drama of nationalism for Wallace's monumentality to illustrate. One of these may well be another version of an old story about the treachery and mediocrity of the great and the good. The perennial crowd-pleasers of ancestral militarism and sporadic Sparticism will then serve, once again, as fair warning to the brokers and hucksters and party hacks who still form the spongy backbone of the national Establishment. Wallace's example of keeping things local as a check on power will also help. At the opening ceremony for the new Parliament, an Edinburgh woman in the crowd said as much in her comment to a journalist: "We can now see the whites of their eyes and we know where their Aunty Jean lives."[26]

But perhaps the best precept Wallace teaches is that people do not always behave the way we expect. Wallace certainly did not, and it may be that the inhabitants of this lumpy corner of the world, whom Tacitus once described as "the last men on earth," may unearth some new political lessons now that they have a chance to chew on the constitutional kernel inside modernity's brittle shell. Scotland's way forward may yet learn how to fuse a cosmopolitan tradition—in which Wallace, for example, was quite the European, and therefore perfectly at home while abroad—with a tradition of popular sovereignty—in which his active local fealty triggered a seditionary appetite for justice. Of course, Scottish experience also portends other, much less savory, futures; a one-way nativist path to parochial sclerosis, or the semiperiphery track of a "Celtic tiger" whose soul has been traded to the multinational leviathans of capital. Place your bets and stay tuned to Radio Caledonia!

NOTES

1. McKenzie, who wrote the first historical account of the 1820 uprising, is quoted in Ellis and Ghobhiann, *The Scottish Insurrection of 1820*, 290–91.

2. The reference is from a nineteenth-century scrapbook of press articles about the Monument Movement in the Stirling Public Library. No citations are preserved.

3. *Stirling Observer*, June 25, 1856.

4. *Stirling Observer*, June 27, 1861.

5. William Drysdale, quoted in Mair, *Stirling*, 207–8.

6. Scrapbook, Stirling Public Library (see note 2).

7. Harvie, *Scotland and Nationalism*, 55. Harvie has written the most absorbing commentaries on Scottish culture and politics from the viewpoint of a native intellectual living in Europe (in Tubingen). See his *Cultural Weapons* and *Travelling Scot*.

8. Withers, "The Historical Creation of the Scottish Highlands."

9. Brown, Paterson, and McCrone, *Politics and Society in Scotland*, 5. For more extensive analyses see Paterson, *The Autonomy of Scotland*; and McCrone, *Understanding Scotland*.

10. Brown, Paterson, and McCrone, *Politics and Society in Scotland*, 11.

11. False consciousness was only one part of the story, however. The paradox of unionist nationalism lives on in the Labour Party and was most sharply distilled in political managers like Willie Ross, Scottish secretary of state in the 1960s and 1970s, who was an ardent nationalist in private and an opponent of home rule in public. Jim Sillars, a Scottish Labour MP, recalls: "Ross in private was one of the most Scottish nationalistic figures I've ever met. He could say things at Burns Suppers—anti-English in their make-up—that I would never dream of saying. But he was simultaneously quite adamant that Scotland should remain an integral part of a unitary state with England. I could never work out this paradox in the personality of Willie Ross" (quoted in Clements, Farquarson, and Wark, *Restless Nation*, 53).

12. Nairn, "The Three Dreams of Scottish Nationalism."

13. Chris Holme, "Connery Quotes from Old Script to Back Yes-Yes," *The Herald* (Glasgow), Sept. 8, 1997, 6.

14. See Cowan, "Identity, Freedom, and the Declaration of Arbroath"; and Watson, "The Enigmatic Lion."

15. Before the Hollywood myth there was a folk myth about Marion Braidfute, the heiress of Lamington, who was Wallace's wife or mistress. In his monograph *William Wallace*, historian Andrew Fisher notes: "She, like another and far more celebrated Marion in an earlier age, belongs to the outlaw tradition rather than to history" (37).

16. Cowan, "Identity, Freedom, and the Declaration of Arbroath," 61.

17. In truth, the Wallace *volte face* is probably no more of a paradox than the story of how the cult of the Stuarts transformed two vainglorious bids to restore an absolute feudal monarch into a populist cause, albeit a decisively "lost cause," embraced, in retrospect, by Scots who would be the first to bristle at the thought of feudalism. The romantic themes of exile, loss, mourning, and the messianic return home (Will Ye No Come Back?) have much more to do with post-Union national therapy than with any royalist longings. See Pittock, *The Invention of Scotland*.

18. Edwards, *A Claim of Right for Scotland*, 13.

19. Quoted in Hague, "Scotland on Film," 78.

20. See Sebesta, "The Confederate Memorial Tartan." For a longer, literary view

of this relationship, discussing such topics as the influence of Scott's *The Lady of the Lake* on the founders of the Ku Klux Klan, see Hook, *From Goosecreek to Gandercleugh*.

21. Stanford Levinson focuses a good deal on the South in his thoughtful analysis *Written in Stone*. It seems appropriate that Gibson's follow-up film, *The Patriot*, is set in the South during the American moment of national liberation.

22. Mel Gibson, "Mel Gibson's Great Scot," interview by Jon Stevens, at http://www.dga.org/news/mag_archives/v21-1/gibson.html.

23. Adam Ferguson, *An Essay on the History of Civil Society* (1767). See Nairn's account of civil nationalism in *Faces of Nationalism*; and Becker, *The Emergence of Civil Society in the Eighteenth Century*.

24. In *A Diverse Assembly*, his judicious selection of texts that document these debates, Lindsay Paterson pinpoints, as a turning point in the direction of radical democracy, SNP vice-chair Isobel Lindsay's 1976 essay "Nationalism, Community, and Democracy." See also Mitchell, *Strategies for Self-Government*; Gray, *Why the Scots Should Rule Scotland*; Crick and Millar, *To Make the Parliament of Scotland a Model for Democracy*; and Scott, *Towards Independence*. Nairn treats the constitutional crisis in *After Britain*.

25. Eleanor Muir, telephone interview with author, summer 2000.

26. Quoted in Annette McCann, "Grand Day Out," *Glasgow Herald*, July 2, 1999.

THE FALL AND RISE

OF PRAGUE'S MARIAN COLUMN

Cynthia Paces

Prague's beautiful monuments, churches, and architectural diversity beckon visitors from all over the world. In Prague, however, empty spaces tell as many stories as the city's many historical monuments. The site of a Stalin statue, which stood in central Prague only from 1955 to 1962, still bears the colloquial name "Stalin hill."[1] Throughout the Communist era, "empty pedestals" once bearing statues of Czechoslovak founder President Tomáš Masaryk reminded citizens of the former leader's democratic ideals.[2] And, on Old Town Square, Prague's most important public space, a plaque embedded in the cobblestones tells visitors in English and in three other languages: "Here did stand and will stand again / The Marian Column of Old Town Square." The plaque commemorates the empty space created when nationalists, celebrating Czechoslovak independence from Austria in 1918, toppled a baroque monument of the Virgin Mary. After the incident the city government swept the rubble away and sent the broken pieces to Prague's Lapidarium of the National Museum.[3] However, Prague could not sweep away the memories of the Marian Column, which had stood on Old Town Square since 1650. Debates about the meaning of this empty space continue to the present day.

"Objects speak."[4] Victor Turner's now-famous dictum instructed anthropologists to listen to the messages embedded in tangible objects: statues, buildings, historical sites. Yet the history of Prague's Marian Column in the twentieth century and in the twenty-first reveals that empty spaces can speak as well. In Prague each dramatic political transformation of the last century recast the message of the empty space on Old Town Square.

CZECH NATIONALISM AND THE MARIAN COLUMN

The Marian Column originally commemorated the Habsburg defeat of Sweden and the subsequent Swedish retreat from Prague at the end of the

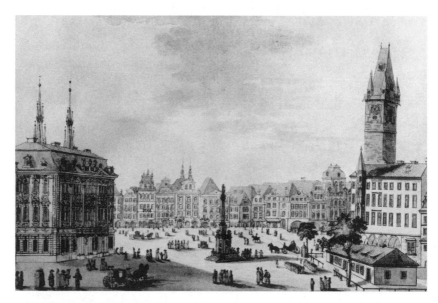

1. Marian Column of Old Town Square, c. 1900.
Permission by Společnost pro obnovu mariánského
sloupu v Praze.

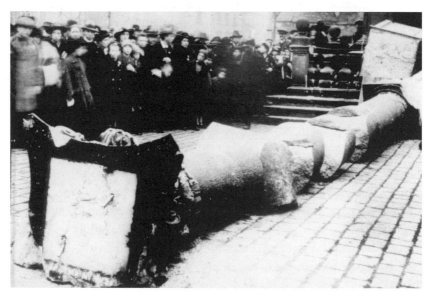

2. Toppled Marian Column on Old Town
Square, Prague, Nov. 1918. Courtesy of the
Prague City Archives.

Thirty Years War. The Victory Column dated from 1650 and represented one of the most important pieces of baroque public art in Central Europe.[5] During the nineteenth century, however, Czech nationalists began to view the column as a symbol of Austrian cultural hegemony in the empire, as opposed to a monument celebrating their city's freedom. As Czech revivalists effectively transformed Prague from a predominantly German-speaking city to the center of Czech culture, Czechs sought to challenge the predominance of Austrian baroque art and architecture in the city.

For Czech nationalists the Marian Column epitomized the Austrian presence in Prague. Although Habsburg emperor Ferdinand III donated the column to celebrate the Swedish retreat, most nineteenth-century Czechs believed that the Marian Column represented the Habsburgs' victory over Bohemian Protestant nobles at the Battle of White Mountain in 1620. The Bohemian Estates' loss at White Mountain led to Habsburg hereditary rights in the Bohemian Crownlands and the forced conversion of the predominantly Protestant region to Roman Catholicism. During this period of Counter-Reformation, the Habsburg-sponsored Jesuits promoted the Cult of the Virgin Mary to attract converts and built Marian Columns and baroque churches throughout the Habsburg lands. According to Czech nationalist historiography, the Battle of White Mountain and the subsequent Counter-Reformation ushered in a period of *temno* (darkness), during which national development halted. The Marian Column reminded nationalists that Habsburg hegemony had stifled a unique national culture.

Although over 90 percent of the nineteenth century Czech population was Roman Catholic, many nationalists began to identify politically with the revived memory of the pre–White Mountain Bohemian heresy, led by Jan Hus in the fifteenth-century. In 1890 Prague nationalist leaders began to raise funds for a Jan Hus Memorial. The martyred Czech priest, who insisted on using the vernacular language in Mass, appealed to Czech nationalists, who were also fighting for language rights in the Germanized Austrian Empire. The Club for the Building of the Jan Hus Memorial in Prague eagerly anticipated 1915, the five-hundredth anniversary of Hus's execution by the Roman Catholic Church, when it would unveil its Hus monument. After bitter public debate and demonstrations by Prague Catholics, the Prague City Council approved Old Town Square as the monument's site partly to counter the symbolism of the baroque Marian Column.

However, some believed that pairing the religious monuments on Old Town Square could actually heal religious tension in the city. Speaking in 1903, at the cornerstone-laying ceremony for the Hus Monument, former Prague mayor and nationalist Jan Podlipný announced that Hus's majestic figure would soon face "the Mother of Christ, for whom Hus had infinite respect."[6] He explained that Hus never renounced the Roman Catholic faith, or devotion to Mary, but opposed the power structure of the Church hierarchy. He further remarked that the Marian Column had no connection to White Mountain, and it was this mistaken notion that accounted for nationalists' bitter feelings. Podlipný's remarks temporarily appeased Prague Catholics, who stopped demonstrating against the proposed Hus Memorial. However, Podlipný's fellow nationalists were furious and would eventually oust Podlipný from the presidency of Sokol, the foremost Czech nationalist organization. The nationalist and socialist press accused Podlipný of making peace with "Hus's murderers."[7]

Other nationalists attempted to show Hus as a purely secular figure who advocated freedom of expression. This casting of Hus as an early democrat and liberal was also meant to counter the overtly monarchial image of the Habsburg Marian Column. One way nationalists attempted to secularize Hus was to bring Czech Jews into his cult. In 1903 the National Union of Czech Jews in Prague, the Circle of Czech-Jewish Youth in Prague, and the Association of Academic Jews in Prague enthusiastically marched in the parade for the Hus Memorial Cornerstone Festival. Even though most Prague Jews remained tied to German-speaking culture, those who identified themselves as Czech were willing to accept a secularized Hus more readily than the Catholics' Marian Column.

Most nationalists despised the Marian Column, yet the baroque statue had tremendous influence over them. Ladislav Šaloun, the Hus Memorial sculptor, told the nationalist press that the Marian Column constrained his artistic freedom. Although he speculated that future generations might consider moving the Marian Column, he had to work under the assumption that both monuments would occupy the square. In addition to the subject matter that inherently challenged the Marian Column, Šaloun's artistic concept also responded to the column's form. The dark bronze and granite sculpture countered the white sandstone Marian Column. Šaloun claimed that he designed the monument to be massive and horizontally oriented to rival the towering baroque pillar.[8] Furthermore, Šaloun complicated the gendered symbolism on Old Town Square. On his Hus Memo-

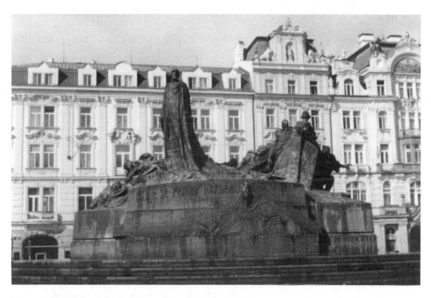

3. Jan Hus Memorial, Old Town Square, Prague.
Photo by Cynthia Paces.

rial he placed a statue of a breastfeeding woman at the feet of Jan Hus. Šaloun's nursing mother figure competed with the Marian Column's image of the maternal. The art-nouveau style secular figure updated the baroque symbol of Mary, depicted as *Maria Regina*, the Queen of Heaven, which was popular with seventeenth-century counterreformers.[9]

The Hus Memorial was unveiled as planned in 1915. However, the tense political situation during the First World War forced nationalists to celebrate their statue quietly and without a corresponding nationalist festival. Czechs resented that Austrian politics had stifled their nationalist passion yet again. With newfound political power after the Great War, however, the Czechs would begin to take more direct action against the symbols of Austrian power.

THE FALL OF THE MARIAN COLUMN

The frenzied mob that crowded Prague's Old Town Square cheered and shouted on the cold evening of November 3, 1918: "Down with it, down!"[10] There was great cause for celebration: less than a week earlier, on October 28, the National Council had proclaimed Czechoslovakia an independent nation-state and had peacefully broken from Habsburg rule in

Austria-Hungary.[11] Rejoicing crowds had gathered in Old Town Square all week, but on this November evening leaders of this mob had a specific purpose in mind. Above the shouts the onlookers heard a loud crack, and then a crash, as firemen with ropes and pulleys toppled the column onto the cobblestones, breaking the baroque column into three large chunks, and shattering the Virgin Mary. Some of Prague's most radical nationalists had finally achieved their goal: removing what they saw as a blatant reminder of Habsburg dominion over the Bohemian Crown lands. These nationalists had purified this public space for a Czech nationalist tradition. Radical Czech nationalists viewed Austria's defeat in the Great War as justice for White Mountain. Toppling the column was revenge.

The mob's leader, František Kysela-Sauer, was a Prague eccentric who flirted with socialism and anarchism, smuggled saccharine during the war, and drank in working-class pubs with Jaroslav Hašek, author of the antiwar novel *The Good Soldier Švejk*. Kysela-Sauer's analysis added the issue of class oppression to the baroque monument's already multilayered meaning. In his writings Kysela-Sauer explained that he recruited factory workers he knew from the pubs for his mob. These national-oriented socialists resented that the Habsburg Army conscripted workers for their main supply of soldiers and that church leaders supported the war.[12]

The Marian Column, according to Kysela-Sauer, was not a religious symbol but a "political symbol" of class oppression. True Catholics followed Christ, he wrote, not the "international, political clerical movement, whose central committee sat in Rome."[13] Although Kysela-Sauer admitted that the column did not directly commemorate the Habsburg victory at White Mountain, he warned that this did not render the monument harmless. Any memorial from the Thirty Years War represented the defeat of Czech culture, especially political, religious, and class liberty.

The destruction of the Marian Column reflected a broader anticlerical movement following independence. As Moric Hruban, a contemporary Czech Catholic politician, remarked: "In Prague one observed the appearance of two main trends of thought: the social revolutionary and the anti-Catholic. The casual observer could not recognize the real situation because everything around was hidden under flags and flowers and covered by a mood of rejoicing for the newly won state and national independence."[14] The Marian Column destruction combined both trends: socialists with nationalist sympathies seized the opportunity to display their

concern over Catholicism's power in the region. Attacks on Catholic statues continued into the 1920s.

Concerned with larger issues in the first week of independence, the Czechoslovak National Council did little to prevent or punish the Marian Column vandals. Yet their terse written response argued that the destruction resulted from a "historical misunderstanding" about the column's original meaning. Lamenting the irrational destruction of the Marian Column, the National Council remarked: "The principle of freedom excludes every violent act, especially during this era of cultivating relations with Slovakia, when we are developing a way for the whole nation to be happy."[15] Suddenly Czech nationalist anticlericalism, traditionally aimed at the Habsburg monarchy, could jeopardize the new relationship with Slovakia, a region with more traditional religious devotion. Nonetheless, Kysela-Sauer believed that the common people should choose the national symbols. When a member of the National Council arrived on Old Town Square to reason with the mob, Kysela-Sauer responded: "You are the National Council. We are the Nation!"[16]

THE RISE OF THE MARIAN COLUMN?

If nationalist socialists truly believed that "clericalism" had been destroyed with the Austrian Empire, it is unlikely they would have reacted so violently against its chief symbol. Indeed, populist political Catholicism had not died, and by the early 1920s, under the leadership of Msgr. Jan Šramek, the Czechoslovak Catholic People's Party had become a moderate, pro-state bloc. According to historian Miloš Trapl, "Nationalism was very characteristic of the Czechoslovak People's Party policy because the leaders wanted to conceal the Austrophile attitudes of Czech political Catholicism as soon as possible."[17] Šramek rode the political tide as early as October 1918, when he helped draft the Czechoslovak declaration of independence and stood with National Council members to proclaim the Republic. In the early 1920s Czech populists broke with the more radical Slovaks and in 1921 joined the governing coalition.

Political Catholicism's success in the next decade led some Catholic leaders to revisit the Marian Column issue. Fearing anticlerical violence in 1918, Catholics did not demonstrate against the column's destruction. By 1923, however, five years after the act, Catholics had renewed

confidence and began to petition for a new Marian Column for Old Town Square.[18]

Arguments for a new Marian Column reflected the new political tone in Prague. Rather than attacking nationalism, these Czech Catholics assured the public that they, too, supported the nation. A new Marian Column would reflect the marriage between Catholicism and nationalism in Czechoslovakia. The populist press, led by Catholic poet and essayist Jaroslav Durych, launched a campaign to raise money for a rebuilt Marian Column, arguing, "The Czech nation is not Hussite and never will be. The Czech nation is Catholic."[19] Therefore, the newspaper argued that the monument in the "most beautiful spot" in the Bohemian Crown lands should reflect the character of the Czech people, not the fantasies of a handful of "elite politicians and professors" who promoted the symbol of Hus.[20] Calling on fellow citizens to join his effort to rebuild the Marian Column, Durych proclaimed, "The old column was an independent gift of Emperor Ferdinand III. The new column will be a gift of the entire nation."[21]

The 1923 campaign raised one hundred thousand Czechoslovak crowns for the rebuilt column, but the Prague city government did not approve the project. The campaign also found little support in the Czechoslovak People's Party, which was more concerned with its place in the governing coalition than with cultural debates. The money raised by the campaign went instead to building suburban churches.

THE MARIAN COLUMN AND THE SECOND WORLD WAR

The dream for a new Marian Column did not die. In May 1939, only two months after the establishment of the Protectorate of Bohemia and Moravia by the German Nazis, a key figure from the interwar struggle over national symbols reemerged. Jaroslav Durych, who led the 1923 resurrection campaign, petitioned Nazi puppet president Emil Hácha to support the rebuilding of the Marian Column on Old Town Square. In his letter he argued, "The destruction of the column of the Virgin Mary has not been atoned for."[22] Unlike the previous Czechoslovak presidents Tomáš Masaryk and Edvard Beneš, Hácha was a devout Catholic. Thus, Durych could appeal to him as a fellow believer, as well as a leader who wanted to portray himself as a true Czech, even though the public knew that Germany was pulling his strings.

Durych did not suggest to the new president that he should abandon

Czech nationalism; instead he suggested that the Marian Column could become a symbol of a new form of Czech nationalism. He explained that Mary "is and has always been the national mother, queen, and protector of the country."[23] The Czechs, in his view, brought shame on their nation by abandoning Mary as their symbol, while neighboring countries continued to call her "Regina." He assured Hácha that he only needed his approval for the project; voluntary associations would raise the necessary funds independently. The Presidential Chancellery responded, promising Durych that his request would be carefully considered. However, during the tumultuous period of the Protectorate and the Second World War, when over 90 percent of Prague's Jewish population was deported to concentration camps and Prague Czechs lived under Nazi rule, the resurrection of the Marian Column never came to fruition. Still, the very fact that the question was even raised in the midst of such international turmoil demonstrates the power the column had on the nation's psyche.

THE MARIAN COLUMN UNDER COMMUNISM

Catholic activists hoped that the end of the war would bring a government willing to support the Marian Column resurrection. However, the Communist government had no interest in a religious revival and quickly suppressed a 1955 campaign of Czech university students to raise funds for the column. Under the Communist regime the empty space on Old Town Square took on new significance. With nationalism no longer at the heart of political discourse, the empty site instead came to symbolize the communist suppression of religion. In an interview with *The Prague Post*, Father Raymond, a Czech priest, explained that believers used the Old Town Square site as a symbol of anticommunist defiance. "During communism, I was watched very closely because I put flowers on the spot every Sunday. But of course they were removed immediately."[24]

Czech Catholic émigrés in the United States also began to identify with the Marian Column as a symbol of the oppression they had fled. In the early 1950s, Benedictine monk, and Czech émigré, Lev Ondrák spoke in New York about religious oppression in Czechoslovakia, suggesting that a Marian Column replica be built to honor victims of religious persecution in Communist states. Moved by Abbot Ondrák's stirring speech, the Vatican appointed papal sculptor Monteleone to cast a replica of the Virgin Mary statue. When completed, the statue was placed at Ondrák's abbey in

Lisle, Illinois, near Chicago. Czech immigrants in the United States contributed to the project, as did Catholics in Czechoslovakia, who gave money to friends leaving the country. A dissident poet, Zdenek Rotrekl, entrusted some gold to his emigrating colleague Emil Petrík, for the Marian statue's crown. Forty years later, in 1993, the Chicago abbey donated their Marian statue to a Prague monastery. Reporting on "Our Lady in Exile's return home," a Catholic magazine recently paid tribute to the courage of Rotrekl in the 1950s: "His gold symbolically sparkled on the crown during an era when he himself suffered in a communist jail."[25]

Rotrekl was not the only poet to be captivated by the rich imagery surrounding the fallen Marian Column. Catholic poet Václav Renc, a political prisoner in Communist Czechoslovakia from 1952 to 1961, wrote *Prague Legend* in 1956. He described the licentiousness of Prague society and likened the mob's glee at their act to an "orgasm, which lasts only a moment."[26] Nonetheless, he insisted that his poem celebrated God's love for the Czech people. Even though the Marian Column had vanished from the landscape, in the poem the Virgin Mary still appeared to Prague citizens during an era that had turned its back on religion.

Even Nobel Prize–winning poet Jaroslav Seifert addressed the issue of the Marian Column. The former communist turned dissident, famous for his melancholic nostalgic poetry, reflected personally on his youthful complicity in destroying tradition. In *The Head of the Virgin Mary* Seifert receives a vision of the "guillotined head" of the Marian Column after his friend asks the poet if he believed in "the afterlife or perhaps something worse."[27] Seifert's narrator suddenly remembers that he gleefully watched the column's toppling, and the Virgin's head rolling toward his dusty shoes. As an old man, sixty years after the vandalism, the narrator regrets his former brashness and asks the Virgin for forgiveness.

In his *Czech Dreambook*, Ludvik Vaculík, the dissident leader of the *samizdat* (self-publishing) movement, also wonders if the Marian Column symbolized the Czechs' complicity in their own fate. As he visits a church in a Prague suburb, which housed a commemorative plaque about the Marian Column, Vaculík reports, "I kept thinking that a nation which tears down the monuments it raises in other moods and avoids revamping its character in favor of revamping the record of its character—such a nation deserves to be blurred."[28] Common themes in Czech dissident literature included the emptiness of culture under communism, the loss of authenticity, and the obliteration of history. Although the Marian Column fell

thirty years before communism's rise, writers used the empty space on Old Town Square to symbolize the void they now felt.

THE MARIAN COLUMN IN POST-1989 PRAGUE

The rapid democratization of politics following the fall of communism has launched a new chapter in the Marian Column debate.[29] This "postmodern era"—as a 1991 Czech art history journal described it—has fostered a multitude of opinions about the Marian Column.[30] Ranging from religious to political to aesthetic, the debates also differ from the past because they have led to the real possibility that the Marian Column will rise again. Opinions about rebuilding the Marian Column appear frequently in art and preservation journals, daily papers and news weeklies, free papers handed out in the Prague metro, and even "roving reporter" sections in which local residents have their picture taken and offer a brief opinion on a current issue.[31]

The Society for the Recovery of the Marian Column was formally established on May 14, 1990, and immediately began to raise funds for the "grassroots" movement.[32] The 130 members have raised 1.5 million of the necessary 4 million Czech crowns (approximately $100,000) from private donations.[33] Donors can contribute to special bank accounts of the Czech Savings Bank or the Canadian Bank of Commerce, a fund established by the St. Cyril and Methodius League of Ontario, Canada.[34] Many members and donors are Roman Catholics, from the Czech Republic and abroad, who view the "empty space" on Old Town Square as a symbol of the religious persecution endured by Catholics in the twentieth century.

The city government has not blocked the society's plans to restore the monument or to investigate the possibility of erecting it as long as no public funds go toward the project.[35] The state's Bureau for the Protection of Monuments has applauded the Society's efforts but has not contributed any funds because technically this is not a "preservation project."[36] Recently the city government expressed a stronger opinion on the matter when Prague mayor Jan Kasl explained that "Town Hall currently has quite different problems" than dealing with the Marian Column.[37]

Nonetheless, Jan Bradna, a Prague sculptor and president of the Society for the Recovery of the Marian Column, has little doubt that public opinion supports his group's efforts. He told the *Prague Post*, "Czech people are happy about the return of such a statue."[38] On November 3, 1993, the anni-

versary of the column's destruction, the Society staked its claim on the monument's former site by laying a plaque into the cobblestones. The plaque reads, "Here did stand and will stand again / The Marian Column of Old Town Square." The proclamation is inscribed in Czech, German, and Latin, as well as English.

There was immediate dissent to the laying of the commemorative—and prescriptive—plaque. Within months vandals attacked the plaque, carving and cementing over the words "will stand again" in each language. A letter to the editor of *Lidové Demokracie* (People's Democracy), a populist news-paper, called the vandalism "a barbarous act" that brought "shame to the whole nation."[39] An opinion piece in a Protestant weekly newspaper, how-ever, explained why the plaque aroused such anger. The author, Josef Gebauer, decried the possibility of celebrating "three-hundred years of Habsburg subjugation of the Czech nation."[40] His article enumerated Habsburg-era injustices and then asked what would be the "historical purpose" of commemorating this era. In particular he cited the perse-cution, executions, and exile of Bohemian Protestants throughout the Habsburg period. Like other anti-Column Czechs, Gebauer admitted that the column originally commemorated the Swedish retreat—not the defeat of the Bohemians—but he argued that its meaning had expanded.

Gebauer also questioned the plans for a new column on historicist grounds. "For a restored column to return to the square, we would also have to refinish Old Town Hall, demolish the Hus monument, rearrange Paris street."[41] His statement alludes to the ever-changing appearance of a living city. It is impossible to restore a site to its original state. His article ends with the reminder: "The pre-White-Mountain square did not have a Marian Col-umn."[42] He subtly argues that if the Czech nation commemorates any past historical period, it ought to be one before the Habsburg victory.

Several academic and cultural journals also responded to the revived debate. Vít Vlnas, an art historian who specializes in Czech baroque, wrote in the cultural review *Přítomnost* (The Present), "Old Town Square cannot be turned into a museum." Vlnas argued that a "baroque Marian Column cannot be an authentic expression of our era."[43] Instead he suggested a modern obelisk dedicated to victims of fascist and communist dictator-ships. The most outspoken critic of the rebuilding efforts, Lubomír Sršen, former director and current research scholar at the National Museum's Lapidarium, agreed: "There is no way to rebuild it exactly as it stood one hundred years ago. I think it should be a modern statue, not a historic

copy."[44] However, in the art journal *Umění and Řemesla* (Arts and Crafts), art historian Ivo Hlobil questioned Vlnas's notion that a restored baroque statue would not represent the present period. Explaining that many movements in art history revive earlier periods, Hlobil argued that historicist art can indeed reflect the values of a present era.[45]

The Society for the Recovery of the Marian Column ultimately decided to build a replica, not a modern statue, even though some members questioned the idea of an "authentic" restoration. Even Jan Bradna, the new monument's sculptor, initially "wanted to do something abstract. Something with a set of hands reaching out to the clock tower and another set mounted by the execution site,"[46] referring to the spot on Old Town Square where twenty-seven Bohemian Hussite rebels were beheaded in 1621, a year after the White Mountain defeat. Thus, Bradna's idea "would represent a bond between modern and past history and help put those souls to rest."[47] Other Praguers also believe the revived column can heal religious wounds. Father Raymond explained, "That column has the potential to form a bond between Protestants, Hussites, and Catholics in Prague. It needs to return to the square."[48] Similarly, Josef Štulc, head of the Bureau of the Protection of Monuments, wrote that the former relationship between the Marian Column and the Hus Memorial formed a "creative dialogue between symbols of both main spiritual traditions, Hussite and Catholic, which together created spiritual life and Czech national culture."[49]

This logic, however, eludes many Czechs, including the Roman Catholic hierarchy, which surprisingly does not support the Marian Column project. Prague Archbishop Miloslav Vlk issued a statement in 1993. "Restoring the Marian Column on Old Town Square is not an official priority of the church, rather [our goal] is to try to revive spiritual life." Furthermore, Vlk feared that a restored Marian Column would increase religious tension in the city. "We do not want to create the impression of rivalry in the arena of ecumenism."[50] Similarly, Petr Ettler, a spokesperson from the archbishop's office, explained that the Marian Column represents "the old church."[51] Officially, the Church leadership has no interest in returning to the Counter-Reformation era. The Roman Catholic Church has not donated any funds to the Marian Column project.

With so much opposition to the monument, and only one-third of the necessary funds collected, the Marian Column's resurrection seems doubtful. Yet the Society continues to work passionately and declares that the column will indeed "stand again."

4. Commemorative plaque with scratched-out inscription.
Site of the fallen Marian Column. Photo by Cynthia Paces.

5. Sculptor Jan Bradna's replica of the Marian
Column Statue. Photo by M. Sošková. Permission by
Společnost pro obnovu mariánského sloupu v Praze.

CONCLUSION

At the heart of the ever-shifting debate about the Marian Column is the Czechs' perception of their own suffering throughout history. Robert Pynsent, an expert on Czech culture, has written that Czechs choose martyrs for national heroes to find historic meaning in four centuries of perceived political and cultural subjugation under the Habsburgs, Nazis, and Communists.[52] One cannot overstress the strange religious history of the nation, which experimented with early Protestantism, experienced forced conversion during the Counter-Reformation, came of age as a nation during the secularizing nineteenth century, and stagnated under an atheist regime. Many scholars—and Czechs themselves—simply dismiss the nation as totally secularized. Yet the polemics surrounding the Marian Column demonstrate that Czech national identity is intrinsically tied to the religious complexities of its history. Those involved in the Marian Column debates during the twentieth century and the twenty-first seem determined to prove that *their* group has suffered the most. Attacking or defending the Marian Column has come to represent a way to heal symbolically.

As contemporary Catholics and Protestants, as well as secular critics, grapple with the empty space on Old Town Square, it seems necessary to point out the religious group missing from the debate. Although Prague's Jews were almost entirely wiped out during the Second World War, their small community of approximately fifteen hundred has recently engaged in the post-1989 debates about national and urban symbols and history. In 2000 they fought to protect an ancient Jewish cemetery unearthed unexpectedly during a construction project and to place explanatory plaques on a controversial eighteenth-century Prague statue proclaiming Christ as "Holy" in Hebrew letters.[53] If, as many have argued, the statues on Old Town Square should acknowledge the suffering as well as the complexities of Prague's religious history, the Jewish contribution to the city's identity also cannot be overlooked.

NOTES

Several people have contributed to this essay and deserve recognition. Special thanks to Jan Bradna, president of the Society for the Rebuilding of the Marian Column, for providing me with photographs and materials. Eagle Glassheim, Claire

Nolte, Alice Podobová, Petr Skalník of Charles University, Čenek Kuta of the Lapidarium of the National Museum in Prague, and Nancy Wingfield all contributed information and source materials. Diane Paces-Wiles assisted with the illustrations. Jay Carter and Nancy Wingfield read drafts and provided helpful suggestions.

1. Macura, "Minus Stalin."

2. Campbell, "Empty Pedestals?"

3. See the museum catalog, *Lapidárium Národního Muzea Praha* (Prague, 1993), 77–78, for photographs of the fragments.

4. Turner, "Liminality and the Performative Genres."

5. Šorm and Krejča, *Mariánské sloupy v Čechách a na Moravě.*

6. Speech reprinted in the Sokol Gymnastics Organization periodical *Věstník sokolský* 17 (1903): 504–5.

7. "Stanovisko," *Právo lidu,* July 7, 1903.

8. "Ladislav Šaloun, o svém Husovi" [Ladislav Šaloun on His Hus]. Newspaper article reprinted from unacknowledged source, no date (most likely 1903). Archiv Hlavního Města Prahy, Spolek Zbudování Pomníku Husova, Notebook 1.

9. See Pelikan, *Mary through the Centuries.*

10. Quoted in Gottfried, "Kterák socha Mariánská byla stržena," 30.

11. Czechoslovakia became a state after the defeat of Austria-Hungary in World War I. The Austrian Bohemian Crown lands of Bohemia, Moravia, and a piece of Silesia joined Slovakia and Ruthenia, formerly of Hungary. Although Czechoslovakia was founded on Woodrow Wilson's principle of national self-determination, it was not monoethnic, since historic borders were also taken into consideration. Consequently, in addition to Czechs and Slovaks, who were legally considered one nationality (Czechoslovak), Czechoslovakia had large German, Hungarian, and Ruthenian populations, as well as a small Polish population.

12. František Kysela-Sauer, "Naše luza, jesuité a diplomaté" [Our Mob, the Jesuits and the Diplomats] (Prague, 1923).

13. Ibid., 24.

14. Hruban, *Z času nedlouho zaslých* [From the Recent Past], 199. Quoted and translated in Hajek, "Catholics and Politics in Czechoslovakia, 1918–1929," 39.

15. Quoted in Peroutka, *Budování státu,* 118. This source, originally published during the 1920s, is a firsthand account of Czechoslovakia's early years by a journalist and close political associate of President Tomáš G. Masaryk. See also *Národní listy,* Nov. 5, 1918.

16. Quoted in Kysela-Sauer, "Naše luza, jesuité a diplomaté," 8. Also quoted in Peroutka, *Budování státu,* 117; and the Catholic newspaper *Lidové listy,* Nov. 11, 1923.

17. Trapl, *Political Catholicism and the Czechoslovak People's Party in Czechoslovakia, 1918–1938,* 9.

18. For a more thorough discussion of Czech Catholic nationalism, as well as the 1923 movement to rebuild the Marian Column, see Paces, " 'The Czech Nation Must be Catholic!' "

19. Jaroslav Durych, "Český národ musí být katolický!" [The Czech Nation Must Be Catholic!] *Lidové listy*, May 10, 1923.

20. Even though one of the main arguments for using Catholic symbols in the new state was that it would appeal to Slovaks as well as Czechs, the populist press still used the terms *Czech nation* and *Czech people* in their articles. It is unsurprising that Slovak nationalists felt distanced from the symbols of their state, when even the Czech groups supposedly advocating their cause often neglected to use the term *Czechoslovak*.

21. Durych, "Český národ" (see note 19).

22. Jaroslav Durych to Presidential Chancellery. Sign.: D 7116 / 39, čís.: D 3078 / 39. Archiv Kancelář Presidenta Republiky.

23. Ibid.

24. J. M. Giordano, "Resurrecting Mary. A Controversial Historical Landmark May Soon Rise Again," *Prague Post*, July 22–28, 1998, B12–13. Thank you to Eagle Glassheim, who provided me with this source.

25. Ludmila Konopíková, "Paní z exilu vrací domu" [The Lady Returns Home from Exile], *Naše rodina* [Our Family], no. 33 (1993): 16–17. See also Ludmila Konopíková, "Strahovské (s)vítání" [Strahov Welcome], *Naše rodina*, no. 44 (1993): 2–3.

26. Renc, *Pražská Legenda*, 16.

27. Seifert, *Hlava Panny Marie*, 9.

28. Heim, "A Czech Dreambook," 80.

29. Slovakia broke from Czechoslovakia in January 1993, removing Slovak Catholics' potential attitudes about the Marian Column from the debate.

30. Hlobil, "Obnova mariánského sloupu?" 97–98.

31. See, e.g., Matej Hušek and Bohumil Vostal, "Obnova monumentu na náměstí má příznivce i odpurce" [Renovating the Monument on the Square Has Supporters and Opponents], *Zemské noviny*, Nov. 3, 1999; and Tomáš Čechtický and Petr Kovařík, "Stín sloupu, stín historie" [The Shadow of the Column, the Shadow of History], *Týden*, Oct. 26, 1998.

32. Giordano, "Resurrecting Mary," B12.

33. Information on the size of the group comes from personal correspondence with Jan Bradna (March 4, 2000). Information on the fund-raising comes from Zuzana Pitrová, "Boj o Mariánský sloup" [Battle over the Marian Column], *Metro*, March 16, 2000.

34. See the self-published brochure *Celonárodní sbírka na obnovu sloupu Blahoslavené Panny Marie na Staroměstském Náměstí v Praze* [All-National Collection for the Renovation of the Most Holy Virgin Mary Column on Old Town Square in Prague] (Prague: Credo, 1996).

35. *Výstava 99. Budoucnost a přítomnost Prahy 1* [Exhibition 99. Future and Present of Prague 1] (III. Ročník, 4.11–7.11.1999). No publishing information. This source is a photocopied guide to a small exhibit held in November 1999 in Wenceslas Square. Eagle Glassheim provided me with this source.

36. Hušek and Vostal, "Obnova monumentu na náměstí má příznivce i odpurce" (see note 31).

37. Pitrová, "Boj o Mariánský sloup" (see note 33).

38. Giordano, "Resurrecting Mary," B12.

39. P. Antonín Odvárka, "Barbarský čin" [Barbarous Act], *Lidové demokracie* [People's Democracy], July 15, 1994, 7.

40. Josef Gebauer, "Na tomto mistě stál a opět bude stát" [On This Spot Stood and Will Stand Again], *Evangelický týdeník* [Evangelical Weekly], no. 41 (1993): 2.

41. Ibid., 2.

42. Ibid., 2.

43. Quoted in Hlobil, "Obnova mariánského sloupu?" 97.

44. Giordano, "Resurrecting Mary," B13. See also Sršen's article, "Je proveditelná rekonstrukce mariáského sloupu na Staroměstském náměstí v Praze?" *Zprávy památkové péče* 59, no. 7 (1999): 233–40.

45. Hlobil, "Obnova mariánského sloupu?" 97–98.

46. Giordano, "Resurrecting Mary," B12.

47. Ibid., B12–B13.

48. Ibid., B13.

49. Josef Štulc, "Památková péče a tolerance," *Zprávy památkové péče* 60, no. 1 (1999): 1–7.

50. Miroslav Frankovský, Milan Zezula, Jaroslav Skarvada, and Miloslav Vlk, "Mariánský sloup na Staroměstském náměstí v Praze" [The Marian Column on Old Town Square in Prague], *Evangelický týdeník* 79, no. 4 (1994): 2.

51. Giordano, "Resurrecting Mary," B13.

52. Pynsent, *Questions of Identity*.

53. Steven Erlanger, "Prague Journal. A City in a Hurry, Stumbling on Its Medieval Dead," *New York Times*, March 20, 2000.

ABORTED IDENTITY

The Commission and Omission of a Monument

to the Nation, Sri Lanka, circa 1989

Kanishka Goonewardena

SRI LANKA IN CRISIS

The doomed competition organized in 1989 to design a "monument to the nation" in Sri Lanka coincided—hardly accidentally—with a grave crisis of this postcolonial state, a former colony (called Ceylon) of the Portuguese (1505–1658), the Dutch (1658–1796), and, most recently and influentially, the British (1796–1948). A terse account of this uniquely overdetermined crisis comes, oddly yet appropriately enough, from a hagiography of a politician who helped precipitate it: that is, Dayan Jayatilleke's tribute to the late president Ranasinghe Premadasa in book form. There Jayatilleke argues forcefully that "the [Sri] Lankan state [then] faced all three major categories of threats that any state could [ever] face."[1] First and foremost—indeed still the most intractable—was the threat to its "territorial integrity," presented by the Liberation Tigers of Tamil Ealam (LTTE or the "Tigers"), who had been fighting militarily for an independent Tamil state in the Northern Province and the Eastern Province of Sri Lanka for almost two decades. Second, as a direct consequence of the first, was the "threat to national independence and sovereignty" (p. 1) posed by the Indian Peace Keeping Force (IPKF), whose presence in the northern and eastern provinces of the country was meant to enforce the terms of the Indo-Lanka Peace Accord signed in July 1987. The latter, though presented and even possibly intended by the two signatory states as a "negotiated" political solution to the increasingly militant "Tamil-Sinhala" ethnic conflict fought between the LTTE and the Sri Lankan armed forces, was nonetheless perceived by Sinhala-Buddhist nationalists as a fundamental violation of their country's independence by an alien force somehow sympathetic to the minority of Tamils. As if these two threats to the Sri Lankan state were not difficult enough, there was a third, orchestrated by the ex-Maoist, anti-Indian, Sinhala-nationalist militant group, the People's Liberation Front

(JVP). Armed with T-56 machine guns (stolen from the armed forces) and led by the charismatic Rohana Wijeweera (with dedicated rank-and-file support from alienated rural youth and university students), the JVP was often misunderstood, especially by foreign commentators, as "Marxist." By 1989 this three-pronged attack—by the LTTE, the IPKF, and the JVP—on the Sri Lankan state was so formidable that Jayatilleke's adaptation of a famous phrase from Lenin to characterize that tense situation is more revealing than hyperbolic: "Sri Lanka, in 1989, was the weakest link in the chain of Third World democracies" (p. 1). What difference, then, could a "national monument" have made?

THE "POSTCOLONIAL" NATION:
BURDENS OF REPRESENTATION

Modern nations, as Benedict Anderson influentially demonstrates, are "imagined communities." In order to be imagined, of course, they must be represented. The more precarious or contrived the national community being imagined, moreover, the greater the need for and burden of representation. But even in normal times such imaginary representations are always called on to perform the well-nigh impossible task of eradicating any sense of the nation as a historical entity or ideological fiction, while presenting it as something eternal. Indeed, what distinguishes the nation from so many other imagined communities for Anderson lies precisely in the manner of its "transformation of fatality into continuity, contingency into meaning."[2] The immortality of the nation so projected points to the affinity of this nationalist imagination with religious worldviews about "man-in-the-cosmos" (p. 10) and explains why so many symbols of nationalism are "cenotaphs and tombs of Unknown Soldiers" (p. 9). Successfully imagined nations, then, "always loom out of an immemorial past, and, still more important, glide into a limitless future" (pp. 11–12). It is this magic of nationalism, its ability to turn "chance into destiny," that enabled Regis Debray to say: "Yes, it is quite accidental that I am born French; but after all, France is eternal" (p. 12).[3] But what if you were accidentally born Sri Lankan?

Then, Sri Lanka, like any other imagined nation, will have to be rendered "timeless." This task, however, will not be easy because the nation-state we now call Sri Lanka was ruled by *several* kingdoms (including a Tamil kingdom in the north) on the eve of colonization, and it was the British who last "unified" it in 1815 (for the first time since the twelfth

century) by subjecting the whole island to its rule, before granting independence in 1948. In any case, rendering the nation as timeless alone would not be sufficient to make Sri Lanka feel like Debray's France. For any adequate representation of Sri Lankan nationalism will be obliged to do much more than this "nationalist minimum," as it were, given the unique difficulties inherent in forging national identities for non-Western, postcolonial states in the modern (or postmodern) world. The compulsion to "be modern while being rooted in tradition" indeed adds a layer of complexity to such "developmentalist" nationalisms that is generally absent from those of the advanced capitalist countries. Sri Lankan nationalists, surely, cannot hope to remain immune from this (West) modernity-tradition (East) antinomy underlying their politics, which was formulated lucidly (well before postcolonial critics were born in the West) in Paul Ricoeur's *History and Truth*, with respect to "the crucial problem confronting nations just arising from underdevelopment," as also a global-local or universal-particular dialectic:

> In order to get on the road toward modernization, is it necessary to jettison the old cultural past which has been the *raison d'être* of a nation? . . . On the one hand, it has to root itself in the soil of its past, forge a national spirit, and unfurl this spiritual and cultural revindication before the colonialist's personality. But in order to take part in modern civilization, it is necessary at the same time to take part in scientific, technical, and political rationality. . . . There is the paradox: how to become modern and to return to the sources; how to revive an old, dormant civilization and take part in universal civilization.[4]

A national monument to Sri Lanka in 1989 was also obliged to address the political crisis facing the country—much of which stemmed from ethnic conflict, itself fueled by the social polarizations resulting from the UNP's economic liberalization policies introduced in 1977.[5] On the *origins* of the ethnic conflict, Ambalavanar Sivanandan, longtime editor of *Race and Class*, is most precise: "When the British left Ceylon in 1948, the lines of communal conflict had already been drawn. One hundred and fifty years of British rule had brought together three different social formations under one central administration for purposes of economic exploitation; but for purposes of political control, the colonial government had reinforced the communal divisions that ran like a seam around these social formations. It divided in order to rule what it integrated in order to exploit."[6]

These were the divisions that first got in the way of a "multiethnic" or "polycultural" *Sri Lankan* nationalism (as opposed to a merely Sinhala-Buddhist one), well before 1948. Since then, the same communal divisions and the "communalist" politics based on them have continued to shape major conflicts not only about political-economic power sharing within the country but also about the meaning of (an "independent") Sri Lankan culture. The bitterly contested "solution" to the political-economic dimension of the ethnic conflict has been, in principle, a new federal constitution, one that would grant substantial political and economic autonomy to each of the nine provinces (*especially* the northern and eastern provinces, where a majority of the Tamil people live) that make up Sri Lanka. This was indeed the overt intent of the Indo-Lanka Peace Accord of 1987, before it encountered fatal opposition as early as 1989.

But the idea of a Sri Lankan federation—otherwise known as the "peaceful," "negotiated," or "political" solution to the ethnic conflict, often advocated as the alternative to the "military solution" but sometimes as a complement to it—has been consistently rejected from two diametrically opposed directions. The LTTE, as campaigners for a separate state called Ealam (that would amalgamate the present territories of the northern and eastern provinces), have refused, in their negotiations with the Sri Lankan government, to accept the constitutional framework of a federal but ultimately *unitary* state as the untranscendable horizon within which solutions to Sri Lanka's ethnic conflict must be sought. From the south, nationalists have tended to see, with equal suspicion, the degree of regional autonomy allowed by a *federal* constitution as a dangerous threat to Sinhala-Buddhist political hegemony and "national" unity—a violation of the supposedly Sinhala-Buddhist *essence* of both the culture *and* the territorial integrity of Sri Lanka. It is no great secret that the inability on the part of Sinhala-Buddhist nationalists to distinguish between "Sri Lanka" and the "Sinhala nation" explains this hostility toward—even complete incomprehension of—the prospect of an ethnocultural pluralism nourished by a measure of regional political and economic autonomy. That President J. R. Jayewardene, who commissioned the national monument in 1989, could himself on numerous occasions slide easily in his rhetoric from the "Sri Lankan" nation to the "Sinhala nation" is now less well known.[7] Yet barely a month before he signed the Indo-Lanka Peace Accord, Jayewardene's Sinhala-Buddhist nationalist ideology was very much in evidence in Colombo's leading daily newspapers:

Sri Lankan nation has stood out as the most wonderful nation in the whole world because of several unique characteristics. *Sinhala nation* has followed one faith, that is Buddhism for an unbroken period of 2500 years. . . . There is no other nation that can boast of such a heritage. . . . The language of the King and the people 2100 years ago had been Sinhala which we speak today. It is one of the oldest Aryan languages in the world. . . . Another unique heritage is the country's history of sovereignty and territorial integrity. No other nation has enjoyed national independence for such a length of time as we have. . . . We are the most wonderful nation in the world. We must be proud of our history.[8]

PLASTIC IDENTITIES: ARCHITECTURE AND POLITICS

Sri Lanka has seen several efforts to create symbols of national identity. These efforts have failed almost invariably, however, because of the "communalism" that prevented them from transcending the country's ethnic divisions.[9] Surely, few could have seriously expected Sri Lankan Tamils to partake in the Sinhala-Buddhist nationalism of Anagarika Dharmapala or to merrily sing along a national anthem written in Sinhala only. But when the occasion arose to design a national flag at the time of independence, for instance, a valuable opportunity became available to imagine the representation of a truly Sri Lankan —rather than a merely Sinhala-Buddhist— identity. But that opportunity was lost.[10] Likewise, the new republican constitution of 1972, while breaking away from some lingering colonial baggage implicit in the "independence constitution" of 1948, regressed on the ethnic issue by registering Sinhala as the official language of Sri Lanka and Buddhism as the official religion, as did the "Sinhala-only" Official Language Act of 1956, which had decisively alienated postcolonial Tamil and other minority aspirations in the country.[11] Apart from the bizarre nationalist moment of winning the Cricket World Cup in 1996 (by convincingly beating favored Australia in the final, and a strong England along the way),[12] perhaps the only exception to a substantial list of squandered opportunities to fashion a Sri Lankan identity encompassing all the ethnocultural groups of the country (or at least one that did not discriminate against the minorities) is to be found in the art of architecture—most notably, in Geoffrey Bawa's highly-acclaimed 1982 design of the complex of buildings housing Sri Lanka's new Parliament.

Although architecture and urban design may not on their own alter the

course of national politics, many postcolonial nations have relied heavily on them for expressions of national identity that assert both independence and modernity—Brasilia being the most spectacular and well-studied case in point.[13] Such design exercises have typically focused on capital cities and prominent state or public buildings. The new Sri Lankan parliamentary complex and the shift of the national capital from the hustle and bustle of Colombo to the relative tranquility of neighboring Sri Jayawardhanapura Kotte in 1982 are not exceptional in this regard. What is special, however, is the architecture itself: how the new parliamentary complex—an "island" of pavilion-like buildings lying on a lake, directly across from an impressive expanse of green open space earmarked for the national monument—manages to embrace symbolically a plurality of ethnic, regional, and historical identities of the country and yet transcend the cleavages between them in a sweeping synthesis of vernacular forms that is unmistakably *Sri Lankan*. Here the form of the whole—anchored by an emphatic composition of traditional roof structures—adds up to a lot more than the sum of its parts. Bawa's architecture in this case is the very opposite of what architectural historians call "historicism"—the pastiche of superficial stylistic eclecticism that goes today by the name of postmodernism. Rather, it is a textbook example of what Kenneth Frampton advocates as "critical regionalism," an architecture that respects local cultures and places while being modern as well; resisting not only the homogenizing moment of "modernism" (more precisely, the so-called International Style), but also the temptation to "learn from Las Vegas" and indulge in what Fredric Jameson once called "a random cannibalization of all the historical styles of the past."[14]

What confluence of subjective and objective factors made such an architectural accomplishment possible? Bawa's privileged upbringing in an elite minority community may have made him particularly sensitive not only to the diversity of Sri Lankan cultures but also to their hybridity. Moreover, as a consummate cosmopolitan who was educated in law and English literature at Cambridge and subsequently trained in architecture at London's Architectural Association, he blossomed into a world-class *Sri Lankan* architect during the "protectionist" period of economic development in Sri Lanka that preceded the free-market policies adopted in 1977—within a cultural-political climate that encouraged creative developments in a wide range of indigenous arts more than does the current milieu of "globalization." Bawa's qualifications to execute the most demanding project of Sri Lankan postcolonial architecture, therefore, were impeccable. His unique

portfolio of accomplishments also meant that Bawa, although by no stretch of the imagination a political "radical," was far more advanced in his appreciation of "multiculturalism" by the early 1980s than most post-modern architects and, certainly, Sri Lankan politicians in power. In a noted study, Lawrence Vale incisively captures his achievement in the parliamentary complex:

> The success of the building is that it does not attempt to capture or represent all Sri Lankan culture with a single image or with a series of images in which each image represents a component culture. Its strength is the multivalence of its references, the willingness and the ability of the architect to draw upon many parts of Sri Lanka's eclectic architectural history. Bawa's parliament building design is inclusive in its approach to history without descending into caricature or pastiche. . . . Bawa's leadership is a milestone for postcolonial parliament building design.[15]

Nowhere was the polysemous character of Bawa's forms and symbols more evident than in the roofs—the visually dominant and unquestionably Sri Lankan element of the whole complex. For the highly distinct roof forms—and the colonnaded verandahs that bring them gently down to earth—allude to a multitude of periods and regions in the country, as well as an array of building types ranging from royal palaces and fortresses to peasant houses and temples of different religions. The architectural forms dominated by those roofs thus refuse narrow classification as Sinhalese, Tamil, Indian, Portuguese, Dutch, or British Colonial. Instead, they power-fully evoke "the long history of intercultural exchange and architectural miscegenation" that is unique to the island of Sri Lanka.[16] It is indeed by virtue of his deft use of the polyvalent imagery obtained from traditional Sri Lankan architectural forms that Bawa has acquired his well-deserved international reputation for having "confronted and transcended both Modernism and tradition."[17]

That all too often Bawa has been poorly understood and hastily hailed in his own country as a mere "traditionalist" is, then, quite unfortunate. But it is also understandable, given the frequent slippage, as we have seen, between "Sri Lankan tradition" and "Sinhala-Buddhist tradition"—that is, the ease with which anyone who is considered "traditional" in Sri Lanka can be readily assumed to be "Sinhala-Buddhist" as well. Even more disconcerting is the discrepancy between Bawa's design for the parliamentary complex and the political intentions of the regime that commissioned it,

1. Aerial photograph of Sri Lanka's parliamentary
complex, and Geoffrey Bawa's early sketches emphasizing
roofs. From Brian Brace Taylor, *Geoffrey Bawa* (1986; repr.
London: Thames and Hudson, 1995).

which are better expressed in the master plan for the new capital city adorned by Bawa's masterpiece: Sri Jayawardhanapura Kotte. For whereas Bawa's design strikes one as a highly original symbolic resolution of the Sri Lankan polity's real contradictions, the new town plan for Kotte appears "in many ways . . . as a temple to Sinhalese nationalism and to the rule of President Jayewardene,"[18] whose government conceived and executed it. In marked contrast to the hybrid architecture of the parliament, "the only culture that seems to be considered indigenous in the iconography of this master plan [for Kotte]," as Vale demonstrates in his careful study, "is that of the Buddhist Sinhalese."[19] Kotte, after all, was the seat of the last Sinhala King (Sri Parakramabahu VI) who "united" the whole island under his rule in 1449 by militarily defeating the northern Tamil kingdom of Arya Chakarvarti—a key historical reference that framed much of the public discourse on the new capital's contemporary political significance. "Along with the establishment of the magnificent new parliamentary complex in the historic Royal City of Sri Jayawardhanapura Kotte," asserted one typical report during the opening ceremonies of the Parliament and the new capital, "a quota of flesh and blood is given to the dry bones of this ancient city to resurrect with renewed prestige the splendour she last enjoyed under King Parakramabahu VI." The sentiments expressed by respected Sinhala-Buddhist journalist and historian Wilfred M. Gunasekara, an ardent admirer of President Jayewardene, also echoed those of the ruling regime: "It augurs well to have the Parliament of the Democratic Socialist Republic of Sri Lanka during the tenure of President J. R. Jayewardene installed in Jayawardhanapura Kotte. This city, which was founded by Alakeswara and adorned by Sri Parakramabahu VI is now enriched by the government of our elected President who will sustain good government in a unified Lanka and foster its culture and learning and inspire his countrymen over generations to come."[20]

THE AESTHETICS AND POLITICS OF
THE NATIONAL MONUMENT

The guidelines accompanying the 1989 design competition for Sri Lanka's national monument—above all, the injunction to adorn it with "traditional motifs" of Sri Lankan art and architecture—were formulated against the backdrop of such Sinhala-Buddhist rhetoric. That was hardly surprising, to the extent *tradition* referred to Sinhala-Buddhist tradition. What *was*

surprising in that context was the design that convincingly won the competition. For the winning design, submitted by two highly talented architects, R. Aluwihare and D. B. Navaratne, not only deviated courageously from the predictably "traditional" design guidelines issued by the presidential secretariat but also confronted creatively the three major cultural-political problems the monument had to address: imagining the nation, negotiating modernity and tradition, and proposing a credible resolution to the ethnic conflict threatening to tear the country apart.

In a specially requested "statement of purpose" accompanying their design, Aluwihare and Navaratne were explicit about what their design for the monument set out to accomplish. They prefaced their intentions, understandably, with the obligatory nod toward the wishes of the presidential secretariat: a national monument, they noted at the outset, is "the greatest of all monuments in a country," and ours must be "commemorative, memorable, and inspiring."[21] It should, accordingly, "commemorate the sacrifice and courage . . . of those who gave their lives." They were willing, in Anderson's terms, to include some "unknown soldiers" in their design. But for what cause did they give their lives? To be sure, for "defeating threats to its independence and security," but also, Aluwihare and Navaratne added, for "a democratic way of life." It is with respect to the specifics of this "way of life" that the expectations of those who organized and judged the national competition—mostly bureaucrats of the presidential secretariat and leading architects and planners in the state sector—were most viscerally tested by the two designers. For they argued that the national monument should "symbolize social harmony and commemorate also the contributions made by the various social classes of Sri Lanka to the goals of the Republic." Even more daringly, they asserted that the monument ought to "symbolize national unity and reconciliation and commemorate the contributions of all [ethnic] communities" to such unity and reconciliation, as well as to "the goals of the Republic."

What could be the basis of such unity? For Aluwihare and Navaratne the political identity—or cultural essence—needed to nourish the modern nation of Sri Lanka does not flow from the old glories of some ancient Sinhala-Buddhist civilization but from its much more recent experience of anticolonial struggle for political independence. According to them it is "in this struggle for independence [that] a new identity of a single people was forged." The assertion was, of course, factually incorrect. In Sri Lanka, it should be recalled, the quest for independence never reached the level of

mass mobilization or the degree of unity it did, say, in India under the auspices of Subhas Chandra Bose and Gandhi;[22] here the "struggle" was more about the peaceful and gradual transfer of power from one group of elites to another. Yet this assertion has had a political utility that renders its "correctness" moot. To wit: this largely fictitious notion of a national identity "forged" during the "struggle for independence," though precariously modern, certainly holds in present-day Sri Lanka more promise for national reconciliation than do the millenarian myths propagated by Sinhala-Buddhist ideologues. Under the current conditions it may well be, in the designers' own words, the only plausible "identity of *one* people brought together by a common history and rising towards a common destiny"[23]—the kind of *Sri Lankan* identity worthy of being represented by a *national* monument. In any case, Aluwihare's and Navaratne's bold acknowledgment of the need for "reconciliation" and "unity" pointed firmly to a sober truth that could scarcely be denied: the unity of the Democratic Socialist Republic of Sri Lanka is now radically undermined by ethnic conflict. Thus the first order of business for a monument to that republic would be to gesture toward reconciliation between the ethnic communities and social groups locked in conflict. For without reconciliation today, there will be no republic to commemorate tomorrow.

What would a monument addressing such concerns look like? If Aluwihare's and Navaratne's statement about *what* a national monument to Sri Lanka ought to achieve surprised many, their demonstration of *how* all that could be realized in three dimensional form was even more shocking—especially for those directly linked to this politically hypersensitive design competition advocating the use of "traditional motifs." In their design the two architects rejected this directive categorically and explained in writing why they "refrained from incorporating . . . [traditional] architectural elements in the design." They maintained that a pastiche of "such historical elements" would not only trivialize their proper meanings in the present context but would also invite us to "always reminisce and keep us in the past without evoking a sense of national progress."[24] In an interview with the author they explained their rejection of "traditional motifs" in the national monument:

> We didn't want to break it down into [traditional] elements, and say that this represents this and that represents that, like in the national flag, where they say that this color represents the Tamils, that color some-

thing else, and the lion the Sinhala people. We didn't want to do that. . . . We emphasized the expressiveness of the monument as a whole, in relation to its context—the parliamentary complex, the lake, the Parade Grounds across from the parliament [on which the monument was to be located]—instead of trying to explain it by breaking up the whole thing into its constituent elements and the symbolic meanings attributed to those elements. We didn't think it made sense to transplant various artistic motifs and architectural details from some ancient era, with no relevance to the present context; such a simple-minded recourse to tradition, we thought, would represent a decadent and hollow present. . . . We don't have any particular element in the monument that can be directly associated with any particular religion or region. So it is everybody's; it belongs to everyone.[25]

How, then, did Aluwihare's and Navaratne's "modernist abstraction" win the competition? The quality of their design, especially the way it relates aesthetically to its context, provides a crucial part of the answer to this question; the rest is explained by the highly influential presence of Geoffrey Bawa in the jury that judged the competition. The most visually stunning yet remarkably austere sculptural feature of the monument consists of nine granite columns of different heights (ranging from thirty to one hundred feet) rising from somewhat random locations on a firmly raised square platform, all linked together by a soaring assortment of giant copper sails. The sweeping, undulating forms of these seemingly free-floating sails, while providing a fine visual contrast to the rigid verticality of the columns, also complemented in scale, form, color, and texture the impressive roof structures (also made out of copper) of the parliamentary complex lying majestically across the lake from the proposed monument. One can easily imagine how this aspect of the prizewinning monument might have pleased Bawa. The bold architectural forms complementing his design for the parliament complex and blending into the surroundings, moreover, were creatively abstract, modernist, and subtle. The two young architects had clearly *understood* and *radicalized* in more abstract form Bawa's own pathbreaking way of representing the hybrid nation architecturally—through a novel composition of polyvalent imagery rather than a conventional postmodern pastiche of traditional motifs. And Bawa did not make much of an effort to keep his opinion on these matters secret. Within the tightly knit community of Sri Lankan architects, even before

2. Model of the Sri Lankan national monument proposed
by R. Aluwihare and D. B. Navaratne. From photograph
provided by Aluwihare and Navaratne.

the result of the competition was formally announced, Bawa was widely
quoted as having said that he "never expected a national monument of
such high standard from this design competition" and that "there was a
large gap separating all the submissions from that of the winners": Alu-
wihare and Navaratne.

The rest of the jury, however, was not so firmly convinced. The kinds of
questions they directed to Aluwihare and Navaratne after deciding that
they had won the competition but before making that decision public—in
a series of special interviews—reveal the nature of their reservations. The
two architects recall those conversations vividly:

> I remember Dr. Roland Silva [the Commissioner of Archaeology] asking:
> "as a member of the jury I will have to answer, justify, this selection to the
> President and the Press. They will ask: why did you select this? OK, this is
> a sculpture but there's no Kandyan roofing in this, there's no *punkalasa* in
> it, there's no *sandakadapahana* in it, there's no lion in it. . . . Then, for
> what reason did you select it?" I can remember very clearly the words he
> used: "I have to give some reason to the Press." . . . Then we knew what
> the problem was. They wanted some kind of answer from us that they
> could give to the press. I think they all agreed . . . OK, this is the right
> thing—the right design. But they did not know how to present it to the

people. I am not saying that they didn't understand what we were trying to say there, but they also had a problem: I mean, how could one talk about a national culture of 2500 years and have a national monument devoid of any traditional motifs?

Aluwihare and Navaratne were thus compelled to explain—not without much hesitation—how their abstract forms in fact were traditional. "Traditional things are there," they remember saying, "but in a different way." For example, "the base of the monument is square, and there is a sandy pathway that wrapped around it: these 'abstract' things you can find even in the ancient religious complexes from Anuradhapura and Polonnaruwa." But some members of the jury turned out to be far more traditional than the two architects had bargained for. When it was suggested to them that they modify the design to include some traditional motifs that were found missing, however, they stood firm. They then pointed out how the entire composition would "just fall apart" if anyone tried to tinker with the various elements of it and insisted on the integrity of their design: "how the elements come together to form the whole is of great importance to the monument—and to the nation too." This difficult debate between the designers and the jury eventually terminated in a fascinating compromise, which Aluwihare and Navaratne saw as a victory for them under adverse circumstances, that is, in negotiation with powerful people who "were not in tune with . . . [the designers'] thinking":

> They insisted at one point that we had to have some traditional motifs
> *somewhere!* They came down to that level. Roland Silva said: "you have to
> have it *somewhere.*" I said, "OK, in that case, we have giant copper sails,
> and on those sails, if you want, you can have engravings of lotus flowers
> or whatever it is that you want. And you will never see them! It will be so
> far above you, you will never see them. But if there's a person who wants
> to be associated with them, then you can *tell* them: it's there, far above in
> the sky! You don't see them; but it's there." We said we would be happy
> to do that—because we thought that would do the least disturbance to
> what we are trying to build.

WHITHER SRI LANKA?

Just weeks before the presidential election in November 1989, the presidential secretariat finally declared Aluwihare and Navaratne the winners of

the competition to design the national monument and awarded them the prize money of Rs.100,000. Since then, however, the two architects have heard nothing about it. Some have attempted—by way of speculative rumor—to attribute the disappointing fate of the proposed monument to the transition of the presidency from Jayewardene to Premadasa in 1989. But for anyone possessing the slightest memory of "communal politics" in postcolonial Sri Lanka, there is not much to choose between these two leaders of the UNP that ruled Sri Lanka from 1977 to 1994 when it comes to the ethnic issue.[26] The fate of the doomed monument is better explained by the design itself and how it was perceived by those who made the decisions both before and after the competition. Its abstract, modern form no doubt offended some, but above all, its visually most striking feature—the columns and the sails—sealed its fate. Amid escalating Sinhala-Buddhist opposition to a new federal constitution granting substantive political autonomy to the nine provinces of the country (especially the Northern Province and the Eastern Province), few missed the meaning of the nine distinct columns—and of the flexible sails linking them. Especially after 1989, the design was very much prone to interpretation by Sinhala-Buddhist nationalists not as a monument to "reconciliation" and "unity," as the two architects intended, but as a paean to the breakup of Sri Lanka. During their interviews with the jury Aluwihare and Navaratne realized, of course, that "someone could say that these nine columns represented the nine provinces to which political power was being devolved at that time." But their belated poststructuralist attempt to suggest that the monument was open to multiple interpretations (for example, "some traditional astrologer could say," they insisted, "that these nine columns referred to the nine planets") convinced no one. Thus the very success of Aluwihare's and Navaratne's design in addressing, with admirable creativity and courage, the possibility of a national imagination, the prospect of a Sri Lankan entry into modernity, and the need for "reconciliation" and "unity" in the face of the ethnic conflict, also paved the way for its eventual demise.

Aluwihare and Navaratne argued eloquently, but in the event unsuccessfully, that the country "needed a change and the national monument was the perfect occasion for a turning point." Ten years later, one sees in the story of this doomed monument a rare opportunity that was missed— to seriously rethink the form and content of modern Sri Lanka's postcolonial identity. With ten years of hindsight, during which time Sinhala-Buddhist nationalism has evolved toward a Sri Lankan form of fascism,

that loss seems all the more tragic. Rather than standing as a monument to a Sri Lankan nation, the aborted monument marks a decisive moment of crisis, stemming from the proven inability of an outmoded Sinhala-Buddhist ethnonationalism to sustain the political unity of Sri Lanka and the lack of a credible new alternative to take its place—an identity faithful to the island's cultural hybridity captured in Bawa's architecture and mindful of the need for "reconciliation" and "unity" articulated by Aluwihare and Navaratne. Antonio Gramsci's remark on a somewhat similar moment in Italian history holds good for the present Sri Lankan situation as well: "The crisis consists," he wrote, "precisely in the fact that the old is dying and the new cannot be born; in this interregnum a great variety of morbid symptoms appear."[27]

NOTES

1. Jayatilleke, *Sri Lanka*, 1.

2. Benedict Anderson, *Imagined Communities*, 10–12.

3. Quoted in ibid.

4. Quoted in Frampton, "Towards a Critical Regionalism," 16.

5. On the political-economic dimension of the Sri Lankan ethnic conflict see the brilliant essay by Newton Gunasinghe, "The Open Economy and Its Impact on Ethnic Relations."

6. Sivanandan, "Sri Lanka," 199.

7. This habit—an occupational hazard of leading Sinhala politicians—is fully endorsed by the leading ideologues of Sinhala-Buddhist *Jathika Chinthanaya* (National Ideology). According to Nalin de Silva: "There is a common culture in this country and we must seek our solutions to our problems within the framework of that common culture. The inherent common culture in this country is . . . best described in Buddhism" (34). Gunadasa Amarasekara, the most eloquent spokesman for *Jathika Chinthanaya*, agrees that "our National Ideology is the Sinhala-Buddhist ideology that has evolved through a period of about two thousand years" and adds: "The main assumption behind *Jathika Chinthanaya* is that, although there are many ethnic groups in this country such as the Sinhalese, the Tamils, and the Muslims, all of them belong to the basically same culture; as such, they must be referred to as one nation. . . . We believe that the people of this country, while belonging to different ethnicities, are bound by the same culture and are heirs to the same *Jathika Chinthanaya*. What is racist about that?" See Amarasekara, *Jathika Chinthanaya saha Jathika Aarthikaya*, 15. The translation of the last quotation is mine. I have attempted to come to terms with the recent ascent of so-called National Ideology in Sri Lanka in "Cultural Politics of Global Capital."

8. *Daily News* (Colombo), June 12, 1987, 1, quoted in Krishna, *Postcolonial Insecurities*, 41.

9. *Communalism* often serves as a code word for (state-sponsored) racism in several discourses on the Sri Lankan ethnic conflict. Sivanandan is correct to note that

> communalism implies a parallel relationship between (communal) groups, antagonistic perhaps but not necessarily unequal; racism connotes a hierarchical relationship of power, institutionalised in the state apparatus. Communal violence, therefore, refers to that which occurs between (communal) groups, not to that inflicted on one group by the state, representing another. Hence, the use of the term (communal) "riots," when what is meant—or should be—is state pogroms. This is not just a euphemism but a violent distortion of the truth—which further adds to the pretended innocence of the state. Communalism is an "afraid" word. (Sivanandan, "Sri Lanka," 234–35)

10. Arjun Gunaratne's diligent research and incisive lecture, "Politics of the Sri Lankan National Flag," delivered at the Center for International Studies, Cornell University, in spring 1996 alerted me to the fascinating "communal" politics of designing the Sri Lankan national flag.

11. Sivanandan, "Sri Lanka," 215, 226.

12. See Ismail, "Batting against the Break."

13. See, e.g., Holston, *The Modernist City*.

14. Jameson, *Postmodernism*, 18–19. See also the distinction Jameson draws between "stylistic postmodernism" and "critical regionalism" in his penetrating essay "The Constraints of Postmodernism," esp. 195.

15. Vale, "Sri Lanka's Island Parliament," 194.

16. Ibid., 197.

17. Ghirardo, *Architecture after Modernism*, 16. A richly illustrated account of Bawa's remarkable oeuvre can be found in Taylor, *Geoffrey Bawa*.

18. Vale, "Sri Lanka's Island Parliament," 200–201.

19. Ibid., 206.

20. Quoted in ibid., 204; see also 194.

21. R. Aluwihare and D. B. Navaratne, "The National Monument: What It Should Achieve and How" (unpublished manuscript, 1989). All quotations in this passage are taken from this (nonpaginated) document, copies of which are available from the author.

22. In his noted essay on postcoloniality, Aijaz Ahmad writes:

> It is the claim of British colonial historiography that Britain bestowed nationhood on India through conquest and administration; for this colonialist outlook, Indian nationhood is certainly a "legacy of imperialism." The fact, however, is that, to the extent that India is a nation at all, it became so not through British administration but in the course of the anticolonial move-

ment, which was internally far more democratic than the colonial state and which mobilised some 20 million peasant households in the struggle against colonialism; the main British contribution to this process was that, at the beginning of the second world war, and in response to the Quit India Movement, Britain made an irrevocable commitment to Jinnah and thereby contributed to the subsequent Partition of the country. . . . Indian nationhood exists in India in the shape of the history of the national movement itself (Ahmad, "The Politics of Literary Postcoloniality," 4).

My point is that the same cannot be said about Sri Lanka without distorting the historical record.

23. Aluwihare and Navaratne, "The National Monument" (see note 21).

24. Ibid.

25. Aluwihare and Navaratne, interview by author. All of the statements hereafter attributed to Aluwihare and Navaratne are taken from my interview with them.

26. When in 1957 the MEP (People's United Front) regime of S. W. R. D. Bandaranaike conceded the injustices meted out to the Tamils by his Official Language Act of 1956 and entered into a pact with the Tamil Federal Party leader Chelvanayakam to redress Tamil grievances—by granting some regional autonomy to the provinces and recognizing Tamil as "the language of administration of the Northern and Eastern Provinces"—it was none other than J. R. Jayewardene (then UNP Shadow Minister of Finance) "who headed a 'pilgrimage' of *bhikkus* (monks) and thugs to the Tooth Temple in Kandy to save the Sinhala-Buddhist polity" (see Sivanandan, "Sri Lanka," 215–16). During the anti-Tamil riots of July 1983, as president he notoriously "failed" to direct the armed forces and the police to restore peace—effectively giving the Sinhala mob organized by virulent Sinhala nationalists in his own party the license to loot and kill Tamils. It was the Indian government—with the threat of war—that forced him into the overdue peace initiative of 1987, the Indo-Lanka Peace Accord that revived and extended the principles (especially on language and regional autonomy) of the short-lived Bandaranaike-Chelvanayakam pact of 1957. (The events surrounding the Indo-Lanka Peace Accord of 1987 are richly documented in Krishna, *Postcolonial Insecurities*.) In this regard Premadasa's record as president—marked by nationalist credentials more overtly anti-Indian than anti-Tamil, but just as opportunistically Sinhala-Buddhist as Jayewardene's—is no better or worse. In short, it is not some radical difference between the politics of Jayewardene and Premadasa that relegated the plans for the monument to the dustbins of the presidential secretariat.

27. Quoted in Perry Anderson, "Modernity and Revolution," 44.

DANCING ON THE GRAVES OF THE DEAD

Building a World War II Memorial in Post-Soviet Russia

Anna Krylova

A MONUMENT NEVER BUILT

Before the storming of the Reichstag on April 30, 1945, soldiers of the Red Army's 150th Rifle Division tore apart red linen sheets and mattresses they found in Berliners' homes. The 150th Rifle Division had a banner made specifically for the roof of the captured Reichstag, and every division also had its own war banner. Nevertheless, individual soldiers made hundreds of personal flags that varied in size from a small red handkerchief to a scarf a meter long. Carrying divisional banners of red velvet and handmade flags of German linen, they began the storming of the Reichstag. After penetrating the building, they left their flags and banners everywhere—on the steps and in the halls, attached to columns, hanging out of windows. By the end of the day, when the battle was over, the Reichstag was completely red. That night, the Victory Banner flew from the dome of the building. On May 2 war photographer Evgenii Kholdei took a picture of soldier Aleksei Kovalev with another red banner at the front entrance of the Reichstag.[1]

Fifty years later, Kholdei's snapshot remained firmly in the "memory of any person who has spent at least a part of his life in the Soviet Union," a writer stated matter-of-factly in *Izvestiia*, one of Russia's main national newspapers.[2] Though the name of the actual soldier in the photo has faded from memory, the image was iconic of the Soviet victory, and its subject was known to the public as the "Soldier-Victor" or the "Soldier-Liberator," holding in his hand the "Red Victory Banner." During its half-century tenure in people's minds and in official propaganda, it acquired a history of its own. The image served as a focal point during annual reenactments on Red Square, in millions of reproductions, in demands for monumentalization as the national memorial to the war, and, more recently, in attempts to topple it from its imaginary pedestal.[3]

The history of the "Soldier-Victor" in the momentous period of transi-

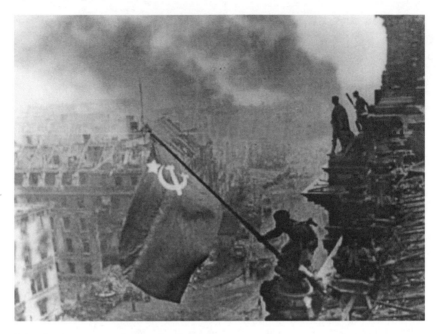

I. Berlin. May 2, 1945. Raising the Victory Banner over
the Reichstag. Photograph by Yevgenii Khaldei.

tion, 1991 to 1995, is a story of a war monument that was never built but, in
its imaginary form, commanded center stage in acute social crises, politi-
cal debates, personal traumas, and street-level confrontations. The 1991
breakup of the Soviet Union initiated meticulous investigations into the
history of the Great Patriotic War, as the Second World War is known to
Russians. Writers, historians, and journalists probed all aspects of the war,
and the results of their research were widely disseminated in the press, in
books, and on national television and radio. This wave of historical revision
on the part of a new post-Soviet intelligentsia struggling for a place in
the new Russia repudiated the Soldier-Victor, preventing a long-awaited
monument from being built in his honor. However, on the streets of
Moscow the image of the Soldier-Victor remained vital in the minds of
thousands of aging veterans who paraded with handmade red banners and
flags to protest the denunciation of their Soviet war past. Demanding a
monument to their victory and keeping its image alive, they erected thou-
sands of personal monuments to their besieged historic accomplishment,
attesting to their deep internalization of the Soviet historical narrative.

THE CRACK IN THE MONOLITH

On the first post-Soviet Victory Day, May 9, 1992, neither municipal nor federal governments hung a single red banner or flag in Moscow, reported the pro-Communist newspaper *Sovetskaia Rossiia*, now part of the opposition press.[4] A Victory Day parade on Red Square and in all major cities, an unfailing feature of Soviet festivities since the early 1960s, was canceled by presidential decree. The arrested state of the construction of the All-Russia War Memorial on the Poklonnaia Gora, hills on the outskirts of Moscow where the monument's first stone was laid back in the 1950s, also testified to the denigration of the Soviet holiday. Nearly fifty years later, the main monument to the Soldier-Victor had yet to materialize, and its absence was considered "one of the achievements of perestroika," complained veterans in their letters to the Communist press. Nowhere was the crack in the imaginary war monolith of the Soviet period more evident than in the defensive correspondence from veterans, who no longer took the construction of the war memorial for granted and demanded that it be built no later than 1995, in time for the fiftieth anniversary of the victory. The Red Victory Banner figured heavily in veterans' letters as the "main element" in the anxiously awaited monument.[5]

In the early 1990s the war regalia of the Soviet period, including banners, flags, medals, and uniforms, were no longer unproblematic symbols of the Soviet victory over Nazi Germany, however. They became sites of acute conflict over the meanings of the Soviet past and the country's war record. Provoking no social antagonism if displayed simply as "relics of the totalitarian epoch" and offered for sale to tourists for dollars or rubles, they invited "insulting remarks" and scorn for those veterans who continued to carry them as meaningful symbols of a past not yet dead.[6] War decorations were derogated as "toys" worn by aged soldiers who themselves became addressed as "decorated Christmas trees," according to leading "democratic" and Communist newspapers such as *Izvestiia, Argumenty i facty, Literaturnaia gazeta, Sovetskaia Rossiia,* and *Pravda.*[7] Incidents ranging from forcible removal of medals to physical attacks were reported regularly. "What kind of saviors are you? You are not saviors, you are enslavers!" young people reportedly cried as they assaulted veterans on the streets.[8]

The halted war memorial and the deprecation of Soviet war regalia, together with the popular hostility toward decorated veterans, were unintended consequences of Gorbachev's stated aim in perestroika to "fill in

the blank spots" in Soviet history.[9] Between 1987 and 1991 the new open-ness allowed different social and generational constituencies of Soviet so-ciety not only to add to the official version of Soviet history but to provide a moral critique of the Soviet historical record and to express publicly their attitude toward the Soviet system. Led by prominent figures of the post-war Soviet intelligentsia—journalists, writers, literary critics, actors, the-ater and film directors, and others—the movement produced a deluge of historical investigations that led to the "historical devaluation" of the whole Soviet period.[10] In the press, literature, and film the intelligentsia embraced with reverence the dissidents—open resistance being a path actually taken by very few before the perestroika years—as they frontally assaulted the key elements of Soviet historical narrative. According to the emergent counternarrative, the Soviet period was a tragic historical mis-take that derailed Russia from its "normal," capitalist track onto a road to "nowhere." Russia's singular historical achievement during the Soviet pe-riod was an object "lesson" to "normal" people to struggle against grand agendas for better societies, as Stanislav Govorukhin, popular Soviet film director, publicist, and politician summarized the new perspective in 1991.[11]

The reduction of the seventy-three years of the Soviet period to a single, grievous error in need of immediate correction posed a retroactive chal-lenge to each alleged Soviet accomplishment. The Great Victory of 1945 became a prime target for further historical investigations in the early 1990s, after the disintegration of the Soviet Union. In the course of a few years the victory transmogrified from what one historian called a "life-giving well from which one could always derive self-confidence, pride, and greatness" into a grand national "defeat."[12] Dmitrii Volkogonov, a success-ful military historian of the Soviet period turned severe critic after 1991, was among the first active proponents of the idea that the Soviet victory in the war against Nazi Germany constituted, in fact, a long-term defeat of Russia since it reinforced and prolonged Russia's sojourn into the historical "nowhere." In the press and in numerous television appearances Volko-gonov also explained away the moral superiority of the Soviet war of liberation from fascism by declaring the ethical identity of fascism and communism.[13]

Disseminated in the post-Soviet press, literature, and TV shows of the early 1990s, the revisionist image of the war cost the Soviet soldier a half century of unquestioned status as heroic defender of the first socialist state, liberator of Europe, and history maker on a global scale.[14] The Soviet

soldier in the revisionist account had to fight on two fronts: on constant guard against the "system" that used him "regardless of losses," he also faced the German invader. Victory, the argument went, occurred despite the "inhuman system," but, simultaneously, it reinforced its evil. Slaughtered without mercy for four and a half years, the soldier figured in post-Soviet writings as a "victim" of circumstances and a "slave" of the Soviet military machine.[15] Within this radical reinterpretation of the war, the very idea of erecting a monument to the Great Victory and its Soldier came to sound inappropriate and unpatriotic, and Soviet-era war medals began to represent the merciless abuse of Soviet citizens by their state. The popular hostility toward decorated war veterans also mirrored the broad appeal of historical "devaluations" put forth by the Soviet intelligentsia in the late 1980s and early 1990s. Words transformed into harassment and physical attacks against aged soldiers who refused their new "devalued" status by continuing to proudly honor and display their Soviet regalia.

"COMRADES IN ARMS AND BROTHERS IN FATE"

In the oppositional Communist press in the early 1990s, radical historical revisions were known as "historical denunciations."[16] Formative moments in the post-Soviet identity of the former Soviet intelligentsia, acts of "historical denunciation" produced a profound personal crisis in the lives of veterans of the Great Patriotic War. Already in the late 1980s, when the then-oppositional "democratic" press had denied the historical dynamism of the Soviet period by reducing it to a seventy-year trip to "nowhere," veterans took "historical denunciations" personally and perceived them as a "campaign" to "discredit" their lives.[17] Veterans exhibited an even deeper identification with the Soviet historical narrative when journalists, historians, and writers made the Soviet war experience a focus of detailed study in the early 1990s. In an attempt to counteract the emerging revisionist interpretation in the democratic press, they generated an avalanche of letters to old and new Communist periodicals.

Sovetskaia Rossiia, a prominent newspaper in Soviet times, occupied a unique place in the journalistic arena in the 1990s. Its post-Soviet editor, Valentin Chikin, a Communist and journalist with a long and successful career in the Soviet press, aimed to transform it into a "people's newspaper" based largely on nonprofessional writing and grassroots correspondence from readers. Between 1991 and 1995 the newspaper devoted more

than 50 percent of its space to letters to the editor, addresses, protests, essays, literary criticism, and critical articles written by an enormous pool of correspondents from all over the Russian Federation. Veterans constituted the most prolific group of contributors to the newspaper. From their letters the editorial board regularly established serials such as "Letters from One Issue to Another" or "From the Stream of Letters," in which veterans attempted to rehabilitate the official Soviet war narrative, to protest the disparagement of it, and to commiserate over its ruin.

In their attempt to combat the "historical denunciations," veterans equated the heroic Soviet narrative with their own personal memories.[18] At the core of the war story, as laid out by authors who identified themselves as ex-soldiers, officers, war invalids, or simply veterans, was the Soviet soldier's role as "defender" of the "first socialist state" and of European civilization. Disabled veteran S. Reshetniak from Perm' was typical in characterizing the ongoing investigation of the war in the post-Soviet media as a maniacal "belittlement" of the war in "world history," identical, from his point of view, with the "belittlement" of the historical mission of the whole war generation.[19]

Forceful restatements of the Soviet war narrative, however, did not diminish the psychological costs that post-Soviet reinterpretations inflicted on the war generation. The new vision of the Soviet soldier—"slave," "victim," "idiot"—as veterans summarized the message in the democratic press, figured in their mail as the source of "unbearable pain" and despair.[20] By 1993, journalists from both the democratic and Communist press identified a new "social phenomenon," suicidal veterans, notable among the rapidly increasing number of suicides in post-Soviet Russia.[21] In 1993 Svetlana Aleksievich, a controversial journalist and publicist, published *Enchanted by Death or On the Powerlessness of the Word and On the Former Life Called Socialism*, in which she compiled interviews with individuals who attempted suicide.[22]

Veterans writing to *Sovetskaia Rossiia*, as well as the newspaper's editor and staff, attempted to devise an alternative to veterans' ultimate solution. Thanks to Chikin's letter-friendly policy, his newspaper functioned not only as a forum for rehabilitating Soviet history but as a rescue operation for individual veterans. Heartfelt expressions of grief, pain, and depression dominated veterans' letters and transformed the newspaper into an emotional outlet for the "burning shame" of post-Soviet "humiliations," as one letter writer put it. As in Aleksievich's interviews, the figure of the soldier

was the central image through which veterans and *Sovetskaia Rossiia*'s journalists narrated their experiences of post-Soviet Russia. The "deprecia-tion of the past" figured in their letters as "desecrating the monument" to the "soldier," "throwing away [his] banner," and, ultimately, "toppling" him from his pedestal.[23]

Articulating the trauma of post-Soviet humiliation through the figure of the deposed soldier, veteran correspondents simultaneously attempted to resurrect the image of the Soldier-Liberator by means of collective and public resistance to "democratic" reinterpretations. In the pages of the newspaper they shared survival skills with their fellow veterans, advising them not to isolate themselves at home but to attend antidemocratic meetings and to participate in protest demonstrations. "Comrades in arms and brothers in fate," Ivan Vasil'ev, veteran from a remote region, called out to his generation on the eve of Victory Day 1992. "Our ranks are shrinking. . . . But as long as we are alive, we must go on. I understand that it is hard. It is hard not so much because of the weight of age and sickness as because of the realization that we have been betrayed."[24] Appealing to his fellow veterans to participate in the Victory Day demonstration orga-nized by the coalition of Communists and nationalists in place of the cancelled state celebrations, Vasil'ev suggested mass action as a means for "going on."

The activities of the following day established the pattern for opposition Victory Day celebrations for the rest of the decade. Mass "Red demonstra-tions," as *Moskovskie novosti*'s journalists characterized them, became a hallmark of the Communist opposition in the 1990s, an organic part of the post-Soviet urban scene, and ranked as a national event. On that day thousands of veterans from all over Russia trekked to Moscow, just as they did in the Soviet time. They flocked to the streets and squares of Moscow to defend their version of the war story. Bedecked in uniforms and medals, marching through Moscow with flags and banners, elderly men and women festooned the city with red for several hours and reenacted their vision of the victory.

The final destination was the "The Grave of the Unknown Soldier," in Aleksandrovskii Sad, the imperial garden adjacent to the wall of the Kremlin. Built in 1967, at the apogee of Soviet-era commemorations of the war, the memorial was dedicated to the millions of Soviet soldiers who contributed to the victory but did not live to see it. Informed by the popular image of the Soldier-Liberator, the sculpture featured the Red

2. Moscow. May 9, 1997. Photograph by Michael David.

3. Moscow. The Grave of the Unknown Soldier.
Photograph by Jeffrey M. Hornstein.

Victory Banner and a Soviet helmet lying beside the eternal flame, which occupied the center of the red marble memorial. Alluded to, but missing from the composition, the soldier rested beneath the flame in the form of the remains of an unknown soldier who died defending Moscow in 1941. From 1967, when the soldier's remains were moved from a common grave forty kilometers away from the capital to a new grave beneath the monument, the Grave of the Unknown Soldier served as a place of remembrance and mourning. For the first time in twenty-five years, living ex-soldiers came to the memorial to mourn not only the dead but also the "devaluation" of their victory and their lives in 1992. "And here we are, by the Grave to the Unknown Soldier," wrote a journalist from *Sovetskaia Rossiia*. "The eternal flame. Flowers upon flowers lay upon the red marble. Everything seems to be the same, as it used to be a year or five years ago. But why, then, are our veterans at a loss and depressed?"[25] For the rest of the decade, the memorial, as a symbol of the public's former respect for the veterans' cause and deeds, served as the main site of veneration among the war generation and the opposition. Lacking a monument of their own, the living veterans shared the monument with their dead comrades in arms.

THE MOST REACTIONARY FORCE

Working against the intelligentsia's revisions of the Soviet war narrative and their memories of the Soviet period, particular to their generation, young journalists not only updated the image of the Soldier-Liberator in the 1990s by turning him into a seventy-year-old veteran but also revealed another attitude toward Soviet "history"—that of cynical rejection. Unlike veterans, who exhibited a deep personal connection with the war and its history, unlike the postwar generation of intelligentsia that produced the historical denunciations of the late 1980s and early 1990s in an attempt to "cleanse" itself of the "Soviet time," the generation that came of age after the 1960s and developed the journalistic style of the 1990s admitted no intimate investment in the Soviet period, whether informing or "deforming." Remembering the Soviet period in the 1990s, members of the later cohorts of the Soviet period defined their relationship with the Soviet system as "rejection." Contrary to the "resistance" paradigm that captivated the preceding generation and implied the possibility of being co-opted by the Soviet historical project, the "rejection" paradigm denied Soviet historicist ideology its penetrating power. Beginning with the gen-

eration that matured during the Brezhnev-era stagnation, the "history of the war" as it was featured in textbooks, literature, film, and art began to acquire an aura of "dead propaganda" devoid of emotional charge, in the words of writer Aleksandr Terekhov.[26] Echoing Terekhov's sentiments, writer Petr Aleshkovskii described how estrangement from the war did not spare its participants either. Veterans appeared to him and his friends as ridiculous, inarticulate, and annoyingly boring thanks to "their pathos" and "memorized clichés" with which he and his friends were unable to identify.[27]

In the next generation a new degree of alienation from the war theme emerged in literal and figurative attacks on the veterans in the streets and in the press. In the early 1990s journalists from the two last Soviet generations fervently embraced the "denunciations" as reassurance of their long-concealed animosity toward Soviet war propaganda and the generation embodying it. The denounced war story served as a frame of reference for their reports on veterans. The young journalists created a genre of ironic commentary that unfailingly depicted the Soviet war story in derisive and mocking terms. Proclamations, statements, and stock expressions from the Soviet period seldom appeared in the post-Soviet press as straight text but were unfailingly imprisoned in quotation marks. In accordance with the stylistic conventions of the Russian language, this custom denotes a writer's ironic detachment from and contempt for an utterance. Along with scornful qualifiers such as "sort of" and "so-called," quotation marks were a central element of journalistic reporting on war-related events of the 1990s.[28] Making quotation marks into tools of professional post-Soviet reporting, journalists turned the Victory and the victor into a "sort of Victory" and a "sort of victor."

In the early 1990s veterans who adhered to the account of the Victory without quotation marks could not escape the newspapers' contempt. Journalists habitually mocked veterans with red banners and refused to allow them the right to feel a sense of loss and pain in relation to the past. Anyone who refused to enclose the old story in quotation marks was, in the eyes of the perestroika generation, an insane victim of Soviet indoctrination. Reporting on the 1992 Victory Day demonstration in Moscow, Dmitrii Pushkar' of *Moskovskie novosti* compared the procession under the red banners to a march of mentally impaired people. "The path towards the center passed by Insane Asylum #3," Pushkar' began his mocking anecdote. "Several patients sat near its gate enjoying the sun. 'Come with

us,' entreated the demonstrators. 'We have not gone completely crazy yet,' the inmates retorted." It went without saying that the veterans' "illness" that compelled them to take to the streets was the "fantasy" that they were "victors" and "liberators."[29]

In May 1993 the democratic press completed its portrait of an aged soldier enmeshed in fantasies of victory. The veteran began to appear as an unrelenting enemy of the "new Russia," acting on his insane impulses. The transition from irritating and contemptible fool to dangerous adversary took place after an open confrontation between demonstrators and the Moscow militia during the 1993 May Day parade, during which four hundred people were injured and one militiaman killed. Raging with hate and thirsting for bloody revenge for their "past," veterans were the main villains in the democratic coverage.[30]

"METAMORPHOSES" ON THE EVE OF
THE FIFTIETH ANNIVERSARY

The 1993 Victory Day Demonstration on May 9, a week and a half after the May Day incident, marked a change in the popular perception of veterans. *Sovetskaia Rossiia* reported a significant shift in the generational composition of demonstrators and focused on a broad range of issues that had become identified in the popular imagination with the aged veterans.[31] Interviewing young people participating in the march, journalists called attention to a new current of sympathy among working-class and military youth toward the elderly. Having witnessed scenes on television of veterans fighting against special militia units wearing bulletproof vests and helmets and armed with plastic clubs, Yu. Reznik, a young veteran of the war in Afghanistan, told *Sovetskaia Rossiia* that he had decided to join the demonstration to "protect" the aged soldiers. For participants in their forties and fifties, joining the Victory Day demonstration was tantamount to defending not only the veterans but also their "Victory"—the socialist system, the Soviet state, and its historical relevance. Closely identifying their own post-Soviet economic deprivation with the fate of the veterans, they invested the war generation with another symbol potent with mobilizing power. Veterans were the preeminent victims of the disastrous economic policies of the early 1990s, and their cause rallied the downwardly mobile across generational and class lines. On the whole the interviews chosen by *Sovetskaia Rossiia* for its May 9, 1993, issue attested to the mobi-

lizing potential of the veteran as a unifying symbol of a cross-generational and cross-class coalition. The veteran's image as the traumatized defender of historical truth was transformed, at least in *Sovetskaia Rossiia*, into a symbol for an array of social maladies, including the poverty and power-lessness wrought by economic reform and of direct physical abuse by the "democratic" power, along with the noble defense of the fruits of the Victory.[32]

The mobilizing potential of the ill-treated and impoverished veteran was lost neither on the leaders of the Communist opposition nor on their archenemy, the "first elected" Russian president, Boris Yeltsin. Both of the major contenders for political power in the middle 1990s, Yeltsin and Gen-nadii Zyuganov, leader of the newly legalized Communist Party of the Russian Federation (KPRF), drew the Soldier-Liberator and his red banner into the center of political struggle. Both democrats and Communists launched focused campaigns for the veterans' vote, as well as for owner-ship of the moral and heroic ideals the war generation had come to signify by 1993. Operating in the new competitive political situation of the middle 1990s, Zyuganov augmented the popularity of his party by drawing on veterans' support as the key moral justification of the Communist cause. For his part Yeltsin attempted to use the newly popular appeal of the veterans' image to halt the plummeting of his government's popularity.

The novelty of the political arena of the middle 1990s originated in the appearance of a massive and well-organized Communist movement as it regained some of its former organizational structure and united moderate Communists and Communist sympathizers. After regaining legal status in 1993, the resurrected Communist Party became the preeminent political force among the opposition and the key contestant for power against Yeltsin's forces. Its five hundred thousand dues-paying members, together with thousands of participants in "red" demonstrations, translated into millions of votes in parliamentary elections. Between 1993 and 1995 the Communist presence in the Federal Assembly of the Russian Federation more than tripled, and Communists outnumbered the next-largest party's representation by nearly fifty percent.[33]

In his campaign Zyuganov drew heavily on the political critique and cultural terms outlined by *Sovetskaia Rossiia* as well as on the veterans' support for the KPRF. The veterans' point of view permeated Zyuganov's public persona and the party's agenda. He embraced it at the moment when protesting veterans, formerly a source of popular "annoyance," be-

gan to personify the humiliation of existence below the poverty level, the pain of the disappearance of familiar social worlds, and severe frustration in the face of the uncertainties of the transitional period, marked by inflation and unprecedented unemployment and income erosion.[34] Using the notions of "veteran" and "soldier" as symbols of post-Soviet grievances and injustices, Zyuganov solidified existing support and expanded his party's base. The Communist leader identified the economic course of the Yeltsin government with having forsaken the "Great Victory," of which the Soviet welfare state was its main fruit. Echoing veterans' letters to *Sovetskaia Rossiia*, he compared the campaign of historical denunciations with "psychological war" and incorporated protest against it into his public statements. To return the Soldier Victor to his figurative historical pedestal was tantamount in the Communist program to returning to the Soviet historical trajectory and relieving Russia's population from the "wild market" of the early 1990s.[35] In 1994 the Communist Party reorganized its calendar around dates central to veterans, establishing May 9 as the beginning of the new year. This new temporality infused the 1994 Victory Day meeting. Zyuganov, along with other opposition leaders, called on thousands of demonstrators to make the next year, May 9, 1994, to May 8, 1995, the terminal period of Yeltsin's democratic rule.[36]

The recovery of the Communist Party and its consolidation of cross-generational support drained support from Yeltsin's government. Having survived popular protest and violent confrontation with the Parliament in September and October 1993, the president and his unstable cabinet faced a spiraling decline in popularity accompanied by regular demands by the Communist opposition for new presidential elections. To secure his presidency, Yeltsin and his opinion management team initiated a concerted campaign to wrest from Zyuganov and the Communists their main source of symbolic and actual support, the veteran. Heavily invested in the anti-Communist critique in the democratic press that defined his character and image, Yeltsin faced the daunting challenge of incorporating the Soldier-Liberator into the anti-Soviet "combat ethos."[37] The project necessarily entailed major revisions to the prevailing democratic war narrative.

The president's first move was to shift the emphasis in Volkogonov's famous dictum that the "people won despite the inhuman system" and "reinforced" its "evil." The new authorized version of the war story removed the soldier from his Soviet historical context and placed him in the less politically sensitive and virtually transhistorical domain of "Russian

imperial might." Heroism, patriotism, and sacrifice, infused with Ortho-
dox Christian motifs of willful self-sacrifice and imperial militarist valor,
were refigured as inherently Russian qualities that endured throughout the
Soviet period.[38] The fruits of the resultant "Victory" were tragically and
criminally stolen from the "victorious people" by the Soviet system. Only
with the restoration of Russia to its proper historical course after 1991,
under the guidance of Boris Yeltsin, could the true promise of the 1945
Victory be fulfilled. The new interpretation crystallized during the 1995–96
presidential campaign in a series of TV advertisements designed by the
president's team. In a memorable scene a veteran looks directly into the
camera, and in a sad and tired manner declares, "I just want my children
and grandchildren to finally savor the fruits of the victory we fought for
and that they didn't let us enjoy."[39]

Between 1993 and 1995 the official reinterpretation proliferated in the
major democratic periodicals that lined up behind Yeltsin to avert the
renewed Communist threat. In order to include their war narratives and
contemporary coverage of veterans' protest in the new authorized version
of the story, the journalists splintered the image of the soldier-veteran.
Starting in 1993, veterans in *Argumenty i facty, Literaturnaia gazeta, Moskov-
skie novosti,* and *Ogonek* occupied a dual position, as a demonstrating "red"
mass, on the one hand, and as an individual captured by a photographer
away from "red" banners, on the other. The former representation was the
familiar insane and aggressive veteran insisting on the "historical signifi-
cance" of his Victory from a Soviet point of view. The latter, according to
Izvestiia journalist Konstantin Kedrov, personified the "enlightened" vet-
erans who had finally realized the deep Russian roots of their struggle
against the fascist invader.[40] He was the "victor" thanks to "his Russian
predecessors," and his "patriotism" was fueled by a "bottomless spiritual
might" and a sense of "national dignity," Volkogonov explained on the eve
of the fiftieth anniversary of Victory Day.[41]

In official statements and programs, as well as in the democratic media
catering to war veterans, the spirit of correcting former mistakes and of
setting the historical record straight prevailed. The presidential campaign
promised veterans that the year of the fiftieth anniversary would witness a
redress of their grievances and public recognition of their heroic deeds in
the People's War. Victory Day was elevated to a holiday without reserva-
tions, reminiscent of the Soviet period in its scale, though filled with new
imperial and orthodox substance. In 1994, for the first time since 1991, the

president announced preparations for a 1995 parade of veterans on Red Square and for a military parade on Poklonnaia Gora, the site of the monument that Yeltsin had, at last, decided to build. The construction of the Monument to the Victory of the Russian Soldier on Poklonnaia Gora was the most expensive gift Yeltsin conferred on the veterans and the Russian public in May 1995. The new imperial image of the Victory and its soldier was fixed in stone on a massive scale, and it strikingly illustrated an uncanny moment in the evolving neoimperial narrative.

The eclecticism of the monument, often remarked on in post-Soviet intellectual communities, resided both in conception and execution and depended as much on representation as on erasure.[42] The central figure, a 141.8-meter spire in the shape of a bayonet, denoted the length of the war. The spire, replete with scenes of battles carved in a socialist-realist manner, was part of architect Anatolii Polianskii's composition that had been rejected by the State Committee during the Soviet period. Architect Z. Tzareteli added to the spire's tip the figure of a Greek war goddess with a laurel wreath in her hand, a traditional element in imperial triumphal arches built to celebrate victorious wars. In Tzareteli's conception the pagan goddess appears to hand her wreath to the Russian Orthodox saint, George the Victor, placed by the sculptor at the base of the spire. Following traditional representations, Saint George appears on horseback, with a spade, striking a dragon beneath him. Tzareteli thus transformed the specificity of the Soviet-Nazi struggle into an age-old Christian story about Russian military courage forever prevailing against the enemy's plot. Not only was the Soviet context expunged, but so was the Soviet text: the Soviet image of the Soldier-Liberator and his red banner was nowhere to be seen. His image was sacrificed in the effort to conform appropriations of Greek and Christian imagery to the needs of the post-Soviet state. The resultant pastiche is a historical monument to post-1991 struggles over the Soviet past and the Great Victory.

CONCLUSION

On Victory Day in Moscow, May 9, 1995, journalists from every major "democratic" and opposition newspaper agreed that two "different nations" celebrated two "different holidays."[43] One nation honored the "Russian soldier" on Red Square. Several hundred veterans in Soviet uniforms marched past Lenin's Mausoleum, the name of the founder of the Soviet

4. Moscow. The War Memorial on the Poklonnaia
Gora. Photograph by Michael David.

5. Detail of the War Memorial on the Poklonnaia Gora.
Photograph by Michael David.

state obscured behind cloth, on which stood president Yeltsin and dignitaries from Europe and the United States. Stressing the "Russian" roots of the Victory, Yeltsin praised the veterans for their heroic struggle on behalf of the Russian motherland. The second part of this celebration took place on Poklonnaia Gora, where the president officially unveiled the new monument, presenting to the veterans a new representation of their victory. Journalists from *Nezavisimaia gazeta*, *Ogonek*, and *Argumenty i facty* repeatedly characterized the veterans participating in the democratic celebrations as "normal" and "real."

Around 11 p.m. the "other nation" began to "pierce" Moscow streets with a "red knife," as Aleksandr Peresvet from *Ogonek* described the demonstration of tens of thousands.[44] Under red banners the opposition's demonstrators marched toward the capital's center, to the Grave of the Unknown Soldier. This "other nation" constructed a figurative monument with words, invoking the image of the "true soldier" affixing his "Red Victory Banner" to the Reichstag. These demonstrators reenacted their vision of the Victory, carrying red flags to the Soviet monument honoring the heroic deed of the Unknown Soldier. The official monument on Poklonnaia Gora was frequently mentioned in interviews with veterans. In the words of Lieutenant General M. G. Titov, the Russified monument at Poklonnaia Gora was testimony only to the "temporary winners," signifying an attempt to steal "our Victory" by "crossing [it] out" of Soviet history.[45]

For several days the "normal" and the "abnormal," the "true" and the "fake" divided the city as each "nation" enacted antagonistic versions of the 1945 victory in the streets and on the squares. The diametrically opposed images of the Soldier, informed by conflicting perceptions of history and meaningful self-realization in it, continue to serve as symbols of the irreconcilable conflict between veterans and intelligentsia, two poles of political counteraction in post-Soviet Russia's early decades.

NOTES

This essay's title was inspired by and is a paraphrase of Bulat Okudzhava's commentary on the moral state of post-Soviet Russian society after 1991 (Okudzhava, "Byloe nel'zia povtorit', I pechalit'sia ne o chem," *Literaturnaia Gazeta*, February 5, 1992).

1. Ed Polianovskii, "Pervyi nad Reikhstagom," *Izvestiia*, May 5, 1995.

2. "Litsa istorii," ibid., May 4, 1995.

3. Nina Tumarkin's *The Living and the Dead* is the best work on the history of war ritual and memorialization in postwar Russia, especially chapters 5 and 6. For works on the war myth during the Soviet period see also Weiner, "The Making of a Dominant Myth"; and Zubkova, *Obshchestvo I Reformy, 1945–1964*, chap. 1.

4. A. Riabov, "Tsvety k reshetke," *Sovetskaia Rossiia*, May 13, 1992.

5. I. Katyshkin, Yu. Votintsev, and E. Znamenskii, "Eto nuzhno zhivym . . . ," *Sovetskaia Rossiia*, May 5, 1991; see also "Vstrecha na Poklonnoi gore. Novye rany schitaiut boitsy," *Sovetskaia Rossiia*, May 9, 1991.

6. Interview of a fifty-two-year-old doctor by Svetlana Aleksievich with Margarita Pogrbitskaia, 1993, "Istoriia o tom, kak nevozmozhno Razliubit' marshi, Stalina I Kubinskuiu revoliutsiiu" in Svetlana Aleksievich, *Zacharovannye smert'iu*, which appears in *Druzhba narodov* 4 (1993): 32; for an overview by a veteran reader of the 1991–95 period, see Aleksandr Boiko, "Geroi strany, kotoroi net," *Sovetskaia Rossiia*, Feb. 16, 1995.

7. See "S prazdnikom Pobedy I nadezhdy," editorial, *Argumenty i facty*, 18 (May) 1991; Andrei Turkov, "Za zhivykh i pavshikh," *Izvestiia*, May 8, 1993; Daniil Granin, "Daty, kotorye vsegda s nami," *Literaturnaia gazeta*, June 23, 1993; Nikolai Ryzhkov, "Kolokola . . . ," *Sovetskaia Rossiia*, May 7, 1994.

8. Granin, "Daty, kotorye vsegda s nami" (see note 7).

9. Mikhail Gorbachev used the phrase "to fill blank spots" in his speech during the commemoration of the seventieth anniversary of the Bolshevik revolution in 1987.

10. In the "democratic" press the period from the late 1980s to the early 1990s was characterized as a period of total "devaluation" that affected Soviet history, holidays, personal memories; see " 'Congratulations' with Victory Day," *Literaturnaia gazeta*, May 6, 1992.

11. Stanislav Govorukhin, *Rossiia . . . kotoruiu my poteriali* (script) (Moscow: "Rotatsiia," 1991), 4; see also Leonid Radzikhovskii, "Boris El'tsyn kak zerkalo russkoi evoliutsii," *Ogonek*, June 13–July 4, 24–26, 1992.

12. Yurii Afanas'ev, "Drugaia voina. Posleslovie k torzhestvam po sluchayu 50-letiia Pobedy," *Izvestiia*, May 17, 1995.

13. Dmitrii Volkogonov, "My pobedili vopreki beschelovechnoi sisteme," *Izvestiia*, May 8, 1993; on Volkogonov in the Communist press see G. Matveets, "Griaz' k monumentu," *Sovetskaia Rossiia*, May 13, 1993; letters from readers, "Strashchaiut po vecheram," *Sovetskaia Rossiia*, April 20, 1995.

14. For reviews of such TV shows as "Krasnyi kvadrat," "Itogi," and "Vesti" see G. Matveets, "Griaz' k monumentu," *Sovetskaia Rossiia*, May 13, 1993.

15. Volkogonov, "My pobedili vopreki beschelovechnoi sisteme" (see note 13); for more on the image of the "Soldier-Victor" in the democratic press see critical reviews by L. Lazarev, "Vse minitsia, odna pravda ostanetsia?" *Literaturnaia gazeta*, June 23, 1993; Yu. Kalinichenko, "Geroi I predateli: novyi vzgliad," *Argumenty i facty*, June 25, 1995; Viktoriia Belopol'skaia, "Triumf very," *Ogonek*, 18, 1995.

16. The Communist press used several clichés to denote post-Soviet revisions of history such as "denunciations," "belittlement," and "blackening"; see A. Riabov, "Tsvety k reshetke," *Sovetskaia Rossiia*, May 13, 1992.

17. S. Reshetniak, disabled veteran, "Nesterpimo videt'," letter to the editor, *Sovetskaia Rossiia*, March 10, 1995.

18. V. Legchilin and I. Sazonov, both war veterans and thirteen signatures, "Prazdnik ilil den' skorbi," letter to the editor, *Sovetskaia Rossiia*, March 11, 1995.

19. S. Reshetniak, "Nesterpimo videt'," and G. Matveets, "Griaz k monumentu," both letters to the editor, *Sovetskaia Rossiia*, May 13, 1993, March 10, 1995; G. Karnov and L. Shestakov, "Strashchaiut po vecheram. Pochemu Volkogonov ne stal Boianom," letter to the editor, *Sovetskaia Rossiia*, April 20, 1995; Leonid Shultz, "Chernaia metka fashizma," *Sovetskaia Rossiia*, March 25, 1995.

20. Geogrii Sechkin and Boris Golyshev, "Uvazhaiut li Russie protivnika?" letter to the editor, *Sovetskaia Rossiia*, April 27, 1995; V. Volkov, "Pro 'vsiakuiu chertov shchinu.' Zametki chitatelia o romane V. Astaf'eva 'Prokliaty I ubity,' " letter to the editor, *Sovetskaia Rossiia*, January 12, 1995.

21. Between 1990 and 1991 twenty thousand more people committed suicide in Russia than a year before, which constituted a total of sixty thousand. By 1995 the annual fifty thousand suicides set Russia ahead of all other nations; three times more suicides were committed in the Russian Federation than in the United States; "Strashnyi record," *Sovetskaia Rossiia*, April 11, 1995.

22. Svetlana Aleksievich, "Zacharovannye smert'iu, in *Druzhba narodov*, April 3, 1993, 72; "Strashnyi record," *Sovetskaia Rossiia*, April 11, 1995.

23. G. Matveets, "Griaz k monumentu" (see note 19); Ivan Vasil'ev, "Tovarishchi po oruzhiiu I brat'ia po sud'be," *Sovetskaia Rossiia*, May 8, 1992.

24. Ivan Vasil'ev, "Tovarishchi po oruzhiiu I brat'ia po sud'be," *Sovetskaia Rossiia*, May 8, 1992.

25. Riabov, "Tsevty k reshetke" (see note 16).

26. Aleksandr Terekhov, interview by "thick journal" *Znamia* 5 (1995): 198.

27. Petr Aleshkovskii, interview by *Znamia* 5 (1995): 183; I explore the cynical culture of late socialism and the post-Soviet period more fully in "Saying 'Lenin' and Meaning 'Party.' "

28. For examples of cynical reporting see "Mai," *Ogonek*, 19–20, 1993: 2; "Kommunisty zashchishchaiut trudiashchikhsia," *Moskovskie novosti*, Jan. 19, 1992; R. Morozov and V. Buldakov, "Prasdnik so slezami na glazakh," *Argumenty i facty* 19 (May), 1993, 2.

29. Dmitrii Pushkar', "Marsh pliuralistov," *Moskovskie novosti*, May 17, 1992; for critical assessments of the post-Soviet reporting in the media see Sergei Baimukhamedov, "My golodnye, my nishchie," *Ogonek*, 3, 1992, 10–11; Turkov, "Za zhivukh i pavshikh" (see note 7).

30. Andrei Kolesnikov, "Beshenye strasti po kommunizmu," *Moskovskie novosti*, May 2, 1993; "Ne zovite nas na barikady," *Literaturnaia gazeta*, May 12, 1993; see also

Chairman of the Supreme Soviet of the Russian Federation R. I. Khasbulatov's report on the May 1 events televised May 4, *Sovetskaia Rossiia*, May 6, 1993.

31. "Chestvovanie Soldat-Pobeditelei. Stolitsa. Prazdnik bez OMONa," *Sovetskaia Rossiia*, May 12, 1993.

32. Ibid.

33. The best work on post-Soviet politics and media is Urban, Igrunov, and Mitrokhin, *The Rebirth of Politics in Russia*; on public opinion in the late 1980s see Wyman, *Public Opinion in Postcommunist Russia*.

34. See a study by The Institute of Socio-Economic Problems and Population, Natal'ia Rimashevskaia, "Reformatory teriaiut sotsial'nuiu bazu," *Moskovskie novosti*, Jan. 16–20, 1994.

35. G. Zyuganov, "Agoniia," *Sovetskaia Rossiia*, March 16, 1993; G. Zyuganov, "My idem vsled za pobeditiliami," *Sovetskaia Rossiia*, May 18, 1995.

36. Sergei Turchenko, "Pod znamenami patriotov," *Sovetskaia Rossiia*, May 12, 1994.

37. This is the term used in Urban, Igrunov, and Mitrokhin, *The Rebirth of Politics in Russia*, 258.

38. See "Chestvovanie Soldat-Pobeditelei," *Sovetskaia Rossiia*, May 12, 1993, which recounts the ceremony marking the opening of the Museum of the Armed Forces on the Poklonnaia Gora.

39. Alessandra Stanley, "With Campaign Staff in Disarray, Yeltsin Depends on Perks of Office," *New York Times*, May 13, 1996.

40. For representations of veterans see photo by Vladimir Bogdanov, *Literaturnaia gazeta*, May 12, 1993, 1; photo by Evgenii Kondakov, *Moskovskie novosti*, May 16, 1993; photo by Nikolai Galkin, *Moskovskie novosti*, May 8–15, 1994; photo by Boris Kremer, *Argumenty i facty*, 18 (May), 1994.

41. D. Volkogonov, "Pravo na pamiat'," *Argumenty i facty*, May 18–19, 1995.

42. Mariia Chegodaeva, " 'Do osnovan'ia, a za tem . . . ,' " *Moskovskie novosti*, June 18, 1995; Aleksandr Burtin, "Smena simvolov," ibid; Oleg Goriachev and Andrei Dorofeev, "I mertvye s kosami," *Argumenty i facty*, May 19, 1996.

43. Aleksandr Peresvet, "Takoi Moskvy my eshche ne bideli," *Ogonek*, 20, 1995; Luiza Gladysheva and Galina Sedykh, "Narodnoe chuvstvo pobedy," *Sovetskaia Rossiia*, May 11, 1995.

44. Peresvet, "Takoi Moskvy my eshche ne videli" (see note 43).

45. Gladysheva and Sedykh, "Narodnoe chuvstvo pobedy" (see note 43).

■ *The two essays in this section contrast the evolution of museum exhibitions in the two main countries the Allies fought in World War II—Germany and Japan. Mary Nolan brings a fresh perspective to the now familiar controversy surrounding the Wehrmacht exhibit on and Berlin Memorial to the Holocaust. Nolan's essay combines an insider's knowledge with historical distance to illustrate how the debate has shifted in the postunification era, changing the nature of the public controversy, not merely the terms of the argument (as, famously, the historian Daniel Goldhagen has done), and becoming more personal, nationalist, contentious, and multivocal.[1]*

The Berlin Memorial represents a conjuncture of two currents: the reuniting of Germany after the fall of the Berlin Wall and a worldwide passion for Holocaust memorials. The political transformation in Japan is less immediately apparent and its relationship to evolving museum programs on the nation's wartime experience has been less studied, especially in Western media. Moreover, Japan is often presented in Western scholarship as essentially stable, if not static, both politically and socially. But perhaps this image of a traditionally oriented, relatively unchanging, society has been created by silencing other narratives, as we see in Daniel Seltz's analysis of how the bombing of Hiroshima and Nagasaki has been represented in Japanese museums. Especially in the last fifteen years, as direct memories of the war recede, debates about the significance and legacy of these events both reveal and mask larger questions about Japan's role in the war.[2]

NOTES

1. See Goldhagen, *Hitler's Willing Executioners.*

2. Readers may want to compare the Japanese museum experiences with the public rancor and censorship that accompanied the *Enola Gay* controversy at the Smithsonian Institution during this same period. An excellent source for such study is Linenthal's and Engelhardt's *History Wars.*

THE POLITICS OF MEMORY IN THE

BONN AND BERLIN REPUBLICS

Mary Nolan

The politics of memory in post–World War II Germany have long been contentious. The public preoccupation with the history and memory of Nazism and the Holocaust, a preoccupation nurtured by historians and public intellectuals, filmmakers and artists, novelists and memoirists—as well as by an eager public that consumes and critiques their cultural productions—dates from the 1960s and 1970s. But the immediate postwar years were hardly ones of silence.[1] Even as Germans denied guilt and knowledge of the past and embraced 1945 as a zero hour or *Stunde null*, they kept alive questions of causation, complicity, and continuity. In West Germany efforts to claim victim status accompanied a general acknowledgment of societal responsibility but not individual guilt. In East Germany responsibility was put on capitalism and the successor state in which it survived, while the working class was celebrated for its resistance or consoled for its victimization.

The politics of memory in the 1960s, 1970s, and 1980s, when initial constructions of the Nazi past were disrupted, revised, and again recontested by such events as the Eichmann trial, the American made-for-TV film *Holocaust*, and the German series *Heimat*, have been well studied. The controversies about history and memory that have accompanied the shift from the Bonn to the Berlin Republic mark a new phase of "coming to terms with the past."[2] The Bonn Republic was built and ruled by the Wehrmacht and Hitler Youth generations. It was, however reluctantly, a nonnational or perhaps a postnational state. Whatever its economic power and military strength, its capacity to exercise those abroad was significantly constrained. And the cold war provided stable ideological tropes and rhetorical forms in which to confront the past and present. The Berlin Republic, an entity still very much in formation, is a national state, able, if not always eager, to intervene in Europe and beyond.[3] It is dominated by the children and grandchildren of those who experienced Nazism and the

Holocaust, those who are children of the cold war or of the post–cold war order.

Three recent controversies have both continued and altered the politics of memory in the Berlin Republic. The first surrounds Daniel Goldhagen's book *Hitler's Willing Executioners*; the second involves a widely traveled photo exhibition, which was provocatively but accurately entitled *War of Annihilation (Vernichtungskrieg): Crimes of the Wehrmacht, 1941–1944*; and the third swirls around the Memorial to the Murdered Jews of Europe or *Mahnmal*, which is to be built in Berlin.[4]

How have both the Bonn and Berlin Republics shaped and been shaped by the politics of memory? Why has the past not passed away, as many hoped and many others feared after unification in the early 1990s? Why, to quote Miriam Hansen and Michael Geyer, does "the present desire and need" the past?[5] Who—in terms of politics and generation—has been involved as both producers and consumers of these controversies? What do these very public and often very acrimonious debates, conducted by prominent public intellectuals, journalists, and academics in leading newspapers and magazines, on TV, and in public lectures, tell us about the nature of the Berlin Republic, the identity of its intellectuals, and the preoccupations of its population? What do they tell us about the elusive German search for "normality"?

The politics of memory have changed in significant ways since unification. First, they are intimately intertwined with the renewed emphasis on the nation and efforts to develop a national, rather than a postnational, identity. Second, more generations are involved. The Historians' Debate of the late 1980s was conducted primarily by those who, at the end of World War II, were adolescents or young men; the controversies of the 1990s include not only the Hitler Youth generation but also the " '68ers" and the younger critics of both their parents and grandparents. Third, debates about history and memory have become more contentious because they no longer center primarily on the uniqueness of the Holocaust or the structural / systemic causes of genocide. Rather, they focus on the identity, behavior, and motives of the perpetrators and on the appropriate commemoration of and compensation for victims. This shift in focus has fueled a counterdiscourse on Germans as victims and on the seemingly agentless production of a diffuse and varied category of victims. Fourth, issues of representation have assumed a new importance in the politics of memory both because the generation that experienced the Holocaust as perpetra-

tors, passive bystanders, and victims is dwindling and because issues of visual evidence, memorials, and museums have come to the fore, creating in Berlin a cityscape filled with the architectural and commemorative evidence of divided memory. The Berlin Republic and Berlin as a city are indelibly marked by the presence of the past as well as by the impossibility of reconciling the memories of perpetrators and victims, of Germans and Jews.

We can begin to understand these changes by looking at the closing act of the Federal Republic's drama of coming to terms with the past—the Historians' Debate of the mid and late 1980s.[6] The Historians' Debate was about the uniqueness of the Holocaust and the place of National Socialism in twentieth-century German history. Conservative historians, such as Ernst Nolte, Michael Stürmer, Klaus Hildebrandt, and Andreas Hillgruber, sought to historicize and relativize National Socialism, to acknowledge but minimize the Holocaust by comparing it to other twentieth-century genocides. Their critics, such as Jürgen Habermas, Martin Broszat, Hans Mommsen, and Christian Meier, vehemently rejected both the methods and conclusions of the conservatives, defended the Western-oriented, postnational Federal Republic, and insisted that coming to terms with the past, to employ the ambiguous phrase that is so often used, was an ongoing process, not a project whose end was in sight.

The Historians' Debate was not about collective guilt, but neither was it about institutional or individual guilt. It was about state structures, such as polycracy, and state processes, such as cumulative radicalization, that enabled genocide.[7] It was not about beliefs and motives, about the actions of specific perpetrators and the fate of particular victims. It was about whether Germany initiated as well as carried out genocide or imitated Stalin and acted out of fear of Asiatic hordes, in Nolte's extreme formulation.[8] It debated the centrality of Auschwitz to Nazi Germany but in terms of Nazism and modernity, the character and continuities of Nazi social policy, and the penetration of Nazi ideology into everyday life.[9] It did not explore and debate the prevalence of anti-Semitism and racist rationalization projects. The Historians' Debate was about industrialized mass murder, not about the face-to-face killings that occurred so massively on the Eastern Front and that were to feature in Goldhagen's book and the Wehrmacht exhibit.

The Historians' Debate ended in victory for those who argued that the past should not pass away, that the Holocaust was unique, and that the

Federal Republic must maintain its commitment to a postnational identity. But this victory, as Dominick LaCapra has argued, was Pyrrhic, the sense of security it imparted false.[10] Controlling the past did not give liberal historians control of the future, for although the past did not pass away, the present did. Of necessity the Federal Republic had left behind Berlin and settled into Bonn, "the Federal village," as it was initially derisively and in the end rather lovingly labeled. Bonn had no complicated and compromised pasts and possessed an emphatically Western location and identity. The Historians' Debate was premised on the impossibility—and for many the undesirability—of reunification, on the continuation of Bonn as capital and divided Berlin as cold war symbol.

To the surprise of right, center, and left alike, scarcely a year after the Historians' Debate ended, the Wall fell, the German Democratic Republic (GDR) collapsed, and East and West were reunified. These events abruptly ended both cold war certainties and symbols and the way these ordained or condemned—depending on one's point of view—Germany to division and the Federal Republic to economic prosperity without military prowess or international clout. The imperatives promoting constitutional patriotism and a postnational identity disappeared, opening the way for a history and a politics that proclaimed and celebrated the category of the nation. A national focus, shared by many on the center and left as well as the right, raised divisive questions about what sort of nation the new Germany was to be and who might become a German.[11]

If 1989 opened the way for a rethinking of the nation, it also encouraged new approaches to history. After being discredited in the 1970s and 1980s, totalitarianism theory has gained a new respectability and, many argue, analytical purchase. It has encouraged a new sort of comparative history, putting the GDR in the place of Stalinist Russia, or alongside it. There were now two dictatorships, whose heritage needs investigation, two pasts that have to be overcome.[12] While there has certainly not been a sea change in German intellectual and political life, politicians, journalists, and historians who espouse more nationalistic views and engage in neototalitarian comparisons are increasingly visible and powerful. These politicians, artists, and intellectuals inside and outside the academy are no longer drawn exclusively from the older generation that fought the Historians' Debate but include many from a younger post-1968 generation.[13] Among journalists Franz Schirrmacher of the *Frankfurter Allgemeine Zeitung* is notable, among historians, Rainer Zitelmann. Many institutions committed to crit-

ical exploration of the Nazi past have changed directors and directions, most notably the Institute for Contemporary History and the Military History Research Office.[14] As the historian Dan Diner so trenchantly put it, the *Bundesrepublik* has become *Deutschland*, and "the constitutive interpretive model of the body politic" is no longer "society" but rather "the nation."[15] It is in this reconfigured political and discursive context that the controversies about Goldhagen's book, the Wehrmacht exhibit, and the *Mahnmal* have played out.

Let us begin with *Hitler's Willing Executioners*, for the book and its author, an American political scientist, were at the center of a storm of scholarly and public debate in 1996 and 1997. The book, subtitled *Ordinary Germans and the Holocaust*, argued that German society had been permeated by a particularly radical and potentially exterminatory form of anti-Semitism long before Hitler came to power. Hitler facilitated the realization of what had long been possible, and Germans participated in the extermination of the Jews with will and conviction, indeed enthusiasm. It was a "German national project."[16] The book, which contained a schematic history and conceptualization of German anti-Semitism and three case studies of police battalions, work camps, and death marches, became a bestseller in Germany, as it had been in the United States, even as it was severely criticized by historians both of Germany and the Holocaust in the two countries.[17] Much of the press coverage from the likes of Rudolf Augstein of *Der Spiegel*, Franz Shirrmacher of the *FAZ*, and Volker Ulrich of *Die Zeit* was hostile or ambivalent, but those public intellectuals were soon won over. Goldhagen's speaking tour—an entirely West German event— was nothing short of triumphal, and in 1997 he received the rarely given Democracy Prize, awarded by the journal *Blätter für deutsche und internationale Politik* and presented by Jürgen Habermas.

Goldhagen's critics were a diverse group. The historians among them reacted, much as their colleagues in the United States did, to the simplicities and distortions of his explanatory framework, the global charges of guilt, and the ahistorical quality of his arguments. Those who had spent their lives studying Nazism were frustrated that their complex arguments about German development, the Nazi state, the diverse appeals of fascism, and the contradictory ways Germans positioned themselves in relationship to the Nazi regime were dismissed. Other journalists and historians accused Goldhagen of reviving charges of collective guilt and condemning Germany eternally to a "special path." The critics' judgments fell on deaf ears.

But what was so compelling about a book that so resoundingly con-
demned Germans as exterminatory anti-Semites for whom genocide was a
national project? In part the appeal came not from the book's originality
but from its single-minded concentration on groups that had been ne-
glected and from its appealingly simplistic argument about causality. Gold-
hagen focused on the perpetrators themselves and their gruesome actions,
on a circle of perpetrators that was far wider than Hitler or a small cadre of
high-ranking Nazi officials. He found a middle ground between struc-
tural / functional arguments that seemed to leave out the moral respon-
sibility of perpetrators by focusing on abstract processes and macroinstitu-
tions and an intentionalism that blamed Hitler while exonerating most
Germans.[18] He described in what some critics regarded as almost por-
nographic detail exactly what ss guards and reserve policemen did in
roundups, on the forced marches back to Germany, and in the camps
where annihilation through work was the norm. Avoiding the well-known
descriptions of the extermination camps with their elaborate division of
labor and industrial mass murder, he depicted the face-to-face interaction
of German perpetrators and their victims. He did not so much focus on
victims as insist that Jews were singled out as Jews, not as part of some
broader politics of racialized rationalization.[19] The shifting of emphasis,
the breaking of silences, the sheer passion with which he wrote proved
extraordinarily compelling. At times, as the historian Atina Grossmann
noted, Germans seem to take "an almost perverse pride" in their extremist
past, to develop "negative nationalism."[20]

The popularity of *Hitler's Willing Executioners* has been attributed not
only to the silences and evasions of the generation that experienced the
Third Reich but also and equally to the 1968 generation, which put the
issue of Nazism pointedly but problematically on the political and intellec-
tual agenda. Nazism was seen by '68ers as a variant of fascism and not as a
lethal variety of anti-Semitism, biological politics, and racism. They sin-
gled out both Nazi and traditional elites, above all capitalists, as perpetra-
tors, while romanticizing workers as heroic but futile resisters, ideologi-
cally uncontaminated bystanders, unwilling soldiers, or political victims.
Searching for the "other" Germany, they viewed the Communist and
Social Democratic Parties as bulwarks against anti-Semitism. They were
vocal about Nazism but not about the Holocaust.[21]

Certainly members of the 1968 generation were reluctant to confront
their parents directly about what they had believed and done during those

fourteen years. It was personally easier and politically more correct to analyze the relationship between fascism and capitalism and warn about its possible reemergence. For some there was a profound ignorance about the Jewish past that had been erased; for others there was an awareness that nonetheless did not encourage questioning or ascribe centrality to the Holocaust.[22] Still others, such as the historian Götz Aly, whose many books explore the contribution of Nazi racial and population policy to genocide, preferred to focus on "the processes of political opinion formation" and on the power structures of the Third Reich and the desk-bound criminals (*Schreibtischtäter*) who ran them. This was, Aly admits, "not out of 'seriousness,' but out of self-protection."[23]

Yet Goldhagen has his own silences and containments, and these enhanced the appealing shock effect of his work. For all that he named perpetrators and their crimes, his ordinary Germans inhabited the ss and the police battalions, not the Wehrmacht in which millions of German men served. For all that he accused Germans of having trodden an anti-Semitic special path, he assured them that exterminatory anti-Semitism had ended with the post-1945 democratization of the Federal Republic. As much as he made the past vividly present, he enabled Germans of the 1968 and 1989 generations to distance themselves from it.

Despite their shortcomings members of the 1968 generation produced critical as well as romantic histories of everyday life—one thinks of Alf Lüdtke's work above all. They founded the history workshop movement, compiled and analyzed oral histories of the Third Reich, and encouraged the uncovering and restoration of Nazi concentration and work camps within Germany. In the words of Atina Grossmann they "did move aggressively to map the 'topography of terror.'"[24] Finally, it was a '68er, the now much-maligned Hannes Heer, who with Bernd Boll and Walter Manoschek produced the Wehrmacht exhibit.

"War of Annihilation: Crimes of the Wehrmacht, 1941–1944" was a photographic documentation of the ways in which the German Army conducted warfare in The Ukraine, White Russia, and Serbia. Produced by one of the few private research centers in Germany, the Hamburg Institute for Social Research, the exhibit comprised nearly one thousand photos, some taken by army propaganda companies, others by soldiers to send home or save as mementos. These photos depict the murder of Jews and so-called partisans by shooting, hanging, and the burning of homes and villages. There are endless columns of POWs and newly dug mass graves

filled with newly shot victims of a war fought outside the rules of war.[25] And everywhere in these photos there are Wehrmacht personnel, ordering, passively watching, logistically enabling, often actively participating and always legitimating the crimes that were occurring. The photos were accompanied by excerpts from army orders and reports as well as from the letters and diaries of officers and draftees. The exhibit, which opened in 1996, toured throughout the former West Germany, hitting all major cities and many smaller ones. It was shown in Austria as well but virtually bypassed the former GDR. By the time it was suspended in November 1999, more than eight hundred thousand Germans had contemplated these horrifying and disturbingly thought-provoking photos.

The Wehrmacht exhibit, like Goldhagen's book, focused on perpetrators and their victims, on crimes and criminals. Like *Hitler's Willing Executioners*, the Wehrmacht exhibit did not present evidence that was unknown to the historical community but rather focused on a particularly sensitive group of perpetrators and presented evidence of their complicity in a most public and visually provocative way. While Goldhagen exposed the actions of the SS and reserve police battalions, the exhibit attacked the myth of the clean Wehrmacht. Contrary to widely held popular belief, the exhibit argued, the Wehrmacht did not stand apart from the Nazi system, the SS, and the genocidal war those institutions waged. Rather, the Wehrmacht was a thoroughly Nazified institution from its officer corps through its enlisted men and draftees. By 1941 it was "Hitler's Army," to borrow the title of Omer Bartov's book, and its members were deeply loyal to the *Führer*. On the Eastern Front it became a criminal organization, which participated in, facilitated, and condoned a war of annihilation that was deliberately fought in disregard of the rules of modern warfare and the Geneva Convention, a war whose aims included the destruction of Jews and the indiscriminate and massive killing of Russian POWs and Russian civilians. It was in precisely these roundups and executions, these hangings and shootings that the Holocaust began. As Jürgen Forster from the Military History Research Office argued, in relation to the Holocaust, the Wehrmacht was perpetrator, instigator, collaborator, and bystander. It was seldom a protester. And only after 1945 did it claim to be a victim of the war in the East against the Soviet Union.[26]

The response to the exhibition was predictably contentious. Politicians from the Christian Democratic Union (CDU) vociferously condemned what they considered a malicious, distorted, and unjustified attack on a

1. Image from the Wehrmacht exhibit: SD officers prepare to hang Moshe Kogan (left) and Wolf Kieper on the market square in Zhitomir, Aug. 7, 1941. Zydowski Instytut Historyczny Instytut Naukowo-Badawczt. Courtesy of USHMM Photo Archive.

cherished institution. Social Democrats were more supportive, although not all wanted to endorse the exhibit or appear publicly at it. The Bundeswehr, despite its commitment to training citizen soldiers, initially forbade its recruits from attending in uniform and prohibited members of the Bundeswehr, including those in the Military History Research Office, from participating in discussions of or activities held in conjunction with the exhibit.[27] In Munich there were street demonstrations against the exhibit, encouraged by the Christian Social Union city government, and in Saarbrücken it was firebombed.

Criticism revolved around themes of collective guilt, one-sidedness, and emotionalism. Harking back to the Nuremberg Trials' exoneration of the Wehrmacht as an institution and its insistence on individual judgments of guilt or innocence, critics maintained that the Wehrmacht was not a criminal organization. Collective guilt was not the issue, however polemically useful raising that specter was. The issue was institutional and individual guilt, on the one hand, and the responsibility of Germans today for recognizing them, on the other hand. Precisely this was so hard to grapple with because the Wehrmacht generation had rebuilt Germany after World War II, and the myth of the Wehrmacht's innocence was woven into the very fabric of postwar politics, culture, and family life. Silence about the Wehrmacht was one price West Germany paid to rebuild and democratize.[28] It was one price East Germany paid to claim a new and innocent socialist identity.[29]

Critics repeatedly charged one-sidedness and distortion. A balanced exhibit would have shown resistance as well as criminality, illustrated the horrendous conditions under which Germans fought on the Eastern Front, depicted more normal fighting and the everyday life of war instead of stringing together atrocities that were committed by only a small minority unrepresentative of the ethos of the Wehrmacht. And a balanced exhibit would not have given in to emotionalism.[30]

The organizers of the Wehrmacht exhibit were criticized for presenting horrifyingly detailed descriptions of shot or hanged victims, mass graves, and masses of POWs and civilians on their way to the grave. The visual representations of the exhibit proved more challenging, compelling, and disturbing than the written word had previously done and reached a far wider and more diverse audience. The ostensible emotionalism and lack of distance of both Goldhagen and the Wehrmacht exhibit came as much from the subject being depicted as from the style and intentions of the

authors. This was not the bureaucratically organized, industrial mass mur-
der of the camps, about which so many Germans claimed not to have
known at the time and from which many could more easily distance them-
selves, even if they were involved with or benefited from the complex
processes of racialization, Aryanization, relocation, round up, selection,
transport, and extermination. This was not the by now iconic representa-
tion of the Holocaust that Barbie Zelizer has analyzed so eloquently—
mounds of Jewish corpses in deserted camps with horrified Allied soldiers
and numb or indifferent German civilians looking on.[31] What the exhibit
depicted was the beginning of the process, not its end; the face-to-face, day-
to day roundups and executions, hangings and shootings, forced marches,
and mass burials on the Eastern Front that preceded and later accompanied
the extermination camps. It depicted the individuals and small groups who
participated, observed, ordered, enabled, and often photographed.[32]

The popular response to the exhibit was less predictable than that of
politicians and public intellectuals. None of the organizers imagined that
the exhibit would draw hundreds of thousands of visitors from the Wehr-
macht generation, as well as their children and grandchildren. For those
who had fought in the East, and the vast majority of German soldiers did
fight there at some point in the war, as well as for their children, the Wehr
macht exhibit broke the decades-long silence about the Eastern Front. The
image of the husband and father who returned home from the Eastern
Front or from years in a Russian POW camp and said absolutely nothing
about his experience pervades postwar literature, memoirs, and memory.
For some the confrontation of public history and private memories pro-
vided an occasion to acknowledge, admit, explain, or try to persuade others
of the truth of what was shown. For others it was a chance to deny or to
argue that others, but not they, were involved. For children who are now
middle-aged, it was a chance to confront and ask forbidden questions or to
deny the very possibility that people they had known and loved could have
done such things. We know something of the range of reactions, for the
exhibit did incite many to speak, and not just in the privacy of their homes
but in letters to the editor, discussions after films and lectures, voluntary
interviews with the local organizers of the exhibit, and even on film in Ruth
Beckermann's *Jenseits des Krieges* (East of War), which was shot at the exhibi-
tion site in Vienna.[33] Some spectators even unearthed their war photos,
diaries, and scrapbooks and donated them to the exhibition's organizers.

In the fall of 1999, when the exhibit was continuing to tour Germany

and was on its way to New York, the controversy escalated markedly as charges circulated that some photos were misidentified.[34] Using evidence from recently opened Polish and Ukrainian archives, the historian Bogdan Musial argued correctly that some photos of corpses showed not the Jewish victims of the Wehrmacht in Tarnapol and Zloczow but rather Ukrainian and Russian victims of the NKVD. "International research has proved that parts of the Wehrmacht were deeply involved in the crimes of the national socialist war of conquest and annihilation," Musial concluded, but "the overwhelming majority of these crimes are not photographically documented."[35] The Hungarian historian Krisztián Ungvary went much further, claiming that only 10 percent of the nearly one thousand photos actually showed the Wehrmacht committing crimes. Using the narrowest possible definitions of *Wehrmacht*, *crimes*, and *responsibility*, he excluded any actions by Ukrainians under Wehrmacht orders or by police battalions associated with the army and included among the perpetrators only those who actually shot, not those who logistically prepared the way, ordered, or observed encouragingly.[36] Although the English version of the exhibit was changed in response to Musial's criticism (but not Ungvary's interpretation), this did not placate critics from the press, the Institute for Contemporary History, or the Military History Research Office.

The exhibit must be closed and permanently, many demanded, for confidence in its accuracy and intentions had been undermined. Tendentiousness, sloppiness, and a naive reading of photographic evidence had produced an exhibit so hopelessly compromised that it was beyond repair.[37] Some, such as the journalist Jörg Friedrich, went so far as to accuse Hannes Heer and the Institute for Social Research of deliberately falsifying evidence and staging an exhibition that deployed evidence and arguments in a "totalitarian" manner, reminiscent of Nazi Germany and the German Democratic Republic. The historical profession would have protested the exhibit, he claimed, had it not already been "coordinated" (*gleichgeschaltet*).[38]

Critics did not deny that warfare in the East was brutal; rather they sought to shift the blame for specific actions from the Wehrmacht to the SS, police battalions, Ukrainians, and others. And brutal acts were not necessarily criminal ones, they insisted. The Wehrmacht was combating partisans, and the army's shootings and reprisals were therefore permissible under the rules of war.[39] The partisan warfare excuse greatly exaggerates the extent of partisan activity, ignores the enormity of those taken in reprisal, and wrongly claims that there was extensive partisan activity in

1941 and early 1942, when so many of the killings depicted occurred.[40] But it proved appealing to many Germans, nonetheless, for it simultaneously absolved the Wehrmacht of responsibility for a war of annihilation, obfuscated its involvement in the Holocaust, and blamed the Russians for what happened to them and to Jews. This is somewhat more complex than Nolte's claim that Hitler imitated Stalin and Germans were reacting to fears of Asiatic hordes, but it moves in the same direction.

Why the intensified charges and escalated rhetoric? The answer does not lie in the charges of Musial and Ungvary alone, although they certainly provided the occasion for an outpouring of criticism. The intensified debate reflected real problems with the exhibit and pointed out the need to interrogate photographic evidence much more rigorously and complexly than the exhibit's organizers had done. But the controversy also reflected the larger cultural and political situation in Germany—the growing visibility of right-wing intellectuals, the more nation-centered and nationalistic historiography of the younger generation, and the movement of both the Institute for Contemporary History and the Military History Research Office away from their initial mission of critically exploring the Nazi era. That few from the liberal center and left rose to the exhibit's defense is a result of the Hamburg Institute's initial arrogant refusal to listen to Musial's criticism and perhaps a reflection of ambivalence about the exhibit's unequivocal condemnation of the Wehrmacht. It is hardly accidental that the controversy reached new heights just as the exhibit was to open in New York City, for it is one thing to wash the nation's dirty laundry in public at home, quite another to do so abroad. The involvement of NATO in Kosovo and the question of the German army's ability to operate abroad further raised the stakes in a debate about what the Bundeswehr's predecessor had done more than fifty years ago.

Finally, the move of the capital from Bonn to Berlin had intensified the desire of many to finally put the past behind, to make the Berlin Republic a "normal" nation-state and Berlin a restored and revitalized national capital, which would deftly avoid architectural styles and monuments reminiscent of the fascist era and appropriately remember the past while not letting it dominate the present. The controversy around the Memorial to the Murdered Jews of Europe or *Mahnmal* illustrates just how difficult those tasks were.

Discussion about a memorial to the murdered Jews of Europe in Berlin began in the late 1980s, spearheaded by the journalist Lea Rosh. On No-

vember 7, 1989, two days before the Berlin Wall opened, a private associa-
tion to promote a memorial to the victims of National Socialism in the
land of the perpetrators was established. Drawing support from the Berlin
and German governments and world Jewish organizations, this association
quickly became mired in moral, political, and aesthetic debates that would
persist for a decade. Should the memorial be located next to the Reichstag,
near the Brandenburg Gate or where the Gestapo headquarters had once
stood and the Topography of Terror exhibit now depicts the Nazi regime's
murderous practices? Should it include all victims or only Jewish ones?
Should it be built by Germans or Jews, by private funds or public monies?
Should there even be such a central memorial at all, or would it be more
effective to reconstruct work, concentration, and extermination camps or
mark the buildings in which Jews had lived, studied, worked, and prayed?
Was the proposed memorial a way of representing the Holocaust for
generations that had not experienced it and assuring that they would take
responsibility for the past of their nation? Or would it, as the architect and
cultural critic Solomon Korn feared, delegate memory to stone and steel in
one restricted area so that current and future Germans could proceed
unencumbered by the past?[41]

These debates were complicated by the Kohl government's decision to
revamp the *Neue Wache* memorial in what was formerly East Berlin. The
Neue Wache or New Guardhouse had housed the king's guard in the nine-
teenth century, become a memorial to the fallen of World War I during the
interwar decades, and served as a memorial "to the Victims of Fascism and
Militarism" in the GDR. After unification Kohl commissioned a "worthy
common memorial for the victims of both world wars, tyranny, racial
persecution, resistance, expulsion, division and terrorism."[42] The center-
piece of this all-purpose memorial, which indiscriminately honored vic-
tims and perpetrators of war, fascism, and communism, was a large-scale
version of a pietà by Kathe Kollwitz. Its dedication read "to the victims of
war and tyranny" (*den Opfer vom Kriege and Gewaltherrschaft*).[43]

Kohl's provocative gesture of visiting the SS cemetary in Bitburg with
then-President Ronald Reagan produced predictable support from the
right, ambivalence or hostility on the left-center and left, and angry rejec-
tion by the Jewish community. Victims and their murderers should not be
jointly commemorated, it was argued. Nor should a memorial to victims
of Nazism be used to promote national identity. Finally, the pietà, a quin-
tessential Christian symbol, implicitly excluded Jews.[44]

In response to the *Neue Wache*'s problematic "community of victims," the decision was made to build a memorial to the murdered Jews of Europe and to them alone.[45] In the view of some, this will create a hierarchy of victims, some of whom might be remembered, others, such as the Sinti and Roma, not.[46] The *Mahnmal* is being built south of the Branden burg Gate, for to use the Topography of Terror site would mean building on land once occupied by the ss and the Reich Main Security Office (*Reichsicherheitshauptamt*) and would require commemorating all the victims of those perpetrators.[47] It is being funded in equal parts by the promotional association, the federal government, and the Berlin city government.

The questions of what message the *Mahnmal* is to convey—a recognition of historical burdens or a warning to the future—and what feelings it is to arouse—guilt, pity, or queries about why and how such a thing could happen—have proven harder to answer. And the wrangling about the form of such a memorial has been protracted and bitter. The jury selected and then rejected the design of the Berlin group around Christine Jackob-Marks, which envisioned a gigantic concrete gravelike structure on which the names of all victims of the Shoa were to be engraved. Kohl and the cdu criticized the design as inappropriately monumental. Jewish groups argued that not all names of victims could be listed and that the idea of raising funds by soliciting contributions for particular names was offensive.[48] Rein hart Koselleck, who decidedly prefered a monument to all victims, expressed bitterness about the *Neue Wache* and the proposed "concrete grave": "After we Germans have beaten, shot or gassed 5-6 million Jews, then dissolved them in ash, air and water, then we volunteer to promise those very same Jews resurrection symbolically."[49]

A new selection process was convened and resulted in the 1998 choice of the Peter Eisenmann–Richard Serra (now just Eisenmann) design, which immediately elicited protest. Nineteen prominent intellectuals, among them Günter Grass, George Tabori, György Konrad, and Marion Gräfin Donhoff insisted: "We do not see how an abstract installation of oppressively gigantic proportions can create a place of still mourning and remembrance that can create a warning or meaningful explanation" (*sinnhaften Aufklarung*). Andreas Nachama, head of the Jewish community in Berlin, suggested not proceeding until a convincing monument could be conceptualized. And Eberhard Diepgen, the cdu mayor of Berlin, remarked disparagingly that the center of Berlin should not become a "mile of memorials" (*Mahnmalmeile*). These doubts from within and without the Jewish

2. Site for the Monument to the Murdered Jews of Europe, April 2000. After a decade of continued controversy the site remains vacant. Photo by Mary Nolan.

3. Photo of the model of the Monument to the Murdered Jews of Europe, April 2000. It is now under construction on this site. Photo by Mary Nolan.

community notwithstanding, the groundbreaking ceremony occurred on January 27, 2000. In predictable fashion Social Democrats participated actively, Diepgen refused to attend at all, and Elie Wiesel suggested that the Germans should formally ask the Jews to forgive them.[50] Actual construction did not begin until 2003. It remains plagued by controversies, most recently about whether construction must stop because the sealant being used on the monument's 2,700 steles is manufactured by Degussa, an affiliate of the firm that manufactured Zyklon B during the Third Reich.

Berlin and the Berlin Republic have not overcome the divided memories of Jews and Germans, victims and perpetrators. Rather, they embody them in both old and new political, discursive, and commemorative forms. Berlin, once the symbol of the clarity of the cold war order, is now the symbol of the division and diversity of the new Germany that cannot be forced into a repressive homogeneous national identity. Building a monument to victims in the land of the perpetrators does not alter the irreconcilable differences between their pasts and the memories of them. Instead of bringing to an end debates about the Nazi past, about Germany's unhappy relationship to modernity, cosmopolitanism, and religious and racial diversity, the Berlin Republic continues to be plagued by them. Think about the uproar over Hans Haacke's installation near the Reichstag. Constructed from soil from every parliamentary district in Germany, it was dedicated not "to the German people" as the Reichstag is but rather "to the population of Germany" and thereby foregrounded the unanswered questions of national identity.[51] The price of moving the capital from Bonn to Berlin has been to increase the centrality of the victims of National Socialism and vastly increase the awareness of the loss to Germany represented by their murder. As much as those on the right and some on the left would like to construct a coherent historical narrative and commemorative culture, that is not possible in Berlin or for the republic that has taken its name.

NOTES

1. Frei, *Vergangenheitspolitik*; Grossmann, "Trauma, Memory, and Motherhood"; Herf, *Divided Memory*; and Moeller, *War Stories*.

2. Among recent works on the last decade of memory practices and politics in Germany, the most interesting are Huyssen, "Present Pasts"; Müller, *Another Country*; Wiedmer, *Representation of the Holocaust in Contemporary Germany and France*; and Young, *At Memory's Edge*.

3. See Markovits and Reich, *The German Predicament.*

4. One could add to this list the controversy surrounding the novelist Martin Walser, who condemned those he claimed "instrumentalized" the Holocaust for political purposes and pleaded for private memory. This controversy is discussed extensively in Müller's *Another Country.* One could explore the enormously positive reception of Victor Klemperer's memoirs, which chronicle an everyday life permeated with anti-Semitism, discrimination, and brutalization, petty and major, that began immediately after 1933 and escalated steadily thereafter (see Klemperer, *I Will Bear Witness*). One could, finally, add the controversies about what compensation German companies owe the survivors from among the eleven million slave and forced laborers they used during World War II.

5. Geyer and Hansen, "German-Jewish Memory and National Consciousness," 185.

6. This was an exclusively West German event. There were no comparably explosive reconsiderations of the Nazi past in the closing decade of the German Democratic Republic. Nor did the subsequent controversies about Goldhagen, the Wehrmacht exhibit, and the Mahnmal involve the former East extensively.

7. See Baldwin, *Reworking the Past.*

8. Nolte, "Die Vergangenheit die nicht vergehen will."

9. Nolan, "The *Historikerstreit* and Social History."

10. LaCapra, "Revisiting the Historians' Debate," 105.

11. The controversies about who could become a German and what sort of nation Germany would be were fought in the political realm around immigration and citizenship legislation and on the streets around attacks on foreigners, above all Turks and Russian Jews.

12. The validity and usefulness of the comparison between Nazi Germany and the GDR is, of course, very open to question. There are continuities and similarities between National Socialist and Communist Germany, just as there are different continuities between Nazi Germany and the Federal Republic. But there are profound differences in the ideologies, goals, and social practices of the two regimes, not the least of which involve racism. And as Hanna Schissler has noted in a more humorous vein, people now stage GDR theme parties, replete with Eastern products, long waits in line, and impersonations of Egon Krenz and Erich Honecker. It is impossible to imagine a Nazi theme party, with impersonators of Hitler, Himmler, and Goering stepping onto the dance floor after their acts. Hanna Schissler, Max Weber chair inaugural lecture, Center for European Studies, NYU, Feb. 2, 2000.

13. While many agree that such a generation exists, there is no consensus about the appropriate name for it. Claus Leggewie has proposed "the Generation of 1989." See Leggewie, "The Generation of 1989," 103–4.

14. The Military History Research Office has moved from Freiburg to Potsdam, the former symbol of Prussian militarism. The Institute for Contemporary History is now run by Horst Möller, a vocal critic of the Wehrmacht exhibit.

15. Diner, "On Guilt Discourse and Other Narratives," 306.

16. Goldhagen, *Hitler's Willing Executioners*, 11.

17. On the German front critics included historians not only on the right but also on the liberal left, such as Eberhard Jäckel, Hans Mommsen, Norbert Frei, and Hans-Ulrich Wehler.

18. For an overview of the intentionalist-structuralist debates see Kershaw, *The Nazi Dictatorship*, 82–106. For a suggestive argument about how to hold both a system and those in it responsible see Tim Mason, "Intention and Explanation: A Current Controversy about the Interpretation of National Socialism," 212–30.

19. The latter argument is made by Götz Aly and Suzanne Heim in their *Vordenker der Vernichtung*; and by Aly in his *Final Solution*.

20. Grossmann, "The 'Goldhagen Effect,'" 120. The term *negative nationalism* is from Heinrich August Winkler, "Lesarten der Sühne," *Der Spiegel*, Aug. 24, 1998, 180–81.

21. Ulrike Becker, et al., *Goldhagen und die deutsche Linke oder Die Gegenwart des Holocaust*, 8–9, 46–47, 56–61. For more complex assessments of worker, Social Democratic, and Communist attitudes toward National Socialism and anti-Semitism see Mason, *Social Policy in the Third Reich*; Mason, *Nazism, Fascism, and the Working Class*; and Nolan, "Anti-fascism under Fascism."

22. Michael Geyer, a historian of the German military, the Nazi state, and the pervasive incorporation of Germans into the regime's many practices of violence, poignantly describes his upbringing in these terms; see Geyer and Hansen, "German-Jewish Memory and National Consciousness," 178–80.

23. Aly, "The Universe of Death and Torment," 173.

24. Grossmann, "The 'Goldhagen Effect,'" 110.

25. The rules of war were explicitly suspended for the Russian campaign, no provisions were made for POWs, and soldiers were ordered to shoot all commissars."

26. Jürgen Förster, talk at the symposium on "Military War Crimes: History and Memory," New School University, New York City, Dec. 4–6, 1999. On how German claims to victim status developed see Moeller, *War Stories*; Frei, *Vergangenheitspolitik*; and Biess, "Survivors of Totalitarianism."

27. "Am Abgrund der Erinnerung," *Die Zeit* 44 (Oct. 28, 1999).

28. Frei, *Vergangenheitspolitik*.

29. As Frank Biess argues, the GDR did not whitewash the reputation of the Wehrmacht, but it did claim that those who had fought on the Eastern Front were not beyond redemption. In the postwar period the focus was on reforming former soldiers rather than holding them responsible for their wartime actions. See Biess, " 'Pioneers of a New Germany.' "

30. For overviews of the controversy about the Wehrmacht exhibit see Michael Z. Weiss, " 'The German Army and Genocide': Bitterness Stalks an Exhibition," *New York Times*, Nov. 6, 1999; and Volker Ulrich, "Von Bildern und Legenden," *Die Zeit* 44 (Oct. 28, 1999). For the Hamburg Institute's assessment of the controversy surround-

ing the exhibit before that controversy escalated markedly in the fall of 1999, see "Am Abgrund der Erinnerung," *Die Zeit* 44 (Oct. 28, 1999), which is an interview with Jan Philipp Reemtsma, Hannes Heer, and Walter Manoschek. For samples of the criticisms see an interview with Rolf-Dieter Müller, historian at the Military History Research Office, in *Der Spiegel*, June 7, 1999; and Krisztián Ungvary, "Richtige Bilder, neue Thesen: Ein Kritiker antwortet Jan Philipp Reemtsma zur Wehrmachtausstellung," *Die Welt*, Nov. 12, 1999.

31. See Zelizer, *Remembering to Forget*.

32. It is extraordinarily difficult to know what those photographs meant to those taking them. One should note, however, that German war photography was very widespread. Thousands of soldiers took tens or hundreds of thousands of pictures. And many survive to this day, sometimes carefully ordered in photo albums and scrapbooks, sometimes stuffed haphazardly into boxes in the attic. Some of these scrapbooks were donated to the organizers of the exhibit. German soldiers also took their 16-mm movie cameras and filmed on the eastern front. The documentary *Mein Krieg* [My Private War] contains excerpts from those films and interviews with the soldiers who shot them.

33. See Ulrich, *Besucher einer Ausstellung*. Beckermann's *Jenseits des Krieges* was released in 1996.

34. In the face of a barrage of pubic criticism, the Hamburg Institute first suspended the exhibition in Germany and then cancelled the planned showing in New York City and other American cities. The institute completely revamped the exhibition to present what it called a more balanced view and reopened it in Berlin in November 2001.

35. Musial, "Bilder einer Ausstellung," 590.

36. Ungvary, "Echte Bilder—problematische Aussagen."

37. Fritz Goettler, "Bilder einer Einstellung," *Süddeutsche Zeitung*, Nov. 9, 1999; "Wehrmachtsausstellung: Kritiker fördern entgültige Schliessung," *Der Spiegel*, Nov. 8, 1999; Klaus B. Harms, "Wissenschaftler werfen Machern der Wehrmachtsausstellung 'zu naiven Umgang' mit Quellen vor," *Saarbrücker Zeitung*, Nov. 1, 1999; Werner Birkenmaier, "Die Macht der Bilder," *Stuttgarter Zeitung*, Oct. 28, 1999; "Die Dokumente sind nicht stichhaltig," interview with Dieter Schmidt-Neuhaus, *Die Welt*, Oct. 26, 1999.

38. Jörg Friedrich, "Die 6. Armee im Kessel der Denunziation," *Berliner Zeitung*, Oct. 30, 1999.

39. Michel Stürmer, "Tod, Trauer und Tabu," *Die Welt*, Oct. 28, 1999; Susanne Leinemann, "Wieviel Verbrechen bleibt, wenn ausgezählt wird?" *Die Welt*, Oct. 28, 1999; Krisztián Ungvary, "Verbrechen und Haftung," *Süddeutsche Zeitung*, Nov. 16, 1999.

40. For a critique of the partisan war excuse see Christian Streit, "Die Kontroverse um die sogenannte Wehrmachtsausstellung" (unpublished ms., Nov. 1999). As Mark Mazower shows, the Nazis used reprisal killings on a vast scale as an instrument of

punishment and intimidation in Greece as well. See Mazower, *Inside Hitler's Greece*, 173–81, 210–18.

41. Korn, "Monströse Platte," 32. Walter Grasskamp shares Korn's fears. See Grasskamp, "Die Behaglichkeit des Gedenkens," 24.

42. See Ladd, *The Ghosts of Berlin*, 218.

43. The *Neue Wache* recalled a similar "antitotalitarian-front" memorial, built in Bonn in 1960, but the implications of constructing a memorial that blurred the distinction between victims of war and victims of genocide in the midst of the cold war and after its end, in Bonn and in Berlin, are vastly different. See Meier, "Zweierlei Opfer," 104; and Meier, "Das Problem eines Berliner Denkmals," 145ff.

44. Ladd, *The Ghosts of Berlin*, 219–24.

45. Christian Meier, who employed the phrase *"Opfergemeinschaft,"* urged its dissolution. See Meier, "Das Problem eines Berliner Denkmals," 153.

46. The journalist Henryk Broder was particularly concerned about this. See Wiedmer, *Representation of the Holocaust in Contemporary Germany and France*, 140.

47. Solomon Korn suggested a memorial across from and in dialogue with the *Neue Wache* and its homogenizing conception of national identity, an idea that I find appealing but that was more confrontational than most supporters of the *Mahnmal* wanted to be. See Korn, "Durch den Reichstag geht ein Riss," 127.

48. "Chronik," *Das Holocaust-Mahnmal*, 284–85. For overviews of the controversy about the *Mahnmal* see Kramer, *The Politics of Memory*, 257–93. See also Wiedmer, *Representation of the Holocaust in Contemporary Germany and France*, 140–64; Young, *At Memory's Edge*, 184–223.

49. *Das Holocaust-Mahnmal*, 107

50. *New York Times*, Jan. 18, 28, 2000.

51. See http://www.bundestag.de/arktuell/presse/p2-00/p2-000126.html.

REMEMBERING THE WAR

AND THE ATOMIC BOMBS

New Museums, New Approaches

Daniel Seltz

Since the end of World War II, the Japanese public has confronted the history and legacy of the wartime period through isolated controversies and debates, ranging from the discovery of military atrocities to textbook revision to forms of official commemoration at museums and memorials. Museums have never reached consensus over what lessons can be drawn from the war and how to communicate them, nor has there emerged an effective means to negotiate and examine these lessons. Debate over war memories in Japan happens in a relatively small rhetorical box, with representatives of the right and the left advocating largely unchanging and sharply contrasting narratives of the war and sharply contrasting interpretations about what Japan should learn from the experience of war. Museums have been unable to provide a forum to expand the limited terms of this debate or to offer new evidence and raise new questions about the war.

Hiroshima's Peace Memorial Park and Museum exists as a site of consensus for the left and right by creating a limited narrative of the atomic bombs and the war. Through its creation of a sacred atmosphere and its elevation of the atomic bomb above historical debate, Hiroshima's museum represents a missed opportunity for renewed and fresh debate over the bombs and the war. However, several new museums around Japan are beginning to move outside the framework of debate reflected at the park and museum in Hiroshima. Opting for a more self-critical and straightforwardly educational approach to war and peace over the religious tone found in Hiroshima, these museums challenge rigid notions of war culpability, present alternatives to the simplified narratives of the war offered by representatives of the right and the left in debates about the war, and articulate a number of visions for what a "peaceful" Japan means today. Beyond considering just World War II, they can help raise a series of underexamined questions related to the interpretation of the war and its

legacies, from the role of Japan's military overseas to Japan's diplomatic relations with its neighbors.

The right wing, most often and notably represented by leaders of the Liberal Democratic Party and the Association for Bereaved War Families, tends to emphasize the sacrifice of those who died in what they claim was a war of self-defense and anticolonialism, directing attention away from the emperor's role in the war. These conservatives often use a religious or quasi-religious rhetoric in discussing commemoration of the war. The left wing, represented by groups such as antimilitary and antinuclear activists galvanized by the hardships of the war, scholars on the left, and the national teachers' union (which has fought for critical historical textbooks and peace education), tends to emphasize Japan's culpability in Asian suffering and attempts to use the memory of Japanese domestic suffering to rally support for continued antimilitaristic policies. For each side of the debate memories of Hiroshima and Nagasaki are central.

The contours of debate about the use of the atomic bombs have also become well worn and familiar. Both the right and the left emphasize the unprecedented power of the bomb and the new forms of suffering that the people of Hiroshima and Nagasaki endured. Both try to generalize this suffering so that the two cities' experiences stand for all of Japan. The right, however, uses the memory of this suffering to obscure prewar and wartime repression at home and brutality abroad, claiming that the bombs cancel out these actions. The left uses these memories to question and criticize wartime colonialism; they use them as a rallying cry against Japanese remilitarization; for a strict reading of article 9 of the Constitution, which prohibits the dispatch of Japanese troops overseas; and against the continued presence of American military bases in Japan.[1]

There is often a nationalist tint to the right's arguments about the war. Those who dissent from the view that the war was fought against encroaching Western colonialism and did in fact result in the end of European colonialism in Asia are often accused of being continued servants to the United States, of supporting a "masochistic" or "Tokyo Trials" view of history. Conservatives, including many members of the Liberal Democratic Party and leaders of the Association for Bereaved War Families, assert that calling the war a "war of aggression" dishonors the veterans and their families and suggests that those who were killed died meaningless deaths (like dogs, they often say). The implications of this argument have been analyzed by the historian Yui Daizaburo. "The 'dog's death thesis,' "

he writes, is the "psychological foundation" for preparation for future wars, and victory in war becomes the only way to make war death truly meaningful.[2]

Arguments from the left, however, have not encouraged dispassionate historical analysis because they rely too much on vague and nebulous calls for national reflection.[3] The Japanese historian Awaya Kentaro wrote in 1991, "I believe that the future of Japan in international society hangs on how widespread and sincere is Japanese soul-searching regarding the events of the first half of the twentieth century."[4] Recently, Okamoto Mitsuo, commenting on the addition of the Hiroshima Atomic Bomb Dome to the UNESCO list of World Heritage sites, wrote, "The Japanese must sincerely reflect upon and learn from the historical background that preceded the Hiroshima tragedy."[5] Putting aside the problem of treating contemporary Japan and all its generational, class, and gender diversity, as a unitary whole, one reads these comments and wonders, how does a whole nation "reflect"? How do we measure the sincerity of national soul searching? Noam Chomsky once wrote that when Americans "lament over the German conscience, we are demanding of them a display of self-hatred,"[6] which, it could be argued, is what writers such as Awaya and Okamoto are asking for, and this is an extraordinary thing to ask of national leaders. This emphasis on acknowledging culpability often has particular purposes. Anzai Ikuro, who, as head of the Kyoto Museum for World Peace at Ritsumeikan University, has put together sharply critical exhibits about wartime Japan, has said that this direct acknowledgment of wrongdoing is necessary primarily so that the bombings of Hiroshima and Nagasaki can be condemned with more credibility.[7] It is this emphasis on the atomic bomb that joins the right and the left in the rhetoric of war remembrance, the right using it to obscure wartime aggression and the left using it as a powerful symbol in promoting an agenda of antimilitarism. The problem with this approach, however, is that out of someone like Anzai's hands, it is too easily reducible into simplistic historical tit-for-tat, where Pearl Harbor cancels out Hiroshima, which cancels out the Nanking Massacre.

Hiroshima's Peace Memorial Park and Museum, as the official site of memory of the atomic bomb, has sought to seek out a place between the poles of the right and left by focusing almost exclusively on the bomb. Like all museums in Japan that address the war, the museum in Hiroshima must balance a number of conflicting political interests in its exhibitions, as well

1. Museum at the Peace Memorial Park in Hiroshima. Photo by Daniel Seltz.

as face challenges unique to the bomb. The left, right, and a survivor constituency that overlaps with both groups all demand a certain interpretational focus. Seeking to balance these multiple and often contradictory purposes, the museum's planners try to offend no one. In its exhibits the bomb is elevated above history, given such power that it obscures the human choices that led to its use. Commemoration takes precedence over learning in Hiroshima—its museum feels more like a temple than a place of historical analysis or criticism—leaving it unable to advance new interpretations or arguments about the bomb and the war.

Founded as part of the city's reconstruction plan, the museum is run by the city of Hiroshima, and it receives no national funds. The park hosts an annual ceremony on August 6 commemorating the bombing and houses the Hiroshima Peace Culture Foundation, which publishes materials related to peace education and the bombing and organizes a number of events concerning bomb-related issues. The museum itself plays almost no civic role in Hiroshima, beyond receiving about 1.5 million visitors per year, a third of whom are students. Opened only three years after the end of the American Occupation, the museum filled an important niche at the time of its opening. Occupation authorities censored almost all graphic depictions and descriptions of the atomic bombs' damage, and the museum, with its almost exclusive emphasis on the impact of the bombs,

sought to fill the gap that had existed in the media. It also provided a physical focal point—a sacred space—for public commemorations of the bomb victims, and for the burgeoning peace movement of the 1950s.

Visitors enter the museum through the East Wing, which was renovated in 1994 to strengthen the museum's treatment of Hiroshima's prewar history. This renovation provoked some debate in Hiroshima but no controversy comparable to the Smithsonian's *Enola Gay* exhibit or even to the opening of the new atomic museum in Nagasaki. Before 1994 the museum's exhibits began at the moment of the atomic explosion and contained no background on the events leading to the bombing. A continuously running film introduces the museum's themes, stating that on August 6, 1945, an atomic bomb "was dropped" on Hiroshima and that vast numbers of its citizens died. The passive voice is everywhere in the museum; one has to look hard to find out that the bomb "was dropped" by the United States Air Force. The film also adds that among those who died were Korean and Chinese laborers forcefully conscripted into service. The film then introduces the museum's universalist mission. The human race "will never be free from the fear of nuclear weapons," it says, and these weapons "threaten the very existence of humanity." Hiroshima will be a beacon of hope amid this fear: "In Hiroshima, with humankind's survival at stake, the race to achieve solidarity among the world's peoples has begun." The museum is an "expression of our desire for world peace and the total abolition of nuclear weapons." The movie makes clear the museum's focus when it asks, "What actually happened on August 6, 1945?" However problematic this limited perspective may be, this question honestly reflects the museum's goal, and it dispels any expectation that the museum will comprehensively treat events far outside of the day of the bombing.

The first room is primarily devoted to local history up to the bombing, detailing Hiroshima's transformation into a military city after the 1890s. This section is innocuous and rather dull. No artifacts accompany the text and photographs until the narrative reaches the 1930s. The explanation for the beginning of the Pacific war is cursory at best. However, these sections on Hiroshima's military history represent a clear break with the museum's previous exhibitions, as does the initial, prominent notice given to non-Japanese victims of the bomb. The planners of this exhibit continually refer to it as *kagaisha tenji* (the assailants' exhibit), which may be overstating its actual function or power, but there are panels that speak directly to Japa-

nese culpability. A panel on the Nanking Massacre states that estimates vary on the number of Chinese killed by the Japanese army, but it is clear that the military's behavior was brutal and atrocious. There is a heavy emphasis on domestic hardship during the war, but the agents of this hardship, those making the decisions that led to food rationing and military conscription, are hard to locate. The use of the passive voice continues, with occasional references to the "national government" as decision makers. A film that rings the center of the room on a semicircle of television screens is accompanied by a label that actually identifies an actor but doesn't complete its statement, reading, "On August 6, 1945, the American Air Force . . ."

This opening section's treatment of two of the most important historical questions about the bomb is quite perfunctory. One label mentions the desire to limit casualties, to strengthen the American postwar position toward the Soviet Union, and to measure the bomb's effectiveness in war. "Why Hiroshima?" asks the following label, answering that its size and shape were suited to the bombing and that because it had not yet been bombed, measuring the effects would be easier. The exhibition text also mentions that the city contained a high concentration of troops, military facilities, and factories. No objects accompany these two crucial panels.

The exhibit then takes a distinctly emotional turn with the effectively understated lone display of a tattered watch stopped at the time of the bombing, symbolizing the ruptures brought about by the bombing. A label explains that with the bombing, Hiroshima ceased to be a mere city and became instead a universal symbol of peace and the hope for peace. There is then a brief treatment of the reaction to the bomb—the time it took to understand that the "new weapon" was an atomic bomb and some preliminary explanation of the effects of radiation. A film here says matter-of-factly what the Smithsonian's Air and Space Museum, in its planned *Enola Gay* exhibition, could not even raise as a question—that the atomic bomb, because of the intense heat and the lingering effects of radiation, is qualitatively different from conventional weapons. The film holds its gaze on babies and corpses in a way that would be unthinkable in the Air and Space Museum, which only recently displayed its first photograph of a corpse.

The second floor covers the city's economic and physical recovery. It mentions the difficulty of rebuilding an urban infrastructure, housing, the rise of a black market, and improvised, open-air schooling. This room also

includes explanations of Occupation censorship policies, which prohibited the publishing of graphic accounts of the bomb, and Occupation authorities' decision to cancel the annual peace festival between 1950 and 1953. Finally, there is a panel on overseas *hibakusha*, mentioning a collaboration between Japan and Korea to open a clinic for victims living in Korea, one of the few positive stories the museum could tell about the relationship between Korean victims and Japan, which has been marked by acrimony over unequal medical care, distribution of benefits, and battles over the placement of a memorial to Korean victims.[8]

The visitor then ascends another flight of stairs into a room that deals with some of the dilemmas and legacies of atomic power. There are lucid explanations of atomic power, a history of nuclear testing, deterrence theory, and the environmental hazards of nuclear power. Though the lighting is brighter here and the panels are more academic and less emotional, the somber music from the film is still slightly audible, and the effect of seeing and reading about explosions of various sorts on films and photographs and in panels keeps the mood somber. This is a universalist room, positing nuclear arms as a threat to the whole world, not a particular country.

The East Wing's final exhibit is the only part of the museum that defines and treats peace as something broader than the extinction of nuclear of weapons. "But we must never forget that nuclear weapons are the fruits of war," declares one label. "Japan, too, with colonization policies and wars of aggression, inflicted incalculable and irreversible harm on the peoples of many countries. We must reflect on war and the causes of war, not just nuclear weapons. We must learn the lessons of history, that we may identify and avoid the paths to war." There is a section on textbooks, which advocates "making our mutual pain a positive gift for the future," but this is still Hiroshima's museum, and it is clear in the final section that the people of Hiroshima are the subjects and the tellers of this story. The East Wing ends by exhibiting Hiroshima's efforts to become a center of internationalism, hosting conferences, conducting antinuclear protests, sending exhibits overseas, and promoting peace studies.

The West Wing of the building, which houses the older exhibit, is separated from the East Wing by a lobby and corridor, giving it the feel of a separate museum. It is devoted almost entirely to exhibiting the damage done on the day of the bombing. It is far more literal, more horrible, and deliberately shocking. The entrance is a dark hall with simulated flames

burning along the walls. The visitor then turns the corner to find wax figures of people who blindly wander through Hiroshima's ruins, their flesh dripping from their bodies.

Whereas the bulk of the East Wing is explanatory and deliberately detached in tone, the West Wing is thoroughly emotional. It focuses on personal, rather than political and economic, stories: the film in the center of the first room displays the words of a poem of a mother describing the loss of her son. Brutally intense and personal effects are displayed—a boy's fingernails and skin kept by his mother, watches stopped at 8:15 A.M., school uniforms, all with names attached to them. Artifacts of physical destruction are also displayed, though these also are inseparable from human artifacts: one section of a concrete wall is imprinted with the shadow of a victim. This harrowing section ends with a summary of the lingering effects of radiation and the difficulties of medical care for survivors. Videos of recollections from survivors play at the exit. The entire section is in tension with the more detached tone and presentation of the East Wing and functions more as memorials do, providing cues to visitors who are probably already familiar with the story that the exhibit describes. The West Wing's exhibitions are the last the visitor sees, creating a dominant tone of memorializing rather than teaching.

It is relatively easy to point out the historical gaps in the exhibitions at the museum and the way that non-Japanese are marginalized in the museum's narrative. The question is why this is, and why the museum has changed so little since its opening. Institutional inertia accounts for some of the museum's tone. It was founded in 1955, before much of the scholarship about the war was even written and before activists on the left and in Asia could consistently demand a critical look at the war. The narrow focus on what happened in Hiroshima on August 6 also reflects survivors' imperatives that this story be told comprehensively and sensitively. However appropriate this focus may be, it does mean that the exhibitions cannot make connections between the bomb and other historical events and that they cannot even ask questions about what military and political decisions in Japan and elsewhere led to the use of the bomb.

Creating a sense of awe about the bomb by elevating it above the causes and effects that are part of the basic study of any important historical event, the park and museum are centerpieces of a culture of remembrance in Hiroshima that reinforces a limited narrative of the war that ultimately dovetails with that of the political right. Ian Buruma has commented that

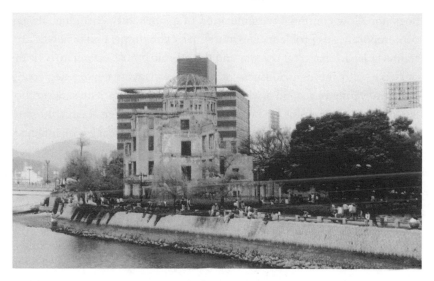

2. Now called the "A-Bomb" Dome (formerly a municipal building), the most famous physical relic of the atomic bombing of Hiroshima. Photo by Daniel Seltz.

in Hiroshima, the message of world peace is "hammered home so re-lentlessly, through memorials, monuments, pagodas, fountains, school-children, missionaries, parks, symbolic tombs, special exhibits, sacred flames, merciful deities, peace bells, peace rocks, peace cairns, statues, and signs, that, in the words of the Italian journalist Tiziano Terzani, 'even the doves are bored with peace,' " Buruma complains that the "seriousness of death can be rendered slightly comical by an exaggerated air of reverence, of ceremony, of awe, where what ought to be moving becomes sentimen-tal, and seems absurd."[9]

While Buruma may be overstating his case, the ubiquity of commem-oration, and its tone of what he calls "emotional moralism," points out the central tension in atomic bomb remembrance in Hiroshima. Hiroshima is not a place of learning. It styles itself, as a publication of the Hiroshima Peace Culture Foundation states, as a "Mecca of World Peace," a place where people come to pray and to seek absolution for the sins of nuclear war. Hiroshima is the center of what looks, sounds, and feels like a reli-gion, and this stance does not allow for critical reexamination; it starts with certain unquestioned assumptions—most important, that the bomb stands above history as uniquely cruel and is absolutely unjustifiable—and moves out from those. The effect is political irrelevance and an inflexibility that

does not allow continual reexamination of a constantly changing, always contemporaneous problem. The museum's exhibitions, unlike newer museums in Japan that treat the war and the atomic bomb, articulate a vision of peace with the consciousness of nuclear war at its center, neglecting social movements around a wide range of social justice issues. Several of Japan's newer museums, to be discussed later, challenge their visitors to expand their conceptions of what causes war and how peace is maintained. They trust their visitors to understand the power that more complicated narratives hold and the power that comes from looking at the war from multiple perspectives.

Setting a pattern of religious commemoration in Hiroshima is useful to the right wing in Japan in arguments over commemoration of the war and the atomic bomb. Ellen Hammond explains that the right wing employs a rhetoric of "non-rationality specifically designed to make historical analysis impossible."[10] Hammond cites the critic Eto Jun, who has written that the Japanese "live with the dead" as an argument for public prayer at Yasukuni Shrine. In an incisive analysis of the controversy over the construction of the War Dead Memorial Hall in Tokyo, to be financed by the national government and administered by the conservative Association of Bereaved Families of the War Dead, Hammond points out that one of the intentions of the museum planners was "a conscious attempt to meld the sacred and the secular: public history would be combined with the commemoration of Japanese military deaths as an act of religious veneration."[11] Though it is with different purposes in mind, this emphasis on religious veneration in Hiroshima is one of the reasons Hiroshima is able to continue to be the site of an uneasy consensus for the right and left and why it is unable to move beyond a conventional and limited narrative of the war. It is only a small step from the language of martyrdom for the civilian dead in Hiroshima to religious veneration of military death in other places of commemoration in Japan, such as Yasukuni Shrine. The message at the Hiroshima museum is that it is less important to carefully study and explain the set of circumstances and contingencies that led to the atomic bombing of Hiroshima than it is to construct religious and quasi-religious monuments and forms of commemoration; prayer triumphs over informed understanding and activism.

Hiroshima's museum is important to both the right and the left, not only for what it says but for what it does not say: it obscures human choices and posits nuclear weapons, not the people who develop and use them, as

the true evil. This is a comfortable compromise for both groups. It may be asking too much of a museum that must satisfy conflicting constituencies to be a place that encourages its visitors to ask new and harder questions about the past. The museum's most important purpose may be to exemplify, consciously or not, the ways in which the legacy of the war and the bombs is and will remain ambiguous and contested.

In the last several years, however, there have appeared a number of museums that treat the wartime history of Japan in a drastically different manner from the Peace Memorial Park and Museum in Hiroshima.[12] Museums in Nagasaki, Kawasaki, Osaka, and Kyoto, among others, represent a new approach to the war among museum professionals in Japan, which is more straightforwardly educational and critical than Hiroshima's. None present hard-and-fast answers to the difficult questions of international conflict resolution, but they do present broader definitions of peace than Hiroshima's museum does. They also challenge the rigid definitions of war responsibility, and of victory and loss, that have emerged since the war. And although they are critical of militarist Japan, they are more frankly international in their approach to the history of war and peace. These museums recognize that if they carefully and coherently let the narrative of wartime Japan unfold, the effect can be as devastating as it is in Hiroshima, with its claims of historical exceptionalism and its feeling of religious awe. Taken together, they explode the myth of Japanese historical amnesia.

Each of these museums emerged from separate circumstances and institutional imperatives, but a number of public controversies in the 1980s and 1990s about the interpretation and memory of the war set the stage for these museums by awakening a number of unresolved historical questions. First, the Ministry of Education's 1982 decision to change a textbook's description of the Japanese army's march into Asia as an "advance" rather than "invasion" raised strong protests among leaders in China and Southeast Asia. Prime Minister Nakasone's attempts to reinstate public prayer at Yasukuni Shrine (he backed off this idea after another storm of protest from Asia) and his policy of increased military spending to become, as he put it, "a normal state," were part of a conscious attempt to place the war further in the distant past and to proclaim a new era for Japan.[13] The release of scholarship detailing the abuse of prisoners of war in the building of the Thai-Burma Railway, the use of human subjects to research biological warfare by Unit 731, and the use of Korean "comfort women," or sex

slaves, for the Japanese army was shocking enough to force the war back into the mass media.[14] The death of the emperor in 1989 and the attempted assassination of Nagasaki mayor Hitoshi Motoshima after he claimed the emperor bore some responsibility for the war also stimulated fresh debate on issues of memory and culpability.[15]

Issues of war memories became even more intense in the 1990s as the fiftieth anniversary of the end of the war approached. The Persian Gulf War and American insistence that Japan "contribute" in some way to the war brought constitutional issues about the deployment of the Japanese military overseas to the forefront and exposed the right-left rift in thinking about Japan's role in international security that dated back to the late 1940s.[16] A proposed national war museum to be built in Tokyo provoked protest over its almost-nonexistent treatment of non-Japanese suffering in its exhibits and the government's plan to hand over administration to the conservative Association of Bereaved Families of the War Dead.[17] The year 1995 witnessed a huge number of publications, documentary films, newspaper and magazine articles, and television specials about the war, many of them quite critical of the emperor and the wartime government.[18] Although this publishing boom brought many of the problems of the war into the open, it did not help to produce consensus about the war in the political arena. In 1995 the Japanese Parliament managed to pass a rather vague resolution of apology to victims of Japanese wartime actions, a resolution that drew international attention and may have ultimately caused more harm than good after the number of compromises and rewordings it went through.[19]

The inability of other public institutions to credibly assess the war convinced Ikuro Anzai, director of the Kyoto Museum for World Peace at Ritsumeikan University, that a new museum could fill an important niche in presenting new information and interpretations of the war. This museum opened in 1992 and draws approximately forty thousand visitors annually. It is the only peace museum in the world administered by a university. Anzai stresses that this museum's lack of reliance on public funds and its access to the resources of a university enable it to be the "intellectual backbone" for local peace museums.[20] Anzai assists with the establishment of new peace museums and is also involved in the seven existing peace museums' networking efforts such as the conference in November 1998 organized by museum directors and peace activists and attended by two hundred people. He hopes that Ritsumeikan's museum

can be counted on to assist local peace museums in the event of public criticism or attacks on their exhibitions. This museum's exhibits on war and peace emphasize the role of individual and group resistance to violence and government repression.

The Kyoto museum begins with a detailed overview of the "Fifteen Year War," frankly explaining Japanese invasions of China and Southeast Asia while also emphasizing the resistance to Japanese rule in their colonies. The section on domestic life during the war also focuses on the difficulties Japanese citizens had in protesting and resisting wartime measures. A chilling simulation of the damage that would have been done to Kyoto had it been the target of an atomic bomb is found at the end of this section. The next major section covers the history of war since 1945 and is sharply critical of the United States in Vietnam. The museum's final section treats the growth of international peacemaking bodies and structures and presents the viewer with provocative ideas about the meaning of violence and nonviolence. A panel quotes the Norwegian Nobel Peace laureate Johann Galtung in proposing that violence encompasses all forces that "stand in the way of the full flowering of human potential," including prejudice, environmental destruction, and economic inequality.

Kawasaki World Peace Museum, just outside Tokyo, is a municipal museum that also opened its doors on April 15, 1992, the anniversary of the Kawasaki air raids, and has averaged about thirty thousand visitors per year since its opening. Kawasaki is a left-of-center city with a strong tradition of labor activism. This museum is unconventional in that only one room in the museum actually exhibits objects and artifacts; other rooms exhibit video and film, which themselves are remarkable for their contemporaneity. The museum features a brief opening section on Kawasaki during the war, a film on the air raids, and films that cover Japanese colonialist policies from the 1900s on, but the museum's scope extends beyond Japan. Following the opening section, there is an explanation of nuclear power and exhibits on the problems of weaponry and waste. Other films cover a wide variety of topics, including biological and chemical weapons, the end of South African apartheid, AIDS, environmental destruction, and land mines. Though this is true pastiche, a theme of power and class difference does run through these films. A separate film called *One Earth, Two Worlds* juxtaposes images of wealthy nations, especially Japan, with those of war- and poverty-wracked places without clean water and food. It is notable that Kawasaki's films celebrate difficult human-

3. Monument to the victims of the bomb at the hypocenter in Nagasaki. The monument is surrounded by cheap hotels. Photo by Daniel Seltz.

itarian work and grassroots peace and social justice movements and do not focus exclusively on high-level, diplomatic peacemaking efforts.

Nagasaki's approach to the bomb is distinct from Hiroshima's. The Nagasaki Atomic Bomb Museum was completed in April 1996 and replaced the International Culture Hall, which was physically deteriorating, as the primary exhibition space for the city's bomb damage. There is no relationship between the Nagasaki museum and the Hiroshima museum, but Anzai, the director of the Kyoto museum, was deeply involved in planning the exhibits for Nagasaki's expanded museum in 1994. The city of Nagasaki funded the construction of the new building at a cost of 5.6 billion yen. Right-wing groups demonstrated against the museum during its first week, but there have been no significant political conflicts around the museum's content since then. This museum begins with a display on the damage from the atomic bomb and then moves backward in time to detail the events leading up to August 9. The high concentration of Catholics in Nagasaki tints the color of remembrance here, making it markedly different from Hiroshima, and producing some images that are consciously about religious martyrdom, such as the head of a statue of Jesus found after the bombing.[21] The first room in the museum features a recon-

structed wall from the Urakami Cathedral, which was destroyed by the bomb. The section that drew the attention of right-wing groups in Nagasaki frankly details the aggressive and often brutal actions of the Japanese military throughout Asia. The final exhibit briefly covers the history of peace movements in Nagasaki, Japan, and the world.

Peace Osaka, founded in 1989, sits on the grounds of Osaka Castle. An introductory panel states that Japan "caused great hardships on the peoples of the Asia and Pacific regions, the battlefields of the 15-year war," and that this museum is a place for "dispassionate and unpretentious reflection." The first floor of the museum covers the Osaka air raids and touches on domestic life during the last four years of the war, mentioning neighborhood associations, school mobilization, nationalistic textbooks, and civil defense measures. Like the Kawasaki and Nagasaki museums, Peace Osaka begins with exhibitions of Japanese domestic suffering and victimization, then moves backward to offer a chronology and explanation leading up to these last years of the war.

The lower floor distinguishes this museum even from the other harshly self-critical peace museums. This exhibit comprehensively covers the period of Japanese expansionism in the 1930s and frankly condemns the military's actions. One panel is entitled "Invading the Asian Continent" and is accompanied by displays of the military's brutal actions in China, including photographs of piles of bones and a photograph of a decapitated head sitting on a fence post. There is a section on the annexation of Korea in 1909 and the subsequent labor conscription of many Koreans, ending with a note that "Japan still has many unsolved problems" regarding the human rights of the 680,000 resident Koreans in Japan today. There is a level of self-accusation in this room that makes the exhibits seem almost as if they were written by the victims of the Japanese. All the place names that have become synonymous with Japanese brutality during the war are covered, from Bataan to Nanking to the Thai-Burma Railway. Culpability for Japanese victimization at Okinawa, Hiroshima, and Nagasaki is pointed squarely at the Japanese government, with one label stating that these events were the "aftermath" of the kamikaze attacks and the Japanese government's refusal to end a hopeless war. The third and final room exhibits a collage of international history from August 1945, falling generally under the theme of international cooperation, with the Lewis Institute clock and its changing settings ringing the room. With photographs of everything from cold war summits to the international exposition that

Osaka hosted, the museum leaves open the question of what exactly constitutes peace.

These museums are not perfect—they could all strengthen their treatment of the 1920s, for example. Most begin their treatment of the war with the worldwide economic downturn at the end of the 1920s, move on to the Manchurian Incident, and go into detail about Japan's march through Asia. As in the Hiroshima museum, the beginning of the war is largely not presented as a story of a series of human choices. It would be helpful to go into more detail about the international geopolitical situation of the 1930s and Japan's relationship at the time to the large colonial powers. Despite this weakness, however, these museums distinguish themselves by their willingness to make distinctions about war responsibility. Hiroshima's museum obscures both the American government's and the militarist Japanese government's choices and actions and puts forth nuclear weaponry, separate from its users, as the true evil. Without visible human agency in the narrative, the deaths in Hiroshima are presented as tragic but unavoidable, an effect separate from any cause. By contrast, the museum at Ritsumeikan University moves beyond traditional discussions of high-level government maneuverings and examines the role of ordinary citizens in resisting the war and of government repression of this opposition. Peace Osaka, by explaining the role of neighborhood associations, small groups that reported acts of disloyalty to the government, raises questions about the complicity of ordinary citizens. In this way viewers are allowed to ponder the notion of what Norma Field has termed "shared but differentiated responsibility."[22] In the terms of this notion a frightened nineteen-year-old soldier during the war faced a totally different set of choices from those of his senior officers, who faced entirely different choices from those of the people in government prolonging the war; and these forms of responsibility differed from those taken on by individuals who faced no choices, who were not alive during the war but have in some way inherited its legacies. When the causes of the war and its persistence are examined closely, it becomes possible to make these distinctions, so no one person or group is forced to bear the weight of fifteen years of death, something the limited terms of the right and left do not now allow. These museums recognize that to distinguish between death that resulted from misguided policy and death that was unavoidable is not to rob either of their meaning. They seek to help visitors to situate themselves in time and place, to understand the multiple perspectives inherent in studying war and peace,

and, most important, to look on various kinds of suffering and understand that this suffering is not inevitable, that it is the effect of various causes, and that responsibility can exist on many different levels.

These museums are navigating uncharted waters and are distinguished from traditional museums by four characteristics. First, museums in Japan have traditionally not been held in high regard by the academic community, and curators, who are often not professionally trained scholars, have not been in a position to put forth new and challenging interpretations of the war. These newer museums are in a better position to do this. Second, these museums are faced with the challenge of positively portraying peace, not only showing, as peace museums have traditionally done, wartime suffering. Some museums exhibit images of prosperity and development as positive developments in a peaceful Japan, but all are still faced with the difficulty of finding material evidence—objects—of peace that is as familiar and evocative as military equipment is of war. Third, these new museums, by emphasizing political activism, especially grassroots peace movements, express the belief that ordinary people can effect change, that visitors can become, as the historian Mike Wallace has put it, "historically informed makers of history."[23] Finally, these museums are able to break out of the familiar language of war museums, avoiding binary distinctions of victory and loss and showing, instead, a series of events happening to different people from different perspectives and asking at what cost we have arrived at the present moment.

This is an important time for the renegotiation of historical debts and legacies in Japan. The generation that experienced the war is dying off at the same time that traditional political arrangements continue to shift, and contemporary debates about the Japanese Constitution, the role of the Japanese military abroad, and the Japan-U.S. security relationship continue to echo back to unsettled questions about the war. R. J. B. Bosworth has written that "turning points in historical explanations are inextricably linked to changes in broader politics and society."[24] Public institutions in Japan, including museums, can work to stimulate a measured and historically informed conversation about the past and its connection to the present.

Museums addressing the war in Japan should first acknowledge that the war is not settled history. Museums should avoid language and exhibition styles that would suggest that they are making a contested narrative official, elevating it above debate. Their goal should be to contribute to a

continuing dialogue, an ongoing argument, about the lessons of the last six decades. Acknowledging that an exhibit is a result of compromise, written by humans who have to interpret limited evidence, can help lower the stakes of the battles that continue to rage around museum construction and exhibition. Part of the reason such extraordinary energy is expended on controversies over the *Enola Gay* exhibit or the museum in Tokyo is that the perception remains that museums will settle, once and for all, arguments about the war. For museums to acknowledge that they cannot do this is not to say that museums are unimportant. They can be places of public involvement and exchange, places that are both separate from politics but not free of it, places that force groups and individuals to articulate their interests with clarity and power, part of an ongoing process that can lead to new forms of consensus about the past. This is not a process that can happen overnight. It is a process dependent on the democratic energy and political engagement that grows independent of museums and free from the environment of intimidation that the right wing has created in its violent reactions to those who would reevaluate parts of Japan's wartime past.

Japanese history deserves to be represented in all its complexity in museums. The gap between the rigid and unchanging public debate about the war and the rich, complicated, and varied private memories of the war should not be allowed to grow larger. These new museums represent a new form of public historical negotiation, placing uncomfortable evidence and narratives before the public. They are beginning to demonstrate the power held in asking hard questions about Japan's wartime past.

NOTES

I would like to thank Maki Kawase for translation assistance. Professor Masatsugu Matsuo, Jennifer Seltz, Steven Lubar, and two anonymous readers provided extremely helpful feedback on earlier drafts of this essay.

1. Hein and Selden, *Living with the Bomb*, 8.

2. Yui, "Between Pearl Harbor and Hiroshima / Nagasaki," 67. See also Hata, "Senso Hakubutsukan ni Nozomarcrumono," 33; and Tanaka, *Senso no Kioku*, 160.

3. The left in Japan has also been wracked by a persistent and crippling factionalism since the 1950s, which has often prevented clear and coherent responses to political crises. The familiarly splintered political activity in Hiroshima in response to nuclear testing in Southeast Asia in 1998 illustrated this.

4. Awaya, "Emperor Showa's Accountability for War," 398.

5. Okamoto, "The A-Bomb Dome as World Heritage," 46.

6. Chomsky, *American Power and the New Mandarins*, 169.

7. Ikuro Anzai, "Sending Peace Message from Ritsumeikan University," lecture dated June 6, 1997. Photocopy in author's possession.

8. See Yoneyama, "Memory Matters"; and Weiner, "The Representation of Absence and the Absence of Representation."

9. Buruma, *The Missionary and the Libertine*, 210.

10. Hammond, "Commemoration Controversies," 109.

11. Ibid.

12. I do not provide an exhaustive list; there are other museums in Japan, many of them quite new, that fit into this category. Terence Duffy describes some of them in "The Peace Museum Concept."

13. See Hicks, *Japan's War Memories*, 55; and Hook, *Militarization and Demilitarization in Contemporary Japan*, 70.

14. Hicks, *Japan's War Memories*, presents a detailed overview of the process by which this scholarship was made public.

15. See Field, *In the Realm of a Dying Emperor*.

16. See Hook, *Japan's War Memories*, 112–26.

17. For an overview of this museum and the controversy see Hammond, "Commemoration Controversies."

18. T. R. Reid, "Japan's Media Re-Fights, Revises WWII," *Washington Post*, Aug. 14, 1995, A13.

19. See Field, "The Stakes of Apology"; and Yui, *Nichibei sensokan no sokoku*, 23.

20. Ikuro Anzai, interview by the author at his Kyoto office, Dec. 23, 1997.

21. Some of these images would be especially jarring to American eyes, and many were, in fact, censored after the war because, as George H. Roeder Jr. has pointed out, they "reduce the cultural distance between Americans and Japanese." See Roeder, "Making Things Visible," 91.

22. Field, "The Stakes of Apology," 414.

23. Wallace, *Mickey Mouse History*, 128.

24. Bosworth, *Explaining Auschwitz and Hiroshima*, 195.

■ The architecture and morphology of cities can themselves be memory sites for national identities, especially when the cities serve as capitals or figure in the national imaginary. These memories are all the more contested when political changes move a city from one jurisdiction to another.

James Carter's essay on Harbin, China, illustrates that the contest over urban identity has a long and global history. Focusing on religious sites, Carter traces the layered and conflicted histories of Harbin as a one-time Russian city and examines how efforts to create tourist interest can mobilize the memorializing of a particular version of the past as a distinctive exotic other. Political transformations can create new urban political identities, but the politics of tourism can give cash value to the memorializing of select pasts.

This process has also been dramatically realized in many of the countries in the former Soviet Union, which have seen resurgent nationalisms strive to authorize a new urban identity for a nationalist project. Vilnius (previously Vilna), the capital of Lithuania, is one such site. John Czaplicka's essay describes efforts to reconstruct a duke's castle to memorialize a romanticized version of the pre-Soviet past. In the rush to reintegrate the city into Europe, curators and archaeologists rebuilding the site risk, in interpretive silences, an ethnic "cleansing" of Vilnius's Jewish past that ironically replays the history of anti-Semitism it seeks to elide.

TOURING HARBIN'S PASTS

James Carter

China's northernmost city, and one of its newest, Harbin wears evidence of its tumultuous twentieth century in its striking juxtaposition of architectural styles. A brief tour of Harbin's Nangang District illustrates the city's many public faces. If you stand today in Museum Square, monuments of many eras surround you. Each evokes different pasts of this city, built in the 1890s by Russian railway engineers, taken over by the Chinese Republic during the 1920s, and occupied for thirteen years by the Japanese-sponsored forces of Manchukuo. Until World War II Harbin's multiethnic community was a rare mix of dozens of nationalities, dominated by Chinese, Russian, and Japanese.

On Museum Square's western side a street separates a monument to Red Army liberators of Harbin in 1945 from an art deco hotel that hosted the Lytton Commission investigating the legitimacy of Manchukuo in the 1930s. To the north former foreign consulates border the Heilongjiang Provincial Museum—a Russian-built structure of the 1910s—and a newly opened thirty-five-story glass and granite hotel. On the south side of the square the oldest extant buildings in Harbin now host pizza parlors and convenience stores. And at the center of the traffic circle is an empty space where once stood the centerpiece of Harbin's Russian community, a wooden orthodox cathedral, built in 1899 and destroyed in 1966.

Proceeding east, through the crowded commercial center of the city, the same retail bonanza that dominates many Chinese cities is punctuated by European-built structures, including the cast-iron facade of the Qiulin Company department store, its current name a homophone of the original Russian owner, Choorin. Further east, past the former American Consulate (now a shoe store), Russian Orthodox, Roman Catholic, and Protestant churches sit as reminders of Harbin's diverse religious past. A Chinese-style tower, a monument to one of its wealthiest citizens of the 1920s, sits opposite.

Nearing the end of the street, the sickly sweet smell of tobacco from the Lopato Cigarette Factory accompanies more familiar scenes of China: three large Buddhist temples line the street to your left, and recorded chants fill the pedestrian plaza. Opposite, a sign directs you toward the Confucian temple, the largest in northeast China. Ahead, under a Russian steeple, is the entrance to the Worker's Culture Park, Harbin's largest amusement park, and a place where the city's several pasts and contentious present vie for primacy.

The entrance to the amusement center was originally the threshold of Harbin's foreign cemetery. The bodies were removed to a suburban grave-yard decades ago, but the headstones were recycled and today serve as path stones linking ice-cream stands to carnival rides. In the shadows of "Harbin Seaworld" polished granite identifies stones that originally marked graves. Fragments of Cyrillic inscriptions reveal traces of Harbin's past foreign community: a forty-eight-year-old man who died in 1924, a teenage boy, and dozens more no longer readable.

The story of the Russian headstones in the Chinese amusement park fits much of the traditional historiography about this city: a Chinese Harbin was built on the bones of a Russian Harbin. But this is a partial—and misleading—glimpse into the city's story. Nearby, in the same park, an outdoor amphitheater used for summer concerts reverberates with louder, and more diverse, echoes of Harbin's past. There large tombstones are now benches for theater seating or are merely discarded among the work-ers' housing and ticket booths. Not only Cyrillic letters were inscribed on these stones; Hebrew markers remind us of Harbin's substantial Jewish community. Many tombstones feature Chinese characters: Harbin's ghosts are not only Russian but Chinese as well. Japanese markers, too, can be found. And, if the wind and traffic permit, strains from the Korean Chris-tian church a few blocks up the street, which the Russians had called *Bolshoi Prospekt*, can be heard. Harbin's cosmopolitan past (it once was home to newspapers published in Chinese, Russian, Ukrainian, Japanese, English, German, Polish, Yiddish, and Korean) is muted but still audible.

Harbin's past is not the province of any single nation or people. It is a city that grew up on the geographical and temporal frontier. It was located in space on the edge of Chinese, Russian, and Japanese spheres of influ-ence. It began existence near the violent ends of imperial Russia and China and the equally violent beginnings of expansionist Japan. Harbin—and Harbin's past—is not so much a place where Chinese replaced Russians as

1. Postcard depicting the entrance to Harbin's Russian Orthodox cemetery and the Church of the Blessed Virgin. Constructed in 1908, these two structures are still in place, one functioning as the entrance to an amusement park, the other as a snack bar.

2. An entrance ticket to the amusement park. The Russian cemeteries, Orthodox and Jewish, were closed in the 1950s and all the bodies removed to other sites, including the Jewish cemetery in the Harbin suburb of Huangshan. Today the site is a city park, including an amusement park and aquarium.

one where many competing groups have struggled for identity, existence, and superiority.

Political and economic struggles over the city's identity shaped much of Harbin's architecture, and these struggles are visible in two prominent examples of public religious architecture, one Asian—the Buddhist Paradise Temple—and one European—the Russian Orthodox Church of St. Sophia. Separated by only a few miles, these structures, both built in the early twentieth century, represent clearly competing traditions, nations, and histories. This competition was perhaps the central theme of Harbin's first century of existence, when Harbin's location near the Russian and Korean borders, and its role in Russian, Chinese, and Japanese expansion, made its history both vulnerable and valuable.[1] The city's various communities erected buildings to provide symbolic, and often spiritual, centers. The Buddhist Paradise Temple, funded by Harbin's Chinese government shortly after gaining power in the 1920s, and the Russian Orthodox Church of St. Sophia, built by the disenfranchised White Russian community later in the same decade, are two examples of this phenomenon. These structures, and others like them, were physical representations of the city's fractured identity.

In recent years, however, the relationship between these landmarks has changed. Local and regional officials have recently financed and overseen the renovation of both the Paradise Temple and St. Sophia Church as tourist attractions. This project has included such other seemingly disparate elements as Harbin's Confucian temple, the city's European-styled downtown district, and its Jewish cemetery. The apparent switch from figuring these two sites as competitive to cooperative suggests that the uses of public space in Harbin have changed, pointing to a diminishing role for the nation-state in the dominant narrative of the city and an increasing role for the regional and global. While previous generations, seeking political legitimacy, emphasized elements of the city that signaled its inclusion in mainstream national histories, political and economic transformations have led entrepreneurial city leaders of the present generation to call attention to Harbin's geographic and historical marginality in pursuit of tourist dollars and development capital.

■ ■ ■

Harbin's physical character has always reflected its political masters and been transformed with each passage of power. Russians built the modern

3. Postcard depicting the Buddhist Paradise Temple (Jilesi) that opened in the 1920s, just outside the entrance to the Russian cemetery. Shown here during the Japanese-sponsored Manchukuo era, the temple was the first example of traditional Chinese architecture in Harbin.

4. Postcard of St. Sophia Church. Completed in the 1930s, St. Sophia's was the center of Harbin's Russian community during the Manchukuo era. After years of neglect it was renovated in the 1990s and reopened as the Museum of Harbin Architecture.

哈尔滨市·索菲亚教堂
Harbin St. Sophia Church

city of Harbin. In 1896 they selected the site of a Manchu fishing village to be the point where their new railway would cross the Sungari River, and from these beginnings the city grew rapidly. Within a generation it was a cosmopolitan city, one of the largest in northeast Asia. Until the Russian Revolution of 1917 it remained a de facto Russian colony, controlled by the czar's government via the Chinese Eastern Railway Company.

During these first twenty years Harbin acquired the look of a Russian provincial city: "as distinctly a Russian city as though it were located in the heart of Russia," in the words of *National Geographic* magazine.[2] As Chinese authorities gained control of the city, though, they sought to give it some of the physical markers of a Chinese city. In 1921 city officials identified a Buddhist temple as the first element in the "Chinafication" (in the words of U.S. consul George Hanson) of their city. The Buddhist monk Tan Xu came to the city in 1922, and his first impressions make clear both the appearance of the city and his purpose in establishing a Buddhist temple there. The city was full of Protestant and Catholic churches, Tan declared, yet "there was absolutely no Chinese Buddhism. . . . For Harbin, *as a Chinese place*, not to have a single proper Chinese temple . . . it was simply too depressing to bear!"[3]

In March 1923 Zhu Qinglan (1874–1941) was appointed chief administrator of the Harbin Special Administrative Region, making him the supreme local military and civilian authority in Harbin, and he claimed "jurisdiction over civil, foreign, judicial, educational and industrial affairs."[4] Harbin's military and civilian power was thus combined in the hands of a single Chinese for the first time, making Zhu the most powerful Chinese in Harbin to date and the most dominant official of any nationality since the Russian Revolution. Zhu was also a devout Buddhist and joined with Tan Xu and others to advocate for the temple's construction.

Construction began in the spring of 1923. Although formally a private undertaking sponsored by the Buddhist Association of Harbin, Paradise Temple was actually an official public work. Beyond the ceding of land "under a long-term lease, free, for the erection of a Buddhist temple" by the Chinese Eastern Railroad, Zhu Qinglan oversaw fund-raising and construction of the temple.[5] As chief administrator of the city, Zhu enforced contributions throughout the Chinese bureaucracy of Harbin and managed small details of the temple's construction.[6]

Paradise Temple was a key component in Zhu's attempt to establish Harbin's Chinese identity. In laying out the year's priorities for 1924, the

year the temple would open, the Chinese daily *Guoji xiebao* (International) declared that an official "so able and experienced" as Zhu Qinglan would in that year make "concerted efforts to bring about improvement and reforms in connections with the railway management and local government with a view to restoring Chinese sovereign rights."[7] The temple was not only a religious edifice but also a physical assertion of Chinese sovereignty.

As Paradise Temple was beginning to rise, in September 1923, construction began on a very different religious edifice a few miles north of the temple's tiled roofs. In Daoli District—Russian parishioners would have called it Pristan—the faithful prepared to build the largest Russian Orthodox Church in Manchuria. The Church of St. Sophia would enlarge an existing church first built in 1907–8. This new church, planned by a prominent Russian architect, would provide the Russian community of Harbin with a new symbolic center around which to rally against the cultural encroachment of both "heathen" Chinese and atheistic Bolshevism. Unlike the Paradise Temple, which enjoyed official government patronage, St. Sophia was funded mainly by private money. Led by clergy from Vladivostok, Orthodox faithful organized the Society to Preserve St. Sophia Church.[8]

The two structures rose in tandem, appropriate for symbols of the city's two largest competing ethnic communities. Paradise Temple was the first to open, at a ceremony on September 28, 1924. All of the major Chinese officials in Harbin, including representatives of all the government bureaus of the Special Administrative Region and the CER, attended.[9] For the first time, Harbin was home to a significant structure designed in traditional Chinese style. Judging from the accounts of an American missionary writing in the *Harbin Daily News*, the temple had the desired effect on the urban landscape: "It is quite striking that here [in Harbin] . . . there should be placed upon the bluff of this city, overlooking the Chinese part of the city and standing between the Russian city and their Christian cemetery, filled with crosses . . . a big, beautiful, really magnificent Buddhist temple, filled with highly colored gods."[10]

To be sure, the addition of one temple to Harbin's urban landscape would not make the city appear Chinese, but its location meant that the temple's symbolic importance far exceeded its physical size. Sitting on a hill overlooking the Chinese district, it added a striking element of traditional Chinese architecture to the city's skyline. It was also the first building exhibiting traditional Chinese features to be erected in Nangang (New-

town) District, the administrative heart of the city and the location of the former Russian governmental buildings, as well as foreign consulates. Finally, it was situated at the base of Harbin's original cruciform layout, within view of the Russians' Christian cemetery and on the road that linked the graveyard with the Christian churches. During Orthodox holy days, such as May 10, when friends and relatives visit the graves of their loved ones, huge numbers of Russians streamed into the cemetery along the only road—which now passed almost beneath the eaves of the Paradise Temple's gate.[11] The Buddhist temple was a tangible reminder to Chinese laborers, international diplomats, and Russian mourners alike that they were living in China, not Russia. No sooner had the temple opened than Harbin's Russians petitioned the city authorities for a new burial ground, one not tainted by the shadows of the "foreign" religion.[12]

Perhaps this unease within the Orthodox community about the proximity of the Buddhist and Christian sacred ground contributed to the funding of St. Sophia Church; it seems more than coincidence that the two buildings were started within months of one another. But although the move to expand the church began around the same time as the decision to build the temple, construction on St. Sophia's was considerably slower. It took more than nine years to complete the building. When it opened officially, on November 25, 1932, the cross-adorned onion dome soared more than 150 feet into the air, dominating the skyline of a city that featured primarily two- and three-story buildings. Able to accommodate two thousand worshipers, it was the largest Orthodox church in East Asia.

The church was also, therefore, the largest in Manchukuo, the Japanese-sponsored state established in the spring of 1932. Nonexistent when the two buildings were begun in 1923, Manchukuo, the "Land of the Manchus," symbolized the fragility of the nationalist project in Harbin and heightened the political conflicts among competing architectural representations. Indeed, many officials who had promoted Chinese nationalism as part of the Republic of China in the 1920s turned quickly to support the new Manchukuo state ideology. Yet Paradise Temple retained its role as a focus for nationalist sentiment even after Japanese forces occupied Harbin in February 1932. Buddhism was a pillar of the new state's ideology, and Manchukuo officials expanded Paradise Temple as an avatar of Harbin's inclusion in the Greater East Asia Co-Prosperity Sphere. At this time a seven-story stone pagoda was added, and the community of monks at the temple grew to more than fifty.

Postwar political change, this time the advent of the People's Republic in 1949, would again transform the public spaces to serve a new revolutionary identity. Initially, while the temple's religious role diminished and the community of monks dwindled, the temple's physical plant remained relatively unchanged. Then, leaders of the Great Proletarian Cultural Revolution including Mao Zedong, launched a campaign to eliminate from China the "four olds": old customs, old habits, old culture, and old thinking. Many of Harbin's architectural treasures fell under attack, including Paradise Temple. Buddhist idols and paintings were defaced and destroyed, elements of the temple's many pavilions were damaged, and the community residing within was evicted. The temple itself closed in August 1966 and did not reopen until January 1979.[13] After it opened, the temple remained unimpressive, squirreled away in a corner of the city just beyond the terminal for several popular bus routes. Beggars seeking relief from China's bumpy transition to a market economy and testifying to the fraying of the state's social safety net frequented the dusty, unpaved road in front of the temple.

St. Sophia's also endured the Manchukuo era and the Chinese Civil War without significant damage. The bulk of Harbin's Russian population repatriated to the Soviet Union just before the severing of relations between China and the USSR in 1960. Partly in response to diminished demand, and partly as a symbolic strike against their Slavic neighbor, Chinese authorities closed the church in 1960. The building became an onion-domed warehouse after that, and perhaps it was this utilitarian role that enabled St. Sophia's to survive the Cultural Revolution of the late 1960s and 1970s. Most of Harbin's Christian churches, including the centrally located St. Nicholas and the riverside Pravienskaya church, were not so lucky and were demolished by rival Red Guard factions in a game of anarchic one-upmanship.[14] The Chinese central government, allegedly with the support of Premier Zhou Enlai, declared the building a protected site in the 1970s. Protected status ensured St. Sophia's survival but not its maintenance. New apartment buildings obscured the church on three sides and made a full view of the building impossible. The interior continued to serve as storage space for nearby work units. Even after other Christian churches in the city reopened in the 1980s, St. Sophia remained an impressive but neglected derelict.

As the new millennium approached, though, both edifices suddenly found themselves the focus of renewed attention. In November 1996 the

Harbin city government announced that it would renovate St. Sophia's and develop it as a museum dedicated to Harbin's unique architectural and cultural heritage. Echoing the drive to build Paradise Temple (and also the nearby Confucian temple) seven decades earlier, the local government launched a public fund-raising campaign.[15] This effort, complete with telethons, raised more than ten million yuan (more than US$1.2 million)—a staggering figure given the economic malaise of northeast China, especially Heilongjiang Province. The entire project included not only the interior and exterior renovation of the church but also the clearing of a 6,648-square-meter (more than 20,600 square feet) plaza surrounding it.[16] Suddenly, St. Sophia's, which a few years before had been only reluctantly acknowledged by many local officials, was publicly trumpeted as "the largest Orthodox Church in the Far East" and a "great architectural product."[17]

With the dawn of the twenty-first century the church became the city's unofficial symbol: press materials announcing Harbin's bid for the 2010 Winter Olympics feature St. Sophia's. Harbin's television station uses the church's silhouette as its logo. Citywide celebrations, such as the fiftieth anniversary of the founding of the PRC or the New Year's 2000 celebration, take place in the courtyard surrounding St. Sophia. Most Saturdays and Sundays, newlyweds fill the courtyard to have their photographs taken in front of the city's new icon. The interior of the church houses an exhibition of Harbin's unique Russo-European architectural heritage. This museum assembles the finest collection of photographs of prerevolutionary Harbin on view, many of which celebrate the city's Russian and European architectural legacy.

Even as St. Sophia's was being renovated, a similar renovation was taking place at the Paradise Temple. In the winter of 1996 a major renovation of the temple's original compound began. The local press proclaimed the importance of this temple, in particular, and of other regional Buddhist centers to the area's history and culture.[18] Along with the original temple grounds, the adjacent compound with the seven-story stone pagoda (constructed in the Manchukuo era) was renovated, including the construction or renovation of five large pavilions, one of which is decorated by an elaborate series of frescoes featuring stories of the life of the Buddha. The last phase of the renovation was complete reconstruction of a Buddhist nunnery, which occupied the lot adjacent to the grounds of the former Russian cemetery. Completed in 1999, these three temple complexes be-

came the centerpiece of a pedestrian zone that extended for some one hundred meters in front of the entrance to the Harbin Amusement Park (the new name of the Culture Park, the former Russian cemetery grounds). The area was paved with white granite stones and adorned with wrought-iron streetlights. Replacing the beggars of a few years before are ice-cream stands, restaurants, and rickshaw drivers dressed in nineteenth-century costume offering tourists rides and photo opportunities.

The renovation and reclamation of the Buddhist temples signified their importance in maintaining the Chinese element of Harbin's past. Yet these efforts have paled next to the tremendous visibility of St. Sophia's Church. In an ironic reversal of earlier roles, St. Sophia's—not the Buddhist or the nearby Confucian temple—has become the symbol of the city's identity. Newlyweds do not pose for photos at the renovated temples; they go to St. Sophia's. Literature about the temples is sparse, unlike the minor industry, targeted toward both Chinese and Russian tourists, that has sprung up around souvenirs of St. Sophia. In contrast to the early 1920s, when city administrators used the Buddhist temple to evoke a Chinese cultural presence in the minds of Harbin's residents, in the 1990s St. Sophia's filled that role.

Sponsored by the Harbin city government and attended by important local and regional officials, the opening ceremony of the church itself was termed a "Baptism" (洗禮, *xili*), and the script for the ceremony relied on the building's role in public memory for effect: "Who are you?" a narrator asked. "You are St. Sophia's church of the Moscow of the East. How many years of hardship have you experienced?" The script continued, leaving no doubt that the church, occupying a place "within the hearts of the people of Harbin," is meant to elicit images of Harbin's past—and not necessarily a Chinese past: "When you toll your bell you again open the floodgates of memory for many."[19]

This encouragement of memories of Russian—or at least a multi-cultural—Harbin reflects the extent to which tourism has supplanted nationalism as the engine of Harbin's public spaces. In earlier decades Chinese-styled landmarks like Confucian temples were employed to evoke memories (real or imagined) of Harbin's Chinese past, in the name of strengthening the city's identity as "a Chinese place."[20]

The "baptism" ceremony to "cleanse [the church] of many months of the dirt and dust of meticulous renovation" continued with oddly evocative religious imagery, proclaiming the end result of the project as the

restoration of this "lofty," "proud," and "holy" structure. Literature commemorating the church's restoration prominently highlights the cross's reinstallation atop the onion dome, a feature that had been absent for an uncertain amount of time. Even though the church's function is no longer religious, the juxtaposition of the church with its rhetoric of baptism and the state's officially atheist stance coexist in awkward symbiosis. The ceremony ended with a hymnlike ode to the church:

> The ringing bell of history
> Resounds in the heart's depths
> Leading (us) on destiny's bumpy road
> Through years and months of memory
> Ah!
> In the dust of this day
> People can see you as though in a dream
> A dove of peace
> Holding a beautiful hope
> Accepting a pure and holy baptism
> Ah!
> In a day of peace like this
> People and heaven are united with you.

■ ■ ■

What do these two religious structures, born and reborn within months of one another, show about the effect of political transformations on the management of Harbin's identity? Something important has changed, enabling—perhaps forcing—Harbin's leaders to celebrate aspects of its past previously shunned. This change is the ascendancy of a new strain of economic modernizers who, in the wake of Mao Zedong's Cultural Revolution, have sought economic growth. In this model these new nationalists are less concerned with the identification of Harbin as "A Chinese Place" than with the development and promotion of an economically vibrant urban center. As the region's heavy industry crumbled, tourism presented an attractive new revenue stream, and the internationalist ideology of China's new modernizers permitted Harbin to capitalize on its multicultural heritage.

As neither Christianity nor Buddhism is indigenous to China, perhaps the use of both the Christian church and the Buddhist temple in the service

of Harbin's public identity points to a new era of Chinese engagement with the world beyond its borders. Unlike the era of their construction, when the temple and the church opposed one another as avatars of different versions of Harbin, today both are celebrated, particularly the more superficially "foreign" of the two. Globalization is commonly construed as the enemy of special local cultures, but here we see its role in the production of a unique local and regional identity, a northeast Asian identity that may embrace both Orthodoxy and Buddhism (at least as parts of its history). The current uses of Harbin's public history evoke the cosmopolitan Tang dynasty of the seventh and eighth centuries, when cultures from throughout Eurasia mingled in the Chinese capital, led by Buddhism and Christianity among other religions.

This interpretation also helps to explain the resurgent interest in Harbin's Jewish community. In December 2000, news outlets reported that Harbin's municipal government was undertaking plans to renovate a Jewish synagogue in the center of Daoli District and turn it into a museum of Jewish culture, paralleling the transformation of St. Sophia Church into a museum of architecture.[21] There is also an intensification of interest in Harbin's Jewish cemetery, Huangshan, located seven kilometers east of the city. This cemetery, with more than eight hundred graves, was moved from the location near the Paradise Temple in 1958 and reopened to the public in April 2000. Most of the remains in the cemetery have been identified, and the site has helped make Harbin a feature of several Jewish Heritage Tours of Asia. City officials have welcomed the descendants of those interred in the cemetery to pay respects and have even launched a Web site to invite relatives and help to positively identify the tombs in the Jewish cemetery.[22] The Web site, which welcomes visitors with the proclamation "History and Future Encounter Here," shows vividly how Harbin's non-Chinese past, denied or muted for so long, is now being celebrated, again, to encourage foreigners to visit the city. Perhaps nationalism, the driving ideology of Harbin's twentieth century, is stepping aside for tourism, a powerful economic lure for the twenty-first. And in that spirit Harbin is now more valuable to its Chinese rulers for its uniquely non-Chinese elements.

Local authorities have marshaled this uniqueness to provide muchneeded revenue for economically depressed Harbin. The extraordinary foreign architectural legacy, which had driven earlier generations to assert the city's Chinese identity, has now become a valuable commodity. Tour-

5. An entrance ticket to Buddhist Paradise Temple (Jilesi). Closed during the Cultural Revolution, the temple is today celebrated as a site linking Harbin with the mainstream of Chinese tradition. It is an active monastery and one of Harbin's most visited tourist sites.

6. Entrance ticket to the Museum of Harbin Architecture, housed in the renovated St. Sophia Church. The site attracts Chinese and Russian tourists and is a popular location for Harbin newlyweds who want to have their photographs taken.

ism has sought to capitalize on this industry. Local colleges offer English-language guidebooks to the city's sites (including both the Paradise Temple and St. Sophia Church). Recently, Heilongjiang University changed the name of its history department to the "Department of History and Tourism" in hopes of attracting new majors. Foreign and domestic visitors are lured by the city's unique heritage, and once there, these visitors are offered books, engravings, and commemorative refrigerator magnets emblazoned with St. Sophia's image.

While the emphasis on tourism as a potential revenue source is not unique to Harbin among Chinese cities, its emphasis on non-Chinese elements of the city may serve to give it a competitive edge as a distinct tourist destination. The most successful Chinese tourist destinations, cities like Hangzhou and Suzhou, attract visitors precisely because they are seen as quintessentially Chinese.[23] There, an aura of timelessness supports the national narrative that today's People's Republic is heir to a millennia-old and easily definable Chinese cultural tradition. Even Shanghai's famous Bund, the greatest concentration of colonial architecture in the city, has lately been challenged by the emergence of the Pudong region, across the Huangpu River, as a commercial center. Increasingly, the modern, Chinese-built television tower at the core of this center is replacing the Bund as a symbol of the city.

At the national level, too, China supports a public face that emphasizes the unity of its past. If one accepts Buddhism as a part of Chinese culture (present in China for more than two thousand years), then the UNESCO World Heritage sites in China all emphasize the mainstream narrative favored by the PRC leadership. Of the sixteen "cultural" (as opposed to scenic) sites, none were built by Europeans, and although several were built by non-Chinese civilizations, all were built by states that either ceased to exist long ago or have been claimed as part of China by the current regime (for instance, the Tibetan Potala Palace in Lhasa and the Mogao Caves in Dunhuang).

Harbin, though, at the edge of Chinese history and territory, seems poised to market its marginality by making it central to tourism, especially as the Chinese appear ever more eager to embrace the non-Chinese as symbols of cosmopolitanism and markers of global social capital. Harbin is entering a new era, in which its past and present are being reevaluated. In the summer of 2000 the Harbin city government dynamited its main office, a Manchukuo-era Classical Greek-revival building, to make way for a new

central square, a new center for public attention in the city. In the coming years perhaps we should look to this space to see what lessons Harbin's rulers have taken about the role of public architecture in this contested city.

NOTES

1. For other details of this competition see Carter, *Creating a Chinese Harbin*. On the Russian founding of the city and the era before Chinese control see Wolff, *To the Harbin Station*.

2. Henry B. Miller, "Russian Development of Manchuria," *National Geographic*, March 1904, 113.

3. Tan, *Yingchen huiyi lu*, 208–9 (emphasis added).

4. George Hanson, "Brief Outline of Political Conditions in North Manchuria from the Chinese Revolution of 1911 to the End of 1923," 32. Enclosed with Hanson to Secretary of State, April 7, 1924. File 893.00 / 5420. United States National Archives, General Records of the Department of State, Record Group 59. Hereafter cited as USNA-RG59.

5. *Russian Daily News*, July 12, 1923. Enclosed with Hanson to Secretary of State, July 20, 1923. File No. 893.404 / 24. USNA-RG59.

6. Tan, *Yingchen huiyi lu*, 223–25.

7. "The Three Great Problems to Be Solved This Year in Connection with the Governmental Administration in the Special Area," *Guoji xiebao*, Jan. 1, 1924. Translated and enclosed with Hanson to Secretary of State, Feb. 21, 1924. File No. 893.00 / 5378. USNA-RG59.

8. *Harbin shizhi, 31: Zongjiao* [Harbin Gazetteer 31: Religion] (Harbin: Heilongjiang renmin chubanshe, 1999), 140.

9. "Jilesi kaiguang zhisheng" [The Magnificent Opening of the Paradise Temple], *Binjiang shibao*, Oct. 28, 1924.

10. *Russian Daily News*, Dec. 23, 1924.

11. One such festival is described in Hanson to Secretary of State, June 11, 1926. File no. 893.00 / 7515. USNA-RG59.

12. "Jilesi lian ji sizhe" [The Compassion of the Paradise Temple Extends to the Dead], *Binjiang shibao*, Nov. 27, 1924.

13. *Harbin shizhi, 34* [Harbin gazetteer 34: Religion] (Harbin: Heilongjiang renmin chubanshe, 1999), 24.

14. St. Nicholas's was dismantled in 1966 under unclear circumstances, but certainly related to the Red Guard activity in Harbin. Pravienskaya was destroyed in the early 1970s.

15. For information on the Confucian temple see Carter, "A Tale of Two Temples."

16. All figures taken from the brochure *Sheng Suo fei ya jiaotang* (St. Sophia

Church), (Harbin, 1997). Special thanks to Lynn Kalinauskas for helping with obtaining materials on the renovation.

17. Ibid.

18. Han Jiang, "Xiaer ta ming—Jilesi tayuan" [Spread Its Name Far and Wide—the Temple of Paradise], *Heilongjiang ribao*, Aug. 13, 1996.

19. "Xili—Sheng Suofeiya jiaotang" [Baptism—St. Sophia Church], in *Quanguo zhongdian wenwu baohu danwei: Sheng Suofeiya jiaotang* [National Protected Cultural Site: St20. Sophia Church] (n.p.: n.d.), 134.

20. This phrase was employed by the Buddhist monk Tan Xu when he articulated the need for a Buddhist temple in Harbin and again by General Zhang Xueliang when he wrote the dedication for the Confucian temple, both in the 1920s. See Carter, *Creating a Chinese Harbin*, chap. 5.

21. "Harbin to Reconstruct a New Jewish Synagogue," *People's Daily* (English online edition), Dec. 11, 2000, http://english.peopledaily.com.cn/200012/11/eng 20001211_57497.html (accessed Feb. 7, 2004).

22. The Web site maintained by the city is www.hrbjewcemetery.com (accessed Feb. 7, 2004).

23. For further reading on these two cities, both important tourist centers for Chinese travelers especially, see, on Suzhou, Carroll, "The Local Articulation of Nationality"; and, on Hangzhou, Wang, "Tourism and Spatial Changes in Hangzhou, 1900–1927."

THE PALACE RUINS AND PUTTING

THE LITHUANIAN NATION INTO PLACE

Historical Stagings in Vilnius

John Czaplicka

In major cities of Russia and of the states formed after the disintegration of the Soviet Union in 1991 a process of reclaiming and reconstructing local, ethnic, and national history continues. In Moscow and Kiev the post-Communist governments have reconstructed major landmark churches torn down during the Stalinist period. In Riga the "House of the Black-heads," a highly ornate mannerist building that was once the pride of the city, has been rebuilt on foundations left empty by the Soviets after World War II. An American building contractor of Latvian-Jewish descent, Sol N. Bukingolts, even speaks of reconstructing Riga's Choral Synagogue. In the Ukrainian city of Lviv a cemetery dedicated to Poles who died fighting Ukrainians in the Polish-Ukrainian war that followed World War I, has been refurbished with Polish support and Ukrainian permission. In the part of former East Prussia now in Poland, Poles are conserving and restoring German war cemeteries. As part of the Lithuanian Parliament's plan to restore the Jewish quarters of Vilnius, Lithuanian, French, and Israeli architects have hatched plans for the rebuilding of the Great Synagogue dynamited by the Nazis.[1]

Perhaps the most significant of all the ongoing projects meant to restore the prewar historical topographies to these cities is the rebuilding of the Lower Palace of the Lithuanian grand dukes in Vilnius, which relates closely to the contemporary formation of a Lithuanian national identity. Each of these projects of historical reclamation derives impetus from a mixture of national and local pride, nostalgia, legitimization, guilt, and the prospect of economic gain through tourism. But common to all of them is an underlying sense of a "loss of history."

The Soviet regime had denied many aspects of local, ethnic, religious, and national heritage in the nations that made up the USSR. So in the post-Soviet period the populations of these new nation-states have sought to redress their loss of history through a reconstruction of their heritage in

place. The concrete markers and reminders erected throughout the cities provide important focal points for the reconstitution of their place-based identities or for strengthening a local population's identification with the cities and towns in which they live. In most cities site-specific histories are being reinscribed by interest groups and governments that have formed only since the end of the Communist period. They are revising the historical topography of the city as they erect monuments to their own heroes and to important events in their own histories—including ones that recall the oppression of past eras by foreign rulers. Through strategies such as renaming streets and squares, designating new historical sites of significance, and opening new museums, these newly empowered social groups rewrite local historical narratives to conform to their visions of shared ethnic and national identity. The histories projected through these commemorative acts often relate to the city's founding and to its continuous occupation by one ethnic group or another and to the acts of violence committed against the local population by foreign invaders and occupiers. As churches closed under the Communists are returned to their congregations and their original use and continue to mark the urban silhouettes, the importance of the heritage and traditions of religion for local history of these cities and towns is reconfirmed. History is not only being recovered; it is also being activated to support the constitution, activation, and confirmation of place-based identities, which are local and often national and ethnic in character.

But such initiatives also serve to legitimize governments and bolster particularistic political movements, which would prefer to distance themselves from the recent Soviet past and to establish their own political-historical heritage. In addition to these collective and official reasons for reformulation of history and heritage, there are many more personal motivations for such change. These include the legitimate wishes expressed by the victims of war, deportation, and exile, who would like to "recover" their hometowns and cities. Such attempts at recovery are further complicated by the descendants of those who left the cities and towns of East-Central Europe, many of whom have "returned" only with an image of a place that was transmitted to them by their parents and relatives. More than a decade ago, the stewardship of history and urban heritage as it is expressed through architecture, material culture, and the setting of monuments passed from the Soviet officials to Estonians, Latvians, Lithuanians, and Ukrainians. The historical representation of the states, the cultures, and the personal and collective memories seated in these cities are now

beholden to the wishes of an electorate and their representatives and subject to public negotiation.

Whatever each of these peoples and their governments decide to preserve, restore, or reconstruct in the fabric of their cities, they are configuring a heritage that will help determine the spirit and direction of newly established nation-states.[2] This is especially true in Riga, Vilnius, and Tallinn, the capitals and thus highly representative cities of the Baltic States. Propelled by the vision of national or ethnic origins and ancestors, the post-Communist governments are composing delimited narratives as a *reaction* to both the Soviet regime and to other historical oppressors and colonizers of the local populations. Each building restored, each monument erected or demolished, each historic site newly marked adds a line to the new historical narratives. And each piece of history put into place may serve to help define the contours and meaning of a place-based identity, which will be supported in countless tours of the cities by schoolchildren and in the everyday experiences of the general urban population. The following essay focuses on the reconstruction of the Lower Palace in Vilnius, a touchstone in the peculiarly Lithuanian narrative of that city's history.[3] That historic seat of Lithuanian rulers sets the post-Communist resurgence of the Lithuanian nation and nationalism in high relief.

AN ARCHITECT OF HISTORY AT WORK ON THE PALACE RUINS

Seeking Napoleonas Kitkauskas, the architect in charge of the Palace Research Center in Vilnius, I entered a nineteenth-century czarist mansion behind the Vilnius cathedral at the very center of the city. An aide brought me into his workspace, a grand, high-ceilinged room that once had been used for formal receptions. The space was subdivided in a makeshift way. Piled on one desk, drawing table, and one set of shelves after the other were books, plans, elevations, maps, blueprints, publications, and files. Because the architect Kitkauskas was temporarily absent from his creative disarray, I left the building and entered a succession of six structures resembling aircraft hangars protecting the main archaeological excavation of the former Lower Palace. The excavated foundations presented an expanse of chambers, rooms, passageways, and vaulting roughly the size of three football fields side by side. The red translucent hangars lent this honeycombed complex a rather theatrical air, especially in places where the truncated medieval brick vaulting had been exposed. The field of ruins appeared the

1. Graphic and printed works providing the basis for a reconstruction of the Lower Palace. On display at the Lower Palace reconstruction site. Photo by Jurgita Remeityte, 2000.

result of some enormous explosion that had cleared away the superstructure to leave only cellars and foundations. One could easily understand how the incomplete site might stimulate the historical imagination.

Ascending from the excavations I found Kitkauskas standing near a peripheral dig at the bottom of the Castle Hill, which is crowned by the remnants of the Upper Castle. That castle occupies the site where Grand Duke Gediminas founded his capital city, Vilnius, in 1323. In the second century after its founding, Vilnius, as the capital of the Grand Duchy of Lithuania, would be at the center of an expanding empire that stretched from the Baltic to the Black Sea to constitute the largest territorial state in Europe. Kitkauskas stood before several new red-brick arches that abutted the historic hill and was advising masons. The face of the elderly but spry architect brightened as I expressed my curiosity about the arches. Gesturing for me to follow, he scampered up the pile of loose topsoil and sand to gain a better vantage point. He stretched his hand back to help me negotiate the loose footing of the steep ascent with leather-soled street shoes.

From this minor elevation before the Castle Hill, we surveyed the work of his master masons, who had repaired the first of several arches using a Baltic brick bonding typical for the region.[4] The arches stood perpendicular to a taller brick wall set as an abutment against the unstable base of the hill. The Lithuanian architect explained that with the application of modern engineering techniques, metal rods and concrete had been inserted deep into the hill for further stabilization. The structural remnants uncovered at this site dated from the sixteenth century and were the work of fortification builders brought from Bohemia by the grand dukes of Lithuania. Originally the abutment had protected the palace of the noble Radziwills (Radvila), which had stood within the confines of the fortified ensemble and had been attached to the grand duke's palace.

The manner in which the modern red brick of the arches extended the centuries-old coursings of gray and worn brick seemed an apt metaphor for the conjuncture of historic reconstruction and historical "revelation" that has been taking place in Vilnius. After the renewed independence of Lithuania in 1991 the "recovery of history" was propelled both by the Lithuanians' wish to "return to Europe" and the will to instantiate markers of a peculiarly Lithuanian national history in the old and new capital city. But this sort of reconstruction had already begun during the Soviet era and depended on the policies of openness, or glasnost, initiated by Gorbachev.

On March 9, 1988, the Institute of History of the Academy of Sciences in the Soviet Republic of Lithuania received a directive to carry out "systematic scientific investigations" of the Lower Palace complex. The aim was to gather material for the eventual reconstruction of this set of structures that had been so important for the history of the Grand Duchy.[5] In October of that same year Lithuanian demonstrators hoisted the yellow, green, and red national flag above the remnants of the Upper Castle for the first time since Lithuania had been incorporated into the Soviet Union in 1944. These seemingly disparate events—the excavation and projected reconstruction of the Lower Palace and the flying of the national colors—indicated the beginning of the reclamation of local history in Vilnius.

Between 1988 and 1991 the world media broadcast images of banned national banners rising above the historic towers of the Swedish Bastion in Riga, the Hermann Tower of the Toompea in Tallinn, and the western tower of the Upper Castle in Vilnius, signaling the dissolution of the Soviet Union. Shortly thereafter, dramatic newsreels showed cranes pulling down statues of Lenin from high pedestals at central locations in these Baltic

cities. Through such symbolic yet concrete and public gestures the Baltic republics in the Union began dissociating themselves from the Soviet regime and reclaiming a silently shared past. In 1987 Lithuanian independence activists took to the streets of Vilnius over the revelation of the secret protocols of the 1939 Molotov-Ribbentrop Pact that divided Poland and the Baltic States between Nazi Germany and the Soviet Union.[6] By 1988 there were larger and more frequent public demonstrations on the anniversaries of mass deportations to Siberia by the Stalin regime. A basic revelation and revaluation of history was taking place and helping to shape the post-authoritarian civic identity in cities such as Vilnius, Riga, and Tallinn. History was, in a sense, going public and becoming site-specific again. What most denizens of these cities privately knew but could not publicly express for fear of reprisals became part of accepted collective knowledge and public discussion. The national "reawakenings," which were grounded in the spread of knowledge about the past, were given impetus by such revelations.

The dramatic events themselves brought attention to the "lost" histories at the sites where they had taken place and fostered a new and open disposition toward researching the past in one's own immediate environment. This development helped undermine the official versions of history by helping to make alternative narratives of the past part of common knowledge and experience. These alternative narratives would be incorporated into new official narratives. Concomitant with this reawakening, the historic topographies of cities like Vilnius shifted as new commemorative sites and elements were inserted into the city and others were removed. At the beginning of this transformative process lies the symbolic raising of a national flag, a manner of laying claim to the city and a signal that the repressed national history and memory could now be articulated freely in public places. Throughout East-Central Europe during the late 1980s and early 1990s analogous events would take place to transform the reception of history. Such symbolic reclamation was the prelude to the physical reinscription of history into the texture of the cities themselves.

FLYING THE COLORS AND REMEMBERING HISTORY

On October 7, 1988, two years before the breakup of the Soviet Union and the declaration of Lithuania's independence, participants in a mass demonstration raised the national tricolor above the western tower on the

Castle Hill. The Lithuanian flag flying on that elevated edifice located at a historic center of the city was visible from any part of the Old Town. The site was well chosen. From the top of that tower any Vilnius resident could enjoy a sweeping overview of the historic district and could begin to comprehend the intricacies of the narrow lanes and multiple courtyards that made up the Old Town's still extant medieval texture. Visitors were usually brought to the viewing platform to get a sense of the whole city. From the elevation one easily saw the socialist periphery from this position in the historic core and could, if so disposed, compare the old and the new cities.

The viewing tower, a vertical element in vivid red brick rising above the trees of the castle mount, punctuates the urban skyline and works as a centering element if one views the city from the surrounding hills. Standing on a wooded hill near the confluence of two rivers, the Neris and the Vilnia, the tower exemplifies in its situation the way Vilnius as a whole is couched in and interpenetrates the natural landscape. The immediate surroundings of the tower hill are places of myth and history that tell of supposed underground passages and underground rivers. At the base of the hill is the significant archaeological site where Kitkauskas plans to rebuild the Lower Palace of the grand dukes of Lithuania.[7]

That edifice once stood in a walled ensemble of significant historical structures such as the cathedral and the new and old armories at the heart of the oldest part of the city. The beginnings of Christianity in Lithuania can be viewed in the excavated remains of the first church in the vaulted crypt of the cathedral. One of the armory buildings houses the fine, well-arranged archaeological exhibition of the national museum; the remnants of ancient Lithuania are now gathered in one place.[8] Adjacent to the cathedral another armory building built in the strict neoclassicism of French revolutionary architecture now offers an exhibition of documents and photographs showing the historical and most recent struggle of Lithuanian patriots against oppression by the Soviet Union.[9] The reconstructed armories are part of an ensemble of buildings rebuilt during the late period of the Soviet Union as an extensive museum landscape.[10]

Above this landscape rises the western tower of the Upper Castle, which has been rebuilt several times but still rests on the original remains of the castle Gediminas built. According to legend, Grand Duke Gediminas decided to found his city here, after a dream in which he saw an iron wolf howling with the voices of a hundred wolves. A pagan high priest inter-

2. Projected reconstruction of the Lower Palace complex in Vilnius
by Napoleonas Kitkauskas. Photo by Jurgita Remeityte, 2000.

preted the dream to mean "that the fame of the city which he was to found
as his capital would spread as far as the voice of the wolf."[11] The Lithuanian
(later the Lithuanian-Polish) dynasties that ruled from here would even-
tually control one of the most powerful medieval-Renaissance states in
Europe. From the residential Lower Palace that had stood at the bottom of
the hill, a succession of grand dukes of Lithuania wrote letters to all the
courts of Europe, and they intermarried with Polish, Swedish, and Italian
nobility. The rulers of the Polish-Lithuanian state patronized the music,
art, and architecture of a broader European culture, and they produced
their own local culture here as well. Together the architectural ensemble of
the Upper Castle, the palace excavations, the cathedral, and the rebuilt
armories form a constellation of cultural-historical landmarks of great
significance for the new Lithuanian state. Since the breakup of the Soviet
Union this historic configuration has been constantly augmented and
transformed.

By occupying the tower situated above and at the center of this historic

constellation in 1988, demonstrators sent a clear signal about political and historical change. "By established tradition it [the tower] is . . . the place where the visible symbol of the ruling power is displayed."[12] Most of the activists who raised the flag must have understood at least a few of its historical implications, for these had been transmitted through local lore as well as official histories. To mark this center or appropriate it, even temporarily, as a national site was to regenerate a series of historic meanings for the city as a whole and to manifest authority. One cannot say which set of historical associations were conjured up in the minds of the tens of thousands who gathered before the tower in 1988, but certainly along with their patriotic feelings their historical imaginations came into play. The reoccupation of the site would be a thoroughly national one, although Vilnius had been until World War II a truly multicultural city of Poles, Jews, Karaites, Tatars, Russians, Byelorussians, and Lithuanians—a fact well noted by Vilnius natives and writers Czesław Miłosz and Tomas Vençlova.[13]

For Lithuanians there had been too much symbolic, imaginary, and historical investment in this site not to understand the signal given by the hoisting of their national banner. One can be relatively certain that most demonstrators had climbed to the top of the tower to view their city—thus taking possession of it with their eyes. So, in a sense, raising the flag at that point became a self-reflexive act that both confirmed their knowledge of the site and freed their imagination to take over the city.[14] Moreover this action, experienced in the company of tens of thousands of other Lithuanians in a public place, expanded individual memories into a collective one at a particular moment of national history. The museum exhibitions about Lithuanian prehistory and history, as well as the projected reconstructions, respond to that act and to the significance of the site.

Such ephemeral but memorable events inaugurated numerous permanent changes in the historical topography of Vilnius during the next ten years. These included removals, recoveries, restorations, reconstructions, and reorganizations of historical markers and monuments. If the original images of the dramatic beginnings to this revision "belong to history," still their effects remain and lend impetus to the restructuring and reevaluation of the city. For instance, in the Cathedral Square adjacent to the Lower Palace excavation a statue of King Gediminas has been erected, while in another central square of the city formerly named after Lenin, not a trace of his likeness remains. Gediminas replaces Lenin. One projection of the state's history replaces another. The vast difference between the two repre-

sentations lies in their historical relation to place. Lenin and Gediminas refer to different narratives of history, one abstract and imposed from the outside, the other site-specific with a firm footing in the structure and material of place. There are many, many other examples of this transformation. The founding of a Jewish museum, the erection of monuments to the Lithuanian resistance, and the dedication of a museum to the Lithuanian genocide (not the Jewish) are among them. Like the story of the Lower Palace, each of these new public displays of history presents a complicated story of public and private, official and unofficial, individual and collective engagement in the recuperation of historical meanings associated with the city.

THE MEANING OF HISTORICAL RECONSTRUCTION

The architect charged with reconstructing the Lower Palace, Kitkauskas, subscribes to a site-specific reconstruction of historical structures and to the replication of all lost historical details. The grand dukes built this edifice in the sixteenth century as the central residence for rulers of a state whose territories extended far beyond the borders of contemporary Lithuania and whose subjects were in a small minority Lithuanian. During the siege of Vilnius by the Muscovite army in 1655 the palace was partially destroyed. After Vilnius was integrated into the Russian Empire (1795), the dilapidated remains were torn down in 1800–1801. At that time the remains of the old city walls and towers, as well as the nearby bishop's palace, were removed. Reconstructing the grand duke's palace would seem to physically and symbolically reverse the Russian incursions into the city and to recall the period before the rule of the Russian Empire (1795–1917), the Polish Republic (1921–1939), and the Soviet Union (1944–1991). In a contemporary Lithuanian understanding of national history the palace may be understood as a link to the history of the city beyond the interregnum of foreign nations (recalling the period of the Lithuanian-Polish Commonwealth) and to the very origins of the city itself. This curious historical projection and the actual physical character of the palace raise questions about the project.

Based on exhaustive research, Kitkauskas designed a scale model of the Lower Palace complex, which is displayed in an exhibition room of the Russian mansion that will be torn down to make way for the planned reconstruction. The model provides only an approximation of the historic

structure based on a variety of sources, principally prints, drawings, and watercolors from the eighteenth century and from the early nineteenth. No actual architectural plans for the palace have survived. These pictorial works provide a fairly exacting sense of the building's general structure especially of the southern and eastern facades. Some of the details such as window embrasures, keystones, entablatures, architectural moldings, and profiles can be reconstructed from the architectural remnants found during the excavations. But because of the limited documentation and because the palace was repeatedly renovated and restored during its history, many details in any reconstruction would be left to a creative historical imagination. For the configuration of structures such as the interior facades of the interior courtyards, Kitkauskas draws analogies to contemporary structures in Vilnius and elsewhere, including the Wawel Castle in Kraków. He wrote his dissertation on the castle complex and is, without a doubt, the foremost expert on its structural components. From his demeanor and openness he appears an honest reconstructeur of the bygone, but he lacks sufficient documentation to eliminate numerous doubts about the correspondence between the reconstruction and the original.

Nonetheless, the three main proponents and protagonists of the reconstruction—Kitkauskas; the archaeologist Vytautas Ubanividus; and the Lithuanian-American head of the castle restoration society, Edmundas Kulikauskas—are bent on rebuilding a potent national symbol on its remnants.[15] Though both the architect and the archaeologist emphasize the need for preserving the "authentic" archaeological remains and allowing public access to them, neither is quite sure how that might be effected if the "replica" of the Lower Palace they project were to be rebuilt. According to them they have decided to rebuild, employing all available "iconographic"[16] materials and remnants, which will be exposed and perhaps incorporated into the facade. These would include original limestone frames of some windows, carved stone architectural reliefs, and heraldry. Their work in gathering the remains is impressive. And it is true that the cell-like divisions of the remnant foundations offer a good idea of the palace's architectural footprint. From the foundations one can estimate the height and girth of the former walls. But despite the full professionalism and utmost care given to researching each detail of the remnant palace, only the southern and eastern facades can be reconstructed with any degree of certainty from relatively detailed pictorial renderings that have survived. For the rest of reconstruction a very informed guesswork

3. Ground plan of the Lower Palace complex with Vilnius Cathedral at upper left. Photo by Jurgita Remeityte, 2000.

4. Various drawings of the Lower Palace archaeological site in Vilnius, a dramatic setting for a restaging of Lithuanian history. Photo by Jurgita Remeityte, 2000.

will play the largest role. The question becomes whether such a crucial structure at the cultural and historic center of a nation should be reconstructed in a way that may prove to be inauthentic should new documents or evidence be found.

There are, however, aesthetic and urban design grounds for reconstruction; it would give closure to the architectural ensemble extending in a semicircle around the base of the Gediminas hill. The building might have a positive influence on further development in the Old Town, because of its respect for scale, proportion, and a conceptualization of architecture as part of the larger urban texture. The historical reasons for a reconstruction down to the imagined details are less convincing.

Kitkauskas hinted at one element of his historical reasoning when he suggested how the excavations in the area had turned up masonry remains predating the assumptions by Polish historians about when Lithuanians had first employed masonry techniques. The findings refuted assumptions by a Polish historian of the interwar period at Stephan Batory University (now Vilnius University), who had perhaps wanted to credit the Poles with bringing civilization to Lithuania.[17] If rebuilding the palace seemed to be a reversal of the effects of Russian domination—which had erased Lithuanian-Polish history in place and destroyed historical monuments erected since the partition of the Lithuanian-Polish Commonwealth—it also seemed to offer a historical example predating the dominance of Polish culture in the city, which had lasted from the second half of the sixteenth century until the 1940s.[18] Poles made up a majority of the prewar population of Vilnius. A third of the population was Jewish, and their history lies elsewhere in the city at the site of the destroyed Great Synagogue, in the eradicated Jewish quarters, and at the site of the oldest Jewish cemetery, where a sport complex now stands. Lithuanians were a small minority. The Lower Palace represented the center of politics and culture in the Grand Duchy, whose Lithuanian grand dukes ruled from this site before the Union of Lublin in 1569, which united Poland and Lithuania in a commonwealth and led to a Polonization of the Lithuanian social elites. Rebuilding the palace might firm up the center of Lithuanian historic presence in the city against the background of Soviet, Polish, and Russian imperial suppression of Lithuanian culture.

A second contemporary reason for rebuilding is implicit. The post-Soviet national awakening betrays traces of anti-Russian, anti-Soviet, and anti-Polish sentiment.[19] These sentiments appear in the way contemporary

Lithuanians are selecting and adopting a heritage in Vilnius.[20] What had originally been an archaeology of the "local" in resistance against the universalist, or indeed global, Soviet-socialist version of history has now become a means of securing the national precedence in place. This understanding of the projected reconstruction also militates against a modernist, international-style building on the site of the Lower Palace, which might not convey the specific history and culture of the city. Both Ubanivicius and Kitkauskas hope the reconstructed palace will be filled with period rooms displaying the artistic and cultural achievements of Lithuania during different eras. The reconstruction was originally intended to be the residence of the Lithuanian president, reclaiming its place as the residence of Lithuania's rulers.[21]

STAGING THE BELATED NATION

Lithuanian art and cultural historian Jurate Markeviciene sees another reason for the replication of historical substance at the palace grounds and elsewhere in the city: the incomplete project of a Lithuanian nation.[22] She sees the palace reconstruction as related to the romanticism and historicism typical of emerging nations during the nineteenth century. In the case of Kitkauskas, who suffered under the Soviets, or Kulikauskas, who returned from exile, there must be also a sense of loss or nostalgia mixed with this romanticism. Only late in their lives could they see their idea of a Lithuanian nation take shape. This idea of a belated nation certainly conforms to a reaction against the cultural hegemony of the Poles and the political domination of the Russians over the centuries.

Yet as Czesław Miłosz has recently suggested in an essay about the recurrence of nationalism in Vilnius, if we try to understand the palace in any purely national-ethnic manner, we may fall prey to semantic misunderstandings.[23] In the contemporary context of national formation, the Lithuanians are extending their *own* history back into time and establishing a type of genealogy of place. Vilnius, which is now the capital of the Lithuanian Republic, is understood as the successor of the Vilnius that was the capital of the Grand Duchy of Lithuania. That state spread from the Baltic to the Black Sea and was a multiethnic state, whose official administrative languages were Old Ruthenian or Old Belarusian, Latin, and eventually Polish (not Lithuanian). Unlike the modern Catholic Lithuanian nation, the chief religion in that multicultural state was Eastern Orthodox

Christianity. There is certainly nothing that forbids the contemporary Lithuanian state and people from claiming the legacy of that historic state, although most contemporary nationalists would prefer to overlook its languages, its multiethnic character, and even its dominant religion.

The ideology of a purely Lithuanian Vilnius derives from this severely delimited understanding of the historic "predecessor" to the contemporary state. The narrow image of a historic Vilnius and Lithuania was nourished by the propaganda fed young Lithuanians in that first modern and independent Lithuania that formed after World War I. During the interwar years the schools of that Lithuanian state taught a generation of Lithuanians to think of Vilnius as their historic and rightful capital. The journalist Birutė Mackonytė noted how young Lithuanians sang songs and recited poems about Vilnius during that period.[24] It is true that a newly reconstituted Poland had illegally annexed the city and its region in 1920. But the historic core land of Lithuanian culture, Vilnius and the regions around it, were largely populated at that time by two distinct and separate cultures, the Poles and the Jews.[25] The Lithuanians made up only the smallest part of the population until the mass murder and deportations associated with World War II and its aftermath changed this situation.[26]

Vilnius was only "returned" to the Lithuanians by the Soviet Union for a short period after the division of land according to the protocols of the Molotov-Ribbentrop pact with Nazi Germany.[27] To cite Miłosz again: "After the division of Poland between Hitler and Stalin many young Lithuanians came to Vilnius. They had to notice, the image of a Lithuanian Vilnius that had been conveyed in lessons at school did not correspond to reality. For Lithuanians only made up a small percentage of the population of the city."[28] Vilnius thus became the capital of Lithuania after a massive "ethnic cleansing" perpetrated largely by the Soviet Russians and Nazi Germans but also with some aid from the Lithuanians themselves.[29] This is a fact of history. That Vilnius is now the capital of a modern and democratic Lithuania is also a fact. The stark disjuncture between the city's past and its present is largely ignored in the current historical revival, which emphasizes the Lithuanian origins and "nature" of the city.

As a capital city Vilnius must represent the nation, and that nation is composed, in its vast majority, of Lithuanians. Generally, capitals are the centers of nations and bear the onus of having to represent the character, the history, and the values of a particular national or ethnic group. National historical representation in major monuments, resounding street

names, heroic cemeteries, and monumental representative edifices hous-
ing governing bodies are concentrated in such capitals. As the embodiment
of the nation, such cities are burdened with the need to display national
symbolism, to host state ritual events in appropriate settings, and to pres-
ent an official history in monuments, museums, and other ways exemplify-
ing the national virtues. All the historical elements of the nation, the
founding fathers, the wars of resistance and liberation fought and won, the
heroes who have sacrificed themselves for the nation, the sufferings under
an oppressive other, and the historic statesmen and others who have con-
tributed to the nation have to be brought together in the capital city to
define its historical topography in a way that conforms with national-
political and national-cultural representation. It is under these constric-
tions that one official narrative replaces another in Vilnius.

This may or may not relate to the city per se and may actually work
toward obscuring any local or pluralistic aspect of the local history. Whether
democratic, socialist, or nationalist, the ideology of state veils local circum-
stance and history. The history of a nation simply trumps that of a city. And
official national history inscribed into a capital city tends to be univocal and
seeks to provide a centering image; this is especially true in the case where a
singular ethnicity monopolizes such official representations as in Vilnius. In
the Latvian Riga the Latvians are historically defining their national capital
city without the participation of the majority of Russians who reside there.[30]
In Ukrainian Lviv it is very difficult to note the past hegemony of Polish
culture in that city without offending national sensitivities. In Vilnius the
need to define, claim, and legitimate a current ethnic-cultural hegemony
allied with a national state derives additional impetus from the memory of
how the Russian Empire, the Soviet Union, and Poland suppressed national
cultural expression and development. The need to represent or "invent" the
national and indigenous in the capital city disallows any concessions to the
"foreign" or multicultural. Such tendencies are underlined in Vilnius, whose
historical character is extremely multifaceted and therefore open to histor-
ical claims from the Poles, Jews, and Byelorussians, as well as from Ortho-
dox Christians. The capital city is burdened with the need to carry the whole
history of the nation, which is by definition translocal and idealizing so that
capitals tend toward the symbolic and legendary types of representation.

The national symbolism and pattern of political legitimization that
might be mediated by the palace is contradicted strongly by another aspect
that Kitkauskas and his colleagues themselves emphasize. The cultural

import of the Lower Palace firmly situates Lithuania within a (Western) European culture. It was no doubt the result of cooperation among many European cultures at work in the city: Italian architects, Bohemian military engineers, Dutch and German craftsmen, as well as indigenous artisans and builders. The rich finds in painted tiles showing common European mythological and folkloristic scenes or showing men and women in sixteenth-century period costume, the architectural fragments in natural stone bearing the coats of arms of European aristocratic houses including the Wasa kings of Sweden, the window casings and cornices that remind of the palace's relationship to the Wawel in Kraków give us a sense of the palace's place in an international culture of its time. The weapon fragments, metal locks, and latches, as well as the minting tools, relate it to the contemporary level of technological development. One cannot dismiss a certain enthusiasm for the exposure of European history—albeit fragmentary—in place. Kitkauskas was magisterial in his presentation of these objects on display while waving a small wooden pointer in an agitated fashion. Yet the project of rebuilding the Lower Palace has not been one to expose the fundament of Vilnius as a city of multiple cultures, religions, and nations.

Ubanivicius, the chief archaeologist at the site of the Lower Palace, clearly emphasizes the national political implications. In an interview he noted that Catherine II of Russia had leveled the structure and that only very late in the Soviet period had permission been given to excavate the site. He outlined the prospective schedule of reconstruction. The first stage, which involves the installation of climatic controls to preserve the archaeological remains, took place in 2003 on the 750th anniversary of the crowning of Mindaugas, the legendary king and first state builder of Lithuania. The second stage, which will involve the completion of the reconstruction, will take place in 2009 to coincide with the first mention of Lithuania in the history books. According to Ubanivicius one should recreate as meticulously as possible the plan, spaces, interiors, and embellishments of the building and only then talk about its functions. He saw no conflict between the need to establish the historical authority of a new nation and state and the authenticity of historic representation.

The site is already being used for public performances of music, dance, and drama. Edmundas Kulikauskas, the Lithuanian-American returnee who heads the castle restoration society, invited me to a historic costume play in the actual remains of the Lower Palace. Bleachers set up on one side

5. One of four airplane hangars protecting the archaeological excavations of the Lower Palace. Photo by Jurgita Remeityte, 2000.

of the excavation allowed a fine view of a stage composed of elements from various historical eras. The remnant structure lent atmosphere to the performance. The stage lighting produced stark contrasts as it illuminated only a limited area, leaving many crevices, passages, and cellar rooms illuminated partially or not at all. On a stone wall at the front of this Piranesi-like complex of ruins perched the stoutly impressive figure of Professor Alfredas Bumblauskas, who served as the storyteller. Wearing a modern suit and wiping his forehead in the heat, Bumblauskas, a professor of history at Vilnius University, and a well-known television personality in Lithuania, recited stories from the early history of the Lithuanian Grand Duchy. At the appropriate cues, actors representing the historic personages emerged from the darkness into the illuminated center stage. Each vignette was accompanied by period music and dance and was performed by well-known choral groups and dancers outfitted in period costumes.

The performance at a historic site was extremely effective and affective. After all, the palace ruins and their immediate environment were the real-life settings for most of those historic scenes. This curious public rendering of a singular strand in the complex weave of Vilnius's past exemplifies the appropriation or construction of a historical genealogy by a people and a nation in place. The reconstructed palace will be part of this project to

compose a national history associated with a specific place, and it will add one aspect to a whole constellation of commemorative devices—monuments, street names, museums, and designated historic sites—that are being used to help engender a place-based identity for the Lithuanians that stands both with history and against it.

On the modern stage of the city beyond the ancient palace confines there are conspicuous absences—the Jews, Poles, Russians, and Eastern Orthodox Christians who helped shape Vilnius but have been relegated to the status of historical "other." In light of those absences the question that constantly poses itself—not only in Vilnius but in Riga, Lviv, Gdansk, Prague, and many other cities of the formerly Communist regions of Europe, as well—is how one could incorporate those historical others. They represented the multiethnic, multireligious, and multilingual character of the cities, now defined so starkly by a resurgence of long suppressed ethnic and national narratives of their current inhabitants. The Lower Palace reconstruction in the context of a Lithuanian national revival remains a suspect venture seen in this context, though it may seem to fulfill a legitimate contemporary need of the Lithuanians to have strong recourse to their own history in their contemporary capital city after a long history of oppression. The reconstruction remains suspect because it appears to follow a pattern of exclusion, appropriation, and legitimization through an instrumentalization of history. Putting the nation too firmly into place in Vilnius means denying both the conflicted richness of its past and the future possibility of fostering tolerance for others through a stark public awareness of the city's multiple histories.

NOTES

I would like to thank Lisa Maya Knauer, Daniel J. Walkowitz, and Skaidra Trilupaityte for their comments and corrections to earlier versions of this text.

1. Before World War II Vilnius was a center of Jewish culture, learning, and political activism in Central Europe. Many Jews referred to Vilnius, with its influential rabbis, Enlightenment, Zionist, and Bund movements, as the "Jerusalem of the North." It was here that the famous YIVO Institute was located.

2. This is a loose paraphrase of the National Historic Preservation Act of 1966 of the United States.

3. The terms *palace* and *castle* are used inconsistently in referring to this historic structure. For the sake of consistency I will refer to the structure as a palace, though at the earliest stages in its development it might be better termed a castle. The

fortified complex of which the palace is an integral part also complicates the designation. However, it is the sixteenth-century version of the palace that is now being rebuilt.

4. An interchanging bond of two stretchers and one header.

5. Napoleonas Kitkauskas, *Vilniaus Žemutines Pilies Rūmai* (Vilnius: Lietuvos Mokslu akademijos Istorijos institutas, 1989), 111.

6. On Aug. 23, 1987, an unsanctioned meeting denouncing the secret protocol was held at the monument to Adam Michiewicz in Vilnius. The meeting was organized by the dissidents Vytautas Bogusis, Petras Cidzikas, Hijole Sadunaite, and Antanas Terleckas. See Zilinsaite, *Lietuvos laisves sajudis*, 10.

7. It is interesting to note the frequency of historical names in these actors. Napoleonas = Napoleon, a curious name for someone living in a country under Soviet-Russian domination. Vytautus (the Great) was one of the grand dukes of Lithuania, who together with King Jagiello of Poland defeated the Teutonic knights. The head of the Old Town Revitalization Agency, Gediminas Ruttkauskas, is named after the founder of Vilnius.

8. *Prehistoric Lithuania: Archaeology Exposition Guide* (Vilnius: National Museum of Lithuania, 2000).

9. *Lietuvos laisvės sajūdis / The Lithuanian Freedom Movement* (Vilnius: National Museum of Lithuania, 1998).

10. The Vilnius palace complex consists of the Old Arsenal and the New Arsenal, where the general historical exhibition of the Lithuanian National Museum is on display. The New Arsenal retained its strict revolutionary classical facade since its building in the nineteenth century. In 1960–65 the architect S. Lasavickas and the engineer N. Kitkauskas restored the New Arsenal and transformed its interior into exhibition halls for a museum. Since 1968 the National Museum of Lithuania has occupied the building with traveling exhibitions, as well as ones of its permanent collections. The eastern building in the Old Arsenal complex was the object of archaeological research from 1972 until 1984. In 1987 the architect E. Purlys refurbished the eastern building of the tripartite ensemble, and it opened as the Museum of Applied Arts. Archaeological investigations were undertaken on the northern and western buildings beginning in 1984. In 1997 the architect V. Paulauskaite restored these buildings. The museum exhibition "Prehistoric Lithuania" opened in 1997 in the northern building, and the western building now houses the museum administration. I want to thank Zygintal Bucys of the National Museum of Lithuania for this information.

11. Zukas, *Lithuania: Past, Culture, Present*, 110.

12. *Lituvos Valstybine Veliava Gedimino Kalne* [The Lithuanian State Flag on the Gediminas Hill] (Vilnius: Lithuanian National Museum, 1998).

13. See Miłosz, "Dialogue about Wilno with Tomas Vençlova."

14. For a very suggestive reading of such "imaginations" see Roland Barthes, "The Eiffel Tower."

15. I interviewed planners, engineers, and architects working on the reconstruction in late May and early June 2000 in Vilnius.

16. Those working at the site frequently used this term to mean "extant architectural details and pictorial materials."

17. Kitkauskas was referring to the book by Juljusz Kłos, a professor at Vilnius University in the interwar period (*Wilno: Wydawn. Oddzialu Wilenskiego Polska*) [Wilno: Tow. Krajoznawczego z zapomogi Ministerstwa W.R. i O.P., 1923]).

18. This is said with the awareness that "Polish culture" was a culture of aristocrats and magnates, who had little in common with the peasants and simple town folk, whether they spoke Polish or any other language.

19. These are considered the foreign rulers of the Lithuanian capital.

20. For a discussion of the anti-Polish sentiments see Snyder, *The Reconstruction of Nations*.

21. The president now resides in the building in which the Russian governor general resided during the nineteenth century.

22. Jurate Markeviciene, interview by author, Vilnius, June 10, 2000.

23. *Frankfurter Allgemeine Zeitung*, Oct. 21, 2000, Bilder und Zeiten. Page I.1)

24. Birutė Mackonytė, interview by author, Vilnius, June 12, 2000. Her father, who taught at the only Lithuanian secondary school in the city, was an extreme nationalist and was arrested by all the various regimes that ruled in the city. He was in opposition until there was an independent Lithuania with Vilnius as its capital.

25. Here exactly whether the local Poles in the countryside were more Belarusians or spoke a correct Polish or even understood themselves so thoroughly as Poles is another question. In any case they spoke a Slavic language quite distinct from Lithuanian.

26. The ethnic cleansing and mass murder associated with that war, crimes in which radical elements in the Lithuanian population took part, are part of the history of the city that is not ignored. Yet the public recognition of the crimes is very limited and remains obscured by the correct Lithuanian understanding of themselves as victims of various historical regimes. Private organizations such as the Center for the Study of the Holocaust and Jewish Culture in Lithuania (Holokausto ir zydu kulturos Lietuvoje studiju centras), directed by Linas Lildziunas, Marina Vildziuniene, and Egle Pranckuniene, do, however, show an understanding among parts of the population that this past must be articulated and confronted.

27. On Aug. 23, 1939, von Ribbentrop and Molotov signed the secret protocol to the Nazi-Soviet Pact that divided Poland, the Baltic lands, and parts of Romania between them. Both sides decided that Vilnius would be separated from Poland and given to Lithuania. On Oct. 10, 1939, the Soviet government agreed to cede the Vilnius region to Lithuania, which had remained neutral in the war. Lithuanian troops entered the city triumphantly on Oct. 28, 1939, but the occupation proved short-lived as the Soviet Socialist Republic of Lithuania was declared on Aug. 3, 1940, forcibly integrating Lithuania and Vilnius into the Soviet Union. On June 22, 1941,

German troops entered Vilnius, and the city was taken from them on July 13, 1944, by the Red Army. In May of 1945 the Socialist Republic of Lithuania was reestablished.

28. Miłosz, "Dialogue about Wilno with Tomas Vençlova."

29. The participation of Lithuanian collaborators in the detention and mass murder of Jews in Lithuania and Vilnius is still not well articulated in public places. On the facade of the courthouse containing "The Museum of Genocide"—i.e., the genocide perpetrated against the Lithuanians—the names of Lithuanians who died in the insurgency against the Soviet Union are inscribed in the individual stones of the building. As Linas Vilziunas, editor of the weekly *7 Meno Dienos*, told me (interview, Vilnius, June 8, Vilnius) in the offices of a Holocaust and Jewish-Lithuanian study center, some of these heroes of the Lithuanian resistance against the Soviets may have been at the same time Nazi collaborators who cooperated or took active part in the eradication of the Jewish communities in Lithuania.

30. Russians make up approximately 60 percent of the population in Riga.

MEMORY SITES:

Marked and Unmarked

■ Landscapes are potent sources of individual and collective memory. However, as the three essays in this section illustrate, there is nothing "natural" about the ways in which the physical evidence of past trauma is interpreted, which sites are sacralized, and whose memories are legitimated. If remembering is a social and often highly politicized process, so, too, is forgetting. Varying political currents may reclaim and reposition obscure episodes from the distant past or move attention away from sites of recent traumas (if not actually erase them).

Very often, in divisive civil conflicts such as those that took place in Latin and Central America in the 1970s and 1980s, social peace is achieved at the price of certain memories. Gruesome events such as massacres and torture are downplayed or portrayed as unfortunate aberrations, and witnesses and survivors are made to understand, in so many ways, that they should put the past behind them. In Chile, the subject of Teresa Meade's essay, an eerie silence surrounds the atrocities committed during the Pinochet dictatorship—as well as the very existence of the Allende government, which was toppled by Pinochet. These silences are paralleled by the incomplete and muted markings of the sites that correspond to those histories—the palace where the coup took place, torture chambers, or graves of iconic figures such as singer Victor Jara. In countries, like Chile, that are struggling to rebuild their economies and find a new foothold in a shifting world system, development policies (structural adjustment or tourist development) can also be effective tools in disciplining oppositional voices.

Sometimes more direct means are employed, as in El Salvador's Chalatenango Province, discussed by Irina Carlota Silber. After the peace accords were signed, the continued presence of both U.S. and Salvadoran military in a region that saw some of the largest and most brutal civilian massacres is a not-so-subtle reminder of the fragility of the peace and the systemic inequalities that helped produce the decades-long conflict and still shape the lives of Salvadoran peasants. However, in both Meade's and Silber's analyses the hegemonic versions can never be complete so long as there are witnesses and survivors who can provide counternarratives.

In both instances the events and sites belong to the recent past but also to a time when nation building had been completed. In Israel, however, the nation is of more recent vintage, and its boundaries and character are still contested. Yael Zerubavel looks at how an almost-forgotten episode of Jewish history, a mass suicide at the Masada fortress, was retrieved and imbued with new meaning in furtherance of the Zionist nation-building project. While many of the memory sites in Chile or Chalatenango may remain invisible to the casual visitor, Masada, by contrast, is nearly unavoidable since it figures heavily in the Israeli government's educational and tourist development programs.

HOLDING THE JUNTA ACCOUNTABLE

Chile's "Sitios de Memoria" and the History

of Torture, Disappearance, and Death

Teresa Meade

Under the banner headline "Unexpected Vistas in Chile" the travel section of the Sunday *New York Times* sought to lure both the adventurous and the sedate to a country of fabulous mountain resorts, lush rainforests, health spas, fine wines, and European-like cities. Nonetheless, Chile's association with military rule and the fame of its ex-dictator, Augusto Pinochet, were considered well enough known to the informed tourist to merit oblique references in several of the featured articles. Inserted in Edward Hower's piece on studying Spanish and living in Chile's capital city of Santiago, right after his account of a night enjoying folk music in the clubs but before his description of his walk among the wealthy mausoleums in the aristocratic section of the municipal cemetery, is a description of the "memorial that has been erected to those who were executed and 'disappeared' during General Pinochet's dictatorship. On a slab of white stone about three stories tall, several thousand names are inscribed."[1] Hower writes little more about the wall, except to point to it as a place where Chileans commemorate their troubled past and to compare it with the Vietnam Veterans Memorial wall in Washington, D.C. In a separate travel piece on the hot springs and health resorts of central Chile, Annick Smith comments: "My companion, Bill, drove while I navigated, both of us a bit frightened, for we were venturing down a foreign road in a country a mere handful of years beyond police-state status, and had only a rudimentary knowledge of the Spanish language."[2] Their fears were unfounded, we discover, as they explored lovely spas and peaceful rural towns in the shadow of the Andean peaks.

If Chile's transition from dictatorship to democracy bears mentioning among the well-photographed articles enticing tourists to its luscious rainforests, endless beaches, and ski resorts, one would presume that an appraisal of the historic events of the 1970s and 1980s infuses the national consciousness. However, a closer look at the way Chile is constructing the

memory of the military period and portraying in museums and national markers the recent history of human rights abuses reveals a deeply contradictory and tentative historical account.

From 1973 until 1990 Chile endured one of Latin America's most repressive military governments. Then in 1990, lulled into allowing a referendum on his future as president because he was convinced the electorate would keep him, General Augusto Pinochet instead found himself voted out of office. The 1990s marked the beginning of Chile's transition from dictatorship to democracy, as thousands of exiles returned from their years of asylum in Europe, Canada, and the United States, and a coalition of Christian Democrats, Socialists, and other parties came to power in a government called the *Concertación*. Throughout the 1990s a Christian Democrat held the presidency, but in January 2000 Chile's transition entered a new phase with the election of Socialist Party candidate Ricardo Lagos to the presidency and leadership of the *Concertación*. Although the first Socialist to win the presidency since Salvador Allende's victory in 1970, Lagos ran on a platform of moderate reforms more similar to European social democracy than Allende's *Unidad Popular* (Popular Unity) socialism.

Chile's center-left democracy that seeks to blend free-market economics with increased spending on social programs is something of a political and economic laboratory. This uneasy balance between reconciling the goals of Allende's democratic socialism with Pinochet's brutal neoliberalism hangs precariously in the political arena and infuses the current debate over public history, especially the extent to which martyrs of the dictatorship should be remembered and how. Beginning in the early 1990s, the democratic government erected a number of historical markers, called *sitios de memoria* (memory sites), to remember those who had suffered and died under the military's rule. These memory sites are public monuments, memorials, and parks that commemorate, pay homage to, and seek to place into the public record the memory of the thousands of people who were disappeared, tortured, and killed after General Pinochet seized power on September 11, 1973.[3]

While pointing to the horrors of the military era from 1973 to 1990, the memory sites nonetheless exist within a society that has not reached any form of reconciliation with the dictatorship or held accountable those who carried out its most egregious acts of violence. Similar to the preserved concentration camps in Germany or the opening of Robben Island in South Africa, Chile's memory sites demonstrate the cost in lives and hu-

man suffering of antidemocratic and dictatorial regimes. As opposed to postwar Germany and postapartheid South Africa, however, Chile has had few trials of its war criminals and the public airing of past human rights violations contained in the National Commission on Truth and Reconciliation (Rettig Commission) resulted in the conviction of only General Manuel Contreras Sepúlveda for the 1976 assassination of the *Unidad Popular* minister Orlando Letelier in Washington, D.C. Military leaders and members of the Pinochet dictatorship enjoy a self-declared amnesty; the doctors who assisted the military torturers continue to practice medicine; the camp guards, military officers, and functionaries of the torture apparatus live in Chile, most drawing hefty military pensions for their years of service to the *patria* (fatherland). Events of the recent past, especially the arrest in England and attempted extradition to Spain of General Pinochet to stand trial for human rights violations, and the election of Socialist Ricardo Lagos to the presidency of Chile, hold out hope that Chilean courts will be forced to hear the many accusations against torturers. In the wake of Pinochet's return to Chile, charges have been brought against several military junta members, although it remains to be seen if they will be convicted and punished.[4] The memory sites thus exist as monuments to the contradictions of Chilean society and to the fragility of its democracy.

Foremost among the sites is Villa Grimaldi, an old villa on the edge of Chile's capital city of Santiago, which the military transformed into a major torture center from 1974 to 1978. About five thousand prisoners passed through Villa Grimaldi, and it is known that 240 of them were killed or disappeared. In 1995 Villa Grimaldi was commemorated as "Peace Park" and stands today as the only memorial of torture in Latin America. Whereas in Argentina there have been trials and convictions of members of the military who carried out the "Dirty War" that resulted in the death, disappearance, and torture of thousands from 1974 to 1983, there is no preserved site one can visit to learn about the torture methods.[5] By contrast, in Chile Villa Grimaldi stands as a remembrance of what the torturers did, while the members of the military government enjoy an amnesty from conviction for any crimes committed during the dictatorship. In addition to Villa Grimaldi there are other monuments in the Santiago General Cemetery, including "The Memorial for the Disappeared"; "Patio 29," a potter's field in the rear of the cemetery where bodies were dumped by the military government, buried in graves marked "NN" for *no nombre* (no name); the grave of Victor Jara, the well-known folksinger and early

1. The main house of Villa Grimaldi, Santiago. "Cuartel Terranova"
was the military code name assigned to the torture center. This photo was
taken on July 18, 1978, during the United Nations Human Rights Commis-
sion visit to Chile. In 1992 Pedro Matta found it in a box of old photographs
at the Archives of the Vicaria de la Solidaridad. Used with permission of
Pedro Alejandro Matta.

martyr of the dictatorship; and, finally, the monument and tomb for for-
mer president Salvador Allende Gossens and his family.[6]

Although the memory sites are open to the public, without an informed
guide it is questionable that the average international tourist, or even
Chilean resident, could learn much history from visiting them. As such,
the current democratic government has fulfilled an obligation to com-
memorate the memory of the victims of the military regime, but it has not
stepped into the volatile territory of drawing lessons from the brutality and
human rights violations that regime carried out. To take the next step—to
provide informed comments at the sites, to make available pamphlets or
audio guides that explained what the military had done—would move
toward assigning blame to the Pinochet government, something that to
date has been approached gingerly in Chile, but has been attempted by the
Spanish magistrate, Baltasar Garzón. Indeed, Judge Garzón's failed effort
to extradite Pinochet from England to stand trial in Spain for the torture
and murder of Spanish citizens who were in Chile during the military
government was opposed by the Chilean government. If the move to

prosecute the torturers in Chile has been halting thus far, the steps to commemorate the victims of torture and death have not set a much faster pace. The moderate *Concertación* government has provided for some remembrance for the families of the disappeared, killed, and tortured but has so far refused to follow up with the educational materials that would encase the existence of torture into the historic memory of Chileans. Many Chileans, one might argue, are content to remain oblivious to the excesses of the military era. Ironically, most of the well-known monuments to the disappeared and to the Allende government are in a cemetery, a place that marks dead memories.

My tour of these memory sites was conducted by Pedro Matta, a former student leader in the 1970s when he was in the law school of the University of Chile, Santiago, and a member of the Socialist Youth (the youth wing of the Socialist Party). Matta had worked for two years after the coup with a number of clandestine groups attempting to rebuild student, trade union, peasant, and community organizations destroyed in the military repression. In May 1975 he was arrested and held in Villa Grimaldi and other detention centers, first as a "disappeared" person (whereabouts unknown and arrest unacknowledged) and later as a recognized political prisoner (but never charged). Thirteen months later, in July 1976, he was released and granted asylum in the United States. After more than a decade in New York and California Matta returned to Chile, where, as a leader of the National Organization of Ex-Political Prisoners, he devotes his time to building the memory sites as recognized locales in Chile. Reconstructing the history of the torture centers, conducting investigations into the lives of those who have been disappeared and killed, and seeking reparations for torture victims and their families are key parts of his work.

According to Matta Chile has had a particular experience, and it is essential that the younger generation be made aware of the impact the military has had (and continues to have) on the nation's history and on the lives of so many of its citizens.[7] Unfortunately, Matta has found little support for his efforts inside Chile. He operates on a shoestring budget, has no institutional backing, and perseveres despite a widespread sentiment that the ugly days of the military regime should simply be forgotten. Nonetheless, Matta contends that there can be no talk of justice in Chile until there is an accounting for what happened in the 1970s and 1980s, and indeed there can be little guarantee against those dark days returning. "We cannot just go forward as if nothing happened," he asserts.[8]

Villa Grimaldi, the first stop on my guided tour with Pedro Matta, was established in early 1974 as an experimental detention center that later developed into one of the most systematic sites for the use of torture in Latin America. Although it is still not known how many torture centers existed in all of Chile, it is believed that there were eighty-seven in Santiago alone, of which Villa Grimaldi was one of the most well-developed. The villa compound, with the main house, surrounding farm buildings, and grounds, stood in the midst of an agricultural area. Built in the nineteenth century by a wealthy Italian immigrant family, it had passed before 1973 to the ownership of Emilio Vasaya, who had used it as a weekend house where he and his family entertained foreign dignitaries and, paradoxically, a number of well-known left intellectuals, including Pablo Neruda, Gabriel García Márquez, and Fidel Castro. Today there are houses nearby, and the street in front is fairly well traveled; but in the 1970s the military acquired the property because it was isolated from Santiago but near a small military airstrip, the Tobalada Airfield.

In 1974 the villa was appropriated by the Directorate of National Intelligence (DINA), the agency engaged in detaining and interrogating prisoners. The DINA transformed it into a torture center in July and operated it as its most important center in Santiago until February 1978.[9] Villa Grimaldi completely ceased operations as a military installation during the 1980s, possibly as a result of increasing international scrutiny on the Pinochet dictatorship and escalating worldwide condemnation of the military's use of torture. With operations moved elsewhere, the villa passed to the CNI (the National Intelligence Council), the fiscal arm of the DINA. In 1987, near the end of Pinochet's dictatorship, the last head of the CNI, General Hugo Salas Wenzel, sold Villa Grimaldi to his wife's sister and her husband, who owned a construction company. They obtained permission to level the buildings in order to construct a high-priced condominium complex on the site. After they had leveled the buildings, but before they were able to erect the condominiums, the press got wind of the story and mounted a campaign not only exposing the official graft involved but uncovering the history of torture that had occurred at Villa Grimaldi. Shortly after the democratic transition in 1990, Villa Grimaldi was turned back to the government and commemorated as a historic "Peace Park" in 1995. Today Villa Grimaldi is a lovely park, with gardens, sculptures, and flowers, but marked throughout with brick plaques and stones naming the various "stations" of the torture (cubicles, electric torture rooms, bath-

2. The Villa Grimaldi National Historic Site, "Peace Park." Santiago, 1999.
Photo by Teresa Meade.

rooms, etc.). The military succeeded in destroying the physical evidence of torture, but Pedro Matta and other historians have been able to piece together a history of the detention experience through interviews with ex-detainees and even from the accounts of a few guards who worked there.

Matta's method of leading us through the site was to reproduce, and even reenact where possible, the day to day operations of the torture center. He put himself in the place of the prisoner (as indeed he had been) and demonstrated the various workings of the site. In this way Matta called on us to imagine what had been there before by describing in minute detail the buildings, the torture devices, the location of guards, the entrance and exit of prisoners and the military, and even the hierarchy of prisoners. We began with the gate where the trucks entered the grounds and proceeded through the entire park. Beginning in 1974, prisoners were brought in helicopters to the nearby airstrip, and from there they were loaded onto trucks and brought the short distance to Villa Grimaldi. Those brought via the airfield were combined with the people who were trucked in from neighborhoods, workplaces, schools, and universities throughout the city. The trucks pulled up to a wooden gate, which remains today, complete with the sliding door that had enabled the guards to check the identity of the driver and his cargo. The prisoners, all with arms tied behind their

backs and blindfolded, were unloaded in much the same way that livestock had been delivered to the villa when it was a country estate. According to testimonies from ex-prisoners, six agents "greeted" the arrivals with clubs. They were then taken to the "grill," a converted metal box spring from a cot, where they were subjected to electric shock torture for sixty to ninety minutes, or not quite enough to kill them. Those who did pass out or suffered heart attacks were revived by attendant physicians who either threw cold water on the victims or performed CPR to keep them alive. Variations on the standard shock torture included turning the "rack" of the bed upside down or conducting the torture in front of the prisoner's friends and family members who were also being held.

Matta's tour elaborated on the sketchy explanations on the brick markers throughout the park, most of which simply labeled pieces of lawn as "location of torture chamber," "dormitory for detainees," "room for electrical shock torture," and so forth. From his own memories and those of other prisoners Matta has reconstructed a detailed plan of Villa Grimaldi's buildings and grounds when it was used as a torture center. The room that had served as the foreman's headquarters in the days of the villa was made into a dormitory of bunk beds; the beds were crammed together, and there was no room to sit up and barely room to walk around. This, along with the converted garage, old water tower, and a few other buildings, became the detainees' permanent home, a place from which they were taken only at mealtime, when they were brought out and seated blindfolded, eight at a time, on a small wall to eat in silence with their heads always down. Twice a day, according to Matta, they were taken to the bathroom, allowed thirty seconds in it, and then returned to their bunks to await the periodic torture sessions. Of the detainees, 20 percent were women, whose treatment was the same as the men's except that they were raped as well as tortured. The prisoners were blindfolded at all times and never allowed to talk, but they did succeed in murmuring to each other while in line for the bathroom or at some other times. Those moments of interaction Matta remembers as crucial to maintaining his sanity.

Other brick markers in the park indicate the *sala de tortura* (torture room), again without explanation. Matta filled in the missing story with descriptions of the types of torture used: having a plastic bag filled with water, feces, or urine held tightly over the prisoners' heads until they almost passed out; being suspended in the air for hours by their hands, or with arms tied behind their backs (which dislocated their shoulders), or

3. Pedro Matta at the original gate to Villa Grimaldi, demonstrating the peephole through which guards identified incoming trucks loaded with prisoners when the villa was a torture center. Santiago, 1999. Photo by Teresa Meade.

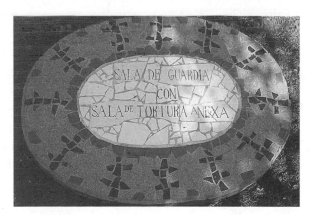

4. Stone marker in Villa Grimaldi indicating "Torture Chamber." Photo by Teresa Meade.

upside down; being subjected to slow rhythmic clapping on their ears which eventually caused permanent hearing loss; being burned with cigarettes all over the body; being run over by a vehicle; and being subjected to electric shocks on all parts of the body, especially on the most sensitive sexual organs.[10]

The site does memorialize those who are known to have been killed or to have disappeared after having been brought to Villa Grimaldi; a wall sculpture at the far end of Peace Park is inscribed with their names. (It does not contain the names of all those who are known to have passed through it.) With maybe one exception, none of the names are well known. Indeed, the regime sought to terrorize ordinary citizens—students, workers, community members—as a means of enforcing total and complete conformity. A perusal of the names reveals at least two sets of brothers and that about a third of Villa Grimaldi's detainees were women. Matta explained that family members of at least five of the women report that the women were pregnant at the time the DINA apprehended them. If the women gave birth, their children have not been recovered and are believed to have been given to the friends and families of the military.

A swimming pool surrounded by a high chain-link fence is another part of the exhibit. The incongruity of a swimming pool bearing the label "torture device" is one of the starkest exhibits on the grounds. The DINA guards had parties by the pool in the summertime, bringing the female prisoners from their cells and forcing them to dance, sit with, and otherwise "entertain" the guards. In addition, the pool parties were a time when camp collaborators, those who were complying with the guards' demands or offering up information, were allowed to sit by the edge of the pool and drink Coca Cola and eat *Tretons* (a well-known Chilean brand of cookies). The pool was also a torture device. Prisoners were dragged by ropes back and forth under the water; at least one is known to have died of that particular torture.

Considering its horrific past, today the well-tended park is itself a contradiction. It is open Tuesday through Sunday from 11 A.M. to 6:30 P.M., and often local schoolchildren and teenagers come to the park in the early evening to talk and hang out. Although the locale is apparently treated with respect—there are no signs of vandalism or graffiti—it is unclear how much the park's young visitors understand of the history commemorated there. In the absence of history lessons in schools and a general effort to make Villa Grimaldi and similar sites understandable to the public, it

5 & 6. The Villa Grimaldi swimming pool and marker, which declares, "Swimming Pool: A Frightening Place." This assessment refers to the way the DINA used the pool as a means for rewarding collaborators and threatening others. In the winter of 1975 a male prisoner was tortured in the pool and reportedly died of hypothermia. Photos by Teresa Meade.

reminded me of the Indian burial mounds kids played on when I was a youngster in the rural Midwest. They were a curious novelty from another era and, since we never read about Native Americans in any depth in our schoolbooks, we presumed they were of no importance.

The memory site that is probably the best known to most Chileans and international tourists is the "Memorial for the Disappeared," a high, long marble wall that stands at the entrance to the Santiago General Cemetery, the city's most important graveyard. It bears the names of the more than three thousand people disappeared or murdered in Chile after the military coup. But rather than simply listing names, like the Vietnam Veterans Memorial in Washington, D.C., the Memorial for the Disappeared contains crypts in the wall. When new bodies are uncovered, or identified as a part of ongoing forensic work in the unmarked graves that are constantly being uncovered throughout Chile, those remains are brought to the wall crypts and the name moves from "disappeared" to "deceased." Inscribed at the top of the wall is a line from Raul Zurita, one of Chile's most important contemporary poets: *Todo mi amor está aquí y se ha quedado: Pegado a las rocas, al mar, a las montanas* (All my love is here and here has stayed: Tied to the rocks, to the sea, to the mountains). The base of the wall is piled high with bouquets of flowers, photographs of disappeared family members with entreaties for their recovery, and posters calling for the government to do more to account for the disappeared. There are always people there.

In another section of the cemetery is "Patio 29," the municipal potter's field where the mutilated, tortured, and executed bodies were dumped by the military government, buried in graves marked "NN." Unlike the Memorial for the Disappeared, this plot has no sign or commemorative explanation to attract the attention of tourists or visitors to the cemetery. After the September 1973 coup the plot was used to bury many bodies found on the streets of Santiago, including those who were killed by multiple gunshots and snipers, those who were executed by machine-gun fire, and those who died while in police confinement. The police and military made no effort to identify those bodies, simply dumping them in graves marked by crude metal crosses with "NN" painted on them. Hundreds of victims, many of whom are still listed as disappeared, were buried there in rough coffins, sometimes two bodies to a grave. In 1982, in an attempt to cover up some of their most egregious excesses, the military government disinterred hundreds of bodies and disposed of them in unknown locales and, reportedly, even ground up the bones into chicken feed. In 1992, after the

7. Memorial for the Disappeared. Santiago General Cemetery, 1999.
Photo by Teresa Meade.

8. Burial vaults, many unmarked, extending along the edge of the
Memorial for the Disappeared wall. Santiago General Cemetery, 1999.
Photo by Teresa Meade.

return of the civilian government, hundreds of remains were found in this plot and, with the help of international forensic specialists, were identified and returned to their families. The bodies usually were then moved to the crypts in the Memorial Wall at the other end of the cemetery.

Across the lane from Patio 29 is the crypt of Victor Jara, one of Latin America's most famous folksingers and guitarists. Jara, one of the most well-known of the victims of the military coup, was arrested on September 11, 1973, at the *Universidad Técnica del Estado* (State Technical University), where he had gone to perform at an engagement arranged prior to the onset of the military coup. Jara's wife, Joan, a British citizen, has been able to gather information from other detainees held with him and piece together the probable events surrounding her husband's arrest and murder. Jara was taken to the *Estadio Chile*, a boxing arena where many prisoners were held before their transfer to the National Soccer Stadium. Along with thousands of others he was detained there, subjected to constant abuse and torture, and, on September 14, probably, he was killed. His body was taken to a city morgue along with many others destined for burial in a common grave. However, a worker at the morgue recognized the famous singer and notified someone to contact Joan Jara. She was allowed to claim his body and arrange to have it buried immediately in the wall at the rear of the Santiago General Cemetery.[11]

Coincidentally, Victor Jara's crypt is only a short walk across the lane from Patio 29, the location where he very well might have been buried had his famous face not been recognized in the morgue. His crypt on the wall, alongside others unrelated to Chilean political causes, is covered with flowers and with signs that visitors have tacked on the wall calling for justice and an accounting of the disappeared; graffiti on the trees nearby proclaims Victor Jara's continued importance as a symbol of cultural resistance.

In another, older, section of the Santiago cemetery among the elaborate mausoleums of the elite founding families of Chile stands the grave of Salvador Allende and his family. President Allende committed suicide at *La Moneda*, the government palace, during the coup rather than allow himself to be taken by the military. His body was taken by military personnel at that time and left in an unmarked grave in Viña del Mar, 140 kilometers from Santiago. In the 1990s Allende's remains were moved to this spot in the main cemetery, where a monument tops an underground cavity containing the bodies of Allende and his daughter, who likewise committed suicide while exiled in Cuba.[12]

9. Mausoleum containing the body of Salvador Allende Gossens and other family members. Santiago General Cemetery, 1999. Photo by Teresa Meade.

Without Pedro Matta's explanations, the visit to Villa Grimaldi and the other memory sites would have been far more superficial, even for someone with a fairly good knowledge of recent Chilean history. As a Latin American historian, teacher, and political activist, I for years have read about, taught, and protested against the antidemocratic Pinochet government. Although not an expert in Chilean history, I considered myself well-informed. Pedro Matta's tour of the memory sites, however, provided me with a far greater depth of understanding of the oppression meted out by the military regime. Few of the survivors of torture have Pedro Matta's stamina and ability to explain what happened to them, an experience he describes as "the depths of the abyss of the human condition."[13] He attributes this to the fact that Villa Grimaldi was actually the second locale at which he was detained. As Matta explains, although he spent several weeks in Villa Grimaldi, he came there after having been held for five days at an even more notorious place, Venda Sexy, so named for the inhumanly bizarre sex games a guard orchestrated there with her dogs and the prisoners.[14] According to Matta, because Venda Sexy had brought him to the brink of death and certain despair, he found Villa Grimaldi more tolerable. In addition, Matta is unique in his dedication to uncovering and preserving the historical record of abuse during the military regime.

Given the scarcity of resources devoted to establishing a public record of what happened in the torture centers, and to finding and accounting for those who disappeared, it appears that many in Chile's governing circles would just as soon the profundity of the inhumane behavior of the Pinochet era remain an abstraction. For the right-wing *Alianza Popular* (Popular Alliance), relegating the ugly picture of torture and brutality to an obscure past allows them to ignore any responsibility for the death, disappearance, and torture they supported. On the other hand, from the vantage point of the moderate / left *Concertación*, acknowledging the abuses, while refusing to press for reparations or to hold the military responsible for human rights violations, allows them to govern without confrontation. The January 2000 presidential victory of Ricardo Lagos, a member of the Socialist Party who ran as the candidate of the *Concertación* and won in a close run-off against the rightist Joaquín Lavín, has renewed hope that human rights violators will be prosecuted. Toward that end Pedro Matta and his allies continue their work on several fronts, both within Chile and internationally. They compile testimony and documentation from ex-political prisoners, from the families of the disappeared, and from guards to substantiate the charges against those who carried out the torture in hopes that they can be brought to trial in Chile. In addition they send their information to human rights groups abroad in case Chile's military torturers can be brought to justice before international tribunals. Ironically, the task of bringing some of the twentieth century's most blatant violators of the law to justice has been, and probably will continue to be, entangled in a web of arcane legal proceedings.

As of this writing, attempts to arrest and punish military officers remain an ongoing part of Chilean politics. In 2002 Chilean judge Alejandro Solis indicted five top intelligence officials from the Pinochet era to stand trial for the murder of former general Carlos Prats. General Prats, who opposed the 1973 coup and subsequently fled the country, was killed along with his wife, Sofia Cuthbert, when their car was blown up in Buenos Aires in 1974.

In August 2003 President Ricardo Lagos took steps to accelerate the prosecution of members of the armed forces charged with human rights abuses, based on the discovery of more victims in unmarked graves. On March 9, 2004, the Chilean Supreme Court convicted four retired army generals—Arturo Ramsés Alvarez Sgolia, Hernán Alejandro Ramírez Hald,

Hernán Ramírez Rurange, and Juan Fernando Torres Silva—for their involvement in the 1981 assassination of a prominent labor leader, Tucapel Jimenez Alfaro. The prosecution of Augusto Pinochet at this point seems unlikely, at least in Chile. He has been stripped of his "Senator for Life" status and charged with numerous rights violations, including kidnapping and murder, but he has been ruled mentally unfit to defend himself. Nonetheless, in February 2004, French Foreign Minister, Dominique de Villepin, announced during his visit to Chile that the French courts may be proceeding with indictments in absentia against Pinochet for human rights violations against French citizens who disappeared in Chile in the 1970s. Human rights advocates in Chile and abroad remain hopeful that Chilean military officers, and even Pinochet himself, may yet be brought to justice.

NOTES

1. Edward Hower, "No Frogs Allowed: In Santiago, a Professor's Sometimes Puzzling Encounters with the Spanish Language," *New York Times*, Jan. 30, 2000, 12.

2. Annick Smith, "Grand Resort's Faded Glory," *New York Times*, Jan. 30, 2000, 10.

3. For more information on the military dictatorship, see Agosin, *Scraps of Life*; Constable and Valenzuela, *A Nation of Enemies*; Drake and Jaksic, *The Struggle for Democracy in Chile, 1982–1990*; Ensalaco, *Chile under Pinochet*; Maloof, *Voices of Resistance*; Oppenheim, *Politics in Chile*; Spooner, *Soldiers in a Narrow Land*; Valenzuela, *The Breakdown of Democratic Regimes*. In my view the best single study of what the *Unidad Popular* attempted to accomplish, and the obstacles it faced, remains Winn's *Weavers of Revolution*.

4. Clifford Krauss, "Pinochet Case Reviving Voices of the Tortured," *New York Times*, Jan. 3, 2000, 1.

5. For information on Argentina's "Dirty War" see Amnesty International, *The "Disappeared" of Argentina*; Timerman, *Prisoner without a Name, Cell without a Number*; Bouvard, *Revolutionizing Motherhood*; Arditti, *Searching for Life*.

6. A number of other memory sites that I was not able to visit, and thus have not been reviewed here, are Venda Sexy, the furnaces at Lonquen, and the Salvador Allende Museum of Solidarity. For more information on these and other detention centers, see www.chip.cl / derechos / campo_santiago_venda_sexy_eng.html and www.chip.cl / derechos / memory_map_eng.html and "A Long-Deferred Museum in Honor of Allende," *New York Times*, Jan. 6, 2000, 1.

In Lonquen limestone furnaces built at the turn of the century were used to bury the bodies of all the male members of two peasant families living in the area. In 1978 the remains of fifteen bodies were found at the bottom of these furnaces. The

discovery and subsequent investigation marked a turning point in the popular understanding of the atrocities of the military government. The owner of the furnaces, a right-wing militant, dynamited the furnaces in 1987 in hopes of destroying a site that was associated with the gross human rights violations of the military era. Isabel Allende's novel *Of Love and Shadows* is a powerful story based on the discovery of the mass graves at Lonquen.

7. According to United Nations estimates about one million Chileans left their country between 1973 and the mid-1980s for political and economic reasons, including several thousand who walked to Argentina in the weeks and months following the coup. In a country of about twelve million inhabitants (fourteen million today), that means about 10 percent left. Of those who were in exile, 30 to 40 percent are believed to have returned to Chile. Some have returned for a short while, but because they could not find work or could not adjust to Chile, they did not stay. Most of the exiles are in Europe (France, Sweden, England), the United States, or Canada (Montreal). See Martinez and Diaz, *Chile: The Great Transformation.*

8. Pedro Alejandro Matta. Interview by author, Santiago, Chile, Nov. 16, 1999. Since my time in Chile Matta has written a guidebook that is available (in English and Spanish) from him, entitled *A Walk through a 20th Century Torture Center: Villa Grimaldi, Santiago de Chile.*

9. Kornbluh, "Chile Declassified"; see also Kornbluh, *The Pinochet File.* There are a number of good books in Spanish that describe the political assassinations in the days after the coup and subsequent repression, including Verdugo, *El Caso Arellano*; and, by the same author, *Interferencia secreta.* Alejandra Matus's book *El libro negro de la justicia chilena* has been banned in Chile because it accuses a Supreme Court member by name.

10. See also O'Shaughnessy, *Pinochet.*

11. There have been various accounts of what happened to Victor Jara before he died. An oft-repeated claim is that his hands were broken at the wrists when he was tortured, apparently as a punishment for his fame as a guitarist in support of the UP government. The only verification for this claim that I was able to find was Joan Jara's observation about the state of his body: "His hands seemed to be hanging from his arms at a strange angle as though his wrists were broken" (Jara, *An Unfinished Song*, 243).

12. More than fifty people were with Salvador Allende in the Moneda at the time of the coup. After they surrendered, they were taken to a military garrison, Regimiento Tacna, where they were tortured and from where they "disappeared." In 1994 the remains of Dr. Enrique Paris, a member of this group, were found in what had been a military base. The forensic examination showed that his legs had been burned with an acetylene torch while he was still alive.

13. Matta, interview (see note 8).

14. Venda Sexy functioned as an "official" detention center with a regular "nine-

to-five" workday schedule, and then the extracurricular torture began at night. One of the guards was a female *carabinero* (policeman) named Ingrid Olderock, who was a dog trainer for the police. She used her particular talents to train a German shepherd dog to rape women. The police called the dog "Bellodilla," which was the name of the head of the Chilean Communist Party. Olderock is alive and lives in Nuñoa (a section of Santiago), where she is retired on a comfortable pension.

COMMEMORATING THE PAST

IN POSTWAR EL SALVADOR

Irina Carlota Silber

I picked up a handful of his curly hair and some bones from his feet and others from his hands and like that little bits of bone. And the shirt, the shirt was red and dried hard by his own blood. I cut a piece of the shirt and put all of that in it, put it in a bag and I carried that bag with me in my knapsack. No one knew, only my girlfriend Lupe. And I carried them with me until I met Rolando and then I went to bury the bones in the cemetery.

—ELSY, women's rights community activist, November 1997

After twelve years of civil war and, as I write, almost a decade of rebuilding, El Salvador's transition from war to a deep peace and participative democracy remains unfinished because the root causes of the war have not been resolved and justice for past human rights abuses is elusive.[1] Whereas official reconstruction is premised on a policy of forgetting a past of violence and injustice, across the nation women's groups, community councils, youth groups, and a diversity of NGOs and grassroots organizations challenge this national policy of reconciliation through their politics and practices of commemoration. In this essay I argue that in impoverished postwar El Salvador, particularly in former conflict zones and sites of revolutionary mobilizing, commemoration involves a tension between remembering and forgetting that takes place in the practices of everyday life. This is a commemoration from the margins, embodied and occurring through space and in talk. As Elsy's words and actions above poignantly illustrate, it is critical to attend to the *unmarked* spots, the everyday landscape scarred by years of violence and suffering and that link private loss with collective memories of the war.

I develop this interpretation of the politics of memory and commemoration below. First I provide a brief discussion of El Salvador's negotiated transition to peace and official reconciliation policies that are predicated on forgetting the recent past. Then I focus on an area of wartime violence

(Chalatenango) and how survivors present conflicting versions of the war and postwar period that impact on commemorative discourses and practices. Specifically, I provide ethnographic analysis of a postwar medical (military) mission. By charting out points throughout this single day, I suggest it be understood as a commemorative event that extended for weeks after. This event analysis illustrates the contextually defined struggle between remembering and forgetting. Circumstances that evoke the war, as much as memory sites and monuments, activate a popular reflection and action. In this case, as two historically oppositional sides of the past conflict meet—Chalatecos and soldiers—what I term a *visceral remembering* creates an embodied commemoration that determines what should be marked or elided in the postwar period.[2] In the context of remembered oppression this social interaction underscored the locally hegemonic metanarrative of unity and sacrifice espoused by many in grassroots and political leadership positions. In doing so it strengthened community solidarity and a regional oppositional identity at a time when increasing local differentiation has created a postwar moment of disillusionment and demoralization.[3] Finally, I provide an argument and contribution for interpreting both social memory and the commemorative practices that arise as profoundly visual and physical experiences that constitute ongoing local and national reconstruction.

BACKGROUND

According to what's said, the problems are being resolved, everyday a bit more. But that is in theory. In reality reinsertion does not exist. . . . Reinsertion has not been resolved because the problems continue. We organized because of these, it is what motivated us, what drove us to an armed struggle, for issues that are still not resolved.—ANGEL, a community activist, September 1997

On January 16, 1992, peace accords brokered by the United Nations were signed between the government of El Salvador's National Republican Alliance (the ARENA Party) and the Farabundo Martí National Liberation Front (the FMLN, formerly a guerrilla group but now an official political party).[4] This agreement officially ended a protracted civil war (1980–92), which was bolstered by U.S. aid that reached $6 billion after a decade. The war claimed the lives of an estimated eighty thousand people, left eight

thousand "disappeared," and displaced one million of El Salvador's five million people.[5] The peace accords marked a historic transition to peace and concentrated on opening the political system, creating a representative democracy, reducing the armed forces, strengthening the judicial system, and reforming the electoral process. Undeniably, great strides have been made in the transition to democracy evidenced in successful demobilization, which often is the first barrier to peace, in the training of a new civilian police force (PNC), in the creation of an Office of the Human Rights Procurator, and in electoral politics.[6] For example, since 1994, four internationally monitored democratic elections have been held and the FMLN has challenged ARENA's one-party dominance, a challenge evidenced in March 2000 as the FMLN won most of the nation's largest municipalities.[7]

However, many scholars, activists, and citizens problematize the meaning of peace given that the majority of Salvadorans live in poverty with poor access to decreasing social services and increasing "random" violence in both urban and rural places. Statistics indicate that violence is as high as it was during the height of the war.[8] Moreover, even though the peace accords resulted in the creation of a Truth Commission to investigate human rights abuses, the findings and recommendations in the resulting *Report of the Truth Commission for El Salvador: From Madness to Hope: The 12–Year War in El Salvador* were in general not implemented.[9] The report concluded that the Salvadoran state, through its systematic institutionalization of violence (armed forces, paramilitary groups, and death squads) was the overwhelming agent of terror.[10] After years of denials, obfuscations, and coverups by the Salvadoran and U.S. governments, the United Nations–supported document confirmed the very accusations of state-sponsored violence against civilians made for more than a decade by many national and international human rights organizations, journalists, activists, and scholars.[11]

In response the Salvadoran government criticized the Truth Commission's findings as a vehicle for building peace, arguing that the truth could create vengeance and derail a fragile democracy. Indeed high-ranking officials of the Salvadoran armed forces who were recommended to be discharged for their crimes against humanity, such as General Rene Emilio Ponce, declared the report illegitimate, "unjust, incomplete, illegal, unethical, prejudiced and insolent," claiming that it infringed on national sovereignty.[12] Then-president Alfredo Cristiani, a central actor in the peace

negotiations, commented, "As far as promoting reconciliation, we think the Truth Commission Report does not fulfill the desires of the majority of Salvadorans, that desire is to forgive and forget the painful past that has caused so much suffering."[13] A few days after the report's publication a general amnesty law was passed that granted absolute and unconditional amnesty to all those involved in human rights abuses before January 1992.[14] To date, only a few high-profile cases have been investigated, and in the majority of these no one has been held accountable for violating human rights. Close to a decade after the signing of peace, impunity prevails, and those responsible for human rights abuses have not been brought to justice.[15] Despite this official posture, however, citizens in places such as Chalatenango reject the call to forget as they negotiate and commemorate versions of the past in their everyday lives.

THE POLITICS OF COMMEMORATION:
BETWEEN REMEMBERING AND FORGETTING

Recent scholarship has theorized on social or historical memory as political practice.[16] And in Chalatenango, as in other former conflict zones, rescuing and commemorating historical memory has become a key organizing trope as the present is shaped by the negotiation of remembering and forgetting both personal and collective trauma. Briefly, social memory has been referred to in a variety of ways: as collective, public, popular, historical, and in-built space. Since Halbwachs's pioneering work, emphasis has been on the social construction of memory.[17] Theorizing on social memory explores how the past is socially constructed and debated and what versions of the past are employed in the present. A significant body of literature explores the relationship between narrative, the social and political uses of oral history, and the cultural construction of place.[18] This essay builds from explorations of memory in everyday life and the ways in which history is embodied in material sites and how people recast meaning on to them.[19] As Abercrombie explains, "People constitute themselves and their social formations in communicative actions and interactions, making themselves by making rather than inheriting their pasts. Recollecting and commemorating the past always takes place in contingent contexts where power is at play. As a result, alternative forms of social memory and alternative possibilities for construing the social are always in

contention."[20] It is to this fluid movement between memory and commemoration that I now turn.

■ ■ ■

In 1993, in the early postwar period when I began fieldwork in El Salvador, I was introduced to Chalatenango's landscape and history through the narratives of civil war survivors and learned how the very existence and rebuilding of repopulated communities commemorated their recent struggle. As I visited many new internationally funded women's development projects across repopulated communities, I listened to the ways in which particular places held multiple meanings for residents. A mango tree, the curve of a mountain, a fork in the road, a church, a school yard—these "unmarked" locations erupted with stories of death, disappearances, escapes, births on the run, neighbors betraying neighbors, and a father, husband, brother, son being ambushed and brutally killed.[21] The relationship between memory, land, materiality, and death pervaded daily life.[22]

Three years later, in 1996, the physical commemoration of this past was evidenced in the many community hand-painted murals, small monuments, and plaques listing the names of the dead and in community places, such as schoolhouses, named after martyred leaders. These places create a continuum of commemoration across the nation that links rural and urban violence such as the rural massacres of civilians (for example, El Mozote and El Sumpul), the assassination of Archbishop Oscar Arnulfo Romero in 1980, and the 1989 killing of six Jesuit priests and scholars at the Central American University (UCA), their cook, and the cook's daughter.[23] Visitors who travel to the chapel at the UCA will find a series of commemorative spaces beginning with art on the walls representing tortured bodies; next door a small museum with photographs and testimonies describes massacres in rural communities across the nation; and in a small room photo albums document the killings at the UCA. These sites embody a historiography that continues to challenge official national reconciliation through privileging an oppositional identification grounded in a polarized political field.

As Aizenberg discusses for Argentina's Dirty War, survivors battle to author, represent, and commemorate their positioned experiences of the past. The questions she raises resonate with the Salvadoran case: "In the face of so many killed, so many bereaved, so many culpable . . . what

should we remember or forget? . . . Who gets to decide? . . . What kinds of memorials—monuments, gardens, plazas—can best carry the burden of active and vigilant memory? Where should these memorials be erected? Who should design them?"[24]

Bodnar also suggests that commemorative events are multivocal and are characterized by a negotiation of different agendas and visions (official and popular) that have as much to do with the past as with relations of power in the present.[25] Interestingly, in Chalatenango, a past and present stronghold of the FMLN, the negotiations involved in *regional* public commemorations evidence a heterogeneity of the local that remains united in opposition to official lines. For although residents did not experience the war uniformly, men and women through different generations share a past as either active participants in guerrilla forces in a multiplicity of positions or as community supporters. Unlike many other situations this is one in which public memory and history are indeed in the hands of "ordinary people"—though nonetheless contentious.[26] Ethnographic data indicate that commemorative sites in Chalatenango are born from survivors' efforts to make sense of the contradictions of the recent past as many turn to their lived history of mobilization, sacrifice, and loss. These acts of remembrance help people make sense of the present, work toward personal and communal healing, and chart an uncertain future. This is a call to remember the past as one of heroic participation, of triumph and suffering, and of Chalatecos as oppositional *luchadores*, as fighters, armed and political, in creating community. This creates a regional political polarity that continues to contest ongoing marginality. The recent past is called upon selectively and politically to commemorate and build a community that still struggles.

This metanarrative is often contested in a variety of community spaces. Many residents place the survival of their household economy over community politics as peoples' access to resources has created postwar stratification and a rupture between a revolutionary discourse and lived reality. In the conversations of daily life, when people visit their neighbors and kin, ride the bus, sit at local *tiendas* (stores), or participate in events, it is common to hear discussions on how Chalatecos have received nothing but sadness and loss from their wartime participation. As thirty-year-old Chayo— a former guerrilla supporter (seamstress), wife of a demobilized combatant, adult literary teacher, tienda owner, community council member, and mother of three—explained to me, "When we first started organizing, they used to tell us 'In twenty-four hours the country is going to be liber-

ated.' . . . But you can see that war is quite painful and it doesn't last from night to morning. . . . Many have to struggle and die. . . . So that was a big lie. . . . The costs are too high to liberate a country."[27]

Often survivors theorize on the past with the comment *"estamos peor que antes"* (we are worse off than before). They conclude that others who fought neither as hard nor as long have received peacetime "benefits" from an undefined system. Whether "true" or not, these conversations exemplify a postwar moment full of disillusionment, a *desencanto* that many Chalatecos in leadership positions critique and attempt to repair. Thus, the sense of belonging that is born from suffering is often decentered by what many define as survivors' "refugee mentality." Local, national, and international leaders assess this as an erroneous assumption of entitlement or expectation of indemnification born from wartime sacrifices. For example, Rolando, a community organizer, grassroots worker, and FMLN political militant voices his concern for Chalatenango's oppositional communities:

> All those people came with many years living as refugees. They came accustomed to receiving everything and up to a certain point, they considered it a right to be given everything. . . . There are people who think that they haven't received any assistance, there are people who say, "I sacrificed in that great struggle, we lost our children, and to date they still haven't given me anything." . . . What are the benefits of the peace accords? Land, and the debt (agrarian and credit) that we still have, that they haven't paid off yet, that has not been forgiven. But we still have people who believe that they are not beneficiaries. A lot of people have houses, half of which were donated, and still they claim that they haven't received any aid. . . . A lot of people thought that because they had worked so many years in the war, they were going to receive an indemnity, that they were going to get paid. But the payment we have is our life, right, and the political spaces conquered to keep on struggling.[28]

Below I provide an example of what I interpret as a commemorative event where these salient differences are elided. In the embodied commingling of historically contentious social actors, residents' *visceral remembering* commemorated the past violence and created a community in solidarity. As I will depict, although new and young faces represented the Salvadoran armed forces, the past infused the present, marking how the armed forces were not simply providing transport. The conditioned responses of years of survival marked the day's events. The recent past of psychological intim-

idation, daily repression of organizing, and the brutality of military opera-
tions was not a distant memory but a living presence articulated in people's
narratives, in their actions and in their silences. As Cole reminds us, memo-
ries are not "equally salient all of the time, and that the process of remem-
bering and forgetting is tied to the very flow of social life and local people's
attempts to control it."[29]

MILITARIZED DEVELOPMENT: U.S. AIR FORCE
AND SALVADORAN ARMED FORCES MEDICAL MISSION

On August 13, 1997, men, women, and children from the municipality of
Las Vueltas stood waiting for transport.[30] They waited from 7 A.M. until
11:30 A.M. for the promised Salvadoran armed forces vehicles to deliver
them to the site of the medical intervention, another community, one hour
away, where they were to receive medical attention from a team of U.S. Air
Force doctors. Many residents began the journey with complaints about
the four-and-a-half-hour delay. Women, for instance, expressed a concern
about returning home in time to attend to their domestic work. Most
people had not packed food, thinking the day would be short, and mothers
with small children were particularly burdened as their young, even before
departure, were already getting hungry. During this time conversations
circulated about the pros and cons of participating with the soldiers, which
residents referred to on this day as on other days as a historic enemy. Many
community residents chose not to participate and expressed the idea that
the event was *pura propaganda* (pure propaganda), a political ploy by the
army and the ARENA government. However, with access to medical care
still scarce in the region, a significant number chose to make the trip.[31] As
community members placed one foot on the army vehicles, they expressed
their criticisms in hushed conversations.

After more than a year of fieldwork where I listened to the violent
narratives of former combatants and their supporters, the image of soldiers
and residents commingling on the back of military trucks was startling (see
fig. 1). Men, women, and children held on for the long bumpy ride ahead,
which ended at three school buildings in an adjacent municipality.[32] Here
they encountered several groups: (1) a U.S. colonel, with his aides, oversee-
ing the mission; (2) U.S. doctors with limited knowledge of the region; (3)
Salvadoran troops, comprising many young recruits and several older and
career soldiers with a history in the recent civil war; and (4) a handful of

1. Salvadoran armed forces transport. Photo by Antonio Rossi. Courtesy of Antonio Rossi.

young, white male, Mormon missionaries, wearing blue pants and white button-down shirts and carrying pocket-sized Bibles. With expressions of earnestness these missionaries served as translators for the monolingual English-speaking doctors.

Residents progressed through bureaucracy and long lines before they received their medical consultation.[33] First, they registered with a Salvadoran soldier. As a woman commented to me, she had not done so since her journey of repatriation (see fig. 2)—a journey well documented in the repatriation literature and testimonial genre as one of courage and grassroots empowerment within a context of militarized surveillance and threat of violent repression. After registering with the soldiers, individuals moved to two other lines. They were encouraged to attend an educational session to help them live hygienically (see fig. 3).[34] The soldier giving the workshop attempted to negotiate a sense of regional solidarity as he explained that he, too, came from an unnamed *pueblito* in Chalatenango. However, unlike other workshops provided by regionally established civil society groups that work on a model of popular education, empowerment, and participative democracy, this session was pedagogically hierarchical.[35] Individuals were lectured, and participation was not facilitated. These were individuals

2. Medical mission registration. Photo by Antonio Rossi.
Courtesy of Antonio Rossi.

3. Dengue fever workshop. Photo by Antonio Rossi.
Courtesy of Antonio Rossi.

4. Soldiers as barbers. Photo by Antonio Rossi.
Courtesy of Antonio Rossi.

I had come to know well, individuals who were typically outspoken. They were silent, however, as the soldier exclaimed, *"Junto podemos prevenir el dengue"* (Together we can prevent dengue). After moving in and out of this schoolroom, individuals were encouraged to groom themselves. Along one fence, free haircuts were provided by Salvadoran soldier-barbers (fig. 4). Implicit in these events was a refashioning of Chalatecos into literally "clean" Salvadorans.[36]

In contrast to the many internationally sponsored events I engaged in as a participant observer during my time in El Salvador—U.S. sister-city commemorative celebrations, parish delegations, European solidarity delegations evaluating their development contributions—a palpable silence marked this development encounter. As residents from the municipality of Las Vueltas waited several hours for their turn with the U.S. doctors, young Salvadoran soldiers walked, sat, laughed in their midst, and watched them. A silver-haired colonel in the U.S. Air Force, a man of Puerto Rican descent, was in charge of the mission. During an informal informational interview, the colonel gave a brief history of this medical mission, dating back to a first visit in 1993.[37] According to the colonel these medical missions were

clearly not intended to solve Salvadoran citizens' medical needs. Rather, he offered that they were useful in terms of the "trainings" people received (that is, the workshop referred to above on dengue fever, which explained that mosquitoes carrying the illness live in puddles of water—something most residents were aware of).

Medically, the doctors offered temporary relief of people's muscular pains and headaches by giving over-the-counter drugs like ibuprofen and by giving some medication for parasites. Most important, the colonel explained that these kinds of missions were politically significant in that they served to unite countries in friendship. He articulated a similar rendering of what many Chalatecos had said earlier in the day, "pura propaganda." When asked about the mission's relationship with the Salvadoran soldiers, perhaps not realizing the loadedness of his answer, he explained that the Salvadoran armed forces were working with them on the mission to maintain order (*"para mantener orden"*). Unlike Chalatecos who contextualized this day's "friendly" events within a past of horrific acts committed by soldiers, the U.S. colonel engaged in a decontextualized interpretation. His remarks erased U.S. complicity in the Salvadoran civil war, well-documented linkages between the U.S. and Salvadoran armed forces throughout the 1980s evidenced in the School of Americas trainings, and the ways in which the United States bolstered the war economy. The colonel chose not to acknowledge and situate the present work within the U.S. and Salvadoran military's historical relationship with Chalatenango's civilians. He offered a "no comment" response when asked about these issues.

My conversations with several doctors showed they knew little about the region's past or present, their lack of knowledge evident in their inability to understand the relatively low turnout for the free services. They also did not make reference to the civil war in El Salvador. However, a Salvadoran officer approached me and immediately began to speak about the war.[38] He positioned me as an international in solidarity "with the people" and in turn offered a different version of regional history, one that countered residents' historical memory and agency, one that claimed that survivor's representations of the past and their actions in the present were incorrect. He based his analysis on seventeen years of service in Chalatenango, years that spanned the civil war.

He reminded me that El Salvador was now at peace and suggested that the communities in northeastern Chalatenango seemed to be unaware of

this transition. As an example, he told me that two days ago the medical mission had been chased out of town in a nearby community. I had heard about this event earlier that morning in Las Vueltas. While residents waited, the story circulated between laughs about how the soldiers had been *rajados* (chased away) by local residents. The medical intervention was closed because, first, residents refused to participate and, second, the community council made a definitive statement by cutting off the community's electrical power supply and thus closing the school facilities for the medical "treatment." Indeed, that morning it was in the telling and retelling of this act of communal resistance that individuals framed their participation with the historically oppositional military. While materially they accepted services, residents remained ideologically loyal in their oppositional politics, although again, abstaining residents critiqued their very participation.[39] For the Salvadoran officer these acts of resistance impeded peace. He espoused what many Salvadorans in leadership positions have pronounced, that in order for the nation to rebuild, the past must be forgotten.

In his narrative, present-day acts of resistance were like those of the past, based on a "deviant" FMLN ideology that, according to his version of history, had caused the civil war. In his telling of the past it was the left that had forced the government to send the military into the region. His words can be read as an attempt to erase a well-documented oral history that testifies to years of repression of an unarmed social movement, to the prewar and wartime reality of the dearth of oppositional political spaces, and to how ultimately violent repression led to a militant revolutionary movement. He presented an apologist's position for the Salvadoran armed forces, a revisionist and official history that sought to repair its poor reputation regionally, nationally and internationally. For example, he explained that, really, there had been just a few military murderers during the war— *"tal vez hubieron unos pocos asesinos."* His objective in participating on the mission was to demonstrate to local residents that the army was indeed their "friend." In essence, he articulated what a former combatant, turned artist, carpenter, community council member, and grain alcohol seller, stated earlier that day in Las Vueltas: this was yet another attempt by the ARENA government to erase the past, to erase people's memory—*"borrar la memoria"*—in an effort to reconcile and win political power, as the presidential election was only two years away.[40]

By 2:30 P.M., with supplies gone, the U.S. doctors had finished their

work, and the school area facilities were closed, including the latrines. With the doctors' departure the Salvadoran soldiers were in charge of organizing the return to the municipality of Las Vueltas. For the next four hours residents again waited through growing hunger and through a drizzle that became a heavy rainstorm. During this time the Salvadoran officials enacted their power via silence. They did not provide people with information regarding the return trip. Interestingly, most community residents, whom I had previously witnessed eloquently complain about a number of poorly managed events, did not ask for information or approach the soldiers.[41] There was however an interesting exception. Margarita, the president of the women's community council in a small *cantón* of Las Vueltas, sat with the soldiers rather than with her neighbors. Rumor circulated that she was matchmaking by introducing her fourteen-year-old daughter to one of the young soldiers (fig. 5). Her spatial association with the army rather than with her neighbors did not sit well with many people, whose displeasure was evidenced by their hushed gossip and their own physical separation from her. Although she had an excuse—her little boy was sick and needed to rest in the soldier's hammock—her actions were read in a moral code of solidarity.

Finally, an army truck arrived and people pushed and shoved to get onboard. After some confusion and too many bodies had crowded onto the truck, the soldiers announced that they would be making multiple trips according to community. Residents responded quickly, finding kin and neighbors and assisting them either onto or off of the vehicle. After witnessing the often slow (though democratic) pace of *campesino* organizing, I realized that the energy and speed of decision making on this day was quite different, as residents of particular communities acted together to facilitate the return home as a united group.

The day proved to be physically exhausting and limited in terms of benefits. Residents who participated in the medical project received some criticism from their abstaining neighbors, who voiced the errors of "selling oneself for an aspirin." While Chalatecos articulated conflicting stances on the merits of participating in officially sponsored initiatives, their invocation of the past commemorated a triumphant Chalateco-revolutionary identity. Indeed, many of the participants were the most vocal critics of the military medical project. In follow-up conversations they interpreted the event as a military maneuver to *engañar a la gente* (trick people) or *conformar a la gente* (make people conform). For many days and weeks this

5. Spaces of solidarity. Photo by Antonio Rossi.
Courtesy of Antonio Rossi.

experience was at the center of their discussions, contributing to a larger discourse of deceit that circulates through Chalatenango and expresses the disillusionment of postwar times. In these conversations the soldiers became nameless and faceless, a commingling of past and present actors of the historic Fourth Brigade. As people recounted the unorganized, useless trip that did not even yield them free aspirin to alleviate their headaches, most commented that it was not surprising behavior from a historically oppressive institution that unfortunately they had come to know so well. As one grandmother from Las Vueltas eloquently explained, one could not forget that this same brigade was responsible for the deaths of countless local residents—the land should be filled with a cemetery of crosses to mark the amount of blood spilled on the road from Las Vueltas to Chalatenango, to commemorate the sacrifices of the dead for the living.

 Although the military civic intervention did not take place in Las Vueltas, the army, *el ejército*, synonymous with *"el enemigo"* (the enemy), roaming through the region invoked a continuum of its past actions and was understood within the framework of a military encounter. The proximity of soldiers on community land, the proximity of residents' bodies pressed up against soldiers as they were jostled to and fro on the back of

military vehicles, created the juxtaposition of past and present. It created a space for the articulation of survivor's memories that, like the testimonial literature produced during the war, serves as a "construct against forgetfulness."[42] The medical intervention was explained within a trajectory of human rights abuses as survivors' memories erupted through corporal interactions and through geography. Scholarship supports this thesis. For example, Rappaport locates memory and history in geography as she asserts that history is encoded in physical places. Geography, she explains, "organizes the manner in which these facts are conceptualized, remembered, and organized into a temporal framework."[43]

CONCLUSION

In social interactions between historically oppositional actors, and in places imbued with recent memories of violence, the present is understood through the refraction of recollecting the past. While in everyday life people's memories of the civil war are contested, indicating people's constant theorizing on the costs of peace, moments such as the event described above mark how survivors continue to create oppositional communities that commemorate a history of sacrifice, suffering, and empowerment, as they live in the gray spaces of horror between remembering and forgetting. As a Chalateco, Jesuit-trained, local parish priest explained to me, the struggles of the postwar period are rendered meaningful through this painful history lived in memory, through what I term the *memory work* of Chalateco social and historical actors. He states, "The postwar is a hard, difficult time. It is like trying to find one's lost voice. It is about trying to make the connection between 1979 and 1997. . . . The Chalateco and Salvadoran peasants, they like to live in the present, and not remember the past, because of the pain. And we have to understand that as well. The anguish, the sadness, so much that was lived . . . but historical memory gives us meaning. It helps us put our feet on the ground."[44]

This relationship between remembering and forgetting characterizes many Chalatecos' memory work. This is a negotiation of commemorating the armed struggle within a postwar political economy of continued inequality and injustice. It is this tension between a growing political frustration at the grassroots level and a history of organizing for social change that is being worked out in the present and that for many, while the

obstacles are numerous, is the central hope for the future. The Las Vueltas parish priest explains:

> The people say, "Gee, they killed all my family. The war, the cause, the revolution, and here I am more screwed than before." Why are they going to become leaders in the community council? Postwar is new. And here the left has been shortsighted and they are falling into bureaucratic pits. They keep falling into centralism. And they keep making that mistake. And they are swallowing complacency and swallowing capitalism. Regarding hope, I think it is important to realize that we have not lost organizing abilities. We only have to strengthen organization. Critical consciousness has not been lost. It's sort of hoarse but it has not been lost. You know that between hoarseness and losing one's voice there is a difference. The organization is half aphonic, the solidarity, the combative community. . . . I have hope that there will come a time when this fatigue will pass and the people will take over.[45]

However, it is precisely this rescuing of combative values of organizing that becomes the issue in postwar times that leave many former activists asking how much sacrificing, how many suffered memories in order to get justice that is still elusive? Even so, despite all its inconsistencies and continued challenges, peacetime is remarkable because this hard-won battle has brought an end to institutionalized violence. And commemorating a history of organizing unity serves to memorialize the political struggle.

This is a selective process of remembering that attempts to silence wartime and postwar injustices within oppositional struggles. At times this process is successful, as indicated in the militarized development encounter. At other times it is contested, for example, by the lives of single mothers, abandoned during and after the war and remarginalized within communities to the point of living well below subsistence needs.[46] The call to remember and commemorate flows through Chalatenango, constructing a vision of community as both place and people, linked not only in the spatiality of everyday life but through time's sufferings. In Chalatenango this is an invocation of trauma not intended to create more suffering but to forge a struggle that leaders believe is not and cannot be over. It is a call for remembering in order to make sense of loss and to seek healing. As in other parts of El Salvador, memorializing the violence of the civil war moves from socialization practices in the home, to community sites of remem-

brance, to yearly interdepartmental vigils commemorating massacres in communities and the assassination of liberation theology church leaders. And while few people may travel to distant rural communities, the sites of so much wartime violence—in the practices of everyday life, in the constant theorizing on the past, in the oppositional discourses that continue, and in the celebrations commemorating the sacrifices of the dead—Chalatecos combat, as reported in a daily Salvadoran newspaper, the national problem of "*Historia de la Memoria Perdida*" (A Story of Lost Memory).[47]

NOTES

The seventeen months of ethnographic research on which this article builds was made possible through the generous support of many institutions and grants: Tinker Research Fellowship, Fulbright-Hays Dissertation Fellowship, Inter-American Foundation Dissertation Fellowship, and Organization of American States Dissertation Fellowship. I also received writing support from New York University's Dean's Dissertation award and the Charlotte Newcombe Dissertation Fellowship. A postdoctoral fellowship at the Rutgers Center for Historical Analysis allowed me to complete the article. I also thank Lisa Maya Knauer, Ayala Fader, Christine Walley, and Tomás José Silber for their insightful readings and helpful comments.

Throughout this piece I provide pseudonyms for the people who agreed to share their time, experiences, and stories with me, as the majority of participants requested. In my editing of transcribed material, I have "cleaned up" the spoken language, making the narratives appear "neater" than the spoken words. The translations into English are mine.

1. Spence et al., *Chapúltepec*.

2. Because of the circumstances of the event, including rain, constant movement, and a tense atmosphere, I was unable to tape-record conversations. However, interspersed throughout the text I include the interpretations from more formal taped interviews. In these different contexts, at different times, I was both the intended addressee and part of a flexibly constituted audience co-constructing the exchange as speakers and listeners shifted during conversations. The text is supplemented by a series of photographs taken by Antonio Rossi.

3. Structures of inequality continue to marginalize places such as Chalatenango. See Spence et al., *Chapúltepec*. Despite years of emergency relief and development aid, Chalatenango is a poor department in the nation as urbanization accelerates and as El Salvador shifts away from a rural-based agricultural economy. Stephen, *Women's Organizations in Post-Conflict El Salvador*, 6.

4. The ARENA party was founded by Roberto D'Aubisson, one of the central protagonists of the death-squad systems.

5. Montgomery, *Revolution in El Salvador*. The United States bolstered the war

economy, increasing spending from $25 million in 1980 to an annual assistance of $500 to $600 million by the mid-1980s. See Binford, "Hegemony in the Interior of the Salvadoran Revolution," 11–12. After a decade this figure totaled $6 billion. Murray and Barry, *El Salvador*, 15.

6. See World Bank, *El Salvador*. The Office of the Human Rights Procurator has been ineffectual most recently with struggles over naming a new director. The PNC has also been increasingly accused of various levels of corrupt activities. Citizens are losing faith in these institutions (Amnesty International, "El Salvador.").

7. In the March 2000 elections the FMLN for the first time won more seats in the legislative assembly than ARENA. See Spence, "Competitive Party Balance," 6–10.

8. Since the signing of peace accords, homicides have increased 50 percent. Statistics evidence that homicide rates are among the highest in all of Latin America: 150 per 100,000 people. The Pan American Health Organization has declared violence an epidemic. See DeCesare, "The Children of the War."

9. There is a growing field of study that focuses on questions of transitional justice and the role of Truth Commissions. See, e.g., Hayner, *Unspeakable Truths*.

10. Of the twenty-two thousand investigated cases of human rights violations from 1980 to 1991, 85 percent were attributed to agents of the state (armed forces, paramilitary groups, death squads). The report found that the FMLN was responsible for 5 percent of cases of human rights abuse. Naciones Unidas, *De La Locura a La Esperanza*, 41–42.

11. See, e.g., Danner, *The Massacre at El Mozote*.

12. Quoted in Douglas Farah, "Salvadoran Military Denounces U.N. Backed Human Rights Report," *Washington Post*, March 25, 1993, A32.

13. Quoted in Douglas Farah, "Salvadorans Ill-Served by Report, Cristiani Says," *Washington Post*, March 19, 1993, A7.

14. The FMLN was not yet a political party, and the law was passed by the ARENA-held National Assembly and signed into law by President Alfredo Cristiani. Recently the amnesty law was upheld as constitutional. This situation is not particular to El Salvador.

15. See Amnesty International, "El Salvador: Peace Can Only Be Achieved with Justice." The report defines impunity as "the failure to bring to justice and punish those responsible for human rights violations" (1).

16. See, e.g., Alonso, "The Effects of Truth"; Bodnar, *Remaking America*; Brow, "Notes on Community, Hegemony, and the Uses of the Past"; Connerton, *How Societies Remember*; and Stoller, "Embodying Colonial Memories."

17. Halbwachs, *On Collective Memory*. There is also an expansive literature on the psychological and cognitive elements of memory.

18. See, e.g., Borneman, "Uniting the German Nation"; Bruner and Gorfain, "Dialogic Narration and the Paradoxes of Masada"; Rappaport, *The Politics of Memory*; and Tonkin, *Narrating Our Pasts*.

19. Cole, "The Work of Memory in Madagascar."

20. Abercrombie, *Pathways of Memory and Power*, 21.

21. By the late 1970s the new teachings of liberation theology grew throughout the region. This contributed to a radicalized peasantry and the "reawakening" of popular movements. See Cabarrús, *Génesis de una Revolución*; and Dunkerley, *Power in the Isthmus*. These movements were met with increasingly violent repression, and by the early 1980s the military and paramilitary presence in Chalatenango was brutal. As a result of this destruction, most community residents were forced to flee their homes. Many joined guerrilla forces and formed a militant revolutionary movement, and others became internally displaced; but most civilians crossed the border into Honduras and lived in refugee camps for varying amounts of time. See Pearce, *Promised Land*. Scholars, development practitioners, and activists have documented this phase of the war and tracked the historic repatriation that began in 1987 as refugees mobilized to return to their place of origin while the war was still ongoing. See MacDonald and Gatehouse, *In the Mountains of Morazán*; Edwards and Siebentritt, *Places of Origin*.

22. Hallam and Hockey, *Death, Memory and Material Culture*.

23. See Binford, *The El Mozote Massacre*, for a discussion on the museum in Morazán commemorating the El Mozote massacre.

24. Aizenberg, "Making Monuments in Argentina, a Land Afraid of Its Past."

25. Bodnar, *Remaking America*.

26. Ibid.

27. Chayo, resident of repopulated community, interview by author, October 1997.

28. Rolando, a community organizer, interview by author, Nov. 1997. Elsewhere I problematize these locally hegemonic constructions forwarded by counterhegemonic groups (NGOs and grassroots groups) as I focus on the discursive strategies deployed by a range of actors that accuse survivors, particularly women, of forgetting their lived history, their memories of suffering, their struggle and thus inadvertently blame rural residents for failures of development and reconstruction. See Silber, "A Spectral Reconciliation."

29. Cole, "The Work of Memory in Madagascar," 627.

30. Las Vueltas was one of the areas hardest hit during the war and one of the original repopulated communities in 1986 (Pearce, *Promised Land*; Hernandez Rodriguez, M. and K. I. Mendez, Marco Historico-Social y Socio-Cultural de Las Vueltas, Dept. de Chalatenango. IV Año de Lic. En Letras [San Salvador: National University, 1996]).

31. The Las Vueltas community health center, although a government-funded clinic staffed by doctors (final-year medical students doing their year of social service before official graduation), a nurse, and community health promoters (*promotoras de salud*)—generally women who received their training during the war—was intended to meet only the population's basic needs. It operated with limited medicines and staff. Often times the doctor did not arrive from San Salvador, and, indeed, there was a confrontation between her and the health promoters and community residents.

32. Throughout Chalatenango large events often take place in the *grupo escolar* [school area].

33. Of the twelve U.S. doctors, four were pediatricians, and one was a dentist.

34. The assumption was that these Chalatecos needed basic education on home and community hygiene; on dengue fever, which was epidemic at the time; and on common parasite problems. Note that while the soldier discussed dengue fever and mosquitoes, the displayed poster on AIDS (SIDA) was never discussed. Based on the spread of AIDS in El Salvador, one of the highest rates in Central America, perhaps this would have been a more useful educational intervention.

35. See Hammond, *Fighting to Learn*, for a discussion on the role of popular education in El Salvador's revolutionary struggle.

36. It was never clear why haircuts were offered, perhaps to address lice, which were a common problem, or perhaps because authorities thought it might be good public relations.

37. The first visit took place in La Union, followed by a mission in San Miguel. He explained that the team we were seeing had worked in Cuscatlan and would be in Chalatenango for two weeks.

38. We code-switched from Spanish to English throughout the exchange. He explained he had received a fellowship to participate in a workshop in Canada in a peace and reconciliation institute.

39. This is a very similar negotiation to that which takes place during electoral campaigns, when ARENA political party members arrive at Chalatenango to give away free T-shirts, baseball caps, playing cards, pencils, etc. in attempts to recruit votes. While some residents refuse these items, many accept the needed material but perform their loyalty to the FMLN in a series of gestures. These include waiting until an FMLN victory to wear the items or turning the T-shirts inside out. Some children even go to the extent of blocking out "ARENA" with black magic marker and writing in red "FMLN" on these items.

40. Note the convergence of ARENA and the military in the resident's theorizing.

41. When I approached an official, he told me "to be patient and have faith."

42. Zimmerman, Marc. 1991. "Testimonio in Guatemala: Payera, Rigoberta and Beyond." *Latin American Perspectives* 71, vol. 18(4): 22–47.

43. Rappaport, *The Politics of Memory*, 10–11.

44. Parish priest, interview by author, Las Vueltas, Oct. 1997.

45. Ibid.

46. See Silber, "A Spectral Reconciliation," chap. 5.

47. Rosalin Hernández, "Historia de la Memoria Perdida," *El Diario de Hoy*, Sep. 14, 1997, 6–7. The Holocaust literature explores the delicate balance between silence and documenting the horrors of genocide by the generation of survivors. See, e.g., Boyarin, *Remapping Memory*.

THE POLITICS OF REMEMBRANCE

AND THE CONSUMPTION OF SPACE

Masada in Israeli Memory

Yael Zerubavel

The creation of a national memory depends to a large extent on the nation's success in constructing myths and symbols, rituals and celebrations, monuments and museums, and other cultural texts that provide symbolic arenas for narrating the nation. These multiple commemorative forms establish a shared history and cultural heritage and highlight major themes of continuity between the past and the present.[1] Hence, significant social and political changes in the nation's life inevitably involve the negotiation and transformation of its collective memory. Under the pressure of a changing political landscape, existing commemorative forms may decline or be subject to reinterpretation, and new commemorative forms may emerge and threaten to take their place.

The sanctification of time and space constitutes an important dimension in the process of constructing a national memory. The memory of certain historical events, which assume the symbolic significance of turning points in the nation's past, may be anchored in a variety of commemorative sites: these can be temporal commemorative loci, such as holidays or memorial days, or spatial commemorative loci, such as the place where an event took place or a monument erected in memory of that event. Texts and rituals constructed around those temporal and spatial sites further reinforce their significance and contribute to shaping the memory of the particular event. Investigating the cultural meaning of the past and its construction and transformation over time, therefore, calls for exploring the specific commemorative loci associated with certain events.

This essay explores the construction of a national memory around a historical narrative and a geographical site and the interplay between their meanings and political uses. The sole narrative about that event, which had been neglected for centuries, was "recovered" from the historical chronicles as an important part of an awakened national memory,[2] while the site that had constituted "a place on the margins"[3] evolved into a popular

destination of youth pilgrimage and a national shrine. Yet the meaning and status of both narrative and site have been subject to major transformations in recent decades. This essay thus examines the reshaping of a national memory under the pressure of a highly dynamic political reality, as it studies the relations between the competing interpretations of the record of the past and the significant changes in the commemorative locus associated with it.

The site in question is a mountain located on the eastern edge of the Judean desert, near the western shore of the Dead Sea. Elevated dramatically above its surroundings at the height of thirteen hundred feet, with a wide plateau at its top, the mountain was used as a site of refuge during the Maccabean period and was rebuilt as a fortress by King Herod during the first century BCE. It is not surprising, therefore, that its name, Masada, implies a fortress in Hebrew. In the middle of the nineteenth century non-Jewish explorers identified the mountain as the location of a Jewish last stand reported by the ancient Jewish historian Josephus Flavius in his opus magnum, *The Wars of the Jews*.[4]

The identification of the site might have remained a footnote in the annals of the modern exploration of the Holy Land had the story of Masada remained an esoteric episode in Josephus's work. Although the event he described goes back to 73 CE, it assumed a major symbolic significance during the twentieth century as a result of the emergence of Zionism as a Jewish nationalist movement and the Jewish immigration to Palestine. Like other nationalist movements, Zionism created its own political spin on Jewish history, selectively highlighting certain aspects of the past and playing down others. The Zionist pioneers considered the period of Antiquity during which Jews lived in their own homeland as the historical foundation and the model for their own national aspirations. Within this framework the ancient Jewish revolts became particularly important as a source of inspiration for the Zionist struggle to revive Jewish national life in Palestine.

Josephus's narrative about the events that took place in Masada at the end of the Jewish Revolt of 66 to 73 CE is included in his *The Wars of the Jews*. Accordingly, Masada remained one of three outposts that continued to hold out against the Romans after the latter had conquered Jerusalem in 70 CE and celebrated their victory in Rome. A Roman army consisting of close to ten thousand soldiers (and aided by a great number of Jewish slaves) put a siege around the mountain, where nearly one thousand Jewish

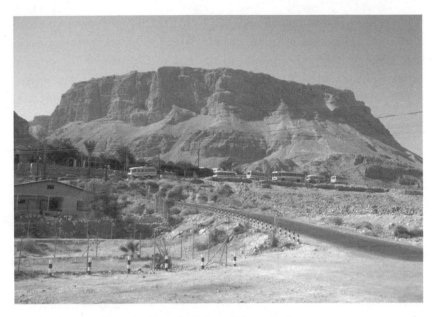

1. A distant view of Masada. Photo by Ya'acov Sa'ar, 1980. Courtesy of Israel's Government Press Office.

men, women, and children had taken refuge. After a prolonged siege, when it became clear that the Romans were about to conquer the place, the leader of the Jewish rebels, Elazar ben Yair, presented his final plan to his men: the men should slay their wives and children and then kill themselves so as to die as free people rather than be enslaved by the Romans: "Since we long ago, my generous friends, resolved never to be slaves to the Romans, nor to any other than God himself, who alone is the true and just Lord of mankind, the time is now come that obliges us to make that resolution true in practice" (Josephus 7.8.6). The leader had to persuade his followers, but at the end they agreed to carry out his plan. Josephus reports that the men had killed their own wives and children and having selected by lots those ten who would slay the others, decided that the last one would set the place on fire before killing himself. When the Romans entered the site, Josephus notes, they were shocked to find 960 dead bodies and only two elderly women and five children who had escaped this scene of death. The awe the soldiers felt at this horrific sight, Josephus writes, denied them any joy of victory.

The author of this narrative, who had initially held a leading position in the Jewish revolt, later chose to surrender to the Romans and devoted his

life to historical writing under the auspices of the Roman court. Although the Church preserved Josephus's works, which provided important documentation of the period related to the rise of Christianity, the original Aramaic version of his *The Wars of the Jews* had been lost.[5] No other ancient Jewish or Roman record recounts a last stand at Masada, and no mention of it exists in the Jewish Talmud. The story of Masada reentered the Jews' records of the past only in the tenth century, when a popular chronicle entitled *The Book of Jossipon* included a modified version of Josephus's narrative.[6] Though now accessible to Jewish readers, the story of Masada remained a marginalized episode that did not leave an obvious mark on Jewish memory.

With the emergence of a new scholarly Jewish interest in ancient Jewish history during the second half of the nineteenth century (the first Hebrew translation of *The Wars of the Jews* was published in 1862) and with the rise of Zionism toward the turn of the century, Josephus's history of the ancient Jewish wars became an important source for Jewish national memory. In the budding national Hebrew culture in Palestine, the Zionist settlers' and the Hebrew youth's intense fascination with the Judean wars of liberation led to an enthusiastic reception of a new, modern translation of *The Wars of the Jews* in Palestine in 1923. A poem entitled *Masada* by the poet-settler Yitzhak Lamdan, which was published four years later, further contributed to a growing public awareness of Masada.[7]

Masada thus began its move from the periphery of Jewish history to the center of Zionist memory. In fitting with the predominantly secular national framework of the prestate period, Zionist memory regarded the ancient men's final act as affirming the existence of a Jewish national spirit of heroism and readiness for patriotic sacrifice in Antiquity, which it described as painfully missing from centuries of Jewish life in exile. The secular national Hebrew culture constructed the ancient Jewish rebels as heroes who should be praised for their defiant spirit and unyielding resistance to the Romans and their honorable choice to die free rather than be killed or enslaved by the enemy. These ancient Hebrews therefore became a positive model for the Zionist Hebrew youth, providing a sharp contrast to the discredited image of the exilic Jew as too spiritual, feminine, and dependent on others.

The geographical site was a critical factor in the rise of the Masada myth within a rapidly developing national culture. "Knowing the land" was a highly important subject in Zionist education that emphasized the study of

Jewish history and the land of Israel through traveling and trekking in it. Masada emerged as a particularly suggestive and challenging destination for such fieldtrips. A new ritual tradition of school trips to Masada by Hebrew youth that began in 1912 indicated its potential educational value.[8] The location of the site in the Judean desert and the lack of roads leading to it required several days of trekking, and the route was physically demanding and dangerous. The youth had to find their way in the desert terrain faced with the heat, the risk of dehydration, and the danger of hostile encounters with Bedouins or of being discovered by the British mandatory police that prohibited those trips. When they arrived at Masada, they had to climb up the slopes with the aid of ropes hanging over the abyss. In spite of several fatal accidents, legal prohibitions, and adults' warnings, the youth insisted on continuing these traditions.[9] Although trips to the Judean desert were officially suspended for several years, Hebrew youth movements and underground groups reestablished them in the 1940s, and they became an important part of the groups' patriotic education and paramilitary training during the war years and after.[10] These hardships reinforced the sense that the trip to Masada was essentially a form of pilgrimage and that reaching it fulfilled a national mission of symbolically reembracing a sacred ancient past. The limited accessibility of the site thus contributed to the appeal of Masada as a national myth and reinforced the association between the story of the ancient last stand with the Zionist emphasis on the revival of the spirit of active heroism, determination, and the readiness for self-sacrifice.

The pilgrimage experience culminated in the act of reaching the top of the mountain, overlooking the huge desert vistas and the Dead Sea. To further enhance this moment, the climb was often scheduled before dawn or during the late afternoon, in time to watch the sunrise or the sunset from the top of the mountain and its remarkable impact on the view of the surrounding desert and the Dead Sea. The pilgrimage lesson was further enhanced by a ritual reading of Josephus's narrative about Masada, followed by excerpts from Lamdan's poem. The powerful impact of listening to Josephus's story at the very site where the event took place contributed to the participants' identification with the ancient Jews who had lived and died on that spot. The dramatic effect of this ritual reading was further heightened when conducted at night by the light of torches. Engulfed by the darkness of the night and the stillness of the desert, the fire inscriptions of "Masada Shall Not Fall Again" further dramatized the educational and

patriotic message of the pilgrimage and turned Lamdan's verse into a collective vow.[11]

The pilgrimage was thus encoded with multiple meanings that supported the powerful mission of narrating the nation. Overcoming the hardships on the way represented the youth's ability to follow the footsteps of the ancient Masada people and their similar resolve to actively contribute to the Zionist national struggle. During the 1940s, within the context of the Nazi persecution of Jews in Europe, it also served to prove the success of the Zionist goal of raising a new type of Jew who would vow to fight until the very end to ensure the national survival.[12] The pilgrimage thus became a ritual of initiation that marked participants' transformation from exilic Jews into native Hebrews. The prevailing custom of holding those trips during the major holidays of Hanukkah and Passover added another symbolic dimension to Masada: since Zionist memory emphasized their historical significance as commemorating successful national struggles, this association lent Masada a redemptive meaning that helped obscure the theme of suicide. Both the geographical and the temporal commemorative loci thus contributed to the evolution of Masada as a key symbolic narrative of patriotism and heroic spirit during the formative years before the foundation of the State of Israel in 1948 and the first decades following statehood.

The rise of Masada as a national myth was based on a selective reading of Josephus's story that ignored or belittled the problematic aspects of a collective suicide and largely drew on contemporary patriotic rhetoric of the nation-building era. As a participant in the early pilgrimage to Masada in 1942 explains the place of the suicide within that framework: "We regarded Masada as a war of liberation, a heroic struggle, a war of a few against many, a war in the name of loyalty to the country and the people. . . . We saw the suicide as an event that happened within the context of that war."[13] Similarly, a youth leader who had played a prominent role in promoting Masada and the youth pilgrimage, Shmaryahu Gutman, describes in an interview with Nachman Ben-Yehuda: "I wanted to bring ourselves, the young adolescents, to the point where they would have the willingness to fight to the bitter end. . . . At some periods we wanted to turn this into a symbol—not to die, not to commit suicide, but to be ready for whatever is required for the goal in which you believe."[14]

The national heroic interpretation thus transforms the story of the last stand at Masada from a final chapter of Antiquity that ends with death and

destruction to a narrative that leads to a national renewal by inspiring the Zionist revival.[15] As Gutman claims: "A generation of youth was raised by Masada. This is the generation that created the state, the generation of defense in its various manifestations. Masada has been the source of power and courage to liberate the country, to strike roots, and defend the whole territory."[16] Masada, therefore, does not refer to a bygone past but serves as a gate to the future and has become a historical metaphor for contemporary Israel. As an Israeli I interviewed on the meaning of Masada said: "The whole country is like Masada. . . . We have to fight until the very end, not to yield and not to give up."

Although Israel achieved independence in 1948, this date does not constitute a landmark in the development of the collective memory of Masada. Israel faced immediate challenges that forged a sense of a continuing struggle through the next decade, as it fought against the Arab countries following its declaration of independence, and as it was faced with accommodating a massive immigration of Jewish refugees from European and Middle Eastern countries in the late 1940s and the 1950s. During the 1950s the national heroic interpretation of Josephus's narrative continued to be predominant. The youth pilgrimage was now organized for young adults as the site became more accessible with the paving of a new road through the Judean desert and the restoration of the ancient "snake path" to reach the top.[17]

The major watershed in the development of Masada occurred in the mid-1960s, when the Hebrew University, with the government's support, undertook a highly ambitious project of excavation and restoration of the site. Led by Professor Yigael Yadin, a senior professor of archaeology and a former chief-of-staff of the Israel Defense Forces (IDF), the archaeological expedition enjoyed a remarkable collaboration and support from various government programs and public agencies. Clearly, the archaeologists' and the government's recognition of the national significance of the site and its strong potential as a tourist attraction explain the scope of this project and the investment of state funds and foreign donations in it. Yadin's decision to open the expedition to Israeli and foreign volunteers further contributed to the publicity it attracted, and news about the excavation, the volunteers, and discoveries made at Masada thus kept it in the limelight for many months.[18] In his popular account of the excavation Yadin openly admits that his approach is to find evidence to support Josephus's account, and his writing reflects his acceptance of the heroic national interpretation of

Josephus's narrative. He repeatedly emphasizes the participants' strong identification with their ancient forefathers who lived and died at Masada,[19] and he articulates his view that the excavation is a sacred national mission: "Masada is no ordinary site, and we had to concern ourselves not only with our own immediate expedition but with the future—with the hundreds of thousands of visitors drawn by the drama of Masada, who would wish to see something of the physical remains of Masada's past. We therefore decided on a procedure quite different from that customarily followed in an archaeological excavation."[20]

The findings from the excavation of Masada became the subject of an exhibit displayed in Israel and abroad. The State of Israel issued a medal in 1965 featuring Lamdan's verse "Masada Shall Not Fall Again" at the front center, while the back carries ben Yair's line: "We Shall Remain Free Men" (see fig. 3). The findings, which became part of the permanent exhibit of the Israel Museum in Jerusalem, and the medal highlight the symbolic importance of Masada in Israeli national memory as a bridge between the past and the future.

The excavations made a profound impact on the site itself. Whereas in the earlier period the physical setting and its symbolic meaning were at the center of the Masada experience and the ancient ruins played a minor role as a backdrop, following the archaeological dig, the restored structures became the focal point of a visit to Masada. The extensive archaeological site that spreads over the vast plateau of almost 2000 feet from north to south and 650 feet from east to west holds numerous ancient structures, including palaces, villas, baths, water cisterns and storage rooms, a synagogue, and a *mikvah* (a ritual bath), as well as later structures added by Byzantine monks. Moreover, Masada was transformed from an open public space accessible to anyone who makes the effort to reach it, during the prestate period, to an official national park regulated by the Israeli National Park Authority, where entry costs money and is limited to official visiting hours. These changes affected, and continue to affect, the character of the site as well as the experience of visiting it.

The surge of nationalism and euphoria in response to the sweeping victory in the 1967 Six-Day War, which followed a period of increasing anxiety over Israel's isolation and ability to survive prior to the war, contributed to a growing identification with the ancient people of Masada. Israeli memory thus constructed a close affinity between the ancient and the modern national fighters, which was clearly manifested in the 1969

2. Israeli youth volunteers work at the archaeological excavation on Masada. Photo by Fritz Cohen, 1963. Courtesy of Israel's Government Press Office.

3. A Masada medal issued by the Israel Government Coins and Medals Corporation in 1965. On the front side (left): the famous verse "Masada Shall Not Fall Again," encircled by figures of soldiers participating in the archaeological excavation at Masada. On the back side (right): image of the Masada mountain, with Elazar ben Yair's words reported by Josephus: "We Shall Remain Free Men." Courtesy of Israeli Government Coins and Medals Corporation.

official burial ceremony of twenty-seven skeletons, identified as the re-
mains of "the Zealots who died in the defense of the fortress two thousand
years ago"[21] (fig. 4). The state of Israel thus provided these bones the same
military burial as contemporary Israeli soldiers who die in the defense of
the state, incorporating the ancient Masada men into Israel's official mem-
ory as the defenders of the Hebrew nation. The Armored Corps' practice
of holding swearing-in ceremonies for its new recruits at Masada was
similarly based on this symbolic identification. These military ceremonies
also continued the 1940s tradition of youth pilgrimages, complete with
trekking through the desert and up the mountain, as well as the use of fire
inscriptions of Lamdan's verse, "Masada Shall Not Fall Again" (see fig. 5).
This ritual tradition continued to highlight Masada's patriotic message of
heroism and resistance to the enemy and ignore the act of suicide.

From the late 1960s on, the popularity of the heroic narrative and the
changes that took place in the site turned Masada into one of Israel's most
important national myths and best known tourist attractions. The control
over new territories in the Judean desert following 1967 made it possible to
construct a much faster and shorter road from Jerusalem to Masada, one
that may take less than a couple of hours to drive. Numerous private tours
and public transportation make the site highly accessible. A cable car saves
visitors the effort of climbing the mountain, and those who wish to get to
the top on foot can take the carefully restored "snake path" that is much
safer and easier than it had been during the earlier trips to Masada. The
highly developed beach resort at the shore of the Dead Sea offers a wide
range of facilities for those who wish to stay in the vicinity of the site and
adds to the appeal of this area. From around forty-two thousand visitors in
1965 and 1966, the number of visitors reached around a half million per year
during the late 1970s and the 1980s and further increased in the mid-1990s.[22]

Although Masada still offers the appeal of a desert site where the heat
poses a challenge even to the modern tourist, a view that is breathtaking,
and a powerful story, the new changes that were introduced at the site
undermined the concept of a long and trying route that was at the core of
the pilgrimage tradition to Masada. Youth movements, military units, and
some school trips, as well as the more adventurous visitors, maintain the
tradition of trekking in the desert and climbing the mountain on foot,
yet most visitors arrive at the site by car or tour bus, and the majority
reaches the plateau by way of the cable car. For most visitors, then, the

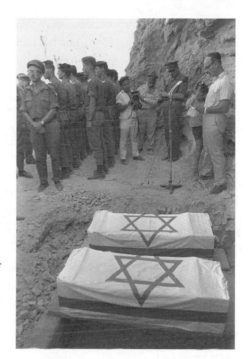

4. Professor Yigael Yadin speaking at the burial ceremony of the remains of the last defenders of Massada, held at the foot of Masada in 1969. Photo by Moshe Milner. Courtesy of Israel's Government Press Office.

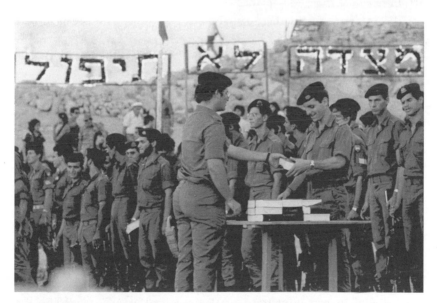

5. Armor Cadets' swearing-in ceremony, with the fire inscription of Lamdan's verse, "Masada Shall Not Fall Again," held at Masada on Oct. 14, 1981. Courtesy of the Israel Defense Forces Spokesperson Office.

once challenging, time-consuming, and risky visit to Masada has turned into an *instant pilgrimage*. Furthermore, the state orchestrates performances that are oriented to tourist consumption, such as the sight and sound show for Israel's thirtieth anniversary, or the extravagant performance of Mahler's *Resurrection* symphony at the site by Israel's national orchestra to mark Israel's fortieth anniversary.[23]

The archaeological excavations transformed the character of the site in other, no less significant, ways. Whereas the Masada myth took hold primarily within the secular national Hebrew culture and around the ritual tradition that developed in the Sabra youth culture, the archaeologists' identification of an ancient synagogue and a ritual bath at Masada changed the definition of this space, rendering it a religiously sanctified ground. A new tradition that Israeli schools initiated, namely, the celebration of bar mitzvah or bat mitzvah ceremonies at the Masada synagogue, has become increasingly popular among non-Israeli Jews since the 1970s (fig. 6). The possibility of holding these ceremonies in the open space in the desert and among the ancient ruins offers a dramatically different experience of this ritual and enhances the importance of Masada for the Israeli tourist industry. In recent decades Masada has been packaged as a desired destination for the performance of these rituals within a broader experience of a "heritage trip" to Israel. As a banner I recently spotted on an Israeli tourist bus succinctly advertises the product: "Bar / Bat Mitzvah on Masada: Discovery. Heritage. Experience."

The site's growing tourist appeal nonetheless weakened its status as sacred national space. The publicity of the excavations made famous the national-heroic myth of Masada, which had been little known outside of the secular national youth culture in Israel prior to the 1960s. As a result the Masada myth began to attract greater critical scrutiny both abroad and in Israel. Moreover, Israel's social and political landscape has gone through dramatic changes since the 1970s: the national consensus began to break down, and the society has become increasingly divided along political, economic, religious, and cultural lines. The Labor Party, which once held the dominant position in Israeli political life, lost its place to the Likud Party in 1977 and the growing split between the right and left has deepened. Religious and immigrant parties emerged as new players in the Israeli political scene, weakening the negative attitude toward the Jewish exilic past typical of the earlier period. The collective trauma of the 1973 Yom Kippur War and the continuing loss of lives in the Israeli-Palestinian

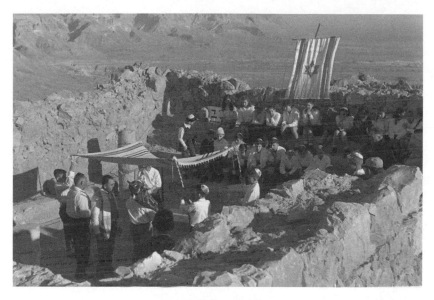

6. A bar mitzvah ceremony conducted at the ruins of the first-century synagogue at Masada. Photo by Moshe Milner, 1967. Courtesy of Israel's Government Press Office.

conflict have enhanced Israelis' identification with Jewish victimization (earlier associated with the history of exile) and led to a more active embrace of the Holocaust and its memory. These changes have given rise to competing versions of Masada in contemporary Israeli society.

The challenge of the national heroic meaning of the Masada myth should be seen within the context of widening rifts within the society and the weakening of other Israeli heroic myths since the 1970s.[24] Even the proponents of the Masada myth have developed an alternative reading of Josephus's narrative that underscores its importance not as a positive model to emulate but rather as a major historical example of the continuing threat on Jewish survival from Antiquity to date. From this interpretive perspective Masada is analogous to the Holocaust, representing Jewish victimization, and Lamdan's famous line, "Masada Shall Not Fall Again," assumes the meaning of "never again" that refers to the Holocaust. This interpretation does not ignore the act of suicide but rather highlights the significance of the horrific situation that the Jews faced, which left suicide as the only viable solution. Ironically, while the national heroic meaning of Masada emerged out of the desire to accentuate the value of "active heroism" in contrast to the Holocaust and to a centuries-old exilic pattern of

victimization and suffering, this reading of the myth collapsed this distinction into a historical analogy.[25]

This reading of Masada recognizes the political uses of the narrative as supporting Israel's determination to remain strong and not to compromise its security in order to avoid the repetition of a Masada situation. It is this meaning of Masada that has turned it into an official stop on VIPs' visits to Israel (see fig. 7), along with Yad Vashem Memorial for the Holocaust in Jerusalem. The visit to the isolated and remote site that is surrounded by the open vistas of the desert provides visitors with a visual representation of contemporary Israel as standing alone, surrounded by Arab countries, left to defend itself or face a destruction similar to that of the ancient Masada people.

■ ■ ■

Following the excavations and the changing political landscape of Israeli life, criticism of the national-heroic myth has come from widely ranging, and at times incompatible, perspectives. While some criticism focuses on the validity of Josephus's narrative and the archaeologists' evidence, its main thrust is directed at the process of transforming this narrative into a highly charged symbolic text that represents modern Israel. I will not dwell here on the scholarly arguments expressing skepticism about the historical validity of Josephus's narrative and questioning its use as a foundation for the construction of a national myth. Suffice it to mention that such arguments target Josephus's personal stake in writing the history of the war in which he took part and the cause that he later abandoned, his personal position in the imperial court, the standards of historical writing in Antiquity that lead critics to consider ben Yair's much quoted speech as fabrication by Josephus, Yadin's admitted bias in interpreting archaeological evidence in support of the national heroic meaning of the myth, and the common reference to the Masada men as "Zealots" that ignores their identification by Josephus as members of the extremist Sicarii.[26]

Much of the scholarly and popular criticism of the glorification of the Masada myth has focused on the problematic aspects of mass suicide that the national heroic interpretation obscures. Here, the criticism stems from divergent ideological perspectives. An intense legalistic religious (*halakhic*) polemic revolves around the debate over whether the Masada men violated the strict prohibition against "suicide" in their choice of self-inflicted death or performed a praiseworthy act of "martyrdom."[27] Other critics

7. U.S. president Bill Clinton (center) visiting Masada
with his family, accompanied by Israeli prime minister
Binyamin Netanyahu and his wife (left). Dec. 15, 1998.
Photo by Avi Ohayon. Courtesy of Israel's Government Press Office.

condemned the suicide on broader ideological grounds, underscoring Judaism's long-standing embrace of the value of survival in the face of persecution. According to this view, by referring to the Masada people as Zealots, the national heroic myth ignores the fact that they represent the extremist Jewish sect of Sicarii, whose views were rejected by mainstream Judaism. Thus, ben Yair's advocacy of suicide represents an attitude that is essentially foreign to Judaism and should not be raised as a model for contemporary Jews.[28] No less powerful is the argument that the construction of the suicide as heroic does not conform to Israeli secular national ideology, which has stressed the value of active resistance to the bitter end. The suicide, those critics argue, is a desperate and escapist solution that opposes the spirit of the new Hebrew culture. It is important to note that while some critics condemn the ancient Jews for their choice at the time, most arguments have been directed at the implications of the glorification of Josephus's narrative to contemporary Israeli society.

These alternative readings thus delegitimize the status of Masada as a national myth, and they object most powerfully to its construction as an inspiration and an educational model for contemporary Israelis. Whether

basing their views on strict interpretation of the religious law, the broader understanding of traditional Jewish values, or contemporary Zionist ideology of active heroism, critics attack the national heroic interpretation of Masada as an expression of fanaticism that would lead Israel to self-annihilation. Both the Israeli left and critics abroad thus warn against a political approach that is shaped by what they call "the Masada complex." Turning Masada into a prism for understanding Israel's present situation, they argue, introduces the risk of its becoming a self-fulfilling prophecy.[29]

■ ■ ■

Interestingly, the growing criticism of the myth, on the one hand, and the enhanced commercialization of the site, on the other hand, have contributed to the decline of Masada in Israeli culture. The site has lost much of its appeal as a national shrine and a destination for youth pilgrimage. The armory corps no longer holds its ceremonies there, having transferred them to its own distinct memorial site in Latrun, on the way to Jerusalem. Although the Ministry of Education recommends a trip to Masada for high school students, the trip is not mandatory, and some educators oppose its implementation on ideological grounds.[30]

Yet today Masada is officially recognized as a "World Heritage Site" that attracts foreign visitors. In 1995, out of 740,000 tourists who visited Masada, 625,000 were foreign visitors. Recently the National Park Authority made an extensive renovation to accommodate an even larger number of visitors and further enhance the appeal of the site as a tourist attraction. The construction of a visitor center and a new underground parking lot, as well as the installation of an improved cable car that can transport up to twelve hundred persons per hour, are among these changes.[31] Another factor in the decline of the appeal of Masada for Israeli visitors may be related to the relatively high cost of the tickets to the park, which may have become prohibitive for large families.[32]

The transformation of Masada from a national site cultivated by the secular Hebrew culture during the prestate and early state period into a religious site today highlights the ironies that continue to mark the development of the site and the Masada myth. The discovery of the synagogue and the mikvah did not only sanctify the space as a religious ground but also provided proof of the ancient Jews' deep commitment to religious values that supports the interpretation of their collective suicide as martyrdom. Ironically, whereas the religious argument was at the center

of the earlier opposition to the secular interpretation of Masada, some Orthodox and Ultra Orthodox circles now embrace the place for its religious symbolic value. Thus, a recent flyer published by the Lubavitcher movement (an Ultra-Orthodox Jewish movement that promotes adherence to religious commandments among secular Jews) uses the archaeological finding to demonstrate continuity within Jewish religious observance. The flyer announces: "Masada Lives! The ancient is modern. . . . The past is present. . . . The Mikvah is Here!" and defines the synagogue and the mikvah as the most important discoveries made at Masada and demonstrate the timeless vitality of adherence to ritual bath laws in Jewish life.[33] In this context Masada no longer represents the continuity of patriotic sacrifice and commitment to defend the country against all odds but rather continuity in Jews' religious observance that secular Israelis have abandoned.

In another ironic twist a recent article entitled "In Jenin Masada Was Buried," written by Juliano Mar-Hamis, adopts the Jewish Masada myth to the Palestinian cause. Published on the Web site of the Israeli propeace organization, Gush Shalom, on June 18, 2002, the piece opens with the following statement: "In the battle of Jenin the Palestinian People erected the mountain of Massada."[34] The Palestinian writer suggests an analogy between "the Jewish myth of heroism and sacrifice" and the Palestinians' death for their national freedom in Jenin and, echoing Josephus's description of the Roman legions who entered the site of Masada in Antiquity, asserts that the Israeli army would not be able to celebrate a victory in the face of this deadly sight. The Palestinian thus turns the Masada myth on its head as he co-opts its national heroic rhetoric in support of the Palestinian cause against the Israelis, who had created this myth. Ironically, however, he addresses Israeli Jewish readers on the left, who are likely to have already rejected the national heroic rhetoric of "the Jewish Masada."

The analysis of the changes in the meaning of Masada thus shows that national memory does not develop linearly or uniformly and that it can continue to be subject to significant modifications over time. While the Masada myth supported the process of nation building during the earlier history of Israeli society, the political pressures of a rapidly changing political terrain have produced multiple, and often incompatible, meanings in later decades. The multiple meanings of Masada that coexist within the culture reflect the breakdown of a national consensus and the deepening political divisions within contemporary Israeli society. The study also re-

veals how changes in the geographical site have played into the overall changing significance of Masada in contemporary Israeli society, reinforcing the weakening of Masada as a national heroic myth. In spite of all these changes the case of Masada illustrates the working of memory through the creation of symbolic bridges between the past and the present. In spite of its twists and changes Masada continues to serve as a lens through which both its proponents and critics examine contemporary political reality.

NOTES

1. Halbwachs, *The Collective Memory*.

2. Lewis, *History*; Zerubavel, *Recovered Roots*.

3. Shields, *Places on the Margin*.

4. Josephus describes the events that took place at Masada in his *The Wars of the Jews*, bk. 7, chaps. 8–9; repr. in his *Complete Works*, 598–603. On the history of the site and its rediscovery see Aharoni, *Metzada* [Masada], 3–26; on the early discovery of Masada see Yadin, *Masada: Herod's Fortress*, 1–2, 231.

5. For Josephus's description of his decision to surrender to the Romans see *The Wars of the Jews*, bk. 3, chap. 8, 514–16. See also *Encyclopaedia Judaica* (Jerusalem: Keter, 1974), s.v. "Josephus"; Thackeray, *Josephus*; and Rappoport, *Josephus Flavius*.

6. Jossipon's version of the fall of Masada differs from Josephus's version in one significant detail, recounting that after having slaughtered their women and children, the men died in the battlefield. See Flusser, *Sefer Yosifon* [The Book of Jossipon], 423–31.

7. The modern Hebrew translation of *The Wars of the Jews* by Y. N. Simhoni was published by the Masada publishing house [*sic*!] in 1923. See also Lamdan, *Masada*; and the English translation by Yudkin in his *Isaac Lamdan*. Both works became widely read. For a further analysis of the impact of this poem on the rise of the Masada myth see Schwartz, Zerubavel, and Barnett, "The Recovery of Masada."

8. On the early trips to Masada, see Ilan, *Li–Metzada be-Ikvot ha-Kana'im* [To Masada in the Zealots' Footsteps]; Ziv, "Lichbosh et ha-Har" [To Conquer Masada].

9. Azaryahu Alon estimates the casualties during those early trips at approximately twenty-five youth in "Me Haya Midbar Yehuda Avurenu?" [What the Judean Desert Meant for Us] in Naor, *Yam ha-Melah u-Midbar Yehuda* [The Dead Sea and the Judean Desert], 270–75; Shmaryahu Gutman, in a radio interview in Kol Yisrael [Israel's Voice] on January 12, 1968: "Shemaryahu Gutman, ha-Meshuga li-Metzada" [Shmaryahu Gutman, the Masada Fanatic]; see also the exchange about the symbolism of Masada for the youth in *Ba-Mahane* magazine (N., "Ken, Lelo Takhlit" [Indeed for No Purpose], 59 [May 11, 1942]: 11; and Ben-Avoya, "Ha-Omnam Lelo Takhlit?" [Is It Really for No Purpose?], 60 [June 5, 1942]: 10).

10. Bitan, "Metzada: Ha-Semel veha-Mitos" [Masada: The Symbol and the Myth]; Zerubavel, *Recovered Roots*, 64–65, 119–29; Ben-Yehuda, *The Masada Myth*, 83–146.

11. On the use of fire inscriptions see Katriel, "Rhetoric in Flame."

12. On the meaning of Masada as a countermetaphor to the Holocaust during those years see Zerubavel, "The 'Death of Memory' and the Memory of Death."

13. Ephraim Bloch in "Si'ah Sayarim" [Scouts' Conversations], in Naor, *Yam ha-Melah u-Midbar Yehuda* [The Dead Sea and the Judean Desert], 243. See also Yigael Yadin's introduction to *Metzada* [Masada], a brochure prepared by Mikha Livne and Ze'ev Meshel, issued by the National Parks Authority, n.d.

14. Ben-Yehuda, *The Masada Myth*, 77.

15. Klausner, *Historia shel ha-Bayit ha-Sheni* [The History of the Second Temple], 289; Weitz, *Seviv Metzada* [Around Masada], 14. The identification with Masada that the pilgrimage tradition reveals was expressed also in the selection of "Masada" to name various Zionist groups, a publisher, and a settlement in Palestine.

16. Gutman, introduction to Ilan, *Li–Metzada be-Ikvot ha-Kana'im* [To Masada in the Zealots' Footsteps], 3.

17. Aharoni, *Metzada* [Masada], 27; and Weitz, *Seviv Metzada* [Around Masada], 16.

18. Yadin, *Masada*, 11–17; Pearlman, *The Zealots of Masada*; Ben-Yehuda, *The Masada Myth*, 50–68.

19. Yadin's subtitle of the Hebrew edition of his book, *In Those Days at this Time*, which is borrowed from the Hanukkah prayer, emphasizes the sense of continuity between the past and the present. See also such statements about the contemporary participants' identification with the ancient Masada people in Yadin, *Masada*, 16–17, 21. See also Baila A. Shargel, "The Evolution of the Masada Myth." *Judaism* 28 (1979): 357–71. For a more detailed discussion of Yadin's views in the context of his biography, see Silberman, *A Prophet from Amongst You.*

20. Yadin, *Masada*, 88

21. *Kol Israel* [Israel's Voice], radio news magazine, July 7, 1969, tape archives of the Israel Broadcasting Authority.

22. The numbers appear to fluctuate during wartime. For more detailed statistics see Ben-Yehuda, *The Masada Myth*, 198–201.

23. These performances were mostly attended by foreign visitors and dignitaries, whereas the Israeli public watched them on television. For the emphasis on the tourist consumption of this national site and the loss of popular appeal see Ronit Vardi, "Metzada" [Masada], *Yediot Ahronot,* Oct. 14, 1988, 1; Yigal Tomarkin, "Ma Bein Mahler ve-Har ha Shulhan be-S.A.?" [What Does Mahler Have to Do with the Mountain?] *Ha'aretz Weekend Magazine,* Oct. 7, 1988, 23; and Hayim Broide, "Metzada Nafla Shenit" [Masada Fell Again], *Yediot Ahronot,* April 8, 1991.

24. For a comparative view of Masada and other major Israeli national myths see Zerubavel, *Recovered Roots*, 147–213; see also Rogel, *Tel Hai*; Harkabi, *The Bar Kokhba Syndrome*; Zertal, "Ha-Me'unim veha-Kedoshim: Kinuna shel Martirologia Le'umit" [The Tortured and the Martyrs]; Sternhaell, *The Founding Myths of Israel.*

25. See Zerubavel, "The 'Death of Memory' and the Memory of Death."

26. For a more extensive discussion of the scholarly debate on the historical and archaeological issues see Ben-Yehuda, *Sacrificing Truth*.

27. Neria, "Hit'abdut Lada'at" [Suicide]; Rabbi Shlomo Goren published his view defending the suicide at Masada in "Mitzvat Kiddush he-Shem le-Or ha-Halakha" [The Heroism of Masada in View of the Jewish Law]; see also Heller, "Masada and the Talmud"; Hoenig, "The Sicarii in Masada"; Hoenig, "The Historic Masada and the Halakha"; Frimer, "Masada in Light of the Halakha"; Kolitz, "Masada: Suicide or Murder?"

28. See Zeitlin, "Masada and the Sicarii"; Zeitlin, "The Sicarii and Masada"; and Zeitlin "The Slavonic Josephus and the Dead Sea Scrolls." See also a series of articles by Weiss-Rosmarin: "Masada and Yavne"; "Masada, Josephus, and Yadin"; "Reflections on Leadership"; and "Masada Revisited"; and Binyamin Kedar, "Tasbikh Metzada" [The Masada Complex], *Ha'aretz*, April 22, 1973, 16 .

29. See, e.g., Alsop, "The Masada Complex"; Alsop, "Again, the Masada Complex"; Alter, "The Masada Complex"; Kedar, "Tasbikh Metzada" [The Masada Complex] (see note 28); Bar-Tal, "The Masada Syndrome."

30. Nonetheless, when a major high school in Tel Aviv decided to cancel its tradition of trips to Masada in 1997 for ideological reasons, this decision provoked public criticism and reanimated the earlier controversy on the meaning of Masada. The debate in response to this decision was carried in a major Israeli paper, *Ha'aretz*. See Merav Nesher, "Shenei Batei Sefer bi-Yeushalayim Bitlu Siyurim Bi-Metzada" [Two Schools in Jerusalem Cancelled Trips to Masada], *Ha'aretz*, March 25, 1997, A1, A8; and Muli Peleg, "Kesem ha-Konsenzus" [The Charm of the Consensus], *Ha'aretz*, March 30, 1997, B2; Letters to the Editor, *Ha'aretz*, April 1, 1997, B14; and Amos Carmel, "Mitos Shelo Nas Leho" [The Myth Has Not Declined], *Ha'aretz*, April 8, 1997, B2.

31. Merav Nesher, "Mashber Arachim al Shevil ha-Nahash" [Crisis of Values on the Snake Path], *Ha'aretz*, March 26, 1997, B2. See also Nesher's report in the same edition, "Pahot Yisra'elim Mevakrim bi-Metzada" [Fewer Israelis Visit Masada] (A5); Irit Rosenblum, "Rachevel Hazar li-Metzada" [A New Cable-Car at Masada], *Ha'aretz*, Aug. 28, 1999; and Esther Zandberg, "Li-Metzada Derech ha-Martef" [To Masada Via the Basement], *Ha'aretz*, Dec. 21, 2000, D1–2.

32. Breude, "Metzada Nafla Shenit" [Masada Did Fall Again], *Yediot Ahronot*, April 8, 1991.

33. The undated flyer is primarily directed to women and therefore highlights the importance of the mikvah and the observance of laws of purity related to its use by women. It provides the phone numbers of both the Lubavitch Women's Marriage Foundation and the Lubavitch Youth Organizations in the New York metropolitan area. I thank my daughter Noga for bringing this flyer to my attention in 2000.

34. See http://gush-shalom.org/archives/mesada_eng.html (accessed March 17, 2004).

■ *The final section of this volume marks a further conceptual shift in reframing what is understood as public history. While the earlier essays invoke the role of the imagination, discourse, and human agency, they primarily concentrate on space and place, on visual representations of public history (even those that have not been fully realized). We are closing the book by opening up the parameters, moving beyond the physical and visual to look at how song, ritual, and other types of cultural performance—broadly defined—become means for contesting dominant narratives.*

As Michel de Certeau eloquently argues, hegemonies are rarely seamless, and acts of resistance are not always overt; ordinary people are remarkably inventive in finding gaps and devising alternative readings.[1] As T. M. Scruggs points out in his discussion of Nicaragua, while the neoliberal regimes installed in the 1990s were relatively successful at removing the traces of the FSLN from the physical landscape and dismantling much of the infrastructure that had fueled the Sandinista-era cultural renaissance, they were unable to erase that legacy from collective memory, especially as reflected in the nation's soundscape. In an ironic twist, popular song forms—both specific songs and musical genres—that had flourished and acquired the stature of state-supported culture under the Sandinista government were now relegated to the sidelines as the national airwaves were dominated by foreign music; however, they did not lose their evocative and provocative power.

Conversely, in South Africa, the new government elected into office in the 1990s chose not to eradicate the monuments erected by the former regimes, most particularly the relics of a war that was seen as a defining moment of Afrikaner nationalism. Recall how East European states in the post-Soviet era (for instance, Krylova's story of the Russian opposition to the Grave of the Unknown Soldier) have sought to remove such icons from previous epochs. In contrast, the ANC attempted to surround the monuments to the Anglo-Boer War with revisionist interpretive frameworks and new public rituals, reclaiming them on behalf of all

South Africans while decentering their primacy. Meanwhile, partisans of the now decidedly minoritarian interpretation continued to challenge the "new orthodoxy" through discursive and performative means.

NOTE

1. Certeau, *The Practice of Everyday Life*.

MUSIC, MEMORY, AND THE POLITICS

OF ERASURE IN NICARAGUA

T. M. Scruggs

For the public commemoration of the sixth anniversary of the *triunfo* (triumph) of the Sandinista Popular Revolution, the FSLN (Sandinista Front for National Liberation) convoked its supporters in Managua on July 19, 1985. The strategic location of the capital city and the massive gathering of sympathizers that would assemble in one spot had been considered too risky in previous years because of the repeated threats of invasion or other major military actions by the overtly hostile U.S. government. At this point the war against the *contra* (U.S.-sponsored counterrevolutionaries) had at least stabilized in the countryside, and the major population zones were secure. The massive assembly of over 350,000, more than one-fifth of the nation's total population, faced the stage built along the shores of polluted Lake Xolotlán, the name being promoted for Lake Managua as part of the revolution's recuperation of the nation's indigenous identity. Music was a crucial element in the successful efforts to oust the Somoza dictatorship and had a prominent role in the social campaigns in the early 1980s. Six years from the day the victorious Sandinista troops entered the city, music was a central part of the Managua proceedings that culminated with one of the first major speeches by newly elected president Daniel Ortega. Carlos Mejía Godoy and his brother Luis Enrique began singing even as partici-pants filed in past the shells of buildings left from the catastrophic 1972 earthquake. The music was a mixture of songs from before the 1979 triunfo and contemporary compositions. The music, like the speeches and crowd-repeated slogans, attempted to summon the ethos of the insurrection into the frustrating struggle in the 1980s to realize the fruits of that victory. Several of the earlier songs clearly reverberated in the memory of much of the crowd, as knots of people started singing along with the amplified music.

One song suddenly galvanized the crowd suffering under the midday

sun. To the surprise of my Chilean friends and me, all around us people who had been passive participants loudly sang out the verses; others knew the melody and filled in whatever lyrics they could remember. Here was a case of suppressed historical memory, encoded in music, which was now finding expression openly in the public sphere. The song, known as "*Que se derramen las copas*" (Let's Fill Our Glasses to Overflowing) or "*Los dueles de Sandino*" (The Sorrows of Sandino), dates from the early 1930s. Written by a Sandino follower, it recounts the nationalistic stance of the Sandino-led Army in Defense of National Sovereignty (*Ejército en Defensa de la Soberanía Nacional*) against the invasion and occupation by U.S. armed forces. The music is a *corrido*, the form widely popular in the Mexican Revolution that became the model for songs composed further south in Nicaragua two decades later. A famous line in the song recounts how Sandino responded in kind to the Marines' introduction of decapitation and disfiguration of prisoners and civilians. Sandino is quoted as saying: "At ten to the penny I sell heads of Americans" (*Yo vendo a diez por centavo cabezas de americanos*). This sentence is the last line in one of the lyrics' four-line *coplas* (quatrains) and, typical of corridos, the words are set to a descending slide in the melody that can be exaggerated to emphasize the punch line. More than fifty years after the song's first appearance, the Sandino supporters in Managua relished singing loudly these and other lines where "The General of Free Men" (as Sandino was widely known) chides those who fear that the North Americans are invincible. Though the song had been harbored in popular memory in the northern highlands, where Sandino's movement had been based, most people at the rally had learned the song from its more recent popularization by various musicians and the dissemination of 1980 recordings by a northern *campesino* (peasant) group.[1] The relearning of this fifty-year-old song provided an aural bridge back to a conception of the Nicaraguan nation that had been heavily repressed after the murder of Sandino and the crushing of his movement in 1934. "Que se derramen las copas" was the best known musical part of the efflorescence of representations and references to Sandino that attempted to redefine the long Somoza family dynasty (1934–79) as a denial of the nation's true spirit and, therefore, a hiatus in the country's genuine history and forward development. Music was used in this process like a lifeline to join the present to an earlier moment.

HISTORY RESURFACING

Music is part of the public sphere where contemporary social forces shape historical memory. Although an "intangible" monument, the semantic content of lyrics and the associative emotional impact of musical style can serve as a vehicle for commemoration and definition of the past. The emotion unleashed by the song "Que se derramen las copas" reveals the profound role music has played in the politics of memory in Nicaragua. During the turbulent last three decades music and other cultural markers have been invoked to define and draw on contested national histories.

To a great extent in Nicaragua, the politics of these contested histories have swung between two poles of national definition. Both are tied up with the country's relation with the overwhelming power of the United States. The view from the right of the political spectrum sees the country's future prospects as dependent on positive relations with the United States and the need to follow its economic programs together with its cultural models. The left-wing pole characterizes the nation's history, especially under the rule of the Somozas, as one of continual subservience to North American power and influence. As articulated by the FSLN this view calls for political and economic relations that allow for a new level of national sovereignty vis-à-vis the United States and celebrates localized models of expressive culture. In a moment of obvious exaggeration, Ernesto Cardenal, poet, priest, and first and only minister of the Sandinista-initiated Ministry of Culture, proclaimed, "All of culture was imported previously."[2] Sergio Ramírez, writer and vice president from 1984 to 1990, stated: "Once we lifted the Yankee stone which weighed Nicaragua down everything that was fundamental and authentic had to surface again, dances, songs, popular art and the country's true history that is based on a continuous struggle against foreign intervention."[3]

In the case of Nicaragua in the twentieth century, the way in which the dichotomy of global versus local cultural models has mapped onto right-left political divisions and the struggle for national definition has been especially pronounced. Of course this correspondence was far from absolute. The Sandinistas promoted a selective utilization of nonnational cultural forms in conjunction with a new appreciation for local cultural product. And at the same time that the new Sandinista Ministry of Culture exalted folk expression as a recuperation of denied cultural history, the

right attempted to use the same traditional religious-based festivities to generate support for the Catholic hierarchy and its conservative politics. It should also be noted that populist claims to a nativist grounding and, therefore, claims of historical legitimacy and continuity can span the political spectrum. Social movements may inherit various kinds of problematic legacies if they adopt or promote expressive forms charged with notions of tradition. Versions of localized cultural expression can be used for all types of political ends, and progressive social movements have often faced folk-rooted forms encumbered with an unwanted political significance already promoted by the dominant ruling structure. For instance, in the Dominican Republic *merengue* was not only identified as the country's most representative national musical form, but it was also connected in the public mind with the dictatorship of Trujillo, who overtly promoted it.[4] However, in Nicaragua, those who opposed the Somoza dynasty did not face this obstacle: no local musical style was particularly linked to Somoza and the ruling apparatus, who were far too infatuated with United States culture to promote much of anything Nicaraguan.

Beginning in the early 1970s, folk-rooted popular music became increasingly identified with the anti-Somoza protest movement and formed an integral part of this movement's claim that the "genuine" culture of Nicaragua had yet to enter the nation's historical stage. After all, the groundswell of politically infused music of the late 1970s was, by definition, one of local creation. Just as important, within all types of music there was a decided turn away from accepting outside artistic forms as inherently superior. Especially among youth in Spanish-speaking western Nicaragua, there was an enthusiasm for things Nicaraguan. With state power, the FSLN dedicated a generous portion of the scant resources available toward support of national artistic and cultural production. In music, state support translated into several new initiatives. A new recording studio and label, ENIGRAC, *Empresa Nicaragüense de Grabaciones Culturales* (Nicaraguan Company for Cultural Recordings), began to amass by far the largest and widest ranging catalog in the nation's history. Housed in Nicaragua's first Ministry of Culture, ENIGRAC focused on recording politically leftist music and traditional folk music. Though many musical groups dedicated to promote social change disbanded during the height of the insurrection, several continued into the 1980s, and new ones formed.[5] By the mid-1980s the label also released contemporary and classics of nonpolitical popular music as well. Besides Nicaraguan political music groups, ENIGRAC recorded several

groups from other parts of Central America. Inspired by the line of volcanoes that runs through the western part of the region, the term *volcanto* was coined (conflating *volcán* 'volcano' and *canto* 'song') as a new label to encompass socially committed Central American music. Nicaraguan volcanto received logistical support from the ASTC, *Asociación Sandinista de Trabajadores de la Cultura* (Sandinista Association of Cultural Workers). CPCS, *Centros de Cultura Popular* (Centers of Popular / People's Culture), were founded in almost every city. Their activities ranged from offering classical instrumental instruction to producing local music concerts in all genres, especially traditional folk music and volcanto. The dance music of choice was Nicaraguan in origin: *palo de mayo* (Maypole), the Caribbean-based music and sensual dance of English-speaking Creoles from the eastern coast. Coupled with the general upsurge of interest to *rescatar lo nuestro* (recuperate that which is ours), the early 1980s represented a new high-water mark for national music.

The heady years of the first half or so of the 1980s were full of promise, missteps, disappointments, and genuine accomplishments. This moment, when the program of the FSLN had a chance to begin to be implemented, was followed by a steady constriction of the economy due to the contra war and a U.S.-imposed economic embargo. Frustrated and ultimately eviscerated by overwhelming economic and military strength, the Sandinista government was steadily forced to curtail funding for cultural programs. Economic support almost disappeared altogether by the end of the decade. The Ministry of Culture closed in 1988, soon to be followed by the demise of the ASTC. Just as significant were the steadily worsening general economic conditions that impacted music in myriad ways. The loss of consumer power meant a loss of revenue for both live and recorded music. Because of the embargo, worn needles on record changers could not be replaced. Guitar strings, even picks, became highly prized. In its last years ENIGRAC abandoned LPs and moved to less-expensive cassette releases, but even so, the populace became increasingly dependent on free radio broadcasting. The growing demoralization brought on a fatigue among the population for music with a political message. Volcanto, so effective in previous social mobilizations, was not able to adjust to this new context. As the fortunes of the revolution waned, so did aspirations for the country to achieve the degree of economic and cultural sovereignty originally hoped for.[6] The cumulative effect worked against all types of national cultural production, especially music.

WRITING HISTORY IN INVISIBLE INK

In the 1990 national elections the FSLN lost decisively to an openly U.S.-supported coalition centered on the country's previously discredited political parties. Post-1990 administrations have embarked on a campaign of redefinition and simple erasure of the 1980s in the nation's psyche. The new leadership representing the nation's major business interests claimed that the FSLN's loss of state power opened up a new era; perhaps it is more accurate to say that an earlier one had been reworked and reinstated. While the previous dictatorship was not reinstalled, in many respects the post-1990 period can be characterized as the business elite's chance to more fully hold the reins of state power partially denied them during the Somoza oligarchy. A different attempt at a historical cultural connection has been at play from the one suggested by the revival of the 1930s Sandino corrido.

Since the 1990 election, the politically conservative national elite has portrayed the Sandinista period as the historical aberration, though the Somoza dictatorship is too widely reviled to be openly legitimized. In an attempt to co-opt the mass insurrectionary activity of the 1970s, the elite have promoted the idea that the overthrow of Somoza in 1979 should have led directly to the type of government elected in 1990. For instance, the Chamorro administration symbolically dismissed the 1980s in the new one *córdoba* note (the national currency). Chamorro's treasury department artists retained the face of the 1980s bill that depicted the victorious 1979 entry by the FSLN into Managua's downtown but on the reverse side added a depiction of voters casting ballots in the second national elections in 1990. The new currency's visual message is that the dictatorship may have ended in 1979, but electoral democracy only began with the 1990 elections. This was an obvious attempt by the new right-wing government to erase from history the first national elections after Somoza in 1984, when international monitors certified that the FSLN won nearly three-fourths of the votes. Through this pictorial message on the *córdoba*, and repeated in a multitude of other ways elsewhere, the post-Sandinista national rulers hammered away against any positive legacy from the 1980s.

To accomplish this historical whitewash in the realm of economics and politics, post-1990 administrations have waged a concerted effort to cast the eleven-year period of Sandinista government as a blanket failure and ascribe all blame for the pummeled economy and the constant military warfare to the FSLN and progressive politics in general. This struggle ranged across the

social spectrum, from stripping property titles received from the 1980s land reform to new textbooks financed by USAID (with a predictable historical narration). The post-1990 leadership offered its own neoliberal ideology and practice as the counterexample to the previous era. Social consequences include a promotion of domestic roles for women, who, in fact, have faded noticeably from view in the public sphere.[7] Disparaging remarks based on ethnicity have reappeared in national political discourse. For instance, in the late 1990s President Alemán repeatedly characterized several of his opponents as *indios*, a label (meant to be disparaging) that referred to the partial indigenous makeup inherent to the overwhelming mestizo (mixed indigenous and European) makeup of the national population.[8]

The rightist governments, however, have had difficulty rewriting a history of the expressive culture that emanated from the 1980s. Few artists in any medium were sympathetic to the new regime's general ideology, much less its near abandonment of funding for the arts in specific. This challenge has been especially acute in the domain of music. No new style or musical movement has arisen since 1990 that openly articulates the strong rightward turn in ideology of the post-1990 governments and their allies. Certainly nothing has developed to date that resonates among the general population with the same force as the politically charged music that played such a decisive mobilizing role in the late 1970s and early 1980s. Rather, ruling neoliberal politics approached music in two ways. First, state support was withdrawn from musical production; support for any socially committed music was strictly prohibited. This strategy was less one of active repression than a hope that volcanto would fade away into irrelevance and disappear. Such a policy of "benign neglect" extended to ignoring the needs of national music in general, replicating the Somoza-era disdain toward nationally produced culture. It should be remembered that this decrease in arts funding took place when the government's financial options had increased; the 1990 election of its favored candidate prompted the U.S. government to immediately end the economic embargo, halt the war, and permit loans from the International Monetary Fund and World Bank.[9]

Second, this attempt at "musical erasure" coincides with the increased dissemination of North American and pan–Latin American commercial popular music. Non-Nicaraguan music has always been an important part of the national musical landscape, but in the 1990s its hold was even stronger than during the late Somoza era. The current ruling elite appear

to look (listen) favorably on (to) a music whose most explicit social message is consumption and a (supposedly) apolitical stance. These strategies have attempted a reconception of the national history that links the country's well-being to a more cosmopolitan, specifically North American, orientation. A visual and aural visit in the 1990s to the same part of Nicaragua as the 1985 commemoration depicted above illustrates the prevailing cultural direction that contested the historical memory carried in the song "Que se derramen las copas."

ACOUSTIC WHITEWASH

When culture and memory are evicted from a city, its places, its locations and its products become mute commodities that can be purchased but not dreamed.
—REBECCA SOLNIT, *Hollow City*

Few places have experienced such wrenching visual transformations as Nicaragua's sprawling capital city. The large black and yellowing-white panoramic photo of pre-earthquake Managua in an upscale restaurant is a regular site of pilgrimage. The photo's downtown, congested with three-story buildings, looks unreal compared to the post-1972 reality of cows grazing in open lots opposite the National Assembly and other governmental buildings. A new look began to develop in 1979. The rubble was finally cleared and a series of brightly colored murals decorated the new children's park and walls along Avenida Simón Bolívar, renamed from Avenida Roosevelt. The Sandinista government did not have funds to build much beyond one set of apartment buildings near the lake, but for the cost of paint localized themes and designs became part of the public landscape. The mural movement expanded to decorate walls throughout Managua and other cities as well.[10] The electoral defeat of the FSLN in 1990 brought in a municipal Managua government under Arnoldo Alemán that embarked on a campaign to erase visual emblems of the previous decade. The white stones on a hill on the west edge of town that spelled out FSLN were first rearranged to spell *FIN* (The End) and later removed. Alemán made a special target of murals, often ordering crews to paint them over at night to avoid the public outcry that greeted each new disappearance. All murals were caught up in the net, even the least political ones, such as the colorful animals and designs in the children's park. By the time Alemán was elected

president in the controversial elections of 1996, few murals of any kind were left in Managua. During his presidency others around the nation were whitewashed as well. The conflict over public signs of memory has been such that the new (old) elite did not attempt to replace Sandinista era murals with new ones that reflect their own politics and aesthetic. Rather, they were simply erased, a return to the blank walls that existed before 1979.

This visual erasure was congruent with an acoustic one. Driving around Managua in the 1990s one could turn on the car radio and search in vain for Nicaraguan music.[11] One might not expect to find volcanto or other music whose lyrics had some engagement with social concerns, but what was remarkable was the absence of any Nicaraguan music. Music stores offered much the same barren soundscape. The post-1990 influx of the upper and upper-middle classes that had taken up U.S. residency in the 1980s (derisively nicknamed "Los Miami Boys") gradually led to the development of an economic and cultural infrastructure to minister to them. Musical instruments and stereo equipment became readily available but at prices that kept them just as unobtainable as before to the majority of musicians and the general population. The increased purchasing power of this small but economically powerful group did not translate into support for national artists. Instead, radio fare and music stores nearly exclusively offered a mix of North American and Latin American mainstream pop music. As noted earlier, nonnational musics have always been popular in Nicaragua. What distinguished the 1990s from, for instance, the 1960s, was the near monopoly foreign musics enjoyed in the media. A sampling of music on the airwaves, or a perusal of music stores, would give little indication of a geographical and cultural specificity that grounds one in Nicaragua. Such a suffusion of metropole music within the periphery (or so-called third world) that Nicaragua inhabits was a measure of the success of the neoliberal model to integrate the country into a globalized economy of the type defined by multinational corporations and finance capital. To a remarkable and unprecedented degree, what was heard was the sound of the metropole.

The constriction of national cultural production had already begun in the late 1980s as a result of continued war and the U.S. economic embargo. In addition, viewed in retrospect, the neoliberal policies officially introduced by the first post-Sandinista government had already been partially

implemented by the FSLN and had taken their toll on the national culture before 1990. In the late 1980s the Front came under criticism for making multiple concessions in this direction, and the state safety net for the popular classes created in the early 1980s had unraveled in much the same manner as government policies required by the International Monetary Fund and World Bank. The full enactment of these policies in the 1990s greatly hastened the decline of the population's purchasing power.[12] Coupled with the lack of state support, most CPCs were forced to close. Those that remained continued in a diminished capacity under the new name *Centros de Cultura* (Centers of Culture), dropping the *Popular* of the Sandinista period. Within a few years the state recording label ENIGRAC closed, and the country's private studios and labels were unable to fill the void. In fact, the main product of the national music industry became bootleg recordings.[13] ENIGRAC's vaults of 1980s recordings were the principal source for releases of Nicaraguan music in the first half of the 1990s, a telling comment on the state of musical creativity and production. A nationally known commentator labeled the 1990s "the decade of the shipwreck of culture."[14]

Also in the 1990s the FSLN diminished its own promotion of socially committed music, once such an important component of national musical creation. As the decade progressed, the leadership of the FSLN veered further to the right in several respects. The Front had to deal with issues of corruption and lack of democratic procedure that often pitted the "old guard" against younger militants. The lack of sustained, radical opposition by the Sandinista leadership developed into a form of cogoverning with the administration of Violeta Chamorro (euphemistically called "governing from below"), which further degenerated into an outright pact with Alemán at the end of the decade in a maneuver to consolidate a national two-party system.[15] Fallout from this change in political direction included the Sandinista party distancing itself from the position it previously espoused on the importance of reintegrating folk-rooted culture into the national culture. The vision of the popular classes and their culture entering the nation's history with the revolution became increasingly muted as the FSLN's leadership promoted an image of the Front as a broad, multiclass national party. The difference in the music the Sandinistas used in their election campaigns clearly reflects the new direction: in 1990, a series of songs with partisan lyrics; in 1996, the "Ode to Joy" from Beethoven's Ninth Symphony.

LENDING A CRITICAL EAR TO THE 1990s

Within the bleak soundscape of 1990s Nicaragua one could still find signs of a legacy of the revolutionary period. Two salient examples are the reverberations of the new conception of the national identity forged in the 1980s and an engagement with nonnational styles that infuses them with new meaning.

Tracing the changes of the lives of individual musicians offers a reveal-ing window onto the shift in music from the flowering of national music in the late 1970s and early 1980s to the 1990s. A handful of the musicians with the highest profiles in volcanto, such as Carlos and Luis Enrique Mejía Godoy, and Katia and Salvador Cardenal, have kept their careers more or less intact into the 2000s. Many other artists, including ones in nonpolitical commercial groups, were forced to abandon music and find work else-where.[16] Another set of musicians moved from groups playing music with some social commentary to popular dance bands. This is true for several leading members of the most successful new Nicaraguan pop music group to appear after 1990, La Macolla (The Gang, or Group). Ronald Hernández was the keyboardist with Mancotal, one of the most prominent volcanto groups and the regular band of leading volcanto singer-songwriter Luis Enrique Mejía Godoy. Macolla's musical director is Andrés Sánchez, the country's most talented jazz-fusion guitarist. In the 1980s he led his own group in this idiom, Praxis, and also joined Luis Enrique Mejía Godoy's reformed group at the end of the 1980s. Other members, such as keyboard-ist Sidar Cisneros, also have a past in volcanto. The upscale dress of sport coats and ties, featured on an early album cover, is a definite switch from the more casual wear of the 1980s (one Mancotal album showed photos of the band in fatigues taken during a visit to an army base).[17]

Despite the nonpolitical nature of Macolla's lyrics, one important aspect of their music remains a type of musical monument to the process of national unification and awareness promulgated during the Sandinista pe-riod. In the early 1980s the music and dance style of *palo de mayo* from English-speaking Creoles on the eastern Caribbean coast exploded in pop-ularity nationwide. Although palo de mayo had had limited exposure in Managua before the revolution, the dance and music became popular for almost all Spanish-speaking Nicaraguans in the 1980s. Black Creoles were (and still are) a rare sight in the western two-thirds of the country, and palo de mayo music and dance was the first sustained encounter with Creole

culture for the majority mestizo population.[18] The FSLN wholeheartedly endorsed and promoted the phenomena, the only time an eastern Caribbean coast style has gained national acceptance. The music and dance coincided with the Sandinista project in several respects. First, Sandinista ideology viewed Creole culture as having been denied its legitimate place in the nation's history. In this sense palo de mayo's acceptance by the Spanish-speaking majority paralleled the goal of legitimizing other folk-rooted popular culture in the nation. Second, the sensual dance took on a symbolic quality that represented the country's newly politically and sexually liberated youth. Finally, the celebration of the denied cultural history of this African-Nicaraguan music from the Caribbean coast was also a key musical part of the move during the Sandinista period to acknowledge the multiethnic makeup of the nation.[19]

Though regionally based culture, including that of the eastern Caribbean region, dropped from the nation's official radar screen in the 1990s, the musical impact of palo de mayo remained embedded in popular memory. Three of the ten songs on Macolla's 1996 album *Bailarlo contigo* (Dance It with You) are either in or partially include palo de mayo style.[20] Certain modifications from the earlier style of the 1980s shows the full integration of palo de mayo into the majority mestizo population. In the 1980s Creole-led bands for the most part sang in their native English for their Spanish-speaking audiences. In the 1990s Macolla indigenized the Caribbean form by changing almost all the verses of their covers of palo de mayo songs to Spanish. The title track, although not credited as such, is actually the traditional song "Read-oh Read-oh." In another well-known palo de mayo number, "Anancy oh," Macolla dropped the original verses altogether and rewrote the chorus using an equal mixture of English and Spanish. They also inserted a short section of rap in Spanish into the middle of the song, a global addition to their western Nicaraguan adaptation of an eastern Caribbean form.

Although the concept of national integration still reverberated into the 1990s, the socioeconomic circumstances for performing a popular national style were qualitatively different from the previous decade. Whereas palo de mayo groups were able to enjoy such success that the style could reign as the nation's most popular dance music in the 1980s, a decade later Macolla found itself swimming upstream against a tide of North and Latin American releases that saturated the air waves and TV shows with video clips. This unfavorable situation confronted the handful of other groups

that formed in this same time period. For example, Andrés Sánchez, Macolla's musical director, also played in the rock group Legado (meaning "cool," "great") that joins the strong current of Latin American rock on the continent.[21] The difference since 1990 for these and other bands is one of degree, not a change from, or to, an absolute. For instance, the Sandinista Television System (SSTV) regularly circumvented the U.S. trade embargo in the 1980s and aired the latest video clips of North American and British pop groups. Nonnational music was fairly easily obtainable on bootleg cassettes. Since then, however, the sheer quantity of imported musics offers Nicaraguan groups steep competition. Perhaps even more significant, local music faces the challenge of finding acceptance in an environment where influence and power look northward for cultural models. Nicaraguan music groups struggle not to be reduced to a negligible niche market of "local fare" within a national musical menu dominated by "global" (i.e., imported) sounds.

The advent of several rock groups in the latter part of the 1990s might be taken as another triumph for the inscription of the nation's historical destiny alongside that of the United States. The turn to rock, however, should not be read as a wholesale adoption of metropole culture that represents a surrender of local agency. Rock actually has a substantial history in Nicaragua, even if it never grew to become as strong a movement as in Argentina and Mexico.[22] For example, in the 1960s several mostly Managua-based music groups created local reinterpretations of U.S. and British rock.[23] Nicaraguan urban youth made this music their own in a process of appropriation and assimilation that took place in other parts of Latin America as well.

There is a long-standing debate within the political left in the so-called third world on the use of metropole musical forms and style for antimetropole politics. A major question within this ongoing discussion is the importance of the *musical* content of a song itself to serve as a referent of the people to whom and for whom the lyrics speak. Here I do not refer to a discourse of authenticity within the global marketing of music under the rubric of "world music," for Nicaraguan musicians have not realistically hoped to enter this mushrooming market.[24] Rather, it is a question of the degree to which support of national sovereignty and efforts at social reform linked to self-determination must inform musical content and cultural models in general. This issue was discussed—with no definitive resolution—among members of the volcanto movement in the 1980s.

While the use of local style can obviously encode a special meaning and amplify the lyrics' meaning, there is now an accumulated history throughout much of the periphery of the use of metropole musical forms, principally rock, as musical vehicles for songs that attack metropole power and its influence in local politics and society.[25]

One example of a Nicaraguan contribution to this creative use of metropole style is the 1999 composition by singer / songwriter Engel Ortega (no relation to FSLN leader Daniel Ortega). Released on the compilation album *Cantautores de Nicaragua–volcanto*, the ska-tinged rock song is entitled "Colón no se murió." The lyrics include these, from verse 3 and the chorus:

> *Ya no me digan que comer,*
> *que pensar, que defecar*
> *Ya no me indiquen lo que es bueno*
> *Y lo que es malo . . .*
> estribillo
> *Colón no se murió*
> *Y aprendió a hablar inglés.*
> [Don't tell me anymore what to eat,
> what to think, what to defecate
> Don't tell me anymore what is good
> and what is bad . . .
> chorus
> Columbus hasn't died
> And he learned to speak English.][26]

This is not the first time socially committed Nicaraguan musicians have used nonnational styles; for instance, in the 1980s several groups integrated salsa and other styles into their repertoire.[27] Engel Ortega first entered the nation's music scene in the last half of the 1980s with several (not very successful) volcanto rock recordings. His more recent repertoire primarily contains ballads and introspective songs with utopian imagery expressed in romantic settings. Since the 1980s Ortega and others have maintained that the essential element that defines volcanto, or any other politically oriented music movement, is the meaning of the lyrics.[28] Such a position does not necessarily deny the evocative power of a locally rooted style, but it does claim an open palette for the creative process. As elsewhere, Nicaraguan rock groups represent a hybrid interpretation of U.S. styles, some explicitly

1. Singer/songwriter Engel Ortega.
Photo by T. M. Scruggs.

imitative but most producing a new synthesis and originality. Ortega's music over two decades is a good example of such a creative hybridity. His music shows that, while clearly inspired by a metropole style, rock music outside the United States can hardly be taken a priori as an indication of the success of the neoliberal model and its concomitant alignment with the United States.

NEW CENTURY, NEW CHALLENGES

Is this [neoliberalism] the model on which business, the media, and the government are gambling? . . . Will the shopping centers sell farmers' milk or artisans' furniture? . . . There will be a place for imported perfumes, but not Matagalpa strawberries; for Kellogg's corn flakes, but not for *pinolillo*; for Nike tennis shoes, but not for shoes made in Masaya; for the Rolling Stones, but not for Camilo Zapata.—JOSÉ LUIS ROCHA[29]

Latin America has the dubious distinction of introducing the transitive verb *disappeared* into the world's vocabulary. This term emerged as the label for the official silence that accompanies the kidnapping and elimination of an individual by the state or allied apparatus. Too often it could also

be accurately used to describe what happens to locally generated cultural forms and national production as a whole under the weight of metropole-model importation and promotion. It is a term that, unfortunately, is largely appropriate to portray what transpired in Nicaragua in the domain of music, and most of the country's expressive culture, in the last decade of the twentieth century. The unfortunate continuance of these policies into the twenty-first century is demonstrated by the March 2001 announcement by the minister of education, culture, and sports outlining a series of spending cuts that will slash cultural programs throughout the country. Following demands communicated by the IMF, the ministry directed the poorly funded Institute of Nicaraguan Culture to close already under-staffed museums and cultural centers throughout the country.[30] For an important segment of the ruling elite who have benefited under the post-1990 administrations, the conservation of and public access to Nic-aragua's national patrimony is sufficiently unimportant that it can be al-lowed to wither and gradually evaporate. Just as all national music, not just socially committed music, was left to wilt in the 1990s, so public memory of the nation's history, not just the left's interpretation of that history, appears to be suffering the same fate. The situation of national culture and patrimony in Nicaragua is similar to that in the rest of Latin America and much of the periphery or so-called third world. These national economies, and therefore locally determined cultural production, appear destined to suffer under continued disadvantage if the current terms of economic globalization remain in force.[31]

Against such a pessimistic backdrop it is important to note signs of hope that have emerged. Following the 1990s there has been a noticeable, if incremental, reassertion of national expressive culture in Nicaragua. After a decade of contraction and retreat, politically progressive cultural workers have begun to organize activities and raise their profile from the nadir of the 1990s. For instance, in February 2001 the Managua bookstore *El Parnaso* hosted the first of an ongoing series of successful *peñas*, evenings of live musical and cultural performances. The same month the Jesuit-led UCA (Universidad Centroamericana) hosted a marathon of national music in a fund-raiser for victims of an El Salvador earthquake; a second marathon took place on July 20, 2002, the day after the annual celebrations of the original revolutionary triunfo.[32] The eight-hour-long concerts brought to-gether an impressive list of the nation's musicians, with volcanto heavily

represented. Other musical events have been organized in Managua that signal a rise in interest in politically conscious cultural production and national music in general.

Although a full explication is beyond the scope of this essay, two conspicuous factors help account for this change. First, the Front's limited and sporadic mobilizations to contest the right's neoliberal policies led many of the best militants to dedicate their political work to various struggles outside the formal structure of the FSLN.[33] These organizations, many aided with NGO (Nongovernmental Organization) funding, created a new space for oppositional cultural work that began to coalesce as the new century began. An example in music is the boost in power of the UCA's radio station and the creation of a new station, Radio Mujer (Woman), both made possible through financial support of West European NGOs. Local music, volcanto in particular, has begun to receive more consistent airplay with its entry into the field of the capital city's commercial radio. Second, these small advances by the left find themselves in the company of a financially driven reawakening of interest (though still quite meager) in traditional cultural products by some business sectors hopeful of future tourism. There has been discussion at the governmental level of the need for cultural product that could provide color and purchasable items for an anticipated, though yet stillborn, tourist industry. Some funding has been allocated for weekly evening cultural fairs in several major cities. As noted by the recent closing of museums, this interest is contradictory at best and has yet to translate into investment of consequence in national cultural production. If tourism does significantly develop, it will open up and reorient contestation over the use and meaning of expressive and material culture laden with notions of tradition. One can only speculate at this point how such an interest might engender a new (most probably paternalistic) attempt to relocate localized nonelite culture within the currently dominant politically conservative narrative of the nation's history.

In the 1980s the left under the FSLN strove to move the perception of the nation's history away from one where progress could be measured in terms of successful imitation of North American culture, especially that of the elite, toward one that saw the creative wellspring of the popular classes as an unappreciated resource that had been prevented from informing the nation's development. The Sandinista revolution posited the valorization

of cultural manifestations of the popular classes as releasing the country's full potential, in fact, as the realization of the previously stunted national project as a whole. At its best this revolutionary politics envisioned localized forms "recuperated" into a public sphere shared with extranational cultural models judiciously adopted and adapted from outside. In the 1990s the conservative politics that promoted an indiscriminate importation of foreign cultural models undeniably achieved a certain success in white-washing from public memory the mostly locally based cultural products with a leftist political message that flourished during the revolutionary Sandinista period. Such a strategy continues to promote a view of the nation's history that links the country's well-being to an emulation of a supposedly more "advanced" cosmopolitan, specifically North American, orientation. This hegemony is challenged by the adaptive strategies of Engel Ortega and others who engage with metropole models and transform them into oppositional cultural products. Together with the recent upsurge of national music activity and its substantial identification with a politics that challenges the reigning neoliberal model, the current ruling elite's conception of the nation's history as most fruitful when bound up with an uncritical embrace of North American culture industry product portends increasing contestation.

NOTES

1. Los Soñadores de Sarawaska, *Cantos de Tierra Adentro* (Managua: Ocarina [later ENIGRAC] MC-004, 1980). For a transcription of music and lyrics with English translation of this version see Scruggs, "Nicaragua," 758–59.

2. Quoted in Zwerling, *Nicaragua*, 46.

3. Quoted in Rowe and Schelling, *Memory and Modernity*, 177.

4. See Austerlitz, *Merengue*.

5. On pre-1979 socially committed Nicaraguan song see Scruggs, "Socially Conscious Music Forming the Social Conscience." For revolutionary music in the 1980s see Pring-Mill, "The Roles of Revolutionary Song"; and Scruggs, "Musical Style and Revolutionary Context in Sandinista Nicaragua."

6. Prevost and Vanden, *The Undermining of the Sandinista Revolution*.

7. Babb, *After Revolution*.

8. Alemán's insults were not meant to actually call someone's ethnicity into question; his targets were obviously mestizos, like himself. Since the early 1900s the western part of Nicaragua has been almost entirely mestizo, the mixture of European and indigenous race and culture. There are still enclaves that define themselves

as, and are considered in the national imaginary to be, indigenous, though this definition is somewhat slippery: the people identified as Indian speak Spanish, wear the same clothes, and are not significantly distinctive in their phenotype from the rest of the national population. The terms *indígena* (indigenous) and even *indio* were invoked in a positive sense in cultural work and pronouncements by the Sandinistas. After 1990 the word *indio* increasingly resurfaced in colloquial discourse as an epithet to imply someone ignorant and backward.

9. Arana, "General Economic Policy."

10. Kunzle, *The Murals of Revolutionary Nicaragua*.

11. Data on the Nicaraguan music industry have never been published. Information for this section and others is based primarily on my own extensive fieldwork that dates from 1984; this research includes a two-year residence (1987–89) and repeated visits since.

12. "Crossroads at the Century's End," *Envío* 18, no. 221 (1999): 3–9; Stahler-Sholk, "Structural Adjustment and Resistance."

13. Since 1990 I have had the "distinction" of having the album of folk music I recorded for a U.S. label (T. M. Scruggs, compiler, *Nicaraguan Folk Music from Masaya* [Chicago: Flying Fish 474, 1988]) being offered for sale throughout Managua in a beautifully color-photocopied bootleg cassette.

14. Arnulfo Agüero, "La década del naufragio cultural," *La Prensa Literaria* (Managua), July 14, 2001, 3.

15. "The Pact's Roots Go Deep and Its Fruits Are Rotten," *Envío* 18, no. 216 (1999): 3–11.

16. Even traditional marimba musicians based in the broader Masaya region fell on hard times in the 1990s, and many abandoned music as a remunerative activity.

17. Luis Enrique Mejía Godoy and Mancotal, *A Pesar de Usted* (Managua: ENIGRAC NCLP-5008, 1985; LP recording).

18. Western Nicaragua encompasses the Spanish-speaking part of the country that contains close to 90 percent of the nation's population. The eastern zone that borders the Caribbean, known (incorrectly) in Nicaragua as the Atlantic Coast, includes two major groups: the Miskitu people, who live along the major rivers in the far northeast; and the English Creole speakers clustered around littoral settlements. The Creole population stems from an arrival early in the colonial period of Africans as slaves and escaped slaves, some of whom mixed with English traders and sailors, combined with the immigration of primarily Jamaican laborers beginning in the early twentieth century. In the early 1980s relations between the western-based FSLN and eastern Miskitu and Creoles got off to a rocky start. Relations with the Miskitu, strategically located along the Honduran border, mushroomed into crisis proportions when ignorance and opportunism on both sides were exacerbated by heavy United States covert (and not so covert) intervention. The crisis gradually diffused in the late 1980s after the mestizo-led Front changed its policy and granted all of the Atlantic Coast substantial autonomy. The sometimes paternalistic attitudes

expressed in the early 1980s of the otherwise politically progressive mestizo cadre betrayed the long-standing and profound lack of knowledge that existed between peoples of the two regions, a gap that palo de mayo played a major role in bridging.

19. Scruggs, " 'Let's Enjoy As Nicaraguans.' "

20. Macolla, *Bailarlo contigo* (Sony Music 464850017, 1996, CD).

21. Legado, *Será de ti* (Managua: Mia Records, MR-1008, 1997, CD). Probably the most bizarre entry into the limited field of Nicaraguan popular music is a CD entitled *Nicaragua* by a group identified as "Nicaraguan Boys." Unfortunately it also has enjoyed substantial visibility to date (e.g., as of this writing it is the only popular music title of Nicaraguan origin available from Amazon.com). The album cover shows a dance couple outfitted in northern Mexican *son jaliciense* dress (typical of mariachis), and the liner notes claim several instruments for Nicaragua that exist only in Guatemala and south Mexico. The album contains Cuban styles done with a Colombian feel, and the same so-called Nicaraguan Boys recorded a CD a few months later entitled *Cuba*. No one in Nicaragua I have talked with knows of this group. Why they would choose a name with so little global market cachet remains a mystery.

22. On Argentina see Vila, "Argentina's 'Rock Nacional' "; on Mexico see Zolov, *Refried Elvis*.

23. See Bolaños, *Los días de la tortuga*.

24. Gilroy, *The Black Atlantic*; Roberts " 'World Music' and the Global Cultural Economy." Cuban music's achievements in the international music industry provide a contrast with a Latin American country that shares a history of U.S. economic embargoes. See Hernández, "Dancing with the Enemy."

25. For several case studies of rock encoding oppositional politics from around the world see Garofalo, *Rockin' the Boat*.

26. "Colón no se murió," *Cantautores de Nicaragua–volcanto* (Managua: ASCAN AV 003, 1999); my translation.

27. The music now known as salsa developed from a reworking of Afro-Cuban popular dance music in various locations, beginning in New York City and Puerto Rico in the 1960s and later in Venezuela and Colombia, but not in Nicaragua. For discussion on the use of salsa in the music of Nicaraguan groups in the 1980s (notably Pancasán and Luis Enrique Mejía Godoy and Mancotal) see Scruggs, "Musical Style and Revolutionary Context in Sandinista Nicaragua."

28. I heard such opinions expressed many times, for instance at a conference on *volcanto* held at the Ministry of Culture, Nov. 16–18, 1988. Ronald Hernández went so far as to hold that the definition of this corpus "has nothing to do with the music" (meaning the musical material as opposed to the lyrics).

29. José Luis Rocha, "Wiwilí with or without Mitch: An X-Ray of Underdevelopment," *Envío* 17, no. 209 (1998): 49. Camilo Zapata is a seminal singer-songwriter credited with creating the *son nica*, a major song form in Spanish-speaking western Nicaragua since the 1940s.

30. "Corte presupuestario afectó 145 aniversario," *La Prensa* (Managua), Sep. 16, 2001, *Nacionales* sec.

31. For case studies in Latin America see Rosen and McFayden, *Free Trade Economic Restructuring in Latin America*.

32. "Woodstock Nica," *La Prensa* (Managua), July 19, 2002, *Revista* sec.

33. This process of disenchantment had been building but held in check even before the 1990 elections. See Quandt, "Unbinding the Ties."

COMMEMORATING THE ANGLO-BOER WAR

IN POSTAPARTHEID SOUTH AFRICA

Bill Nasson

The Anglo-Boer War, or Boer War, or South African War of 1899 to 1902 (readers may take their pick) ended in victory for Britain, completing that country's long imperial conquest of southern Africa. For the British it was the biggest "small war" of the late-Victorian empire and proved to be unexpectedly hard going. For the defeated Boer republicans of the Transvaal and Orange Free State, the ruthlessness of the war's prosecution by Britain inflicted a deep historical trauma on modern Afrikaner society. For all inhabitants of the region the Anglo-Boer conflict laid the foundations for South African union in 1910 and the formation of an Anglo-Afrikaner white segregationist state. As a historical forge in the making of modern South Africa this war is perhaps best seen as the modest equivalent of the American Civil War or the Spanish Civil War.[1]

In the national construction of South African historical memory there can be little doubt that the war of 1899 to 1902 has counted far more than any other armed conflict. Unlike misty precolonial warfare or the grim white-black frontier and land wars of the seventeenth, eighteenth, and nineteenth centuries, it is Anglo-Boer War remembrance and commemoration that has become inscribed most visibly in the bony interior landscape of South Africa. It is there in post-1902 monuments, war memorials, and the cemeteries of Boer and British combatants and Boer concentration camp victims, to say nothing of an imposing literary epitaph and other significant cultural traces of war memory.

At the same time, in political character this twentieth-century public history never served as the universal history of South African society, as representation of its imperial-republican clash became that of a "white man's war" or of a European conflict that merely happened to be conducted in Africa. For several decades, then, a white and almost exclusively Afrikaner war commemoration and observance carried not a trace of acknowledgment of the combat experience and civilian losses of the tens of

thousands of black people who were caught up in hostilities in one way or another.

To understand what has been happening to official Anglo-Boer War commemoration since the 1994 political transition to majority rule, we need briefly to summarize its dominant earlier expression in South Africa. To simplify: through the 1910–48 segregationist and 1948–94 apartheid eras there was some general political and cultural continuity. By touching virtually every Afrikaner household, the war provided a representative emblem of "Afrikanerness" or a robust nationalist Afrikaner identity through the twentieth century.[2] Equally, for subdued English-speaking white citizens, memory of the war hung as a discomforting cloud. "Englishness" made it difficult to avoid being compromised politically by an irredeemably suspect Anglo-imperial ancestral connection.

Last, for the post-1912 South African Native National Congress, later the African National Congress (ANC), the Anglo-Boer War was of no particular consequence, viewed as a grubby colonial squabble over who would be top dog and command the land and labor of a conquered black majority. Even though some of its early scholarly figures like Sol Plaatje and Silas Molema did something to document the significance of the war for rural blacks, for over eight decades the ANC studiously avoided any kind of Anglo-Boer War commemoration.[3] Thus, whether in 1920 or 1990, to invoke the war was simply to underline the absence of any historical consensus on its meaning in contemporary South African political culture.

How has the end of the apartheid order and the incremental growth of a more common society begun to affect Anglo-Boer remembrance? The most obvious first point is that the centenary of the war arrived just as a majority black political elite was replacing Afrikaner nationalist power. With a changed historical context and a society directed by the new liberation aristocracy of African nationalism, some observers assumed that the natural inclination would be to get busy with the creation of its own post-apartheid national mythology of freedom, struggle, martyrs, and liberators. What price national memory of a white Anglo-Boer War, especially centenary commemoration of an episode imprinted with traditionalist Afrikaner memories of a sacred war of resistance and survival? As the country set out to fashion a new and more collective kind of historical memory, the standing of a minority "white man's war" looked bound to be deflated.

Taking its cue, the *Johannesburg Sunday Independent* concluded in 1995 that the war had now become a remote and unimportant episode from a

vanished European imperial age. History had put "the do-or-die battle between Afrikaners and English-speakers into its proper, smaller, context. White men were never going to win indefinite control of this African continent."[4] Public historians also anticipated ways in which popular war remembrance would now be shifting. The disintegrative power of the antiapartheid struggle had not only subverted the old white nationalist context. It had also liberated its text. As the great external repositories of public memory, war memorials and monuments now faced a liberating future in which they would be divested of the symbolic "Boer" or "Afrikaner" Party, and political power accrued in the apartheid National Party epoch. Now emancipated, they bore the subversive potential of transmuting into open "texts," mnemonic reminders of how a particular South African community (no longer special or privileged) interpreted the partisan meaning of the defining war in its history.[5]

Yet in some other ways the advent of the Anglo-Boer War centenary was accompanied by a distinct overlap of modes of thought and language between an old society and the new; the break with apartheid was not a complete rupture with the vintage imperialist war grievances of a crumbling Afrikaner nationalist past. So, in reaction to the 1995 British Royal family visit in the wake of South Africa's return to membership of the British Commonwealth, the extreme right Afrikaner Boerestaat Party declared Queen Elizabeth unwelcome in its imaginary "Boerestaat of Transvaal and the Free State." The "great grand-daughter of a cruel Queen," she was the descendant of a degenerate aristocratic family that had "committed the infamous holocaust in which a sixth of our people were murdered in concentration camps."[6] In similar vein a flutter of Afrikaans newspaper correspondents in 1998 and 1999 proposed a symbolic "war crimes tribunal" for the British general Lord Kitchener, an overdue hearing that would be attended "with great satisfaction . . . most particularly by the Boers who fought against Kitchener's barbarism."[7] According to J. A. Marais, "son of a Boer father" who had died in South Asia as an exiled prisoner of war, the most valuable "commemoration of the outbreak of the Boer War" would be to bring down history and spiritual law on the memory of "a British Hitler" guilty of committing "genocide" through his antiguerrilla strategy of concentration camps. The austere remnants of Britain's notorious internment camps at places like Paardeberg and Brandfort amounted to South Africa's Auschwitz or Dachau, "a war crime to be neither forgotten nor forgiven."[8]

This strident moral language also spoke for a distinctive new level of public inclusivity in the late 1990s, opening the meaning of the war to expressions of common national anger over the cruelties and losses of the 1899–1902 conflagration. This rising mood was caught nicely when liberal English-language papers joined the Afrikaans press in calling for the British prime minister, Tony Blair, to apologize for his country's dubious South African war record. If it could be done to the Irish for the potato famine and to Indians for the Amritsar massacre, why could London not be penitent toward injured Afrikaners for the past horror of the camps, asked leading writers in the *Sunday Times* and in *Beeld*. The reason was obvious, snorted an astute Afrikaans journalist in *Rapport*. While there were "many Irish and Indian voters in the United Kingdom," there was "not a single Afrikaner voter."[9]

Meanwhile, amid a flood of centenary commemorations, there were numerous press calls for a balance to be struck between presenting it all as battlefield tourism (see figs. 1 and 2) and recognizing the war as an encompassing tragedy that had sucked in not only whites but also black South African society. In turn, as one might have predicted, there were black commentators who turned their back on this, dismissing the very idea of a newly expanded, national war centenary commemoration. Why, in this view, mark a squalid colonial squabble between white men, an episode with no resonance for African political culture?

Writing in the *Weekly Mail and Guardian*, the journalist John Matshikiza dismissed lofty calls for the wartime role of blacks to be recognized and scoffed at political moves to incorporate black experience in public rituals of remembrance. "It was a white man's war," he declared; "since neither side asked them to join the fight as equals, there is nothing in this centenary for their descendants to celebrate. . . . It's like calling on the Native Americans to celebrate the landing of the Mayflower, or to join the reenactment of the Boston Tea Party." Matshikiza was especially critical of contemporary academic historians who have done a good deal to bring black war experiences to the usual war narratives, arguing that this was entirely confected or artificial historical revisionism. As the majority had been powerless to shape the war, they could have no legitimate recognition as historical participants in Anglo-Boer hostilities. Dismissing new initiatives to fashion popular acknowledgment of black combat involvement (see fig. 3), Matshikiza insisted, "any attempt to turn the *Amabhuwnu* or Boer War into our collective history is like calling a spade a sunflower."[10]

Designer Tours presents:

THE ANGLO-BOER WAR - WESTERN CAMPAIGN
CENTENARY COMMEMORATION TOURS

1. South African tourism company: 1999 brochure, Anglo-Boer War tourism program. From the Anglo-Boer War–Western Campaign; Centenary Commemoration Tours.

OFFICIAL CARRIER TO THE ANGLO-BOER WAR.

Sunday Times,
October 24 1999

Mere coincidence that we play England during the Anglo-Boer War centenary celebrations? We think not. 'Vat hulle manne! Vat hulle!'

SOUTH AFRICAN
AIRWAYS
www.saa.co.za

2. South African Airways newspaper advertisement, Oct. 1999. Courtesy the *Sunday Times* (Johannesburg).

3. Cartoon depicting the unveiling of a new statue of an African combatant alongside a Boer soldier and beneath the gaze of the nineteenth-century Transvaal president, Paul Kruger. Courtesy *Cape Times* (Capetown), Oct. 12, 1999.

In an even more Africanist version of such sentiment, Motesko Pheko advised his readers in October 1999, the centenary of the outbreak of war, that the hostilities had amounted to nothing other than "a war between two colonial thieves, fighting over the diamonds, gold and land of the African people." Had it been "utterly forgotten" that "Africans had fought many of their own heroic wars of national resistance against colonialism"? "When," he asked rhetorically of the country's new ANC leadership, "will they begin to commemorate their own heroic wars to defend their country against colonial aggression?"[11] Joining in, a squad of the country's more earnest scholarly historians also came out against the enduring whiteness of the Anglo-Boer War commemorative message. In July 1999 they called for an international boycott of all centenary war conferences and other acts of war remembrance on the grounds that as public history, the conflict was continuing to affirm an unacceptable historical image, that of "a war having been fought between white males on battlefields."[12] While nobody seems to have taken much heed of this, it is the kind of view to earn top marks for postapartheid political correctness.

Nonetheless, alongside this debate quite another level of commemorative consciousness was forming within ANC ranks in the 1990s, signaling a shift away from previous instincts to ignore, to forget, or to spurn any forms of war commemoration. The issue, instead, was how to go about

transforming the orthodox meaning of the war, or how to imagine it anew, in a way that faced the future, not the past. One approach was to take the conflict's traditional legacy of anti-imperialist, republican Boer commando resistance and concentration camp torment, and to cut it loose from its exclusivist, ethnic association with conservative Afrikaner nationalist history. Fired with new patriotic intimations, a changed focus on the war could play its educational part in the building of a common South African identity; as growing numbers of citizens felt able to connect to its memory, this could encourage a democratic culture of "nation-building."

Take, as a ready example, the argument of the prominent ANC personality and constitutional court judge Albie Sachs In the early 1990s Sachs argued that idealism and the universal story of the struggle for human freedom lay at the core of the Boer War, making it the good war for all South Africans. Grafting the "liberation struggle" language of the 1980s and early 1990s on to the stock of a nineteenth-century colonial war, he stressed "pride in the heroic struggle of the Boer fighters in our history." So exemplary was this story of armed endeavor that "any history of human rights culture had to take into account the fate of the women and children in the concentration camps." After all, concluded Sachs, "so much of Afrikaans history is part of the struggle for freedom. *Vryheid* (Freedom) has real resonance and meaning for us all."[13]

Naturally, such recasting of the war and its assimilation to a new, post-apartheid South Africanism is a model illustration of how a new national agenda seeks to appropriate a one-sided past to the needs of a many-sided present. Sachs's notion of the war as a lesson lingered, and as the October 1999 centenary approached, other commentators sought to grind out a new lens of political understanding. The Anglo-Boer War was now to be viewed as the greatest of a long series of colonial South African Wars, one in which "virtually all ethnic groups played a shared role," thereby minting "the common historic destiny of all South Africans."[14]

In a ripple of provocative inversion that sought temporarily to refashion traditional war iconography, a leading Cape Town artist dressed up a prominent statue of the famous Boer general Louis Botha, depicting him as a Xhosa *abakhwetha* initiate into tribal manhood (see fig. 4). Pioneering another countertradition, government officials put on public display a group of African children dressed in white bonnets to represent Boer farmwomen and red coats to make them British soldiers. Why they were also wearing toy plastic police helmets, conveying the faraway flavor of the

4. Parody by artist Beezy Bailey: public statue of
the Boer general Louis Botha decorated to resemble
a Xhosa youth during an initiation ritual. Courtesy
Cape Times (Capetown), Sep. 22, 1999.

5. Black South African children dressed to portray Boer
women and British troops at October 1999 ceremony.
Courtesy *Cape Argus* (Capetown), Oct. 11, 1999.

London bobby, remains an intriguing mystery (fig. 5). While one must presume that the ceremonial intention was not to be comic, this outlandish spectacle must certainly have taken some planning imagination.

This ascendant nationalist vision stimulated liberal newspaper calls for the October centenary rituals and ceremonies to be grasped as an opportunity for what the *Sunday Times* called a "re-examination of South Africa's past by the light of its recently-acquired freedoms." As an instance of their emancipatory reach, the paper applauded the manner in which a descendant of a Boer soldier was pointing to "a more imaginative, third millennium revision of the war." This interviewee, Abrie Oosthuizen, had publicly lamented the divisive consequences of the apartheid version of war history that had been drummed into his generation of Afrikaners. "A very neglected aspect of this history," he reflected, "is that we did not use the common ground we had with the blacks of this country. . . . We did not make more of the black concentration camps to . . . emphasize the common suffering, which is the most important unifying factor between us and the blacks."[15] That African sacrifice, noted another Afrikaans-speaking observer, was as yet "commemorated by no memorial other than memories passed on to the second, third and fourth generations."[16]

Such sober sentiment was not the only notable feature of the commemorative war mood toward the end of 1999. First, there was a fairly vociferous range of public calls on Britain to apologize for its brutal conduct of the war, with the *Cape Times*, for example, lining up behind the Afrikaans press to claim that "a full apology would do much towards closing this chapter in our history."[17] During their South African visit for the centenary opening, Queen Elizabeth and the Duke of Kent obliged with prim expressions of "sorrow" and "regret" for the loss of both black and white life during 1899–1902 (fig. 6); while pointing out that these comments fell short of a desired public admission of guilt, the Afrikaans *Beeld* welcomed the Royal establishment's comprehension of the need for public "reconciliation."[18]

Second, for some journalists the Boer refugee agony and high mortality rates of British concentration camps resembled "ethnic cleansing," a fearsome image that sought to portray the war in South Africa as a massacre, a Bosnian or Rwandan conflagration of the early twentieth century. Indeed, in commemorative public history one of the staple interpretations of the war saw it as a metaphor for inhumanity in South Africa, a national Pandora's box of evil. Third, the 1999 centenary interest stimulated demands for war reparations. Most of these demands emanated from embittered far-

Moved, but no apology on Boer War

Pretoria – Britain's Queen
Elizabeth said yesterday no one
could be unmoved by the suffering
in British concentration camps
during the Anglo-Boer War a
century ago, but she stopped short
of making an outright apology.

"No one who reads of the distressing
conditions in the detention camps
which held both white and black
detainees, could fail to be moved even
today, 100 years later.

"It is surely right that we commemo-
rate the centenary of this war in a spir-
it of reconciliation," the Queen told a
banquet on the first day of her state
visit to South Africa.

6. Queen Elizabeth II expresses first official British
regret over conditions of war. Courtesy *Cape Argus*
(Capetown), Nov. 11, 1999.

right Afrikaner political organizations and cultural associations, who called
for "war guilt" funds for the past ruining of fertile agricultural land by Brit-
ish war making and for the catastrophic losses of the internment camp
"holocaust."[19]

Other reparations claims were lodged by several rural African commu-
nities that had loyally collaborated with British forces. Elderly tribal pa-
triarchs appealed either to the British government or directly to the Crown
to honor known or imagined 1902 rewards or war bounty, which pre-
viously had either been disowned or had not been recognized. Thus,
the Tshidi-Baralong of Mafekeng, who had sacrificed much while aiding
Baden-Powell's garrison during the celebrated Mafekeng siege action, tried
to reactivate an ancient 1903 claim for unpaid wages, loss of comman-
deered livestock, and requisitioned property. Chiefly elders estimated
1899–1900 losses at the current equivalent of 3.8 million pounds sterling.
The British High Commission in Pretoria received this novel chit with
baffled politeness.

Elsewhere, there was an even more fanciful stab at making good for

past historic wrongs. Several leading literary figures, such as the virtuous Afrikaans writer, Antjie Krog, weighed in with ideas on how to make the war a lubricant of national reconciliation, using its historical resonance to mould contemporary understandings of how South Africa has become what it is. With the Anglo-Boer conflict moving to the center of public remembrance, Krog conjured up the text of a counterfactual white South African history between 1902 and 1910. This was a story containing a different post–Boer War moral parable in which the end of the conflict was a great, lost opportunity, the consequences of which had scarred the rest of twentieth-century South African life.[20]

What was this wasted alternative version? It was beguilingly simple. Had British army commanders like Kitchener and Lord Roberts been obliged to appear before a judicial "war crimes" tribunal, some 1902–1903 confessional version of the post-1994 Truth and Reconciliation Commission, twentieth-century South African history would have been healthier. Why? If Britain had been forced to face up to "Truth and Justice" after the Anglo-Boer War, acknowledged its shameful war conduct, and done more to ease the national pain of defeated Boer die-hard or *bittereinder* fighters, last-ditch nationalist veterans might not have borne home with them the trauma that would endure through their lives and harden their politics of survival through racial mastery. Given timely forgiveness, healing, and "reconciliation," the radical bittereinders might have been left less bitter, and the character of apartheid could have been less harsh. It is difficult to take such wistful notions at all seriously, however, for we can never know a history that did not happen.[21]

Still, in political terms, it is not hard to see why this kind of approach was so readily digested by certain Afrikaner commentators, adding a further interesting centenary epilogue to Anglo-Boer War introspection. In this interpretative turn those who constructed and enforced apartheid had been the sufferers of total war; therefore, in some fundamental way it was really Britain's hounding of the Boers and not Afrikaner nationalism that was culpable for the excesses of white South Africa after 1948. "The war was used in the 1930s to awaken Afrikaner nationalism, because of the impoverishment of Afrikaners," observed "Dawie," the columnist for *Die Burger*. This feverish climate produced "an aggressive and intolerant nationalism that flirted with national socialism and then tried to guarantee its own existence through a massive social engineering program. This chain reaction had been set in motion by British imperialism." But the moment

had arrived to let bygones be bygones and for "divided historical experiences to be grasped, so that all could live peaceably and easily together in the new South Africa."[22]

The most assiduous reworking of all was that undertaken by the ANC government, the more surprising given the historical register of South Africa's black resistance movements. For many decades, as I have already noted, any organizational "remembering" of the Anglo-Boer War was resisted on the basis of a perfectly reasonable assumption. British imperialists had promised the "rightless" black majority a better deal after the war but had instead betrayed their political interests; Afrikaners, granted, had sacrificed much in a great anticolonial struggle but had then gone on to oppress others through apartheid.

However, the national patriotic possibilities associated with public war centenary interest ended ANC indifference. The war was now to be commemorated as a crucial episode in South Africa's painful experience of European imperialism and to be used to express a more "representative understanding" of national historical heritage. As Deputy President Jacob Zuma declared on Heritage Day in September 1999, "to facilitate an equitable, inclusive and representative understanding of history," it was imperative for "South Africans to revisit their common history and acknowledge the role of black citizens in events like the Anglo-Boer War."[23]

This view was expanded, in an altogether more grand manner, by President Thabo Mbeki. Accompanied by the Duke of Kent and a large procession of dignitaries and invited guests, Mbeki officially launched the Anglo-Boer War commemorative cycle in the small and obscure Free State town of Brandfort. This was a prosaic spot to which, in earlier years, the apartheid authorities had banished Winnie Mandela as an internal political exile. That symbolism may or may not have been coincidental to the choice of location.

The president laid wreaths on the graves of Boer and British war dead (see fig. 7) and on the recently located burial sites of some Africans, in an area located for identification and preservation as a black concentration camp by the Ministry of Arts and Culture. Several experts questioned the authenticity of this concentration camp site "discovery," pointing out that the graves may not have been those of war victims, but the political allure of a black Brandfort camp made a compelling confection. In the face of right-wing Afrikaner resentment of the government's "over-eagerness to focus on the role of blacks," and stiff criticism of the "unfeeling" omission of a singular "Afrikaner representative" from the Brandfort invitation list,

7. President Thabo Mbeki marks Boer and British graves in the Orange
Free State. Courtesy *Cape Argus* (Capetown), Oct. 15, 1999.

Mbeki was adroit. While calling for recognition of the "lost" story of black
involvement in the war, he also paid fulsome tribute to "the brave Boers
and Boer Women" who had lined up behind Transvaal president Paul
Kruger and "challenged the British Empire a hundred years ago."

The country "pays homage to them," nodded Mbeki, "because they
had the courage to take on a Goliath in defense of their freedom . . .
because in struggle, they asserted the right of all colonized people to
independence." The "courage and sacrifice" displayed in that quest was
cause for patriotic elation, for this had become ingrained "in the common
history of all South Africans, whatever their race or color."[24] For the ANC
the time of the war had become a revisionary time, as a new South African
nationalism broke bread with the old nationalism based on the survival
narrative of Afrikaner history. With the Anglo-Boer War absorbed as an
epic strand of a linear South African struggle for freedom, just as the
antiapartheid battle was another herculean part of that struggle, so the
fallen Boer commando bittereinders of 1902 would find a sacred place
alongside fallen black nationalist guerrilla comrades of the 1970s, 1980s, and
1990s. Their common heroism under arms would fertilize a new "postco-
lonial" kind of historical memory for South African citizens who were now
all supposed to behave like patriots.

In another celebratory dimension the government also authorized or
licensed a politically digestible new name for the war. According to the
deliciously pedantic deputy minister of arts and culture, Ms. Brigitte Ma-
bandla, as hostilities had "involved more than white-on-white violence," in

the interests of accuracy the war needed to be authoritatively retitled. As the Anglo-Boer South African War it would reflect involvement by both white and black. Any commemorative activity was to be an exercise "in nation-building through inclusivity, promoting reconciliation, presenting a balanced picture of the war, and raising heritage awareness."[25] On the face of things this was all well and good, given the appalling record of previous white minority governments in denying black war experience any place in official remembrance.

Nevertheless, the new nationalist commitment to public representation of Anglo-Boer War history was not without its own problems. For a start there was a distinctly statist tinge to the whole public history exercise; it is the Ministry of Arts and Culture which saw its role as assuming responsibility for historical "truth-telling," for reeducating a mass public with a war interpretation more appropriate to a postapartheid civic culture. Thus, toward the end of 1999 the ministry established an official panel of black and white scholars to produce an approved new version of the war and announced the convening of a state-sponsored national conference in August 2000 that would pioneer a focus "on the role and suffering of blacks during the War."[26] The development of a postcolonial historical memory through centenary commemoration was not "a matter to be dealt with solely by civil society" but something in which "an increasingly nationalist black government . . . had to make its influence felt."[27]

So it would now be the state that would tell South Africans and the world what the war had actually been like, and it would be through its chosen historians that the rewritten popular story would be articulated. Against this background more than one ANC minister rounded on South African historians for having neglected their duty in taking no account of the impact of the war on the black population, a vital element "either suppressed or ignored" up to the present.[28] Yet in setting out to correct matters, a new official history promises only to reinvent the wheel. For more than two decades historians from South Africa as well as Britain have been doing much to provide a more "inclusive" understanding of the war, one that gives due importance to the question of black participation.[29]

In view of the existence of an established "progressive" war historiography political criticism of contemporary scholars would appear to be either misplaced or just odd. Or perhaps it is not really so odd. If 1994 has come to represent Year Zero for the liberation from apartheid and construction of a new historical heritage for a changed society, any ruling nationalist project

to redeem South African history has by definition to push its own authorial voice. In time, who will remember that as far back as 1977 it was a white historian in an Afrikaans university who first placed African war refugee experience in the academic record of the 1899–1902 war?[30]

The tone of that official voice leads us to a further and final difficulty with the government's relationship to centenary war "heritage." For Minister Mabandla, Africans who intervened in the war seemed to have had little cause or sense of purpose, their wartime lot being to endure or to die. Misused or cheated through "subterfuge," they were "largely victims."[31] This mechanistic approach became a core focus of the 1999 commemorative representation. As passive victims, especially in their segregated British internment camps, Africans were portrayed by official centenary speakers as having come through hostilities almost entirely as suffering refugees. In the straightforward sense of being victims of British imperial inhumanity, they could be seen as occupying a wretched spot alongside stricken Afrikaner civilians (see fig. 8). The effect was to encode another public version of the old nationalist Afrikaner imagery of the helpless fatalism of female camp captivity and sacrifice. Continuing this gendered depiction of stoic maternal endurance, there was now merely a new set of skeletal people to rise up eventually from terrible days.

One can, of course, understand the utility of such perspectives to the nation-building project, the earnest weaving in of a history of communal suffering as part of the saga of everyone's anti-imperialist war experience. As a "legacy project," commemoration of the "conflictual aspect" of South African history could aid the search for "justice, reconciliation and symbolic reparation," argued two notable scholars in the field of public history and heritage.[32] But, as ever, any form of nationalist history ignores the simple fact that history is too awkward or too messy for single, easy truths. While tens of thousands of Africans died in camps as victims of Britain's scorched earth tactics against its rural guerrilla enemy, many more thousands did not.

These individuals were not hapless victims or pawns of a white war. Instead, as shrewd agents in their own lives, they made their own choices and negotiated participation in the Anglo-Boer War on their own terms. Some were willing British collaborators; others intervened to fight independently, driving Boer landlords off their lands and seizing livestock and other property. Yet others loyally served Boer masters as trusted servants or profited from the war as agricultural producers. In other words, the black story in the war is too sprawling, too varied, too complex, and too

8. Black war refugees in a British army concentration camp.
Courtesy *Cape Sunday Argus* (Capetown), April 3–4, 1999.

ambiguous in its particulars to be reducible to a plain public history chronicle of bearing witness to helpless suffering.

There is nothing wrong with new popular perspectives on this conflict, nationalist or otherwise, to enrich ordinary understanding at its centenary and thereafter. Younger Afrikaner historians, after all, started reexamining the Anglo-Boer War quite sometime ago. The real issue is whether the intellectual engagement with the national centenary advances genuine historical knowledge or imagination. It may well have been inevitable that from 1999 to 2002 the musty image of "the white man's war" would be translated more to "the black man's war," but war is peculiarly susceptible to being turned into one or other prevailing myth.

In its remembrance ceremonies conducted on behalf of the "imagined community" of the South African nation there was a sense that the ruling party's version of the war was on course to become a myth of "historical realism" or "inclusive heritage" in the cause of unifying the nation after apartheid. As the writer Bryan Rostron noted early in 2000, "social harmony" was becoming "the new orthodoxy," in which an overriding emphasis on "the triumph of the human spirit" was smothering the "place of critical evaluation."[33]

Ultimately, the test of any programmatic war remembrance must re-

main that of how well it comes to terms with the deep contradictions and muddle of the 1899–1902 hostilities and, it must be said, how much it acknowledges the stark ironies of this war in national South African history. In October 1999 President Thabo Mbeki publicly condemned the brutality of the British Empire's concentration camp policy, reminding the country once again of the excesses of power.

Almost exactly ninety years earlier, elite members of South Africa's conservative Native Congresses, from which the ANC would spring, thanked London's "able administrators" for their "great work" in having "controlled Native refugees, and for all that has been done in protecting, housing and feeding them in the camps."[34] This is by no means the only ring of irony. It was all very well for African and Afrikaner nationalist luminaries to have come together in the injured innocence of shared suffering and to reprimand Britain for its nasty imperialist conduct. In truth, it made for a sorry spectacle. As Albert Grundlingh reminded us in a recent issue of the *Chronicle of Higher Education*, by the end of 1902 most English South Africans and pacified Afrikaners were prepared to let bygones be bygones, provided they could share the bread of union in 1910 and leave blacks the crust, yet some politicians were now "trying to prove who suffered most." What this resembled was "a rather tawdry spectacle of the Olympics of suffering."[35] Past shadows thrown by the war are not necessarily all that compatible with a new consensual vision of its history. And, at bottom, even this strain has not run very deep. After the 1999 centenary flourish, state interest in a reworked public history of the war largely waned. Three years later, invitations to a June 2002 commemoration (sponsored by a commercial bank) to mark the end of the war gave it a fresh date, 1899–1901. These invitations were reissued with a line thanking "those who bothered to point out an error."[36] As ever, it turns out that the state is rarely famous for its grasp of historical accuracy.

NOTES

1. Nasson, *The South African War, 1899–1902*, 262.
2. Grundlingh, "War, Wordsmiths and the 'Volk,'" 52.
3. See Plaatje, *Native Life in South Africa*; and Molema, *The Bantu Past and Present*.
4. *Johannesburg Sunday Independent*, Dec. 31, 1995.
5. Brink and Krige, "Remapping and Remembering the South African War in Johannesburg and Pretoria."

6. *Die Burger* (Capetown), March 1, 1995.

7. *Rapport* (Johannesburg), April 12, 1998; *Beeld* (Johannesburg), April 26, 1998; *Die Burger* (Capetown), May 7, 1999.

8. *Sunday Times* (Johannesburg), April 5, 19, 1998.

9. *Rapport* (Johannesburg), April 12, 1998.

10. *Weekly Mail and Guardian* (Johannesburg), Oct. 15–21, 1999.

11. *Sunday Times* (Johannesburg), Oct. 16, 1999.

12. *Cape Times* (Capetown), Aug. 3, 1999.

13. Cited in Grundlingh, "War, Wordsmiths and the '*Volk*,'" 54.

14. *Cape Times* (Capetown), Oct. 11, 1999; *Star* (Johannesburg), Oct. 16, 1999.

15. *Sunday Times* (Johannesburg), Oct. 10, 1999.

16. *Beeld* (Johannesburg), Nov. 6, 1999.

17. *Cape Times* (Capetown), Oct. 11, 1999.

18. *Beeld* (Johannesburg), Nov. 11, 1999.

19. *Die Volksblad* (Pretoria), Nov. 3, 1999.

20. *Diamond Fields Advertiser* (Johannesburg), Oct. 23, 1999; *Star* (Johannesburg), Oct. 18, 1999.

21. *Weekly Mail and Guardian* (Johannesburg), Oct. 8–14, 1999.

22. *Die Burger* (Capetown), Oct. 9, 1999.

23. *The Citizen* (Johannesburg), Sep. 24, 1999.

24. *Rapport* (Johannesburg), Oct. 10, 1999; *Beeld* (Johannesburg), Oct. 12, 1999; *Cape Times*, Oct. 15, 1999.

25. *Cape Times* (Capetown), Oct. 6, 1999.

26. *Sunday Times* (Johannesburg), Oct. 16, 1999; M. Xulu, International Conference on the Participation of Blacks in the Anglo-Boer War: Call for Papers, communiqué, Department of Arts, Culture, Science and Technology, Pretoria, January 25, 2000.

27. Grundlingh, "The Anglo-Boer War in Twentieth-Century Afrikaner Consciousness," 260–61.

28. *Sunday Argus*, Oct. 3, 1999.

29. See, e.g., Warwick, *Black People and the South African War, 1899–1902*; Nasson, *Abraham Esau's War*; Nasson, *Uyadela Wen'osulapho*; and Nasson, "Africans at War," 126–40, and "Black Communities in Natal and the Cape," 38–55.

30. See Spies, *Methods of Barbarism?*

31. *Cape Argus*, Oct. 8, 1999.

32. Dominy and Callinicos, "'Is There Anything to Celebrate?'" 392.

33. *Cape Argus*, Jan. 10, 2000.

34. Quoted in Karis and Carter, *From Protest to Challenge*, 18.

35. Quoted in Linda Vergnani, "Scholars Unearth Evidence of the Boer War's Black Victims," *Chronicle of Higher Education*, Jan. 7, 2000, 19.

36. My thanks to Dave Kaplan for bringing this to my attention.

BIBLIOGRAPHY

Abercrombie, Thomas. *Pathways of Memory and Power: Ethnography and History among an Andean People*. Madison: University of Wisconsin Press, 1998.

Agosin, Marjorie. *Scraps of Life: Chilean Arpilleras: Chilean Women and the Pinochet Dictatorship*. Trans. Cola Franzen. Trenton, N.J.: Red Sea Press, 1987.

Aharoni, Yohanan. *Metzada* [Masada]. Tel Aviv: Ma'arkhot, 1958.

Ahmad, Aijaz. "The Politics of Literary Postcoloniality." *Race and Class* 36, no. 3 (1995): 1–20.

Aizenberg, Edna. "Making Monuments in Argentina, a Land Afraid of Its Past." *Chronicle Review*, June 21, 2002, B10–11.

Aleksievich, Svetlana. *Zacharovannye smert'iu*. In *Druzhba narodov* 4 (1993).

Allende, Isabel. *Of Love and Shadows*. Trans. Margaret Sayers Peden. New York: Knopf, 1987.

Alon, Azaryahu. "Me Haya Midbar Yehuda Avurenu?" [What the Judean Desert Meant for Us]. In Mordechai Naor, ed., *Yam ha-Melah u-Midbar Yehuda* [The Dead Sea and the Judean Desert], 270–75. Idan Series no. 14. Jerusalem: Yad Yitzhak Ben-Zvi, 1990.

Alonso, Ana Maria. "The Effects of Truth: Re-Presentations of the Past and the Imagining of Community." *Journal of Historical Sociology* 56 (1988): 33–57.

Alsop, Stewart. "Again, the Masada Complex." *Newsweek*, March 19, 1973, 104.

——. "The Masada Complex." *Newsweek*, July 12, 1971, 92.

Alter, Robert. "The Masada Complex." *Commentary* 56 (June 1973): 19–24.

Aluwihare, R., and D. B. Navaratne. Interview by Kanishka Goonewardena. Nugegoda, Sri Lanka. Dec. 19, 1999.

Aly, Götz. *Final Solution: Nazi Population Policy and the Murder of European Jews*. New York: Arnold and Oxford University Press, 1999.

——. "The Universe of Death and Torment." In *Unwilling Germans? The Goldhagen Debate*. Minneapolis: University of Minnesota Press, 1998.

Aly, Götz, and Suzanne Heim, *Vordenker der Vernichtung: Auschwitz und die deutschen Pläne für eine neue europäische Ordnung*. Frankfurt: Fischer, 1993.

Amarasekara, Gunadasa. *Jathika Chinthanaya saha Jathika Aarthikaya* [National Ideology and National Economy]. Maharagama: Chinthana Parshadaya, 1993.

Amnesty International. *The "Disappeared" of Argentina: List of Cases Reported to Amnesty International, March 1976–February 1979.* London: Amnesty International, 1979.

——. "El Salvador: Peace Can Only Be Achieved with Justice." April 5, 2001. AI Index: AMR 29 / 001 / 2001.

Anderson, Benedict. *Imagined Communities: Reflections on the Origin and Spread of Nationalism.* Rev. ed. London: Verso, 1991.

Anderson, Perry. "Modernity and Revolution." In *A Zone of Engagement,* 25–55. London: Verso, 1992.

Appadurai, Arjun. "Disjuncture and Difference in the Global Cultural Economy." *Public Culture* 2, no. 2 (spring 1990): 1–24.

Applegate, Celia. *A Nation of Provincials: The German Idea of Heimat.* Berkeley: University of California Press, 1990.

Arana, Mario. "General Economic Policy." In *Nicaragua without Illusions: Regime Transition and Structural Adjustment in the 1990s,* ed. by Thomas W. Walker, 81–96. Wilmington, Del.: SR Books, 1997.

Arditti, Rita. *Searching for Life: The Grandmothers of the Plaza de Mayo and the Disappeared Children of Argentina.* Berkeley: University of California Press, 1999.

Assmann, Jan. "Kollektives Gedächtnis und kulturelle Identität." In *Kultur und Gedächtnis,* ed. by Jan Assmann and Tonio Hölscher, 9–20. Frankfurt am Main: Suhrkamp, 1988.

Austerlitz, Paul. *Merengue: Dominican Music and Dominican Identity.* Philadelphia: Temple University Press, 1997.

Averill, Gage. *A Day for the Hunter, a Day for the Prey.* Philadelphia: Temple University Press, 1997.

Awaya Kentaro. "Emperor Showa's Accountability for War." *Japan Quarterly* 38, no. 4 (Oct.–Dec. 1991): 386–98.

Babb, Florence. *After Revolution: Mapping Gender and Cultural Politics in Neoliberal Nicaragua.* Austin: University of Texas Press, 2001.

Baldwin, Peter, ed. *Reworking the Past: Hitler, the Holocaust, and the Historians' Debate.* Boston: Beacon, 1990.

Bar-Tal, Daniel. "The Masada Syndrome: A Case of Central Belief." Discussion Paper 3. International Center for Peace in the Middle East, 1983.

Barthes, Roland. "The Eiffel Tower." In *The Eiffel Tower and Other Mythologies,* 3–17. New York: Noonday Press, 1979.

Bartov, Omer. *Hitler's Army: Soldiers, Nazis, and War in the Third Reich.* New York: Oxford University Press, 1991.

Becker, Marvin. *The Emergence of Civil Society in the Eighteenth Century: A Privileged Moment in the History of England, Scotland, and France.* Bloomington: Indiana University Press, 1994.

Becker, Ulrike, Frank Behn, and Clara Fall. *Goldhagen und die deutsche Linke oder Die Gegenwart des Holocaust.* Berlin: Elefanten Press, 1997.

Ben-Ari, Eyal, and Yoram Bilu. *Grasping Land: Space and Place in Contemporary Israeli Discourse.* Albany: SUNY Press, 1997.

Bennett, Tony. *The Birth of the Museum.* London: Routledge, 1995.

Ben-Yehuda, Nachman. *The Masada Myth: Collective Memory and Mythmaking in Israel.* Madison: University of Wisconsin Press, 1995.

——. *Sacrificing Truth: Archaeology and the Myth of Masada.* Amherst, N.Y.: Humanity Books, 2002.

Beverley, John, and Marc Zimmerman. *Literature and Politics in the Central American Revolutions.* Austin: University of Texas Press, 1990.

Bhabha, Homi K. *Nation and Narration.* London: Routledge, 1990.

Biess, Frank. "'Pioneers of a New Germany': Returning POWs from the Soviet Union and the Making of East German Citizens, 1945–1950." *Central European History* 32, no. 2 (1999): 143–80.

——. "Survivors of Totalitarianism: Returning POWs and the Reconstruction of Masculine Citizenship in West Germany, 1945–1955." In *The Miracle Years: A Cultural History of West Germany,* ed. by Hanna Schissler, 57–82. Princeton, N.J.: Princeton University Press, 2000.

Binford, Leigh. *The El Mozote Massacre: Anthropology and Human Rights.* Tucson: University of Arizona Press, 1996.

——. "Hegemony in the Interior of the Salvadoran Revolution: The ERP in Northern Morazán." *Journal of Latin American Anthropology* 4, no. 1 (1999): 2–45.

Bitan, Dan. "Metzada: Ha-Semel veha-Mitos" [Masada: The Symbol and the Myth]. In Mordechai Naor, ed., *Yam ha-Melah u-Midbar Yehuda* [The Dead Sea and the Judean Desert, 1900–1967], 221–35. Idan Series no. 14. Jerusalem: Yad Yitzhak Ben-Zvi, 1990.

Bodnar, John. *Remaking America: Public Memory, Commemoration, and Patriotism in the Twentieth Century.* Princeton, N.J.: Princeton University Press, 1992.

Bolaños, Miguel. *Los días de la tortuga.* Managua: Anamá Ediciones, 1996.

Borneman, John. "Uniting the German Nation: Law, Narrative, and Historicity." *American Ethnologist* 20, no. 2 (1993): 288–311.

Boswell, D., and J. Evans, eds. *Representing the Nation: A Reader. Histories, Heritage, and Museums.* Routledge: London, 1999.

Bosworth, R. J. B. *Explaining Auschwitz and Hiroshima: History Writing and the Second World War, 1945–1990.* New York: Routledge, 1993.

Bouvard, Marguerite Guzman. *Revolutionizing Motherhood: The Mothers of the Plaza de Mayo.* Wilmington, Del.: Scholarly Resources, 1994.

Boyarin, John. *Remapping Memory: The Politics of Timespace.* Minneapolis: University of Minnesota Press, 1994.

Brink, Elsabe', and Sue Krige. "Remapping and Remembering the South African War in Johannesburg and Pretoria." *South African Historical Journal* 41 (1999): 404, 418–21.

Broun, Dauvit, R. J. Finlay, and Michael Lynch, eds. *Image and Identity: The Making and Re-Making of Scotland through the Ages.* Edinburgh: John Donald, 1998.

Brow, James. "Notes on Community, Hegemony, and the Uses of the Past." *Anthropology Quarterly* 63, no. 1 (1990): 1–6.

Brown, Alice, Lindsay Paterson, and David McCrone. *Politics and Society in Scotland: 1707–1995*. Basingstoke: Macmillan, 1995.

Bruner, Edward, and Phillis Gorfain. "Dialogic Narration and the Paradoxes of Masada." In *Text, Play, and Story: The Construction and Reconstruction of Self and Society. 1983 Proceedings of the American Ethnological Society*, ed. by E. Bruner and S. Plattner, 56–79. Washington, D.C.: American Ethnological Society.

Bucur, Maria, and Nancy M. Wingfield, eds. *Staging the Past. The Politics of Commemoration in Habsburg Central Europe, 1848 to the Present*. West Lafayette, Ind.: Purdue University Press, 2001.

Buruma, Ian. *The Missionary and the Libertine*. Boston: Faber and Faber, 1996.

——. *The Wages of Guilt: Memories of War in Germany and Japan*. New York: Farrar, Straus, and Giroux, 1995.

Cabarrús, C. R. *Génesis de una Revolución: Análisis del Surgimiento y Desarrollo de la Organización Campesina en El Salvador*. Mexico: Ediciones de la Casa Chata, 1983.

Campbell, F. Gregory. "Empty Pedestals?" *Slavic Review* 44, no. 1 (spring 1985): 1–15.

Caplinskas, Antanas Rimvydas. *Vilniaus Gatves: Istoria Vardynas Zemelapiai* [Vilnius Streets: History, Street Names, Maps]. Vilnius: Charibde, 2000.

Carroll, Peter J. "The Local Articulation of Nationality: The Role of Historicity and 'National Essence' in Republican China's Urban Modernity." In "City and Nation: Rethinking Place and Identity," ed. by Michael Peter Smith and Thomas Bender. Special issue, *Comparative Urban and Community Research* 7 (2001).

Carter, James. *Creating a Chinese Harbin: Nationalism in an International City, 1916–1932*. Ithaca, N.Y.: Cornell University Press, 2002.

——. "A Tale of Two Temples: Nation, Region, and Religious Architecture in Harbin." *South Atlantic Quarterly* 99, no. 2 (spring 2001): 97–119.

Certeau, Michel de. *The Practice of Everyday Life*. University of California Press: Berkeley, 1984.

Chomsky, Noam. *American Power and the New Mandarins*. New York: Vintage, 1969.

Clausen, Søren, and Stig Thøgersen. *The Making of a Chinese City: History and Historiography in Harbin*. Armonk, N.Y.: M. E. Sharpe, 1995.

Clements, Alan, Kenny Farquarson, and Kirsty Wark. *Restless Nation*. Edinburgh: Mainstream, 1996.

Cole, Jennifer. "The Work of Memory in Madagascar." *American Ethnologist* 25, no. 4 (1998): 610–33.

Confino, Alon. *The Nation as a Local Metaphor: Wurtemberg, Imperial Germany, and National Memory, 1871–1918*. Chapel Hill: University of North Carolina Press, 1997.

Connerton, Paul. *How Societies Remember*. Cambridge: Cambridge University Press, 1989.

Constable, Pamela, with Arturo Valenzuela. *A Nation of Enemies: Chile under Pinochet*. New York: Norton, 1993.

Cowan, Edward J. "Identity, Freedom, and the Declaration of Arbroath." In Broun, Finlay, and Lynch, *Image and Identity*, 246–61.

Crick, Bernard, and David Millar. *To Make the Parliament of Scotland a Model for Democracy*. Edinburgh: John Wheatley Centre, 1995.

Cullen, Michael S., ed. *Das Holocaust-Mahnmal: Dokumentation einer Debatte*. Munich: Pendo, 1999.

Danner, Marc. *The Massacre at El Mozote: A Parable of the Cold War*. New York: Vintage Books, 1994.

Davie, George. *The Democratic Intellect*. Edinburgh: Edinburgh University Press, 1964.

DeCesare, Donna. "The Children of the War: Street Gangs in El Salvador." NACLA 22, no. 1 (1998): 21–29.

Deutsche, Rosalind. *Evictions: Art and Spatial Politics*. Cambridge, Mass.: MIT Press, 1996.

Diner, Dan. "On Guilt Discourse and Other Narratives." *History and Memory* 9, nos. 1–2 (fall 1997): 301–320.

Dominy, Graham, and Luli Callinicos. " 'Is There Anything to Celebrate?' Paradoxes of Policy: An Examination of the State's Approach to Commemorating South Africa's Most Ambiguous Struggle." *South African Historical Journal* 41 (1999): 384–403.

Drake, Paul W., and Ivan Jaksic, eds. *The Struggle for Democracy in Chile, 1982–1990*. Lincoln: University of Nebraska Press, 1991.

Drema, Vladas. *Dinges Vilnius* [Lost Vilnius]. Vilnius: Vaga, 1991.

Duara, Prasenjit. *Culture, Power, and the State: Rural North China, 1900–1942*. Stanford, Calif.: Stanford University Press, 1988.

———, ed. *Remaking the Chinese City: Modernity and National Identity, 1900–1950*. Honolulu: University of Hawai'i Press, 1999.

Duffy, Terence. "The Peace Museum Concept." *Museum International* 45, no. 177 (Nov. 1993): 4–8.

Duncan, Carol. *Civilizing Rituals: Inside Public Art Museums*. London: Routledge, 1995.

Dunkerley, James. *Power in the Isthmus: A Political History of Modern Central America*. London: Verso, 1988.

Edwards, B., and G. Siebentritt. *Places of Origin: The Repopulation of Rural El Salvador*. Boulder, Colo.: Lynne Rienner, 1991.

Edwards, Dudley Owen, ed. *A Claim of Right for Scotland*. Edinburgh: Polygon, 1989.

Ellis, Peter Berresford, and Seumas Mac A'Ghobhainn. *The Scottish Insurrection of 1820*. London: Pluto, 1989.

Ensalaco, Mark. *Chile under Pinochet: Recovering the Truth*. Philadelphia: University of Pennsylvania Press, 1999.

Eyerman, Ron, and Andrew Jamison. *Mobilizing Traditions in the Twentieth Century*. Cambridge: Cambridge University Press, 1998.

Feitlowitz, Marguerite. *A Lexicon of Terror: Argentina and the Legacies of Torture.* New York: Oxford University Press, 1998.

Field, Norma. *In the Realm of a Dying Emperor.* New York: Vintage, 1993.

——. "The Stakes of Apology." *Japan Quarterly* 42, no. 4 (Dec. 1995): 405–25.

Fisher, Andrew. *William Wallace.* Edinburgh: John Donald, 1986.

Fitzgerald, John. *Awakening China: Politics, Culture, and Class in the Nationalist Revolution.* Stanford, Calif.: Stanford University Press, 1996.

Flusser, David, ed. *Sefer Yosifon* [The Book of Jossipon]. Jerusalem: Bialik Institute, 1978.

Frampton, Kenneth. "Towards a Critical Regionalism: Six Points for an Architecture of Resistance." In *The Anti-Aesthetic,* ed. by Hal Foster, 16–30. Seattle: Bay Press, 1983.

Frei, Norbert. *Vergangenheitspolitik: die Anfänge der Bundesrepublik und die NS Vergangenheit.* Munich: Beck, 1996.

Frimer, D. "Masada in Light of the Halakha." *Tradition* 12 (summer 1971): 27–43.

Garofalo, Reebee, ed. *Rockin' the Boat: Mass Music and Mass Movements.* Boston: South End Press, 1992.

Geyer, Michael, and Miriam Hansen. "German-Jewish Memory and National Consciousness." In *Holocaust Remembrance: The Shapes of Memory,* ed. by Geoffrey Hartman, 175–90. Cambridge, Mass.: Blackwell, 1994.

Ghirardo, Diane. *Architecture after Modernism.* London: Thames and Hudson, 1996.

Gillis, John. *Commemorations: The Politics of National Identity.* Princeton, N.J.: Princeton University Press, 1994.

Gilroy, Paul. *The Black Atlantic: Modernity and Double Consciousness.* Cambridge, Mass.: Harvard University Press, 1993.

Giordano, J. M. "Resurrecting Mary. A Controversial Historical Landmark May Soon Rise Again." *Prague Post,* July 22–28, 1998, B12–13.

Goldhagen, Daniel Jonah. *Hitler's Willing Executioners: Ordinary Germans and the Holocaust.* New York: Vintage, 1997.

Goonewardena, Kanishka. "Cultural Politics of Global Capital: National Socialism in Sri Lanka?" In "Globalization, Postmodernism, and Fascism: Reflections on Ideology, Urban Space, and the Cultural Politics of Global Capital from Colombo and Los Angeles," 328–69. PhD diss., Cornell University, 1998.

Goren, Shlomo. "Mitzvat Kiddush he-Shem le-Or ha-Halakha" [The Heroism of Masada in View of the Jewish Law]. *Mahanaim* 67 (1963): 7–12.

Gottfried, Libor. "Kterak socha Mariánská byla strzena" [How the Marian Statue Was Demolished]. *Dějiny a součástnost* 5 (1994): 29–30.

Grasskamp, Walter. "Die Behaglichkeit des Gedenkens." In Cullen, *Das Holocaust-Mahnmal,* 20–30.

Gray, Alasdair. *Why the Scots Should Rule Scotland.* Edinburgh: Canongate, 1992.

Grossmann, Atina. "The 'Goldhagen Effect': Memory, Repetition, and Responsi-

bility in the New Germany." In *The "Goldhagen Effect": History, Memory, Nazism—Facing the German Past*, ed. by Geoff Eley, 89–130. Ann Arbor: University of Michigan Press, 2001.

——. "Trauma, Memory, and Motherhood: German and Jewish Displaced Persons in Post-Nazi Germany, 1945–1949." *Archiv für Sozialgeschichte* 38 (1998): 215–39.

Grundlingh, Albert. "The Anglo-Boer War in Twentieth-Century Afrikaner Consciousness." In *Scorched Earth*, ed. by Fransjohan Pretorius, 242–65. Cape Town: Human and Rousseau, 2001.

——. " 'War, Wordsmiths and the *Volk*': Afrikaans Historical Writing on the Anglo-Boer War of 1899–1902 and the War in Afrikaner Nationalist Consciousness, 1902 1990." In *Mfecane to Boer War: Versions of South African History. Papers Presented at a Symposium at the University of Essen, 25–27 April 1990*, ed. by E. Lehmann and E. Reckwitz, 48–65. Essen: Die Blaue Eule, 1992.

Gunaratne, Arjun. "Politics of the Sri Lankan National Flag." Lecture delivered at the Center for International Studies, Cornell University, Ithaca, N.Y., spring 1996.

Gunasinghe, Newton. "The Open Economy and Its Impact on Ethnic Relations." In *Newton Gunasinghe: Selected Essays*, ed. by Sasanka Perera, 183–203. Colombo: Social Scientists' Association, 1996.

Gussew, Katarina. "Wilno, Wilna, Vilnius-Hauptstadt Litauens." In *Die Wiedergefundene Erinnerung: Verdrängte Geschichte in Osteuropa*, ed. by Annette Leo. Berlin: Basis Druck, 1992.

Hague, Euan. "Scotland on Film: Attitudes and Opinions about *Braveheart*." *Etudes Ecossaises* 6 (1994): 75–89.

Hajek, Frank Joseph. "Catholics and Politics in Czechoslovakia, 1918–1929; Jan Šramek and the People's Party." PhD diss., Emory University, 1975.

Halbwachs, Maurice. *On Collective Memory*. Ed. and trans. by Lewis A. Coser. Chicago: University of Chicago Press, 1992.

——. *The Collective Memory*. Trans. Francis J. Ditter and Vida Vazdi Ditter. New York: Harper and Row, 1988.

Hallam, Elizabeth, and Jenny Hockey. *Death, Memory, and Material Culture*. Oxford: Berg, 2001.

Hammond, Ellen H. "Commemoration Controversies: The War, the Peace, and Democracy in Japan." In Hein and Selden, *Living with the Bomb*, 100–119.

Hammond, John. *Fighting to Learn: Popular Education and Guerrilla War in El Salvador*. New Brunswick, N.J.: Rutgers University Press, 1998.

Harkabi, Yehoshafat. *The Bar Kokhba Syndrome*. Chappaqua, N.Y.: Rossel Books, 1983.

Harvey, David. "Monument and Myth: The Building of the Basilica of the Sacred Heart." In his *The Urban Experience*. Baltimore: Johns Hopkins University Press, 1989.

Harvie, Christopher. *Cultural Weapons: Scotland and Survival in a New Europe*. Edinburgh: Polygon, 1992.

———. *Scotland and Nationalism: Scottish Society and Politics, 1707–1994.* London: Routledge, 1994.

———. *Travelling Scot: Essays on the History, Politics, and Future of the Scots.* Glendaruel: Argyll, 1999.

Hata Eimi. *Senso no Hakubutsukan.* Tokyo: Iwanami Shoten, 1995.

Hayner, Priscilla. *Unspeakable Truths: Confronting State Terror and Atrocities.* London: Routledge, 2000.

Heim, Michael Henry, trans. "A Czech Dreambook: Excerpts from Ludvik Vaculík's *Český snář.*" *Cross Currents: A Yearbook of Central European Culture* 3 (1984): 71–86.

Hein, Laura, and Mark Selden, eds. *Living With the Bomb: American and Japanese Cultural Conflicts in the Nuclear Age.* Armonk, N.Y.: M. E. Sharpe, 1997.

Heller, Bernard. "Masada and the Talmud." *Tradition* 10 (winter 1968): 31–34.

Herf, Jeffrey. *Divided Memory: The Nazi Past in the Two Germanys.* Cambridge, Mass.: Harvard University Press, 1997.

Hernández, Deborah Pacini. *Bachata: A Social History of a Dominican Popular Music.* Philadelphia: Temple University Press, 1995.

———. "Dancing with the Enemy: Cuban Popular Music, Race, Authenticity, and the World-Music Landscape." *Latin American Perspectives* 25, no. 3 (1998): 110–25.

———. "A View from the South: Spanish Caribbean Perspectives on World Beat." *World of Music* 35, no. 2 (1993): 48–69.

Hicks, George. *Japan's War Memories: Amnesia or Concealment?* Brookfield: Ashgate, 1997.

History and Memory. Passing into History: Nazism and the Holocaust beyond Memory. [Fall 1997] 9:1 / 2.

Hlobil, Ivo. "Obnova mariánského sloupu?" [Renovated Marian Column?]. *Umění a řemesla* [Art and Crafts] 3 (1991): 97–98.

Hobsbawm, Eric, and Terence Ranger, eds. *The Invention of Tradition.* Cambridge: Cambridge University Press, 1992.

Hoenig, Sidney B. "The Historic Masada and the Halakha." *Tradition* 13 (fall 1972): 100–115.

———. "The Sicarii in Masada: Glory or Infamy?" *Tradition* 11 (spring 1970): 5–30.

Hogan, Michael, ed. *Hiroshima in History and Memory.* New York: Cambridge University Press, 1955.

Holston, James. *The Modernist City: An Anthropological Critique of Brasilia.* Chicago: University of Chicago Press, 1990.

Hook, Andrew. *From Goosecreek to Gandercleugh: Studies in Scottish-American Literary and Cultural History.* East Linton: Tuckwell, 1999.

Hook, Glenn. *Militarization and Demilitarization in Contemporary Japan.* New York: Routledge, 1996.

Hruban, Moric. *Z času nedlouho zaslých* [From the Recent Past]. Rome: Krestanská akademie, 1967.

Huyssen, Andreas. "Present Pasts: Media, Politics, and Amnesia." *Public Culture* 30 (2000): 21–38.

——. *Twilight Memories: Marking Time in a Culture of Amnesia*. New York: Routledge, 1995.

Ilan, Zvi. *LiMetzada be-Ikvot ha-Kana'im* [To Masada in the Zealots' Footsteps]. Tel Aviv: Shreberk, 1973.

Ismail, Qadri. "Batting against the Break: On Cricket, Nationalism, and the Swashbuckling Sri Lankans." *Social Text* 50 (spring 1997): 33–56.

Jameson, Fredric. "The Constraints of Postmodernism." In *The Seeds of Time*, 129–205. New York: Columbia University Press, 1994.

——. *Postmodernism, or, The Cultural Logic of Late Capitalism*. Durham, N.C.: Duke University Press, 1990.

Jara, Joan. *An Unfinished Song: The Life of Victor Jara*. New York: Ticknor and Fields, 1984.

Jayatilleke, Dayan. *Sri Lanka: The Travails of a Democracy, Unfinished War, Protracted Crisis*. New Delhi: Vikas, 1995.

Josephus, Flavius. *The Wars of the Jews*. In *Complete Works*. Trans. William Whiston. Grand Rapids, Mich.: Kregel, 1960.

Judson, Pieter M. *Exclusive Revolutionaries: Liberal Politics, Social Experience, and National Identity in the Austrian Empire, 1848–1918*. Ann Arbor: University of Michigan Press, 1996.

Kammen, Michael G. *Mystic Chords of Memory: The Transformation of Tradition in American Culture*. New York: Knopf, 1991.

Kaplan, Flora, ed. *Museums and the Making of "Ourselves": The Role of Objects in National Identity*. London: Leicester University Press, 1994.

Karis, Thomas, and Gwendolyn M. Carter, eds. *From Protest to Challenge: A Documentary History of African Politics in South Africa, 1882–1921*. Vol. 1. Stanford, Calif.: Hoover Institution, 1972.

Karp, Ivan, and Steven Levine, eds. *Exhibiting Cultures: The Poetics and Politics of Museum Display*. Washington, D.C.: Smithsonian Institution Press, 1991.

Katriel, Tamar. *Performing the Past: A Study of Israeli Settlement Museums*. Mahwah, N.J.: Lawrence Erlbaum, 1997.

——. "Rhetoric in Flame: Fire Inscriptions in Israeli Youth Movement Ceremonials." In *Communal Webs: Communication and Culture in Contemporary Israel*, 51–70. Albany: SUNY Press, 1991.

Kershaw, Ian. *The Nazi Dictatorship: Problems and Perspectives of Interpretation*. London: Edward Arnold, 1989.

Kirshenblatt-Gimblett, Barbara. *Destination Museum*. Berkeley: University of California Press, 1998.

Klausner, Yosef. *Historia shel ha-Bayit ha-Sheni* [The History of the Second Temple]. Vol. 5. Jerusalem: Ahiasaf, 1951.

Klemperer, Victor. *I Will Bear Witness: A Diary of the Nazi Years*. 2 vols. New York: Random House, 1998, 1999.

Kolitz, Zvi. "Masada: Suicide or Murder?" *Tradition* 12 (summer 1971): 5–25.

Korn, Solomon. "Durch den Reichstag geht ein Riss." In Cullen, *Das Holocaust-Mahnmal,* 124–29.

——. "Monströse Platte." In Cullen, *Das Holocaust-Mahnmal,* 36–41.

Kornbluh, Peter. "Chile Declassified." *The Nation,* Aug. 9 / 16, 1999, 21–23.

——. *The Pinochet File: A Declassified Dossier on Atrocity and Accountability.* New York: New Press, 2003.

Koshar, Rudy. *Germany's Transient Pasts: Preservation and National Memory in the Twentieth Century.* Chapel Hill: University of North Carolina Press, 1998.

Kramer, Jane. *The Politics of Memory: Looking for the New Germany.* New York: Random House, 1996.

Krishna, Sankaran. *Postcolonial Insecurities: India, Sri Lanka, and the Question of Nationhood.* Minneapolis: University of Minnesota Press, 1999.

Kritzman, Lawrence D., ed. *Realms of Memory: Rethinking the French Past.* 3 vols. Under the direction of Pierre Nora. New York: Columbia University Press, 1996–98.

Krylova, Anna. "Saying 'Lenin' and Meaning 'Party': Subversion and Laughter in Soviet and Post-Soviet Society." In *Consuming Russia: Popular Culture, Sex, and Society since Gorbachev,* ed. by Adele Barker, 243–65. Durham, N.C.: Duke University Press, 1999.

Kunzle, David. *The Murals of Revolutionary Nicaragua.* Berkeley: University of California Press, 1995.

LaCapra, Dominick. "Revisiting the Historians' Debate." *History and Memory* 9, nos. 1–2 (fall 1997): 80–112.

Ladd, Brian. *The Ghosts of Berlin: Confronting German History in the Urban Landscape.* Chicago: University of Chicago Press, 1997.

Lamdan, Yitzhak. *Masada.* Tel Aviv: Hedim, 1927.

Langer, Lawrence. *Holocaust Testimonies: The Ruins of Memory.* New Haven, Conn.: Yale University Press, 1991.

Lavie, Smadar. "Blowups in the Borderzones: Third World Israeli Authors' Gropings for Home." In *Displacement, Diaspora, and Geographies of Identity,* ed. by Smadar Lavie and Ted Swedenburg, 55–96. Durham, N.C.: Duke University Press, 1996.

——. *The Poetics of Military Occupation: Mzeina Allegories of Bedouin Identity under Israeli and Egyptian Rule.* Berkeley: University of California Press, 1990.

Leggewie, Claus. "The Generation of 1989: A New Political Generation." In *Rewriting the German Past: History and Identity in the New Germany,* ed. by Reinhard Alter and Peter Monteath, 103–14. Atlantic Highlands, N.J.: Humanities Press, 1998.

Levinson, Stanford. *Written in Stone: Public Monuments in Changing Societies.* Durham, N.C.: Duke University Press, 1998.

Lewis, Bernard. *History: Remembered, Recovered, Invented.* Princeton, N.J.: Princeton University Press, 1975.

Lindsay, Isobel. "Nationalism, Community, and Democracy." 1976. Repr. in Paterson, *A Diverse Assembly,* 96–101.

Linenthal, Edward T., and Tom Engelhardt, eds. *History Wars: The* Enola Gay *and Other Battles for the American Past.* New York: Henry Holt, 1996.

Lipsitz, George. *Dangerous Crossroads: Popular Music, Postmodernism, and the Poetics of Place.* London: Verso, 1994.

Lowenthal, David. *The Past Is a Foreign Country.* Cambridge: Cambridge University Press, 1985.

Lüdtke, Alf. *Eigen-Sinn: Fabrikalltag, Arbeitererfahrungen und Politik vom Kaiserreich bis in den Faschismus.* Hamburg: Ergebnisse Verlag, 1993.

MacCannell, Dean. *The Tourist: A New Theory of the Leisure Class.* New York: Schocken, 1976.

MacDonald, M., and M. Gatehouse. *In the Mountains of Morazán: Portrait of a Returned Refugee Community in El Salvador.* New York: Monthly Review Press, 1995.

Macura, Vladimir. "Minus Stalin." In *Masarykové boty* [Masaryk's Shoes]. Prague: Praška imaginace,1993.

Mair, Craig. *Stirling: The Royal Burgh.* Edinburgh: John Donald, 1996.

Malachowicz, Edmund. *Wilno: Dzieje, Architektura, Cmentarze.* Wroclaw: Oficyna Wydawnicza Politechniki Wroclawskiej, 1996.

Maloof, Judy, ed. and trans. *Voices of Resistance: Testimonies of Cuban and Chilean Women.* Lexington: University Press of Kentucky, 1999.

Markeviciene, Jurate. "Genius Loci of Vilnius." *Vilnius: Lithuanian Literature, Culture, History* [magazine of the Lithuanian Writers' Union], summer 1999, 101 24.

Markovits, Andrei S., and Simon Reich. *The German Predicament.* Ithaca, N.Y.: Cornell University Press, 1997.

Martínez, Javier, and Álvaro Diaz. *Chile: The Great Transformation.* Washington, D.C.: Brookings Institution and the United Nations Research Institute for Social Development, 1996.

Mason, Tim. "Intention and Explanation: A Current Controversy about the Interpretation of National Socialism." In *Nazism, Fascism and the Working Class,* ed. by Jane Caplan, 212–30. Cambridge: Cambridge University Press, 1995.

———. *Social Policy in the Third Reich: The Working Class and the National Community.* Providence, R.I.: Berg, 1993.

Matta, Pedro Alejandro. *A Walk through a 20th Century Torture Center: Villa Grimaldi, Santiago de Chile.* Santiago: Productora Gráfica Andros Limitada, 2000.

Matus, Alejandra. *El libro negro de la justicia chilena.* Buenos Aires: Planeta, 1999.

Mazower, Mark. *Inside Hitler's Greece: The Experience of Occupation, 1941 1944.* New Haven, Conn.: Yale University Press, 1993.

McCrone, David. *Understanding Scotland: The Sociology of a Stateless Nation.* London: Routledge, 1992.

McDonnachie, Ian, and Christopher Whatley, eds. *The Manufacture of Scottish History.* Edinburgh: Polygon, 1992.

Meier, Christian. "Das Problem eines Berliner Denkmals." In Cullen, *Das Holocaust-Mahnmal,* 145–57.

——."Zweierlei Opfer." In Cullen, *Das Holocaust-Mahnmal*, 104–9.

Miłosz, Czesław. "Dialogue about Wilno with Tomas Vençlova." In *Beginning with My Streets: Essays and Recollections*. New York: Farrar, Straus, and Giroux, 1991.

Mitchell, James. *Strategies for Self-Government: The Campaigns for a Scottish Parliament*. Edinburgh: Polygon, 1996.

Moeller, Robert G. *War Stories: The Search for a Usable Past in the Federal Republic of Germany*. Berkeley: University of California Press, 2001.

Molema, S. M. *The Bantu Past and Present*. Edinburgh: Green, 1920.

Montgomery, Tommie Sue. *Revolution in El Salvador: From Civil Strife to Civil Peace*. 2nd ed. Boulder, Colo.: Westview Press, 1995.

Mosse, George L. *Fallen Soldiers: Reshaping the Memory of the World Wars*. New York: Oxford University Press, 1990.

Müller, Jan-Werner. *Another Country: German Intellectuals, Unification, and National Identity*. New Haven, Conn.: Yale University Press, 2000.

Murray, K. *El Salvador: Peace on Trial*. London: Oxfam UK and Ireland, 1998.

Murray, K. and Tom Barry. *Inside El Salvador: The Essential Guide to Its Politics, Economy, Society, and Environment*. Albuquerque, N.Mex.: Resource Center Press, 1995.

Murray, K., Ellen Coletti, and Jack Spence. *Rescuing Reconstruction: The Debate on Post-War Economic Recovery in El Salvador*. Cambridge, Mass.: Hemisphere Initiatives, 1994.

Musial, Bogdan. "Bilder einer Ausstellung: Kritische Anmerkungen zur Wanderausstellung 'Vernichtungskrieg: Verbrechen der Wehrmacht 1941 bis 1944.'" *Vierteljahresheft für Zeitgeschichte* 47, no. 4 (1999): 563–91.

N. "Ken, Lelo Takhlit" [Indeed for No Purpose]. *Ba-Mahane* 59 (May 11, 1942): 11.

Naciones Unidas. *De La Locura a La Esperanza: La Guerra de 12 Años en El Salvador. Informe de La Comisión de la Verdad para El Salvador*. New York: United Nations, 1993.

Nairn, Tom. *After Britain: New Labour and the Return of Scotland*. London: Granta, 2000.

——. *Faces of Nationalism: Janus Revisited*. London: Verso, 1997.

——. "The Three Dreams of Scottish Nationalism." 1970. Repr. in Paterson, *A Diverse Assembly*, 31–39.

Naor, Mordechai, ed. *Yam ha-Melah u-Midbar Yehuda* [The Dead Sea and the Judean Desert, 1900–1967]. Idan Series no. 14. Jerusalem: Yad Yitzhak Ben-Zvi, 1990.

Nasson, Bill. *Abraham Esau's War: A Black South African War in the Cape, 1899–1902*. Cambridge: Cambridge University Press, 1991.

——. "Africans at War." In *The Boer War: Direction, Experience, and Image*, ed. by John Gooch. London: Frank Cass, 2000.

——. "Black Communities in Natal and the Cape." In *The Impact of the South African War*, ed. by David Omissi and Andrew Thompson. London: Palgrave, 2002.

——. *The South African War, 1899–1902*. London: Arnold Press, 1999.

——. *Uyadela Wen'osulapho: Black Participation in the Anglo-Boer War.* Johannesburg: Ravan, 1999.

——. "Waging Total War in South Africa: Some Centenary Writings on the Anglo-Boer War, 1899–1902." *Journal of Military History* 66, no. 3 (2002): 813–28.

——. "The War One Hundred Years On." In *Writing a Wider War: Rethinking Gender, Race, and Identity in the South African War, 1899–1902,* ed. by G. Cuthbertson, A. Grundlingh, and M-L. Suttie. Athens: Ohio University Press, 2002.

Neria, Moshe Zvi. "Hitabdut Lada'at: Giborei Metzada le-Or ha-Halakha" [Suicide: The Masada Heroes in View of the Jewish Law]. *Or ha-Mizrah,* Jan. 1961, 8–12.

Nolan, Mary. "Anti-fascism under Fascism: German Visions and Voices." *New German Critique* 67 (winter 1996): 33–55.

——. "The *Historikerstreit* and Social History." In Baldwin, *Reworking the Past,* 224–48.

Nolte, Ernst. "Vergangenheit die nicht vergehen will." In *Historikerstreit: Die Dokumentation der Kontroverse um die Einzigartigkeit der nationalsozialistischen Judenvernichtung.* Munich: Piper, 1987, 39–47.

Nora, Pierre. "Between Memory and History: Les lieux de mémoire." *Representations* 26 (1989): 7–25.

——. *Les lieux de mémoire.* Vol. 1. Paris: Editions Gallimard, 1984.

——. *Places of Memory* [Les lieux de mémoire]. Vols. 1–4. Chicago: University of Chicago Press, 1996.

——. *Realms of Memory: The Construction of the French Past.* 7 vols. New York: Columbia University Press, 1997.

Okamoto Mitsuo. "The A-Bomb Dome as World Heritage." *Japan Quarterly* 44, no. 3 (July–Sep. 1997): 40–47.

Olick, Jeffrey K., ed. "Memory and the Nation." Special issue, *Social Science History* 22, no. 4 (winter 1998).

Omissi, D., and A. Thompson, eds. *The Impact of the South African War.* London: Macmillan, 2002.

Oppenheim, Lois Hecht. *Politics in Chile: Democracy, Authoritarianism, and the Search for Development.* Boulder, Colo.: Westview Press, 1993.

O'Shaughnessy, Hugh. *Pinochet: The Politics of Torture.* New York: New York University Press, 2000.

Paces, Cynthia J. " 'The Czech Nation Must Be Catholic!' An Alternative Version of Czech Nationalism during the First Republic." *Nationalities Papers* 27, no. 3 (1999): 407–28.

Passerini, Luisa. *Memory and Totalitarianism.* Oxford: Oxford University Press, 1992.

Paterson, Lindsay. *The Autonomy of Scotland.* Edinburgh: Edinburgh University Press, 1994.

——, ed. *A Diverse Assembly: The Debate on the Scottish Parliament.* Edinburgh: Edinburgh University Press, 1998.

Pearce, J. *Promised Land: Peasant Revolution in Chalatenango, El Salvador.* London: Latin America Bureau, 1986.

Pearlman, Moshe. *The Zealots of Masada: The Story of a Dig.* New York: Charles Scribner's Sons, 1967.

Pelikan, Jaroslav. *Mary through the Centuries.* New Haven, Conn.: Yale University Press, 1996.

Peroutka, Ferdinand. *Budování státu.* 3rd ed. Vol. 1. Prague: Lidové noviny, 1991.

Pittock, Murray. *The Invention of Scotland: The Stuart Myth and the Scottish Identity, 1638 to the Present.* London: Routledge, 1991.

Plaatje, Sol. *Native Life in South Africa.* London: King, 1916.

Prevost, Gary, and Harry E. Vanden, eds. *The Undermining of the Sandinista Revolution.* New York: St. Martin's, 1997.

Pring-Mill, Robert. "The Roles of Revolutionary Song: A Nicaraguan Assessment." *Popular Music* 6, no. 2 (1987): 179–90.

Pynsent, Robert. *Questions of Identity: Czech and Slovak Ideas of Nationality and Personality.* Budapest: Central European University Press, 1994.

Quandt, Midge. "Unbinding the Ties: Popular Movements and the FSLN." *NACLA Report on the Americas* 26, no. 4 (1993): 11–14.

Rappaport, Joanne. *The Politics of Memory: Native Historical Interpretation in the Colombian Andes.* Cambridge: Cambridge University Press, 1990.

Rappoport, Uriel, ed. *Josephus Flavius: Historian of Eretz Israel in the Hellenistic-Roman Period.* Jerusalem: Yad Yitzhak Ben-Zvi, 1982.

Renc, Václav. *Pražská Legenda* [Prague Legend]. Prostejov: Credo, 1994.

Roberts, Martin. " 'World Music' and the Global Cultural Economy." *Diaspora* 2, no. 2 (1992): 229–41.

Roeder, George H., Jr. "Making Things Visible: Learning from the Censors." In Hein and Selden, *Living with the Bomb,* 73–99.

Rogel, Nakdimon. *Tel Hai: A Front without Rear.* Tel Aviv: Yariv-Hadar, 1979.

Rosen, Fred, and Deidre McFayden, eds. *Free Trade Economic Restructuring in Latin America.* New York: Monthly Review Press, 1995.

Rosenfeld, Gavriel D. *Munich and Memory: Architecture, Monuments, and the Legacy of the Third Reich.* Berkeley: University of California Press, 2000.

Rowe, William, and Vivian Schelling. *Memory and Modernity: Popular Culture in Latin America.* New York: Verso, 1991.

Russo, Henry. *The Vichy Syndrome: History and Memory in France since 1944.* Cambridge, Mass.: Harvard University Press, 1991.

Sakolsky, Ron, and Fred Wei-han Ho, eds. *Sounding Off! Music as Subversion / Resistance / Revolution.* New York: Autonomedia, 1995.

Samuel, Raphael. *Theatres of Memory: Past and Present in Contemporary British Culture.* New York: Verso, 1994.

Schwartz, Barry, Yael Zerubavel, and Bernice Barnett. "The Recovery of Masada: A Study in Collective Memory." *Sociological Quarterly* 27 (1986): 147–64.

Scott, Paul. *Towards Independence: Essays on Scotland.* Edinburgh: Polygon, 1991.

Scruggs, T. M. " 'Let's Enjoy as Nicaraguans': The Use of Music in the Construction of a Nicaraguan National Consciousness." *Ethnomusicology* 43, no. 2 (1999): 297–321.

——. "Musical Style and Revolutionary Context in Sandinista Nicaragua." In *I Sing the Difference: Identity and Commitment in Latin American Song*, ed. by Jan Fairley and David Horn, 117–34. Liverpool: Institute for Popular Music / University of Liverpool Press, 2002.

——. "Nicaragua." In *The Garland Encyclopedia of World Musics: South America, Mexico, Central America, and the Caribbean*, ed. by Dale Olsen and Daniel Sheehy, 747–69. New York: Garland, 1998.

——. "Socially Conscious Music Forming the Social Conscience: Nicaraguan *música testimonial* and the Creation of a Revolutionary Moment." In *From Tejano to the Tango: Popular Musics of Latin America*, ed. by Walter A. Clark, 41–69. New York: Routledge, 2002.

Sebesta, Edward. "The Confederate Memorial Tartan." *Scottish Affairs* No. 31 (spring 2000): 55–84.

Seifert, Jaroslav. *Hlava Panny Marie* [Head of the Virgin Mary]. Prague: Národní muzeum, 1998.

Shargel, Baila A. "The Evolution of the Masada Myth." *Judaism* 28 (1979): 357–71.

Shields, Rob. *Places on the Margin: Alternative Geographies of Modernity*. London: Routledge, 1991.

Shohat, Ella. "The Narrative of the Nation and the Discourse of Modernization: The Case of Mizrahim." *Critique* 10 (spring 1997): 3–18.

Silber, Irina Carlota. "A Spectral Reconciliation: Re-building Post-War El Salvador." PhD diss., New York University, 2000.

Silberman, Neil Asher. *Between the Past and the Present: Archeology, Ideology, and Nationalism in the Modern Middle East*. New York: Holt, 1989.

——. *A Prophet from Amongst You: The Life of Yigael Yadin—Soldier, Scholar, and Mythmaker of Modern Israel*. Don Mills, Ontario: Addison Wesley, 1993.

Silva, Nalin de. "Aliens." *Economic Review* 16, no. 2 (May 1990): 34.

Simonett, Helena. *Banda: Mexican Musical Life across Borders*. Middletown, Conn.: Wesleyan University Press, 2001.

Sivanandan, A. "Sri Lanka: A Case Study." In *Communities of Resistance: Writings on Black Struggles for Socialism*, 199–250. London: Verso, 1990.

Slyomovics, Susan. *The Object of Memory: Arab and Jew Narrate the Palestinian Village*. Philadelphia: University of Pennsylvania Press, 1998.

Snyder, Timothy. *The Reconstruction of Nations: Poland, Ukraine, Lithuania, Belarus, 1569–1999*. New Haven, Conn.: Yale University Press, 2003.

Sommer, Doris. *Foundational Fictions: The National Romances of Latin America*. Berkeley: University of California Press, 1991.

Šorm, Antonín, and Antonín Krejca. *Mariánské sloupy v Cechách a na Morave* [Marian Columns in Bohemia and Moravia]. Prague: Tisteno a vydáno u A. Danka, 1939.

Spence, Jack. "Competitive Party Balance: Following Left Gains in El Salvador's March Elections." *LASA Forum* 21, no. 2 (2000): 6–10.

Spence, Jack, David Dye, Mike Landrin, and Geoff Thale, with George Vickers. *Chapúltepec: Five Years Later: El Salvador's Political Reality and Uncertain Future.* Cambridge, Mass.: Hemisphere Initiatives, 1997.

Spies, S. B. *Methods of Barbarism? Roberts and Kitchener and Civilians in the Boer Republics, January 1900–May 1902.* Cape Town: Human and Rousseau, 1977.

Spillman, Lyn. *Nation and Commemoration: Creating National Identities in the United States and Australia.* Cambridge: Cambridge University Press, 1997.

Spooner, Mary Helen. *Soldiers in a Narrow Land: The Pinochet Regime in Chile.* Berkeley: University of California Press, 1994.

Stahler-Sholk, Richard. "Structural Adjustment and Resistance: The Political Economy of Nicaragua under Chamorro." In Prevost and Vanden, *The Undermining of the Sandinista Revolution,* 74–113.

Stephen, Lynn, Kelley Ready, and Serena Cosgrove. "Women's Organizations in El Salvador: History, Accomplishments, and International Support." In Krishna Kumar, ed. *Women and Civil War: Impact, Organization, and Action.* Boulder, Colo.: Lynn Rienner Publishers, 2001.

Sternhaell, Zeev. *The Founding Myths of Israel.* Princeton, N.J.: Princeton University Press, 1998.

Stoller, Paul. "Embodying Colonial Memories." *American Anthropologist* 96, no. 3 (1994): 634–48.

Tan Xu. *Yingchen huiyi lu* [Recollections of the Material World]. Repr. Shanghai: Shanghai foxue shudian, 1993.

Tanaka Nobumasa. *Senso no Kioku.* Tokyo: Ryokufu, 1997.

Taylor, Brian Brace. *Geoffrey Bawa.* Rev. ed. London: Thames and Hudson, 1995.

Thackeray, Henry. *Josephus: The Man and the Historian.* New York: Ktav, 1968.

Timerman, Jacobo. *Prisoner without a Name, Cell without a Number.* Trans. Toby Talbot. New York: Random House, 1981.

Tonkin, Elizabeth. *Narrating Our Pasts: The Social Construction of Oral History.* Cambridge: Cambridge University Press, 1992.

Trapl, Miloš. *Political Catholicism and the Czechoslovak People's Party in Czechoslovakia, 1918–1938.* Boulder, Colo.: Social Science Monographs, 1995.

Tula, Maria Teresa. *Hear My Testimony: Human Rights Activist of El Salvador.* Ed. by L. Stephens. Boston, Mass.: South End Press, 1994.

Tumarkin, Nina. *The Living and the Dead: The Rise and Fall of the Cult of World War II in Russia.* New York: Basic Books, 1994.

Turner, Victor. "Liminality and the Performative Genres." In *Rite, Drama, Festival, Spectacle. Rehearsals Toward a Theory of Cultural Performance,* ed. by John J. MacAloon, 19–41. Philadelphia: Institute for the Study of Human Issues, 1984.

Ulrich, Bernd, ed. *Besucher einer Ausstellung: Die Ausstellung "Vernichtungskrieg. Ver-*

brechen der Wehrmacht 1941 bis 1944" in *Interview und Gespräch*. Hamburg: Hamburger Institut für Sozialforschung, 1998.

Unger, Jonathan, ed. *Chinese Nationalism*. Australian National University Contemporary China Papers. Armonk, N.Y.: M. E. Sharpe, 1996.

Ungvary, Krisatián. "Echte Bilder—problematische Aussagen. Eine quantitative und qualitative Analyse des Bildmaterials der Ausstellung 'Vernichtungskrieg—Verbrechen der Wehrmacht 1941 bis 1944.'" *Geschichte in Wissenschaft und Unterricht* 50 (1999): 584–95.

Urban, Michael, Vyacheslav Igrunov, and Sergei Mitrokhin. *The Rebirth of Politics in Russia*. Cambridge: Cambridge University Press, 1997.

Vale, Lawrence. "Sri Lanka's Island Parliament." In *Architecture, Power, and National Identity*, 190–208. New Haven, Conn.: Yale University Press, 1992.

Valenzuela, Arturo. *The Breakdown of Democratic Regimes: Chile*. Baltimore: Johns Hopkins University Press, 1978.

Vardys, V. Stanley, and Judith B. Sedaitis. *Lithuania, the Rebel Nation*. Boulder, Colo.: Westview Press, 1997.

Venclova, Tomas. "Litauen: Das Erbe des Gediminas." In *Transit Europäische Revue*, no. 2 (summer 1991): 133–41.

Verdery, Katherine. *The Political Lives of Dead Bodies: Reburial and Postsocialist Change*. New York: Columbia University Press, 1999.

Verdugo, Patricia. *El Caso Arellano: Los zarpazos del Puma*. Santiago: CESOC, 1997.

———. *Interferencia secreta*. Santiago: Sudamericana, 1998.

Vila, Pablo. "Argentina's 'Rock Nacional': The Struggle for Meaning." *Latin American Music Review* 10, no. 1 (1989): 1–28.

Vilniaus Zermutines Pilies Rumai. Vols. 1–4. Vilnius: Lietuvos MA Istorijos Institutes, 1989, 1991, 1995, 1999.

Wagner Pacifici, Robin, and Barry Schwartz. "The Vietnam Veteran Memorial: Commemorating a Difficult Past." *American Journal of Sociology* 97, no. 2 (Sep. 1991): 372–420.

Wallace, Mike. *Mickey Mouse History and Other Essays on American Memory*. Philadelphia: Temple University Press, 1996.

Wang Liping. "Tourism and Spatial Changes in Hangzhou, 1900–1927." In *Remaking the Chinese City: Modernity and National Identity, 1900–1950*, ed. by Joseph Esherick, 107–20, 236–37. Honolulu: University of Hawai'i Press, 1999.

Warwick, P. *Black People and the South African War, 1899–1902*. Cambridge: Cambridge University Press, 1983.

Watson, Fiona. "The Enigmatic Lion: Scotland, Kingship and National Identity in the Wars of Independence." In Broun, Finlay, and Lynch, *Image and Identity*.

Watson, Rubie S., ed. *Memory, History, and Opposition under State Socialism*. Santa Fe, N.Mex.: School of American Research Press, 1994.

Weiner, Amir. "The Making of a Dominant Myth: The Second World War and the

Construction of Political Identities within the Soviet Polity." *Russian Review* 55, no. 4 (Oct. 1996): 638–60.

Weiner, Michael. "The Representation of Absence and the Absence of Representation: Korean Victims of the Atomic Bomb." In *Japan's Minorities: The Illusion of Homogeneity*, ed. by Michael Weiner, 79–107. New York: Routledge, 1997.

Weiss-Rosmarin, Trude. "Masada and Yavne." *Jewish Spectator* 31 (Nov. 1966): 4–7.

——. "Masada, Josephus, and Yadin." *Jewish Spectator* 32 (Oct. 1967): 28, 30–32.

——. "Masada Revisited." *Jewish Spectator* 34 (Dec. 1969): 3–5, 29.

——. "Reflections on Leadership." *Jewish Spectator* 33 (March 1968): 2–5.

Weitz, Yosef. *Seviv Metzada* [Around Masada]. Jerusalem: Sifriyat Adama, 1963.

Welch, Holmes. *The Buddhist Revival in China*. Cambridge, Mass.: Harvard University Press, 1968.

Wiedmer, Caroline. *Representation of the Holocaust in Contemporary Germany and France*. Ithaca, N.Y.: Cornell University Press, 1999.

Winn, Peter. *Weavers of Revolution: The Yarur Workers and Chile's Road to Socialism*. New York: Oxford University Press, 1986.

Withers, Charles. "The Historical Creation of the Scottish Highlands." In McDonnachie and Whatley, *The Manufacture of Scottish History*, 143–56.

Witz, L., G. Minkley, and C. Rassool. "No End of a (History) Lesson: Preparations for the Anglo-Boer War Centenary Commemoration." *South African Historical Journal* 41 (1999): 370–87.

Wolff, David. *To the Harbin Station: The Liberal Alternative in Russian Manchuria*. Stanford, Calif.: Stanford University Press, 1999.

Wood, Elisabeth J. *Forging Democracy from Below: Contested Transitions in South Africa and El Salvador*. Cambridge: Cambridge University Press, 2000.

World Bank. *El Salvador: Rural Development Study*. Washington, D.C.: World Bank, 1998.

Wyman, Matthew. *Public Opinion in Postcommunist Russia*. Birmingham: University of Birmingham Press, 1997.

Yadin, Yigael. *Masada: Herod's Fortress and the Zealots' Last Stand*. New York: Random House, 1966.

——. Introduction to *Masada*, a brochure prepared by Mikha Livne and Ze'ev Meshel, issued by the National Parks Authority, n.d.

Yang, Rongqui, and Xie Zhongtian. *Tianjie yicai: Haerbin zhongyang dajie* [Heavenly Street of Many Splendors: Harbin's Central Street]. Beijing: Jiefangjun wenyi chubanshe, 2000.

Yoneyama, Lisa. "Memory Matters." In Hein and Selden, *Living with the Bomb*, 202–31.

Young, James E. *At Memory's Edge: After-Images of the Holocaust in Contemporary Art and Architecture*. New Haven, Conn.: Yale University Press, 2000.

——. *The Texture of Memory: Holocaust Memorials and Meaning*. New Haven, Conn.: Yale University Press, 1993.

Yudkin, Leon I. *Isaac Lamdan: A Study in Twentieth Century Hebrew Poetry.* Ithaca, N.Y.: Cornell University Press, 1971.

Yui Daizaburo. "Between Pearl Harbor and Hiroshima / Nagasaki: Nationalism and Memory in Japan and the United States." In Hein and Selden, *Living with the Bomb,* 52–72.

——. *Nichibei sensokan no sokoku.* Tokyo: Iwanami Shoten, 1995.

Zeitlin, Solomon. "Masada and the Sicarii: The Occupants of Masada." *Jewish Quarterly Review* 55 (April 1965): 299–317.

——. "The Sicarii and Masada." *Jewish Quarterly Review* 57 (April 1967): 251–70.

——. "The Slavonic Josephus and the Dead Sea Scrolls: An Exposé of Recent Fairy Tales." *Jewish Quarterly Review* 58 (Jan. 1968): 173–203.

Zelizer, Barbie. *Remembering to Forget: Holocaust Memory through the Camera's Eye.* Chicago: University of Chicago Press, 1998.

Zertal, Idith. "Ha-Me'unim vcha Kedoshim: Kinuna shel Martirologia Le'umit" [The Tortured and the Martyrs: On the Construction of a National Martyrology]. *Zemanim* (spring 1994): 26–45.

Zerubavel, Yael. "The 'Death of Memory' and the Memory of Death: Masada and the Holocaust as Historical Metaphors." *Representations* 45 (winter 1994): 72–100.

——. *Recovered Roots: Collective Memory and the Construction of Israeli National Memory.* Chicago: University of Chicago Press, 1995.

Zhang, Fushan, ed. *Lishi huimou—20 shij de Harbin. Harbin shihua* [A Glance Back at History—Harbin's Twentieth Century: Historical Words on Harbin]. Harbin. Harbin chubanshe, 1998.

Zhang, Fushan, and Zhou Shuxiu. *Harbin geming jiuzhi shihua* [History of the Original Sites of the Revolution in Harbin]. Harbin: Heilongjiang renmin chubanshe, 1995.

Zilinsaite, Julija, ed. *Lietuvos laisves sajudis* [The Lithuanian Freedom Movement]. Vilnius: Lietuvos Nacionalinis Muziejus, 1998.

Zimmerman, Marc. 1991. "Testimonio in Guatemala: Payera, Rigoberta and Beyond." *Latin American Perspectives* 71 (18) 4: 22–47.

Ziv, Yehuda. "Lichbosh et ha-Har: Rishonei ha-Ma'apilim el ha-Har" [To Conquer Masada: The First to Climb the Mountain]. *Cathedra* 90 (1998): 115–44.

Zolov, Eric. *Refried Elvis: The Rise of the Mexican Counterculture.* Berkeley: University of California Press, 1999.

Zubkova, E. Yu. *Obshchestvo I Reformy, 1945–1964.* Moskva: IzdTsentr "Rossiia Molodaia," 1993.

Zukas, Saulius. *Lithuania: Past, Culture, Present.* Vilnius: Baltos Lankos, 1999.

Zwerling, Philip. *Nicaragua: A New Kind of Revolution.* Westport, Conn.: L. Hill, 1985.

DISCOGRAPHY

Macolla. *Macolla y sus exitos*. MA 1000. CD [n.d.].

Mejía Godoy, Carlos y los de Palacagüina. *Azúcar y pimienta*. Mántica-Waid. CD [1996].

Mejía Godoy, Carlos and Luis Enrique. *Astillas del mismo canto*. Mántica-Waid. CD [1999].

Nicaragua Boys. *Nicaragua*. Herisson vert 54104. CD [1996].

Pastor, Luis. *Solo Sueños*. Nicarib NCD-007. CD [1998].

Various. *Cantautores de Nicaragua—volcanto*. ASCAN. AV 003. CD [1999].

Various. *Nicaraguan Folk Music from Masaya*. Flying Fish Records 474. LP. Comp. T. M. Scruggs [1988].

Various. *Vocanto Joven*. Managua. ASCAN. ACD 004. CD [1999].

NOTES ON CONTRIBUTORS

JAMES CARTER is assistant professor of history at Saint Joseph's University in Philadelphia, where he teaches courses on East Asian History. He is author of *Creating a Chinese Harbin: Nationalism in an International City, 1916–1932* (Ithaca, N.Y.: Cornell University Press, 2002).

JOHN CZAPLICKA is an art and cultural historian and chair of the German Study Group at Harvard's Center for European Studies. Among his most recent publications are two edited volumes: *L'viv, Lwów, Lvov, Lemberg: A City in the Crosscurrents of Cultures* (Cambridge, Mass.: Harvard University Press, 2003); and, with Blair Ruble, *Composing Urban Histories* (Baltimore: Johns Hopkins University Press, 2003). He is currently researching the rewriting of urban histories in post-Communist East-Central Europe.

KANISHKA GOONEWARDENA is an assistant professor in the Programme in Planning, Department of Geography, University of Toronto. He teaches urban design, planning, and critical theory, and he has written on globalization, postmodernity, urbanism, and nationalism in Sri Lanka, Los Angeles, and Toronto.

LISA MAYA KNAUER is an assistant professor of anthropology and African / African-American Studies at the University of Massachusetts at Dartmouth, a member of the *Radical History Review* editorial collective, and a documentary filmmaker. She was a founding member of the artists' collective REPOhistory, which created numerous public history / art installations between 1991 and 2000. Her publications include chapters in *Queer Spaces* (Seattle: Bay Press, 1997) and *Mambo Montage! The Latinization of New York* (New York: Columbia University Press, 2001).

ANNA KRYLOVA is an assistant professor of modern Russia and the Soviet Union at Duke University. She is currently working on a book entitled "Beyond Marx and Enlightenment: From Organic Bolshevism to Soviet Culture, 1880s–1930s." Her publications have focused on Soviet and Russian identity and culture and its generational and gender aspects during the Soviet and post-Soviet years. She has also written on American and Russian historiography.

TERESA MEADE teaches Latin American History at Union College. She is the author of *A Brief History of Brazil* (New York: Facts on File, 2003) and *"Civilizing" Rio: Reform and Resistance in a Brazilian City, 1889–1930* (University Park: Pennsylvania State University Press, 1997). She is coeditor (with Merry E. Wiesner-Hanks) of *A Companion to Gender History* (Oxford: Blackwell Publishing Ltd., 2004).

BILL NASSON is a professor of history at the University of Cape Town and an editor of *The Journal of African History*. His publications include *Abraham Esau's War* (Cambridge, U.K.: Cambridge University Press, 1991; repr. 2002); and *The South African War, 1899–1902* (New York: Arnold, 1999). His concise history of British imperialism, *Britannia's Empire* (Gloucestershire: Tempus), is due out in 2004.

MARY NOLAN is professor of history at New York University. She is the author of *Visions of Modernity: American Business and the Modernization of Germany* (New York: Oxford University Press, 1994); and is coeditor of a collection of essays entitled *Crimes of War: Guilt and Denial in the Twentieth Century* (New York: New Press, 2003). She is currently writing on anti-Americanism.

CYNTHIA PACES earned her PhD in East-Central European history from Columbia University. She is an associate professor of history at the College of New Jersey, where she teaches courses on European and women's history. She has published numerous articles on Eastern Europe, national memory, and gender and is currently writing a book about national and religious symbols in Prague.

ANDREW ROSS is professor of American Studies at New York University, and the author of several books, including, most recently, *Low Pay, High Profile: The Global Push for Fair Labor* (New York: New Press, 2004) and *No Collar: The Humane Workplace and Its Hidden Costs* (New York: Basic Books, 2003). He has also edited several books, including, most recently (with Kirstein Ross), *Anti-Americanism* (New York: NYU Press, 2004), and *No Sweat: Fashion, Free Trade, and the Rights of Garment Workers* (New York: Verso, 1997).

T. M. SCRUGGS, ethnomusicologist and musician, is associate professor at the University of Iowa. He has published in audio, video, and print format on Central American music and dance. His research on Trinidadian steel pan is forthcoming in *Multidisciplinary Perspectives on Musicality* (Iowa City: University of Iowa Press) and on jazz saxophonist Von Freeman in *Current Musicology* 71–73:179–99 (2003). He will guest edit the forthcoming issues of *World of Music* (on global religions' impact on local musical practice) and the *Revista de Historia* [Managua, Nicaragua] entitled "Music as Social Protagonist in Nicaragua, 1960–1979."

DANIEL SELTZ was a Fulbright Fellow at Hiroshima University from 1997 to 1998. Coauthor, with Jonathan Krasno, of *Buying Time: Television Advertising in the 1998 Congressional Elections* (New York: Brennan Center for Justice, 2000), he is a recent graduate of New York University School of Law.

IRINA CARLOTA SILBER received her PhD in cultural anthropology from New York University in September 2000. She has been a Postdoctoral Fellow at the Rutgers Center for Historical Analysis, a Rockefeller Fellow at the Virginia Foundation for the Humanities, and, in 2003 and 2004, a Visiting Scholar at New York University. She is currently completing her book, based on her dissertation, tentatively titled, *Broken Promises and Bankrupt Dreams: Rebuilding Post-War El Salvador*. Her work is a gender analysis of postwar reconstruction processes in Chalatenango, El Salvador, a former conflict zone.

DANIEL J. WALKOWITZ is the director of College Honors and professor of history at New York University. He is the author of *Working with Class: Social Workers and the Politics of Middle-Class Identity* (Chapel Hill: University of North Carolina Press, 1999); and *Worker City, Company Town: Iron and Cotton-Worker Protest in Troy and Cohoes, New York, 1855–84* (Urbana: University of Illinois Press, 1978). He has edited, with Lewis H. Siegelbaum, *Workers of the Donbass Speak: Survival and Identity in the New Ukraine, 1989–1992* (Albany: SUNY Press, 1995); with Michael H. Frisch, *Working-Class America: Essays on Labor, Community, and American Society* (Urbana: University of Illinois Press, 1983); and, with Peter N. Stearns, *Workers in the Industrial Revolution: Recent Studies of Labor in the United States and Europe* (1974).

YAEL ZERUBAVEL is the founding director of the Allen and Joan Bildner Center for the Study of Jewish Life and the chair of the Department of Jewish Studies at Rutgers, The State University of New Jersey. She is the author of *Recovered Roots: Collective Memory and the Making of Israeli National Tradition* (Chicago: University of Chicago Press, 1995), which won the 1996 Salo Baron Prize of the American Academy for Jewish Research. She has been studying the representation of patriotic sacrifice in Israeli culture and is currently working on a book, *Desert Images: Visions of the Counter-Place in Israeli Culture*.

Library of Congress Cataloging-in-Publication Data
Memory and the impact of political transformation in public
space / Daniel J. Walkowitz and Lisa Maya Knauer, editors.
p. cm. — (Radical perspectives)
Includes bibliographical references and index.
ISBN 0-8223-3377-5 (cloth : alk. paper) — ISBN 0-8223-3364-3
(pbk. : alk. paper)
1. Monuments—Political aspects. 2. Memorials—Political
aspects. 3. Public art—History—20th century. 4. Art and
state—History—20th century. 5. National characteristics.
I. Walkowitz, Daniel J. II. Knauer, Lisa Maya, 1956–
III. Series.
NA9345.M46 2004
720′.1′03—dc22 2004011862